The Sexual Perspective

First published in 1986 to wide critical acclaim, *The Sexual Perspective* breaks new ground, bringing together and discussing the work of artists who are gay/lesbian/queer/bisexual. For the first time, painting, sculpture and photography which reflect the artist's sexual orientation are freely talked about and analysed, and placed within their artistic, social and historical context. The book challenges the conventional view that issues of sexual identity have no place within art.

The Sexual Perspective traces the influence of Renaissance concepts on later generations of artists; it also looks at the way photography has been appropriated to express a range of sexual interests and scrutinises the codes used by artists to convey feelings and emotions which can not be openly shown. Artists discussed include Duncan Grant, Ethel Walker, Francis Bacon, David Hockney, Andy Warhol, Duane Michals, Robert Mapplethorpe, Harmony Hammond and Jody Pinto. Emmanuel Cooper's broad approach includes discussion of the lives of gay/lesbian/queer/ bisexual artists to illuminate their work, particularly in view of social and legal constraints. Other themes include the limitations of representation and the role of art in defining and shaping attitudes. Since the first publication of *The Sexual Perspective*, two significant developments have taken place: in a new and fully illustrated chapter, Cooper discusses increased lesbian visibility within the visual arts, and the thoughtful response to the AIDS epidemic.

Cooper writes clearly and entertainingly about art, sexuality and gender. Lavishly illustrated, often with rarely seen images, the author's text is a vital contribution to current debates about art, gender, identity and sexuality.

Emmanuel Cooper is a widely respected critic, author, broadcaster and film maker. He has written extensively on art and sexuality for such journals as *Gay Times* and *Creative Camera*, and on art for *Time Out* and *Tribune*. His many books include *Fully Exposed: The Male Nude in Photography* (1991).

'A coherent and tight art history ... a truly groundbreaking book.'
City Limits

'A treasure trove of gay artists and artworks of the last 100 years.'
The Philadelphia Inquirer

'An excellent overview.'
Feminist Bookstore News

'*The Sexual Perspective* not only abounds with fascinating information and insight but is an invaluable historical overview of mainly lesbian and gay artists over the past 100 years. ... It presents a vast variety of lesbian and gay artistic expression and importantly paves the way for potentially stimulating and enriching developments for our thoughts and feelings about sexuality. Emmanuel Cooper is to be congratulated for his efforts in providing us with a stimulating book, which doubtless many will find an enduring source of enlightenment and pleasure.'
Lesbian and Gay Socialist

'Earnest, comprehensive and profusely illustrated ... Cooper deserves credit for tracking down a horde of specimens and outlining each one's life and work. ... All future attempts to come to terms with modern gay culture will have to consult what amounts to an encyclopedia of gay art history. ... Cooper has performed an invaluable service by surveying most of the known ground.'
The Advocate

'Emmanuel Cooper is the most indefatigable chronicler of lesbian and gay art in Britain. ... An extraordinary amount of work has gone into the researching of this book which opens up long vistas of possibility for other writers to explore in its wake. It is a remarkable achievement, and another milestone in gay cultural history.'
Gay Times

'The standard work on the subject ... Emmanuel Cooper has done us a great service writing *The Sexual Perspective* by tracing the origins of gay art and its development to the present day, and letting us see — for it is lavishly illustrated — the products of their endeavours.'
Scots Men

THE SEXUAL PERSPECTIVE

Homosexuality and Art in the Last 100 Years
in the West

Second Edition

Emmanuel Cooper

London and New York

First published 1986
by Routledge & Kegan Paul

Second edition published 1994
by Routledge
11 New Fetter Lane, London EC4P 4EE

Simultaneously published in the USA and Canada
by Routledge
29 West 35th Street, New York, NY 10001

Printed and bound in Great Britain by
Butler & Tanner Ltd, Frome and London

British Library Cataloguing in Publication Data

A catalogue record for this book is available from the British Library

Library of Congress Cataloging in Publication Data

Cooper, Emmanuel.
 The sexual perspective: homosexuality and art in the last 100
years in the West / Emmanuel Cooper.
 p. cm.
 Previously published: 1986.
 Includes bibliographical references and index.
 1. Homosexuality and art. 2. Art, Modern—19th century. 3. Art,
Modern—20th century. I. Title.
 N72.H64C66 1994
 701'.03—dc20 93–41921

ISBN 0-415-11100-5 0-415-11101-3 (pbk)

To David

WEST GRID STAMP						
NN		RR	2/95	WW		
NT		RT		WO		
NC		RC		WL		
NH		RB		WM		
NL		RP		WT		
NV		RG		WA		
NM		RW		WR		
NB		RV		WS		
NE						
NP						

Contents

Illustrations

Acknowledgements

Writing a book which ranges so widely over so many areas has involved the time and patience of many friends and acquaintances. All have generously supplied information, given advice and made suggestions. It is not possible to mention everyone but I would particularly like to mention the help given by Barry Prothero and to acknowledge the generosity of David Cheshire, Librarian at Cat Hill, Middlesex Polytechnic, in searching out references. Others who have commented on various chapters or who have made constructive suggestions include Jeffrey Weeks, David Horbury, Nigel Young, Simon Watney, Sarah Benton, Tony Benn, Peter Bradley, Judy Collins, Jeffery Daniels, Michèle Fuirer, Ed Hermance, Alison Henegan, Francis King, François de Louville, Frances Partridge, Edward Lucie-Smith, David Locker, Richard Shone, Richard Ormrod, Timothy d'Arch Smith, Michael Regan, Bryan Robertson, Professor Trevor Thomas, John Russell Taylor, Tom Wakefield, and Peter Webb. Lastly I want to thank all the artists who have provided illustrations or spoken openly about their work and themselves. Without them this book would not have been possible.

Introduction

Artistic', 'aesthetic', 'musical' or 'sensitive' have all been terms used to suggest male homosexuals. The profession of the artist has traditionally offered homosexuals an outlet for their sensitivity, a place where, however limited, some expression of their sexuality can be made without fear of ridicule or dismissal, a relatively safe community within which some sort of identity could be established. The Gay Liberation Movement, taking up many of the ideas developed within the Women's Movement, has brought a new awareness of how homosexuality has been and is represented in the arts. Recent studies of film, literature and poetry have examined the attitudes implicit within the way gay men and lesbians have been described and throw new light on to the often veiled imagery, the coded references and the stereotypical representations of homosexuality.[1] The visual arts have so far received only cursory attention.[2] The work of individual artists has been studied but no writers have brought together the work of artists who were, or are, 'homosexual' (a term used in this Introduction to describe both men and women) or attempted to look at how their sexuality has been expressed in their art. This is the aim of *The Sexual Perspective*.

The book first and foremost documents the lives, experiences and work of western artists who were or are 'homosexual', particularly in the last one hundred years. Whenever possible this is set within the social, economic, legal and artistic constraints of their times. The bringing together of the lives and work of such artists constructs the individual response into a fascinating and revealing collective history. Such a study highlights three significant points particularly relevant to the visual arts.

The first is how and to what extent the artists' own awarenesses of themselves as homosexuals has influenced their work, and where relevant this is discussed. The second is how, given the cultural modes and social

attitudes of society, artists have achieved both a self-representation and questioning of their sexuality. Such self-representation both reflects and contributes to a growing awareness of the gay identity in contemporary society. This work is discussed in detail in the final two chapters.

The third and most important concern is defining who was or was not 'homosexual'. The term itself is comparatively modern and its meaning has changed over the years. Equally, details of artists' lives are not always known; direct evidence in the form of letters, diaries and writings makes for clearer recognition but this is more problematic when evidence is circumstantial or based on studio gossip, accusations, artists' relationships and on particular sorts of images in their work. Close friendships between members of the same sex, though often significant, do not necessarily indicate that the relationship is homosexual.

The concept of what constitutes 'the homosexual' has altered greatly over the last five hundred years and this has influenced the expression of homosexual desire. For instance, in Renaissance Italy the homosexual as we think of him/her today did not exist. Expressions of love (such as those found in Michelangelo's poetry for other men) and sexual acts between men were well known, and, if made public, condemned. Leonardo da Vinci and Botticelli were accused publicly of such acts. Yet they were thought of as committing such acts rather than as 'homosexual'. Since then, particularly in the last one hundred years, a major change has been the emergence of the homosexual as an identity separate from the heterosexual.[3] The term 'homosexual', meaning someone who has an emotional as well as a sexual identity with members of the same sex, was not coined until 1869. The use of the term 'gay' to signify the homosexual's chosen form of identity has only come into widespread use in the West in the last fifteen or twenty years.

In the book I concentrate throughout exclusively on artists who may be considered to have defined themselves as homosexual or had significant relationships with members of their own sex. *The Sexual Perspective* allows us to see how the feelings of homosexual artists *can*, but need not, become the basis of either covert or explicit identities and self-affirmations. The book also explores to what extent art reflects, and to what extent it contributes to, the gradual emergence of open lesbian/gay identities.

The major concerns of the book are with painting, sculpture and photography produced in the last one hundred years in Britain, the USA and France. The first chapter by way of background describes the great flowering of painting and sculpture by men whose sexual orientation was towards other men, that took place in the patriarchal society of Renaissance Italy. The major part of the book deals with the work of artists in the last one hundred years. Most, though not all of the artists have been concerned with aspects of representational rather than abstract art.

This book does not, however, set out to be a 'Who's Who' of artists who were or are homosexual. Many artists have not been included through pressure of space and some artists are discussed because of their influence on, rather than their sexual relationships with, artists who were homosexual.

Writing in the *International Journal of Sexology* (vol. 8, no. 1) 'Homosexuality and the Arts', Michail Alexander wrote 'Nothing affects [the artist's] work in a more direct way than sex. It affects practically every aspect of art, may it be productive or reproductive art.' Alexander's implication that sexual desire will manifest itself in an artist's work suggests that if we look carefully we will see evidence of it. However, the question of how homosexual desire has been expressed and the modes it can take has not been discussed and this is one of the principal aims of this book.

Representations of same-sex love have been made many times in the past. Mythology, religion and history have provided a wealth of material and many examples of homosexual love which have inspired artists. The story of Ganymede and Jupiter is one of the most common, while the notion of the androgyne (a word formed from the Greek 'andro' meaning male, and 'gyne', female) suggests a blend of both sexes and provided a subtle way of suggesting a 'third sex' which could be homosexual. The androgyne was used by Leonardo da Vinci and the artists of the aesthetic movement amongst others, though for slightly different reasons. More recently artists working today have used the androgyne to question the contemporary stereotypes of masculinity and femininity.

Religion too has provided a wealth of incidents and relationships which when presented in a particular way can suggest homosexuality. The nakedness of St Sebastian, for example, has been used not to show the humiliation of the saint but as an excuse for a display of the male naked body. The strong relationship between David and Jonathan continues to provide a means of suggesting the sensitivities of the homosexual presence.

Between men the idea of close, romantic or intense friendships carries the possibility that such relationships may be regarded as homosexual. This occurred less frequently for women. In the nineteenth century, outside of heterosexual relationships women had no independently defined sexuality, though many struggled and protested against this. Some women found the context of close friendships a means of expressing emotional and perhaps sexual feelings for other women. Whether such relationships can be described as lesbian has become a major debate within the Women's Movement. Carroll Smith-Rosenberg in 'The Female World of Love and Ritual'[4] put emphasis on genital contact to define heterosexuals and homosexuals, while Marjorie Housepian Dobkin in

The Making of a Feminist: Early Journals and Letters of M. Carey Thomas explains that the term 'lesbianism' is today used to imply both emotional and physical involvement.[5] However, Lillian Faderman[6] argues that a lesbian *sexual* identity is in fact a male imposition and that to question female–female relationships on the basis of male–male relationships is an extension of male analysis. In this book I have taken broad working definitions of homosexuals which refer to female–female and male–male eroticism.[7]

Both men and women are included in *The Sexual Perspective*, even though the identities they seek to establish are very different and though both have experienced different oppressive attitudes of society. Women have generally had so little status (or a very defined status) or power in Western society that it has been considered unnecessary to control their sexual activity. The notorious Labouchere Amendment in Britain, making all homosexual acts between men illegal did not extend to women because such sexual expression between females was not thought possible.

A primary struggle for women has been to achieve independence from male domination. While there have been no legal constraints to prevent lesbians from expressing their sexuality, the difficulties of achieving sufficient financial and social independence to do this were often overwhelming. To find a 'voice' to do this has been even more problematic. Significantly, the expression of lesbian feelings was by artists who were both rich and sufficiently independent to set up their homes in other countries. The French nineteenth-century artist Rosa Bonheur wanted to achieve equal artistic status with men. Her challenge to the male-dominated academies of France and England was not by her radical artistic ideas but by being a better and more successful academic artist. Her own lesbian sexuality was expressed only indirectly in her work. In contrast the work of the American artist Romaine Brooks was concerned with making her life as a lesbian a central feature. Extremely wealthy, and without the financial restraints of having to produce commercial work or the need for patrons, she could afford to follow her own ideas, painting only the pictures she wanted in a style which expressed her feelings.

Within the Women's Movement in the last twenty years important debates questioning artistic values and male-dominated practice have brought a new awareness of how art reflects the ideology of the society in which it was produced.[8] Feminists have challenged many of the notions of the objectivity of art and aesthetics. However, almost none of the feminist studies on women artists (with one or two notable exceptions[9]) have even mentioned, let alone discussed, lesbianism. Only recently in Britain have small groups of women artists raised the particular concerns of lesbians. In America, especially in the last few

years, some lesbian artists have made their sexuality central to their work, concentrating not only on representations but also on the emotional and physical aspects of love between women.

It is of little surprise that given the legal, social and religious restraints on male homosexuals, few were able to deal with their sexuality in their work. For example, it was not until the publication of official records from the archives of Florence in 1896 that it was known that accusations of homosexual behaviour had been made against Leonardo da Vinci in 1476. The deliberate suppression of such information ensured that his reputation as an 'asexual' artist, 'married to his art', continued and that the great genius was not tarnished by being thought homosexual. In England it was not until 1967 that some homosexual acts between males were decriminalised. In the USA the laws vary from state to state: in some states homosexual acts fall within other broader restrictions while in others homosexual acts are not forbidden. On the Continent in general the legal position again varies from country to country.

Legal restraint, social taboo and religious dogma not only limited open expression by artists who were homosexual but also helped shape society's disapproving attitudes: nevertheless homosexual expression was not eliminated. The results of being 'found out', however, the fear of exposure and the guilt of being homosexual have been powerful forces in driving homosexuals underground. The result of 'exposure' can nowhere be better demonstrated than in the life and work of the English artist Simeon Solomon. After his trial and conviction for a minor homosexual offence in 1873 many of his friends turned against him even though they were perfectly well aware of his sexual activities before his arrest. Some artists, such as George Reynolds, who were homosexual left the country for fear of being implicated in similar behaviour. Indeed, many artists have only been able to establish a life for themselves away from their homeland.

In patriarchal societies in which men have the greatest access to power, to be a male homosexual is to be 'less than a man', or to be 'like a woman'. In a society in which art is thought to be 'women's work' male artists have often been thought of (incorrectly) as homosexual. It is not without irony that some of the most talented and creative artists of the Renaissance were homosexuals. While this was not mere accident, it is not intended to uphold the theory that the majority of artists are homosexual.

Just as there is no category 'women's art', there is no question of attempting to define 'gay art'. By openly discussing the homosexual presence in art, the concept of art being removed from everyday life is challenged and the formalist argument that places the emphasis on the analysis of formal elements rather than on content of art is questioned. All artists respond to the society of which they are a part in particular

ways. The homosexual artist's response is governed by concerns which heterosexuals do not have and it is this which forms a large part of this book. When artists who are homosexual are denied the means to express their sexuality, their art itself may become that means, even if this demands changing or subverting art.

There is no space in this book to discuss homosexual subjects painted by artists who were not, as far as is known, homosexual.[10] However, homosexual subjects of paintings by such artists as Courbet, Jules-Robert Auguste, Ingres or Toulouse-Lautrec, who all showed lesbian love scenes, demand some comment for the light they throw on contemporary attitudes. The scenes these artists painted are titillatory and also serve a function in relieving the tensions of repressed sexuality within the male viewer. By transferring the homosexual content on to members of the opposite sex, it makes a subject safe and hence non-threatening. At the same time, it still allows it to have an existence in the world. Such representations by heterosexuals of male homosexuality are rare.

The knowledge that an artist was or is homosexual is not intended to 'explain' their work nor is it to suggest a particular context within which to view it. It is, rather, the start of a process to look again and recover what has traditionally been omitted from the history of art using this to inform the present. What we can do most profitably is re-examine the work and lives of artists to search out from secrecy, prejudice, distortion and myth the homosexual presence and its wider significance in identifying homosexual expression.

Within the last twenty years or so, attitudes and responses have broadened. The laws regulating homosexuality have generally relaxed, social stigma, though still present, is less acute and the growth of the Gay Liberation Movement has raised consciousness and awareness of oppressive attitudes. The appearance of 'confessional' paintings such as those by David Hockney in the early 1960s has made it much easier for homosexual artists to take homosexuality as their subject matter if they wish. Also an awareness of the 'homosexual tradition' whether in literature, poetry or in film has been a means for homosexual artists to begin to create an identity in a society dominated by heterosexual values. Likewise the growth of the lesbian and gay subculture has given rise to various diverse representations of homosexuality. All have found a place in art.

All art builds upon previous art, whether it is by tearing it down or developing it; today artists who are homosexual have a wide number of responses; some want to celebrate their homosexuality, some to use it to comment on the world, others to take existing meanings of images to subvert accepted ideas and notions.

But even today some people still regard homosexuality as a stigma or, in looking at art, an irrelevance. Owners have refused permission for

pictures to be included, some artists and art historians have refused to co-operate in open discussions of the subject or to contribute to *The Sexual Perspective*. If this book helps to make the homosexual presence in art more public and encourages artists to take it as their subject matter, then it will have achieved much.

Emmanuel Cooper
London May 1986

Introduction to Second Edition

Since the first publication of *The Sexual Perspective* in 1986, the production of art by artists who are gay or lesbian has been prolific. Two major themes have emerged. The first is the greatly increased lesbian visibility within the visual arts, with exhibitions and books raising relevant and challenging ideas about lesbian identity and detailing the way many lesbians have reacted against the idea that the audience for their work should be controlled, insisting instead that its rightful place in the mainstream, to be seen alongside all other art. The other major theme has been the thoughtful response by artists to the AIDS epidemic. AIDS activists have engaged with social issues on a broad front; in the USA they have attacked government inactivity and business interests, and confronted prejudice with well-designed and effective combinations of graphics and text, arguing that art has the power to save lives. Artists working within the context of art galleries have also taken AIDS as their subject matter, using metaphor and a wide range of references to convey concern, make comment and express anger.

Coverage in the gay and the art press has been extensive. Art journals such as *Art in America* and *Artforum* have carried reports and thoughtful reviews of AIDS-related work. Single and mixed exhibitions by artists have demonstrated the breadth and extent of individual vision, both in reflecting and in some cases helping to shape changing gay identity, and in bringing a new awareness of the impact of the AIDS epidemic. Monographs on individual artists, such as those published by Gay Men's Press in the UK, but distributed round the world, have found both a sizable and an informed audience. Wider surveys like Tessa Boffin and Jean Fraser's *Stolen Glances: Lesbians Take Photographs* have added greatly to the growing body of critical literature on visual art and photography in particular.

As well as detailing the work of significant artists, the new chapter in this edition touches on some of the problems facing visual artists. These include the difficulties and limitations of representation, and the need to extend the audience for the work. What is clear is that much of the work expresses a new-found confidence which builds upon accepted modes of representation. Some of this strength is conveyed in the concept of 'queer art', an expression of diversity which challenges conventional identities, insisting that homosexual men and women demand equality on their own terms. The role of art in defining and shaping attitudes and ideas as well as celebrating homosexual diversity is now well established—aspects taken up and further explored in this new edition.

Emmanuel Cooper
London, January 1994

1 · The Mirror of the Soul

The great resurgence of interest in Greek art and thought that was a fundamental part of the Italian Renaissance took the perfect male nude as the ideal physical form, able to convey the finest qualities of strength, courage, vitality, nobility, energy and intelligence. While the female nude was descriptive of a particular form of sensuality, the male nude evoked the idea of the perfect society in which man could relate freely and possibly sexually. The perfect male form was considered the mirror of the soul. Conventionally, the male nude in art was thought to be as close to sexual neutrality as the human body could achieve, possessing noble proportions, ideal muscle formations, fine skin quality, well-modelled facial features and strong, alert posture.

If the Greeks aimed to achieve the perfect, sexually neutral body, this was rarely the intention of Renaissance artists who conveyed the all too human qualities of sexual desire by placing the figures in their work in specific situations. The depiction of the male nude was dominated by the expressive brilliance of Michelangelo Buonarroti and by the more scientific approach of Leonardo da Vinci. Other artists responded to their genius and were influenced by their work and ideas. In Northern Europe, the work of Albrecht Dürer had a similar powerful effect.

Within certain privileged sections of Renaissance society homosexuals could be relatively open about their sexual desires while artists could express homosexual subject matter through the use of myth, legend and religion. Dante gives some indication of the prevalence of homosexuality within mediaeval and Renaissance society in Italy when he described it as 'the vice of Florence'.[1] In Italy artists were not required to marry in order to achieve social and professional status as the examples of Leonardo and Michelangelo make clear. This is in marked contrast to Northern Europe where marriage was essential for social respectability.

Dürer (1471-1528) married in 1494, very much against his will, and immediately left by himself for Italy.[2]

Despite the relatively liberal attitudes in Italy, many artists were brought before the courts charged with having committed homosexual acts. It was not possible to live a completely free and open homosexual life. But the structure of society and the general liberal attitude did permit homosexual activities and relationships to a degree. The system of young apprentices working in the artists' studios provided opportunities for sexual friendships to develop without attracting public attention.

In Northern Europe there was generally less tolerance of homosexual behaviour and even successful and famed artists were persecuted with the full force of the strict law. In 1654 the internationally known Belgian sculptor and engraver Jérôme Dusquesnoy (1602-1654) was accused of having abused two boys in the Chapel of Ghent. After several periods of interrogation he was sentenced to death. Despite pleas from royal and religious patrons, he was lashed to the stake, strangled and burned in the City Grain Market.

Many artists found great inspiration in neoplatonist philosophies and particularly in the ideas of Marsiglio Ficino who had translated Plato's writings. Neoplatonism sought to reconcile and combine the philosophy of the ancient Greeks and the beliefs of the Christian church. In neoplatonist circles there was also great emphasis placed on the importance of the subjective expression of the individual artist. This was very different from the mediaeval tradition in which the emphasis had been on the expression of objective Christian truth when the artist was more often than not an anonymous artisan. It was a philosophy which regarded beauty, particularly that of the male body, as the visible evidence of the Divine, and it followed that it was possible to express solemn and even religious sentiments through classical themes.

For many, admiration for the classical Greeks and their way of life implied an acceptance of homosexual relationships. In the eighteenth century, when interest in the ancient civilisations intensified, Winckelmann's admiring studies of Greek culture recognised that homosexual relationships were common and accepted within it. Other artists and writers looked back at the society of ancient Greece as a 'Golden Age', free from guilt, when the male body in all its unadorned splendour could be freely admired as an object of sexual desire and beauty. Such open expression is unusual in Western culture. At other times various codes and other means have been developed through which homosexual themes can be expressed. One of the more obvious situations in which homosexual sentiments could be expressed acceptably was in the male bath house. Michelangelo included such a scene in the background of the *Doni Tondo* and Caravaggio set *The Martyrdom of St Matthew* in a bath house. In Northern Europe, Dürer's engraving *Men's*

Bath introduced specific erotic allusions with penis-shaped taps and tree trunks and so on making the sexual content explicit.

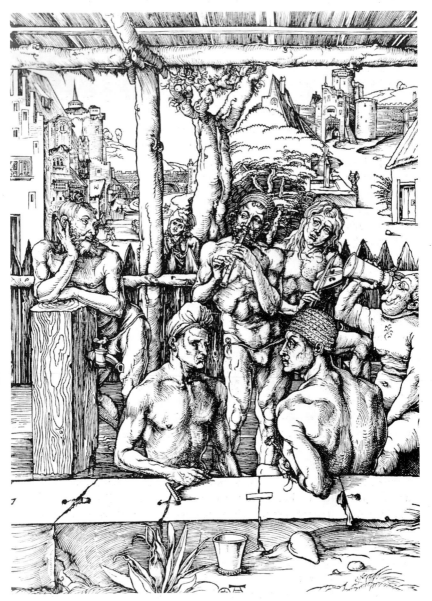

1.1 Albrecht Dürer (1471–1525) *The Bathhouse* (detail). Wood engraving. Homoerotic allusions abound, for instance in the shape and position of the water spout, in the form of the tree trunk, the plants, rocks and so on

In Italy, Donatello (1384–1460) and Botticelli (1445–1510) were two of the first artists to explore the possibilities opened up by the new found freedoms of the Renaissance. Stories and gossip about Donatello's homosexual relationships with his assistants abounded. Born Donato di Niccolo Donatello, he became one of the most influential artists of the fifteenth century, giving his prophets and saints a sinewy vitality and a particularised character which implied first-hand study from life.

The most specifically sexual example of his sculpture, *David* c. 1430–32 (Bargello, Florence), is one of his most homoerotic. The bronze David is a youthful figure standing some five feet high, one foot resting on Goliath's

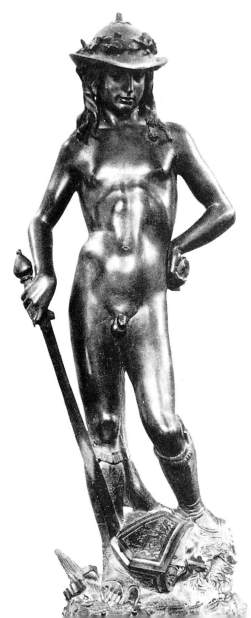

1.2 Donatello (1386–1466) *David* (c. 1430). Bronze. Height 158 cm (62 in) (*Museo Nazionale, Florence*)

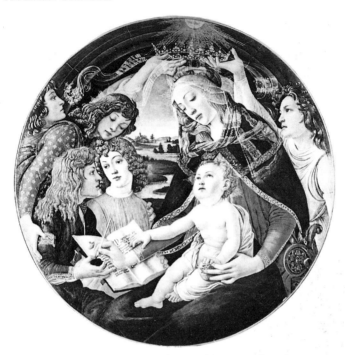

1.3 Sandro Botticelli (1445–1510) *Madonna of the Magnificat*. Diameter 112 cm (44 in) (*Galleria degli Uffizi, Florence*)

helmet. The feather from the wing on the helmet curves gracefully up the side of his leg and gently tickles his crotch, a studied rather than an accidental placing. The *David* originally stood in the garden of the Medici Palace and would have been seen and admired by Michelangelo.

Botticelli (1445–1510) was born Alessandro di Mariano Filipepi in Florence. He studied in Filippo Lippi's workshop, getting his first commission around 1470. Intellectually he was stimulated by the new philosophies, although often torn between solemn religious beliefs and pagan ideas. Commissioned by Lorenzo di Pierfrancesco de' Medici, a wealthy Florentine with interests in Platonic philosophy, he painted some of his most famous mythological paintings including *The Birth of Venus* c. 1481 (Uffizi Gallery, Florence). Much of his work has a delicate if melancholic sentimental grace, with an emphasis on the flowing quality of linear movement. In his portrayal of women, whom he often painted nude, he conveys a modest sensuality while giving them a feeling of unreality. It was these women who were the great inspiration for the English Pre-Raphaelite painters in the nineteenth century.

In contrast, the males in Botticelli's paintings, in particular the angels in the religious pictures, explore a wider range of 'types'. Traditionally angels were minor characters, taking secondary roles. They were asexual

since theologically they were neither male nor female. For the homosexual, this offered a particular means of identification which could be used to suggest a 'third sex'. Hence Botticelli's angels are given an ambiguous sexuality. In the *Mystic Nativity* c. 1500 (National Gallery, London) angels surround the byre with the infant Jesus. They embrace and gesticulate, generally animating the central scene. In this later painting, the angels are more flamboyant and feminine than in the *Madonna of the Magnificat* c. 1480 (Uffizi Gallery, Florence). The group of four wingless angels is almost totally self-absorbed. Rather than attending to the infant and the Madonna, with their flowing locks and smooth cheeks they direct their tender, adoring concern at each other. The look of innocence and of sensual pleasure of these angels contrasts with the more worldly, knowing glances of the group in the *Madonna of the Pomegranate* c. 1490 (Uffizi Gallery, Florence). Though they carry such items as a garland of red roses and lilies, symbolising Mary's purity and love, they show no interest in the mother and child and are more concerned with gossiping or gazing directly out of the picture.

An altarpiece of much the same date *Virgin and Child with Saints* (Sta Barnaba, Florence) demonstrates Botticelli's skills in handling a large composition as well as his sensitive delineation of individual character. Despite their sweet looks, the angels are worldly and knowing. The three saints who stand on the right, St John the Baptist, St Ignatius and the Archangel Michael, are almost life size and each has a distinct and dramatic presence. St John is taut and anguished, St Ignatius, known as 'the beloved of Christ', is old and sagacious, while the youthful, smooth-faced Archangel Michael wears his armour lightly, with a peaceful, almost languid pose which suggests that it is highly improbable that he should be involved in war.

In 1502 Botticelli was anonymously accused in the Uffiziali di Notte, the institution through which Florentine citizens were able to denounce each other for real or imagined crimes, of committing sodomy with one of his assistants. Such information gives weight to the analysis that Botticelli's work was not merely about the formal relationship between Christianity and classicism, but also contains an expression of his own concerns. Interestingly, Botticelli never left the family home but lived and worked there until his death. Vasari[3] relates that Botticelli came under the influence of Savonarola who particularly condemned 'the love of beardless youths' in 1494. He produced little work in his later years, although he did continue working for Lorenzo di Pierfrancesco de' Medici. His work may have been inhibited by an awareness that he had been eclipsed by other artists and his trial in 1502 may have had a profound psychological impact.

The struggle to find an acceptable voice with which to describe a forbidden sexuality is central to the work of Leonardo da Vinci and

Michelangelo. They were very different in temperament and approach and both professionally and sexually they were rivals. So talented and able were they that in any other society the two men might have taken up other professions. In Renaissance Italy, art was the profession outside of the church which offered the freedom and scope for their brilliant abilities, energies and sexual interests.

While Leonardo (1452–1519), the elder of the two, was generally outgoing, gentle and without deep religious beliefs, Michelangelo (1475–1564) was more introverted, often withdrawing from society and friendships sometimes for years on end, and he was deeply religious. Both artists have become victims of a profusion of myths and labels around their lives and their work. Some writers ignore the question of sexuality, while others deny that the basis of both artists' work is a great love and sexual desire for members of their own sex.

Leonardo da Vinci, the model of the 'true renaissance man', was learned in a wide range of sciences, art and invention. Vasari,[4] the greatest source of information on Leonardo, describes him as having 'a personal beauty (which) could not be exaggerated, whose every movement was grace itself'. Other writers also noted his handsome good looks and his 'beautiful head of hair which he wore curled down to the middle of his neck'.[5] Vasari describes Leonardo as 'nearer to being a philosopher than a christian'. As a humanitarian he bought and released caged birds and he ate no meat because of his love of animals, yet he spent days dissecting decaying corpses or designing war machines.

At the age of twenty-four, Leonardo was implicated in an anonymous denunciation of homosexuality.[6] The accusation involved a seventeen-year-old male prostitute, Jacopo Saltarelli, who was said to have had homosexual relations with several men including Leonardo and Leonardo's teacher, Verrocchio. All were acquitted. Leonardo's sexual interests centred on younger men, many of whom he took on as assistants. One of these was Salai (a nickname meaning 'little devil'), 'an attractive youth of unusual grace and good looks, with very beautiful hair which he wore in ringlets and which delighted his master'. Vasari's description fits one of Leonardo's favourite 'types' of men, the androgynous youth. Salai seems to have been hopelessly spoiled and indulged by Leonardo. In 1497 a bill for expensive clothes for Salai prompted Leonardo to write 'This is really the last time, dear Salai, that I am giving you more money.'[7] Nevertheless, he lived with Salai for eighteen more years. Other close friendships were formed with his assistants who were as likely to be selected for their beauty as for their talent. It is worth noting that none of his assistants gained a reputation as an artist. Francesco Metzi lived with Leonardo until his death and inherited much of his estate which included clothes, books, notebooks, drawings and portraits. Part of his garden was left to his servant Batista

de Villani and the rest went to Salai.

In 1472 at the age of twenty, Leonardo was taken on as an apprentice in Verrocchio's studio and he may have posed for Verrocchio's statue of *David* (Bargello, Florence) which was made around this time. Leonardo established one of his most significant types, the androgyne, in his first surviving figure painting, an angel in Verrocchio's *Baptism of Christ by St John* (Uffizi Gallery, Florence). The angel's face is rounded, the cheeks fruit-like, the hair abundant and delicate. The type persists throughout Leonardo's work. Similar characteristics occur in his last picture, the *St John* in the Louvre. The androgynous figure of the saint conveys a beatific mystery in the sensual, rounded flesh and the sweet, enigmatic smile. The exotic figure has an almost coy expression and the wistful eyes suggest a dream-world of fantasy and hope. The *Bacchus*, also in the Louvre, has similar androgynous qualities and, like St John, Bacchus is also linked with homosexuality. It was these androgynous figures which inspired artists of the Aesthetic Movement at the end of the nineteenth century (see chapter 4). They saw in Leonardo's figures visionary qualities unsullied by the materialistic values of the commercial world.

Leonardo's mystic androgynes contrast with the muscular male nudes of Michelangelo and with the careful, realistic studies of men by Luca Signorelli. The fact that Leonardo studied anatomy in detail and approached his work as much as a scientist as an artist suggests that his use of androgynous men was deliberate and precise. It was a rejection of the muscular form of the male nude and expressed a more ambiguous male sexuality, one which did not accept a sharp polarisation of the sexes and which used the male to convey expressions of 'female' qualities.

One of Leonardo's key drawings is the allegorical composition *Pleasure and Pain* (Christchurch Library, Oxford). It shows a muscular male figure with two pairs of shoulders, two heads and two penises, all issuing from a single trunk. Pain is old, bearded and frowning; Pleasure is young, wistful and 'feminine'. In a single figure Leonardo portrays two contrasting ages of man, his looks, his experience and his desire. Pain may be a self-portrait expressing his suffering as a homosexual, experiencing the pain of desire for Pleasure.

Though conveyed in a different style, similar contradictions are present in Michelangelo's sculpture *Victory* 1520 (Palazzo Vecchio, Florence) and in his painting *The Holy Family* (*The Doni Tondo*) 1504–6 (Uffizi Gallery, Florence). Like *Pleasure and Pain*, *Victory* gives a revealing insight into the artist's own view of himself and his symbolised homosexuality. *Victory* shows a slim, handsome, full-length nude holding an older, bearded man in powerless subjugation. Ostensibly the sculpture is about the victory of youth over old age, virtue over vice, and good over evil. These readings become sharper and more relevant to

Michelangelo's life when the graceful slightly effeminate youth is recognised as a portrait of his beloved friend Tommaso Cavalieri, while the older man is a self-portrait.

Michelangelo was fifty-seven when he met Cavalieri in Rome in the summer of 1532. Handsome and with a sharp intelligence, Cavalieri was in his early twenties and came from a wealthy and influential Roman

1.4 Leonardo da Vinci (1452–1519) *St John the Baptist* (c. 1509–16). Oil on panel. 57 × 69 cm (27.25 × 22.5 in) (*Louvre, Paris*)

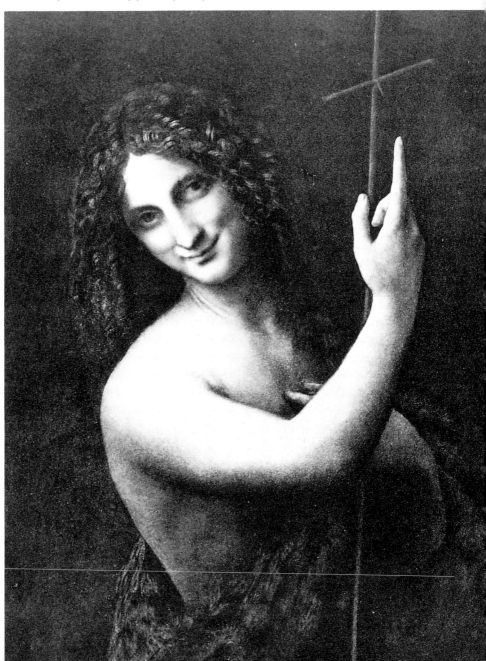

family. Michelangelo's passionate love for him is described in sonnets which are as concerned with physical as well as emotional love—'My sweet lord whom I desire forever in the eager embrace of my unworldly arms.'[8]

In Cavalieri's beauty Michelangelo found a source of inspiration and encouragement. He executed drawings and paintings, directly relating to his love for Cavalieri, which he gave to him. These included the two versions of the myth of Jupiter and Ganymede. Ganymede, a shepherd boy and son of Tros, the legendary king of Troy, was of such beauty that Jupiter fell in love with him and, in the guise of an eagle, carried him off to Olympus (Royal Library, Windsor Castle).

The relationship between Cavalieri and Michelangelo echoes the Platonic ideal of an older, mature and successful man teaching and loving a much younger man. It is doubtful if their relationship was sexual. Cavalieri may not have returned Michelangelo's passion and it is possible that it is the artist's 'desire' which is the conquered 'vice' in the sculpted *Victory* group. Michelangelo's friendship with Cavalieri lasted for thirty-two years, until the artist died in his friend's arms in 1564.

Michelangelo's view of himself and his homosexual desires is expressed in his art and in his poetry. As Howard Hubbard writes so pertinently of his art: 'It is the most personal and autobiographical of the entire renaissance, and shows his physical passion for the body to an overwhelming degree.' His large and expressive male nudes range from youth to old age. Few other artists of the time used nude figures so consistently and in such a range of contexts, or painted them with such passion, using the naked body as an expression of 'truth'. Fashioned in the form of God, the naked human body is not concealed by the vanity or deceit of adornment.

In search of 'truth', Leonardo da Vinci looked at the structure of the body, dissected corpses and studied muscle and bone formation, perhaps partly as an escape from looking too closely at the emotional significance of the figure. In contrast, Michelangelo's main concern was with the emotional effect of the male body rather than with its scientific investigation. His nudes are not naturalistically rendered but with their exaggerated musculature they are drawn and painted in ways which convey feeling and emotion. Some figures were considered inappropriate for their context. Naked figures in the *Last Judgement* on the altar wall of the Sistine Chapel were made 'decent' by Daniele da Volterra who added discreet drapery after Michelangelo's death.

The later works are different in feeling and intention from those of his earlier periods. When he was fifteen he was taken into the school set up in the Medici gardens and his work was noticed by Lorenzo the Magnificent. Donatello's *David*, which was displayed in the garden, may have influenced an early statue, *Bacchus* 1496–8 (Bargello, Florence). This

work explores the ambiguities which the subject allows and already Michelangelo had the ability to convey particular meanings. In the *Bacchus* he implies homosexuality by giving the figure, as Vasari[9] notes, 'a marvellous blending of both sexes—combining the slenderness of a youth with the rounded fulness of a woman'. The god of wine is shown naked, gazing lewdly at his sacred liquid. Around his legs a satyr plays, holding and eating the grapes in Bacchus' hand. Significantly, Bacchus also holds the 'skin' of earthly passions.

Shortly afterwards he produced the magnificent sculpture *David* 1501–4 (Accademia, Florence) which was seen to represent the Utopian ideals of

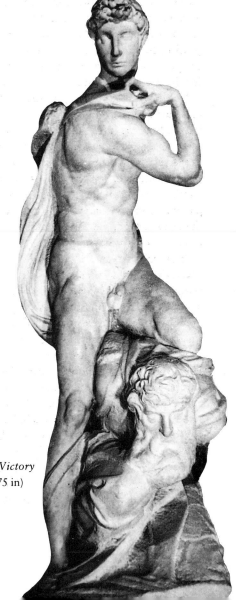

1.5 Michelangelo Buonarroti (1475–1564) *Victory* (c. 1530/33). Marble. Height 261 cm (102.75 in) (*Palazzo Vecchio, Florence*)

the new Florentine republic. Standing eighteen feet tall, David is shown in quiet repose before his battle with Goliath, confident in his ability to tackle and defeat the enemy. Simple and superb in its understanding of anatomy, the sculpture presents a classical image of idealised youth, combining the expression of strength and assurance with a highly sensuous treatment of the male body.

Executed in the same period as the *David*, the *Doni Tondo* 1503-4 (Uffizi, Florence) places the male nude within a different context. At first glance the *Doni Tondo* is a hymn of praise to the closely interlocked and unified family group which dominates the central foreground of the composition. In the distant background naked men lounge in familiar and close proximity as though in a bath house or gymnasium. Mid-way between the two groups, a figure moves forward gazing longingly at the holy family. Conventionally this figure is John the Baptist, a link between the 'old' world and the 'new', between the unenlightened past of the pagan classical world and the enlightened Christian age. Psychologically Michelangelo may be expressing his own longing for respectability while pushing his homosexual desires into the background.

Michelangelo wrote a series of poems in which he describes his love and sexual desire for young men and the frustration and transcendence of his passion. For Gherardo Perini, whom he met in 1522, he wrote: 'Here, my love ravished my heart and life. Here, his fine eyes promised me succour, yet he took it away from me. Here, in infinite sorrow, I wept and saw the departure of this stony-hearted man who had revealed me to myself and no longer wanted me.'[10] Similar sentiments were expressed in lines written after the death of fifteen-year-old Cecchino dei Bracci whom he met in 1544. 'I who was only given over to you for an hour, I am given over to death forever.'[11] Well aware that physical love placed the salvation of his soul in jeopardy, he was willing to take the risk. In a note to Febo di Poggio he wrote: 'I shall always be at your service with loyalty and love,'[12] adding that he desired his welfare 'more than his own salvation'. Over the years, translations of his poetry have consistently changed 'his' to 'her' in the last line of his love poem to Cavalieri: 'Nor is there aught can move a gentle heart, or purge or make it wise, but beauty and the starlight of his eyes.' As Vasari says, a commonly held view of Michelangelo's sexuality was that he was married to his art. Another writer claims that he was 'to a certain extent Androgynous'.[13] His biographers have been reluctant to recognise that Michelangelo's homosexual desires are fundamental to an understanding of his art.

Both during his life and after his death Michelangelo's work was a source of inspiration for many artists, including Raphael (1483-1520), Pontormo and Bronzino. Giovanni Antonio Bazzi, known as Il Sodoma (1477-1549), drew his chief influences from Leonardo da Vinci and from

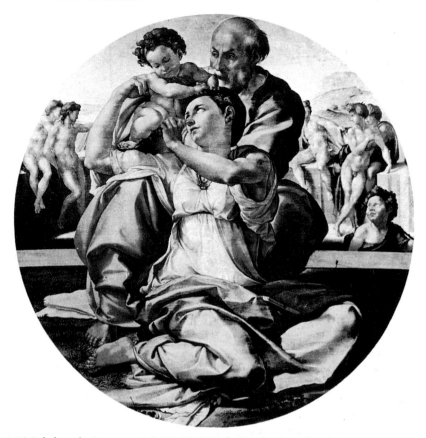

1.6 Michelangelo Buonarroti (1475–1564) *Holy Family (Doni Tondo)* (1503/4). Tempera on circular panel. 91 × 80 cm (36 × 31.5 in) (*Galleria degli Uffizi, Florence*)

Raphael with whom he worked on murals in Siena. According to Vasari,[14] Sodoma was licentious and dishonorable, forever keeping company with 'boys and beardless youths' of whom he was 'inordinately fond'. This reputation earned him the nickname 'Il Sodoma', but far from feeling ashamed he took the name with pride. On one occasion when his horse won at the races he was cheered in the streets by the young boys and at his own request called 'Sodoma', much to the disapproval of other Florentines.

Generally considered eccentric, Sodoma was also called 'Il Mattaccio', 'the Fool', because of his endless games with his apprentices and because of his passion for the odd and unusual animals which he kept in his house. Sodoma worked mostly in and around Siena, tending to paint poetic, gentle scenes without violence. The picture *Jesus at the Column* (fragment, Pinacoteca, Siena) contrasts the soft, sensual curve of Christ's body with the well-defined, solid muscular build. The head of Christ,

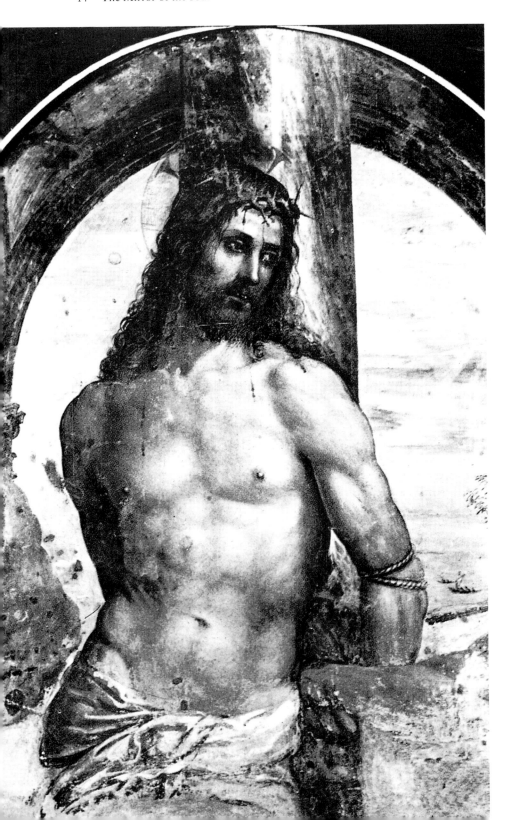

with its melancholic look, recalls that of Christ in Leonardo's *Last Supper*. The tender mood of the painting was also expressed in the affectionate figures in *The Marriage of Alexander and Roxana* (Farnesina, Rome). The gentle poetry of his painting, however, is in great contrast to his life, which continued to be as flamboyant and extrovert as his name. His marriage in 1510 to Beatrice, the daughter of a wealthy family in Siena, did not survive, according to Vasari. Though they had a daughter, Sodoma's behaviour disgusted his wife and she refused to live with him.

Benvenuto Cellini (1500–1571), the Florentine silversmith, has left a racy autobiography[15] which gives a vivid account of the Renaissance craftsman, proud of his skill and independence, boastful, quarrelsome and superstitious. He also enjoyed sexual relations with women and men whenever the opportunity arose. The work of Michelangelo was his greatest source of artistic inspiration.

One of the most startling passages of Cellini's autobiography is his defence of the homosexual. Accused of being an 'ugly sodomite', he replied: 'Would to God that I understood so noble an art as you allude to: they say that Jove used it with Ganymede in Paradise, and here on earth it is practised by some of the greatest emperors and kings.' In 1557 Cellini was accused of sodomy with one of his apprentices, Cencio, by the boy's mother. Cellini denied the charge but, fearing harsh punishment from Cosimo I, he left immediately for Venice until the storm had died down. Cellini finally married in his old age, after having had a series of children by different women over the previous twenty years.

Well-known as a goldsmith and a metalworker, Cellini also modelled statues, attempting to come to terms with the principles of Hellenistic sculpture in such works as *Apollo and Hyacinth* 1547 (Bargello, Florence) and *Perseus with the Head of Medusa* 1554 (Loggia dei Lanzi, Florence). With *Ganymede*, Cellini was content to restore an ancient torso, recognising its strength and beauty. Perhaps Cellini's most surprising and startling carving was a marble crucifix of 1556–62 now in the Escorial, the Monastery of San Lorenzo near Madrid. Breaking convention, this major sculpture shows Christ completely naked and is freely rendered. The head is large and important, the body is small and immature in contrast.

Of the other artists of the late Renaissance, two of the most well-known whom we know to have had major homosexual relationships are Jacopo Carucci da Pontormo and Agnolo Bronzino. The greatest insights into the life of Pontormo (1494–1557) come from his obsessive,

1.7 Il Sodoma (Giovanni Antonio Bazzi) (1477–1549) *Jesus at the Column* (*Pinacoteca, Siena*)

introspective paintings and from the surviving fragment of his diary[16] which details his activities and describes his melancholy. Entries record his obsession with the food he eats, his health, his visitors and his tempestuous relationship with Naldini, his apprentice. He adopted Battista Naldini, a foundling from the Hospital of the Innocents, as his son. Pontormo graphically records his distress at Naldini's absences and his sufferings at the hands of this mischievous young man. In fact Naldini was a talented draughtsman and imitated Pontormo's skills with ease. Pontormo also records his work for the day, listing the drawing of an arm, a torso, a thigh and so on. This confirms what is apparent in his paintings, that he assembles his figures in sections, rather like manikins, exaggerating some parts and making others smaller to stress the mood and feeling. His drawings reveal his pleasure in studying the youthful male body and reflect his infatuations with young boys. Figures, particularly those of young boys, are often posed with their legs apart to display their genitals and the images combine youthful innocence with mischievous sexual allure.

One of Pontormo's best-known paintings of his early period, *Joseph in Egypt* 1518-19 (National Gallery, London) includes a portrait of his first apprentice, Bronzino, at the age of fifteen. He virtually adopted Bronzino as his son. The painting is ambitious in the way in which it attempts to construct space, and while it is architecturally improbable, it demonstrates Pontormo's ability to deal with crowded and complex compositions. The elegant, naked male statues seem as alive and living as the figures which hurry to and fro in the rest of the picture. Throughout his life the artist remained a close friend of Bronzino, his most important apprentice, seeing him regularly when the company of others was shunned. The depth of their relationship is vividly described in the emotional sonnets which Bronzino wrote when Pontormo died in 1556. Some of these take the form of prayers to the departed spirit whom he sees as his father, brother, friend and master. Bronzino asks for pity for his neglected, lonely life and for recognition of his obscure, bitter existence.[17] It is a view of life that can be perceived in Bronzino's paintings.

Bronzino (1503-1572) was only nine years younger than his teacher, who encouraged him to study the work of Michelangelo. He was particularly impressed by the *Doni Tondo* for its spiritual qualities, the elegant handling of the difficult, twisted figure composition, and its smooth paint finish. He may also have recognised the complex view of sexuality the painting expressed. Bronzino adapted the powerful but controlled imagery of Michelangelo into a style which combined great technical virtuosity, particularly in the quality of the surface, with a cold treatment of his subjects, producing exquisitely finished works which are devoid of any emotional feeling. In one of his most famous paintings,

Venus, Cupid, Folly and Time 1545 (National Gallery, London), the use of carefully placed masks is emblematic of the emptiness behind the surface appearance.

The *London Allegory*, as the painting is sometimes called, is Bronzino at his most skilful. Brilliantly painted with a polished finish, the painting shows Venus in a frankly erotic embrace with her son Cupid. The smooth, rounded, outstretched buttocks of Cupid suggest a deliberate homoerotic note. The allegory implies that existence is a hard, hollow shell, without feeling or passion, sympathy or regret. Behind the finely painted surface there is a sense of echoing void.[18]

The theme of incest which is found in the *London Allegory* recurs in Bronzino's work, and other sexual ambiguities are expressed in *Venus, Cupid and Jealousy* c. 1550 (Szepmureszeti Museum, Budapest) and *Venus, Cupid and Satyr* c. 1555 (Colonna Gallery, Rome). In the latter picture, the satyr's sexual leer could be aimed at Venus or Cupid's out-thrust buttocks.

1.8 Pontormo (1494–1557) *Vertumnus and Pomona* (1520/21). Left side of lunette (*Poggio a Caiano, Villa Medici*)

Cosimo de' Medici, a strict and unfeeling puritan, was Bronzino's patron for thirty years. The artist produced court portraits almost to order. With few exceptions, he painted his subjects alone with some symbol of their interests such as a book or classical statuette. The minute details of dresses and rich costumes, the marble-white, dead flesh, and the formality convey a sense of existential aloneness. He paints the wealthy and powerful frozen in a world from which there is no escape. The *Grand Duke Ferdinand 1 dei Medici* (Philadelphia Museum of Art) is shown naked in a back-view in the guise of Orpheus, ambiguously holding his musical instrument. *Andrea Doria* c. 1550 (Brera Gallery, Milan) is posed as Neptune, again naked. The figure is given a provocative and sexually suggestive pose, holding a cloth in front of his groin but allowing it to fall to reveal the base of his penis.

Bronzino's many pupils included Alessandro Allori whom he adopted as his son much as Pontormo had adopted and cared for him, and in the last years of his life he lived with the Allori family. Bronzino's deeply pessimistic view of life, expressed most vividly in his ornate poetry, prefigured a much later philosophical debate about the nature of existence and its purpose.

A year after Bronzino's death, the iconoclastic Caravaggio (1573–1610) was born. He developed a very different style of painting based on a close observation of the world in which he lived. Peasants, labourers and working youths were rendered in a graphically realistic manner. The male nude was not used to evoke classical ideals and spiritual purity but rather to suggest avarice, to solicit sexual attention and to invite homosexual caresses. His art, which is psychologically as well as physically direct, employs a realism which can nevertheless be intensely spiritual.

Like Cellini and Sodoma, Caravaggio was noisy, temperamental, and sometimes violent. On one occasion he was charged with murder and had to flee the country. His life and his art are almost inseparable and many of his paintings reflect his taste and moods. He was particularly attracted to young men and it is reported that his sudden departure from Messina in 1609 was a result of his paying too much attention to schoolboys at play. He is also recorded as sharing a 'bardassa' with his friend Onorio Longhi, with whom he lived.[19]

Caravaggio often worked for patrons who shared similar tastes. Cardinal del Monte entertained friends to the accompaniment of transvestite singers and dancers. The *Amore Vincitore* c. 1601–2 (Staatliche Museum, Berlin) was owned by the Marchese Vicenzo Giustiniani who is reputed to have kept it hidden behind a curtain. Selected visitors were proudly shown the painting as a suitable climax to a tour of the Marchese's collections.

The greatest influence on Caravaggio was Michelangelo, to whose

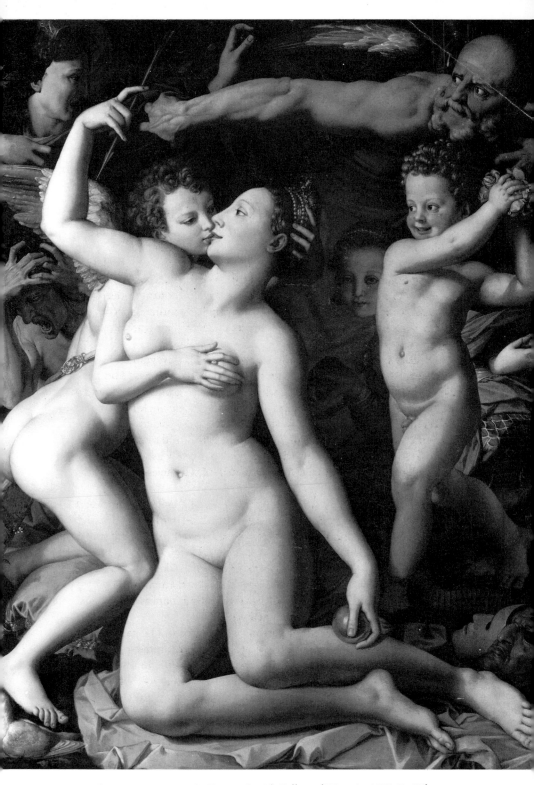

1.9 Agnolo Bronzino (1503–72) *Venus, Cupid, Folly and Time* (c. 1542–5). Oil on panel. 146 × 116 cm (57.5 × 45.75 in) (*National Gallery, London*)

work and ideas he constantly referred but often reversed. Where Michelangelo described an intellectual and physical ideal, Caravaggio showed reality; where Michelangelo depicted lyricism and poetry, Caravaggio chose an earthy and grubby humanity. *Amore Vincitore* is possibly Caravaggio's most notorious painting.[20] The theme of Cupid treading on the symbols of human endeavour, war, music, and learning, is conventional but his treatment of it is not. The realistically painted peasant youth used as the model seems to have been taken directly from the streets of Rome. Despite his angel's wings, his cheeky smile is almost a sexual leer and his sexual pose frankly solicits.

Similar invitations are found in *Bacchus* (Uffizi, Florence) and *The Lute Player* (Hermitage, Leningrad). The youthful figures, shown with their shirts slipping seductively off their shoulders, are based on conventional sixteenth-century portraits of courtesans holding flowers or fruits, but the gentility and refinement of the earlier models have gone. Chubby faced and slightly androgynous youths seek to engage the spectator, offering an allurement such as a glass of wine or the bow of a violin. The suggestive look, the pout, the half-opened mouth, the large bowl of fruit or vase of flowers, emphasise the idea that it is sex that is also being offered. In *Boy Bitten by a Lizard* (National Gallery, London), a similar youth appears again with his shirt falling off his shoulder, and love is suggested by the rose which he wears behind his ear. The young man starts back from a bowl of fruit, his fingers spread in a theatrical gesture, presumably bitten by the lizard which lurks amid the roses and cherries. The moral tale that pleasure has a price and that unsuspected dangers lie beneath beautiful appearances gives a particular edge to the youth's seductive attraction.

The homoerotic elements are also present, although less obviously, in the religious works. In *The Calling of St Matthew* c. 1600 (Contarelli Chapel, San Luigi dei Francesi, Rome), Matthew is part of a group seated at a table counting his money. An attractive youth with smooth, round features leans on his shoulder. The subject is conventional but the intimacy is not. Neither is a male bath house a usual setting for *The Martyrdom of St Matthew* c. 1600 (Contarelli Chapel). St Matthew lies fully clothed on the edge of the bath dominated by his naked executioners and framed by naked men moving dramatically away from the scene. One of the fleeing figures is a self-portrait.

The Conversion of St Paul c. 1601 (Cerasi Chapel, Sta Maria del Popolo, Rome) provides the most unconventional and suggestive pose to be found among his religious subjects. The muscular St Paul lies on the ground on his back, his arms stretched out to the divine light which streams from above, his legs raised and bent at the knee. In portraying St Paul in the spiritual ecstasy of his conversion, Caravaggio has used an image of physical and earthly passion, posing him in the physical

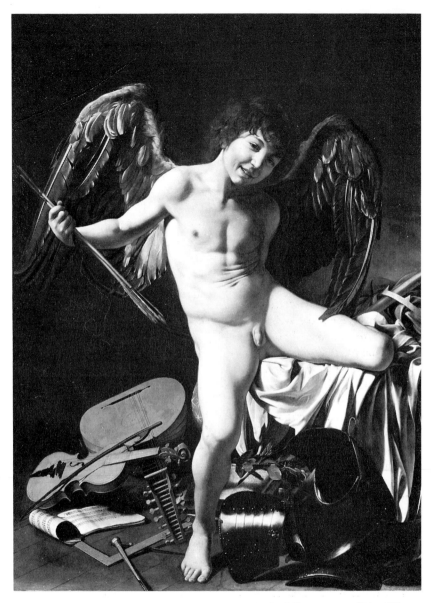

1.10 Caravaggio (1573–1610) *Amore Vincitore* (1598–9). Oil on canvas. 154 × 110 cm (60.5 × 43.25 in) (*Staatliche Museum, Berlin*)

position of the receptive partner in homosexual lovemaking.

Within the revolutionary developments in art and aesthetics that took place in the eighteenth century, the Greek ideal was again hailed as the basis of all true and perfect art, but the male nude which was so characteristic of the Renaissance was less freely used. The most

influential writer on this theme was the German Johann Joachim Winckelmann (1717–1768) who was homosexual. Born the son of a shoe repairer, he developed a passionate love of classical antiquity and ancient art. In 1755 he wrote a small but prophetic book about the beauties of ancient art, even before having seen any of it in its native setting. He proposed that the only way to greatness was by imitating the ancients, not by mere copying but by a recreation of the Greek spirit. He described ancient art as embodying noble simplicity and calm grandeur.

Shortly after publishing his first book, Winckelmann moved to Rome where he became librarian to Cardinal Albani and soon established himself as a highly regarded scholar and antiquarian known throughout Europe. In 1765 J.H. Fuseli published an English translation of Winckelmann's book under the title *Reflections on the Painting and Sculpture of the Greeks*. One of the most perceptive appreciations of Winckelmann's work was by Walter Pater in his book *The Renaissance* (1873). Winckelmann died as a result of an attack from a young man with whom he had established a sexual liaison and who had tried to rob him of his collection of coins.

In his writings Winckelmann made it clear that it was the spirit of Greek art he advocated, not the mere copying of Greek forms. Many neoclassical sculptors sought a lifeless ideal in the removal of all human imperfections, but Antonio Canova (1757–1822) came closest to Winckelmann's ideas.

Canova's father and grandfather had been sculptors and early on he displayed a brilliant talent, producing the highly accomplished *Orpheus and Euridice* when he was sixteen. In 1781 he settled in Rome, eventually living with his younger half-brother Giambattista Sartori. They were constant and inseparable companions, Sartori read to Canova while he worked and during visits to famous people he noted down the conversations. He cared for the ailing sculptor until he died and was his sole heir and executor. One of Canova's less 'finished' pieces was a marble head of Sartori executed in 1822. Its surface was not smoothed over in his usual polished finish but still carried the traces of the sculptor's 'excited powers'.[21]

Canova specialised in 'finish', smoothing the surface by rubbing, filing and polishing. The naked figure of *Napoleon 1* 1811 (Apsley House, London) is finished in this way and though large, it does not successfully achieve the heroic splendour of the emperor. Even Canova's drawings of the male nude show idealised muscular forms with classic Greek profiles.

The nineteenth century heralded the start of a new, modern society with a growing awareness of same-sex relations, particularly between men. The family was seen as being the centre around which relationships were formed. Bonds outside this were viewed with suspicion and disfavour. The Irish-born artist William Mulready (1786–1863) serves as

a good example of how sexual desires can be concealed. Mulready, a meticulous technician, specialised in genre paintings of contemporary life, with no overt indication of homoerotic interest. The exact nature of Mulready's friendship with John Linnell (1792–1882) still remains unclear, but the discovery of letters by Mulready's wife in which she complains of his desire for young men confirms his homosexual interests.[22] It caused their marriage to fail. Some of the effects of fear of exposure and the concealment of feelings of guilt on artists who had homosexual desires is demonstrated in the work and life of the American neoromantic painter Washington Allston (1779–1843). Phoebe Lloyd[23] has suggested that by taking as his subject the life of St Peter for several important paintings over a span of sixteen years, the theme may have autobiographical resonance, providing insights into the artist's troubled life. Phoebe Lloyd puts forward the idea that Allston saw in St Peter a figure of his own homosexual conflicts and denials. It was not until the latter part of the nineteenth century that artists who felt similar emotions were able to express their deep felt desires—the mirror slowly started to clear, if not shine.

2 · Free from the Itch of Desire

Plato's phrase 'free from the itch of desire'[1] can be appropriately applied to much of the idealism of late nineteenth-century art. While there was great respect for the study of the nude, its erotic implications were carefully directed, particularly in the case of the male. Female nudes were frequently shown and there was a great emphasis on their physical and sexual attractions, but the male appeared less often and with any sexual suggestion suppressed. While classical antiquity and Greek culture in particular stood as the unchallenged ideal in all things cultural, it was in a suitably cleaned-up version. Careful censorship ensured that undesirable aspects of classical culture, particularly references to sexual behaviour, were removed.

Michelangelo's *David* donned a fig leaf, as did the statues in the Tuileries Garden under Eugénie's instructions. The story of Ganymede was virtually re-written and serves as a typical example of the abhorrence with which homosexuality was regarded. In 1788 Dr Lemprière described Ganymede as being 'carried away by an eagle to satisfy the shameful and unnatural desires of Zeus'.[2] Though morally disapproving, this version of the story is more or less accurate. Nearly fifty years later in 1842, Charles Anthon excluded 'everything offensive' in his *Classical Dictionary*. Now Ganymede was 'carried off to Olympus by an eagle to be cupbearer of Jove'.[3]

The three major influences, of antiquity, the study of the nude (usually in French private academies) and the use of the camera, inspired an art that was by and large set out of doors and depicted healthy vigorous males often in the full glow of youth. The fascination for antiquity was particularly evident in the work of Lord Leighton, whose work and imagery lay so clearly in the delightful and unproblematic world of the ancient Greeks and Romans. Other artists, including Eakins, Tuke and

Reynolds, were also attracted by the Greek way of life, particularly when it was set out of doors. There is in their paintings a strong emphasis on the purity and innocence of male comradeship with sometimes more than a hint of an underlying theme of homoeroticism. In contrast to Leighton's avowed historical paintings, Homer's realism did not rely on variations of long-established styles or ancient settings, but with the events and imagery of his own times.

A period spent in France was considered to be essential for American and British artists. Not only could the skills of drawing and painting be learned (in which the study of the nude was central) but the cultural air of the capital broadened horizons. Art was seriously discussed and the work of the artist respected. Paris was considered to be the centre of the art world, and exhibitions of overseas work in the French capital, particularly from the Far East, added to the exotic air of change. New ideas and theories about the use of colour were discussed, painting techniques and subject matter were changing and many experiments made.

Within the study of the nude, the camera provided a stock of images from which artists could work, and was also a 'tool' for complex experiments designed for learning more about the figure, particularly how it moved. Eakins became a highly accomplished and inventive photographer, while Tuke arranged to have photographs taken of carefully posed figures from which he could paint and draw. Homer saw the documentary photographers Matthew Brady, Alexander Gardner and Timothy O'Sullivan at work in the American Civil War and their photographs influenced his paintings of this subject.

As the nineteenth century progressed homosexuality began to establish a limited representation in art and literature, although without label or definition. The American poet Walt Whitman was the first writer to articulate homosexual emotions involving sex and love with any clarity and this found a relatively direct response in the paintings of Eakins and Tuke.

The problem of defining the sexuality of these artists remains. Though none can be seen as homosexual in the modern sense of the word, all expressed at some time powerful homoerotic qualities in their work. Some, such as Eakins, were married; others had relationships with women. All had significant friendships with men.

Of the traditional school, it is Frederic (later Lord) Leighton (1830–1896) whose work above that of all nineteenth-century artists perfectly exemplifies the established notion of 'true art': the display of great skill, a particular sort of realism, and themes from ancient Greece or the Bible which ennoble and uplift the spirit. Classical contexts could be safely used for scenes of highly erotic and sensuous celebrations of the naked female body (though pubic hair was omitted), while paintings of the naked male body were far more circumspect. Only rarely were genital

details shown: concealing drapery or artful poses ensured modesty.

Leighton's biographers, Leonée and Richard Ormond, advise caution in identifying Leighton as homosexual, though they do acknowledge that Leighton 'fulfilled some part of himself in the company of young men'.[4] They also point out that his male models and protégés were also remarkably good-looking. For example, Leighton described the model for his early drawing *Vicenzo's Head* as the 'prettiest and wickedest boy in Rome'.

The Ormonds' suggestion that Leighton 'found a fulfilment as much emotional as purely sexual' in the young and very young of both sexes does not recognise the difficulties homosexual men face in expressing feelings for younger men in a society which is in general far more accepting of relationships between men and girls. The fact that 'the most intimate man-friend of Leighton's life' was the homosexual Henry Greville is more indicative of Leighton's interests.

As a youth Leighton travelled widely in Europe, studying art in Florence and Frankfurt, and later in Paris. In the 1850s he was described by Otto Doner von Richter as 'a youthful handsome man, full of the love of life and energetic, diligent, strong in health, having all the promise of a gifted painter'.[5] In Florence in 1856 Leighton met Greville, a wealthy aristocrat. Their friendship, close and at times intense, continued until Greville's death in 1872. Letters from Greville to Leighton are little short of love letters; Greville addressed Leighton with nicknames, 'Fay' and 'Bimbo', and often spoke of his feelings for his friend. He was also aware of the imbalance of their relationship, realising that the depths of his emotions were not reciprocated by Leighton: 'God bless you, my very dear boy—you are not so fond of me as I am of you, be sure of it. Take care of yourself and write too and love your old Babbino,' wrote Greville. Asking on another occasion 'I don't quite understand what it is you are doing in Italy except amuse yourself. Is there any other—? how long will it be before I see you? Addio, caro caro tanto, tanto. H.'[6] Unfortunately Leighton's letters to Greville have been lost.

Though the friendship with Greville was close and long-lasting, Leighton found relationships with much younger men, often in less favourable social and economic positions than himself, much more to his liking. He met young artists, helping them to get commissions. When these failed, he paid them regular sums of money. Early enthusiasms were not diminished when his protégés married. Leighton's will left the bulk of his estate to his sisters, but significant legacies were left to friends of long standing who included George Mason, a less than successful artist, Giovanni Costa, an artist he had met in Italy, and Dorothy Dene, a model and actress with whom he became friendly towards the end of his life.

His great enthusiasm for Greek culture included much wishful thinking about the idealism of an imagined past. Unlike the paintings of

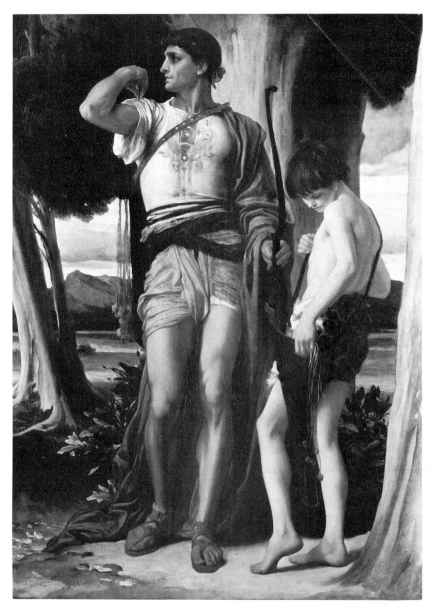

2.1 Frederic Leighton (1830–96) *Jonathan's Token to David* (c. 1868). Oil. 171 × 124 cm (67.5 × 49 in) (*The Minneapolis Institute of Arts*)

contemporary artists such as Lawrence Alma-Tadema (1836–1912) and Albert Moore (1841–1893), who used similar settings for winsome and sometimes explicitly sexual celebrations of the pleasures of the young female body, Leighton's compositions seem stiff, proper and stern.

Leighton gained respect where other artists gained affection.

In contrast to the chaste look of his females, nude or clothed, the male figures are given character and masculine idealised bodies, though they are rarely seen without a deftly placed loin cloth. Although some, like Icarus in *Dedalus and Icarus* 1869, look ineffectual, almost androgynous, in other paintings nude males are treated in terms of a heroic, classicising ideal. The startling realism of the nude in the bronze *Athlete Struggling with a Python* 1877 (Leighton House, London) produces a study of deep physical awareness. The detailed modelling of the sinews and muscles creates a work of great realism and strength which had a liberating effect on the younger generation of British sculptors after the bland coldness of neoclassical marble. It is tempting to read into Leighton's forceful statue a representation of his own conflicts and struggles.

Some of this passion spills over into Leighton's quieter, less dramatic paintings. *Hit* c. 1893 (Roy Miles Gallery, London) shows a youth wearing a laurel wreath being shown by an older man how to handle a bow and arrow. Similar sentiments are expressed in *Jonathan's Token to David* c. 1870 (Minneapolis Institute of Art), illustrating lines from 1 Samuel 20, 35: 'And it came to pass in the morning that Jonathan went out into the field at the time appointed with David, and a little lad with him.' Swinburne's description in *Essays and Studies* catches its mood. 'The majestic figure and noble head of Jonathan are worthy of the warrior whose love was wonderful passing the love of woman, the features resolute, solicitous, heroic. The boy beside him is worthy to stand so near; his action has all the grace of mere nature as he stoops slightly from the shoulder to sustain the heavy quiver!' Ostensibly both pictures are 'innocent' images of platonic friendship, expressed through physical proximity; they suggest a sexual as well as an emotional intimacy in which the homoerotic element is subtly but pervasively present.

Leighton's work was enormously popular, his successful life well ordered and, to outward appearance, without problems. As an elegant bohemian he threw bachelor parties to which artists and royalty were invited, yet in private he suffered continually from various physical and nervous ailments all his life. As President of the Royal Academy he was diligent in trying to improve standards and was rewarded by being made a peer of the realm shortly before his death, the only artist to be so honoured. In the last years of his life he found time to commission work from Charles Ricketts, Laurence Housman and Aubrey Beardsley, three young artists whom he greatly admired. He was particularly pleased with Ricketts' drawing *Oedipus and the Sphinx* and was persuaded by Beardsley to contribute two drawings to *The Yellow Book*.

Though they painted in different styles, Leighton had much in common with John Singer Sargent (1856–1925). They were acquaintances

and both had a great need for respectability and a desire for privacy. Both were careful to maintain outward appearances, but both acknowledged their emotions and feelings for the male body in their art.

Born in Florence of American parents, Sargent studied in Rome, Nice and Paris, and travelled extensively around Europe and North Africa before settling in Whistler's old home at 33 Tite Street, Chelsea, London, in 1884. At the age of twelve, Sargent was drawing classical and neoclassical sculptures of Antinous, Hercules and Perseus at the Vatican, and the study of the naked male form was an important element in his training.

By 1890, Sargent had acquired a large and fashionable portrait practice and it was as a society portraitist that he was to become well-known. This public image shielded him from prying eyes as well as providing him with a successful living. Yet his portraits of women often include an element of satire and a slightly mocking hint of disapproval. While the

2.2 John Singer Sargent (1856–1925) *Figure Study*. Watercolour on paper, 47 × 54.5 cm (18.5 × 21.5 in) (*National Museum of Wales, Cardiff*)

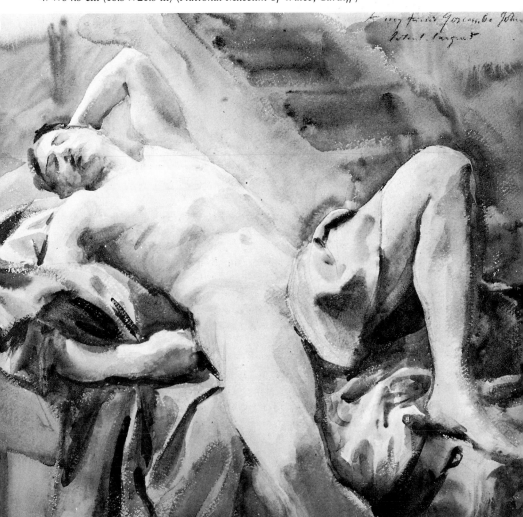

portraits gained Sargent a respectful and admiring following, they were seen by his contemporary artists as a sell-out to modish fashion and monetary success. A portrait of the artist W. Graham Robertson 1894 (Tate Gallery, London) has come to typify the aesthetic dandy of the period. Tall, elegant and with a thin, sensitive face, Robertson is posed with one hand on his hip and the general effect of the portrait is to suggest androgyny.

In 1890 Sargent accepted a mural commission for the new Boston Public Library. He executed many preparatory drawings of the male figure, either naked or partially clothed. Angelo Colarossi, the model who posed for Leighton's *Athlete and Python*, sat for some of these drawings. Sargent later collated a selection of these studies into a sketch book which is now in the Fogg Art Museum, Harvard Universitity.[7] The twenty-nine charcoal drawings span the years 1890–1915. In their fresh, spontaneous directness they give a glimpse of his response to masculine physicality and show his awareness of the attractions it offered. One of the models stands legs apart, arms folded, with an heroic appearance, while another, viewed frontally, is given a particularly bold treatment and carries a self-conscious sense of masculinity. All the drawings are carried out swiftly and loosely in charcoal and are only remotely related to conventional academic studies or highly worked life drawings. Little of this vitality is carried through to the completed murals in the Boston Library or in the classical figures in the Boston Museum of Fine Arts c. 1916–25.

The same physical awareness in the drawings is expressed in some late watercolours, for example *Nude Man Lying on a Bed* 1917 (private collection). Painted in Florida, the intimate and warm image has none of the theatricality or dramatic effects often found in Sargent's portraits. From a position at the top corner of the bed, the artist looks down from behind on the figure lying on the bed smoking a cigarette. The model's strong, suntanned legs and body are emphasised by the lighter patch where shorts were worn, conveying a sense of heat and of outdoor pursuits, in a gentle and relaxed pose. It is a sensual, intimate painting which unashamedly makes use of the voyeuristic position of the artist to look and admire without touching. It is as if the artist wanted the model to ignore his presence. Much the same feelings are conveyed in *Study of the Male Nude* 1917 (National Museum of Wales) which with an unstudied naturalism tenderly describes the sleeping figure in the intimacy of the studio.

Ever aware of protecting his reputation, Sargent was cautious in the face of public comment. For example, he declined to become a regular contributor to *The Yellow Book* for fear of being associated too closely with Aubrey Beardsley. He was equally conservative in his views on art, disliking Roger Fry's Post-Impressionist Exhibition in London in 1911.

Fry did not admire Sargent's work. Writing in the *Athenaeum* about *On His Holidays* 1902 (Merseyside County Council) he was far from enthusiastic. The lyrical study is of the fourteen-year-old son of the artist's friend George McCulloch, shown resting by the side of a fast-flowing river after salmon fishing. Fry wrote: 'The pose is recorded with photographic accuracy and with photographic indifference ... we are convinced at once of the actuality of everything and then—we may find the beauty or significance of it all for ourselves. Mr Sargent will not help us.' What Fry ignored, or failed to recognise, was Sargent's response to the innocent attractions of the youth.

Sargent offered little information about his work or his sexual preferences. He is generally described as being 'emotionally inhibited'.[8] Certainly he found great pleasure and security in the companionship of his sisters and nieces and in the domestic atmosphere which they provided. He enjoyed close friendships with among others the French painter Paul Helleu and with Nicola D'Inverno, his valet, who had been brought to London as a child by immigrant Italian parents. D'Inverno entered his service when he was nineteen in 1892 and worked for him until 1917. But much of the 'evidence' for Sargent's sexual interests lies in his drawings and watercolours rather than his more formal paintings.

During a visit to Philadelphia in 1903, Sargent asked his host to arrange a visit to meet Thomas Eakins (1844–1916), a painter then very much out of fashion. Sargent greatly admired Eakins' paintings and immediately suggested that he should have an exhibition of his portraits. Eakins' reputation was as a realist painter, concerned with American themes and subject matter, but with great emphasis on the study of the nude figures, especially that of the male. Following the example of the Greeks and the artists of the Renaissance, Eakins saw everything that was perfect in the naked male body.

Eakins combined in his work two current trends: like his near contemporary Winslow Homer, he sought to express a new realism and awareness taken from the world in which he lived and the people he knew. As neighbour of the poet Walt Whitman, who lived in nearby Camden, he was familiar with the poet's work which had been published since 1860. He may also have been sensitive to the idea of the new America in general and homosexual feelings in particular.

Whitman, aware of the reverence for classicism among poets and painters, did not want America to take on a pseudo-Greek landscape and avoided mythological or historical references in his poetry. Nevertheless, running through his most influential work is a steady insistence on the importance of male comradeship, values which referred to America's pioneering past as well as having a resonance with the ancient Greeks. It was inevitable that Whitman's ideas about male comradeship were recognised by many as declarations of homosexuality, attracting

supporters from across America and from Europe. Though Whitman was reluctant to acknowledge the homosexual content in public there is little doubt about the emotions he described. Judging by his paintings, Eakins was also well aware of Whitman's ideas, attending a meeting on Whitman's poetry with his friend Samuel Murray. Eakins' fascination with the Greek way of life and male comradeship is evident in his carefully composed paintings of naked youths set in classical Arcadian scenes.

Eakins was born into a middle-class family in Philadelphia and, except for visits to Europe, lived in the city all his life. Strong, handsome and athletic, he led an active outdoor life. Talented at arts and sciences, he enrolled for a brief period at the Pennsylvania Academy of Art, before spending four years at Jefferson Medical College, gaining a knowledge of anatomy equal to that of any physician but little training as an artist.

2.3 Thomas Eakins (1844–1916) *Arcadia* (c. 1883) Oil. 98.1 × 114.3 cm (38.62 × 45 in) (*Metropolitan Museum of Art, New York: Bequest of Miss Adelaide Milton de Groot, 1967*)

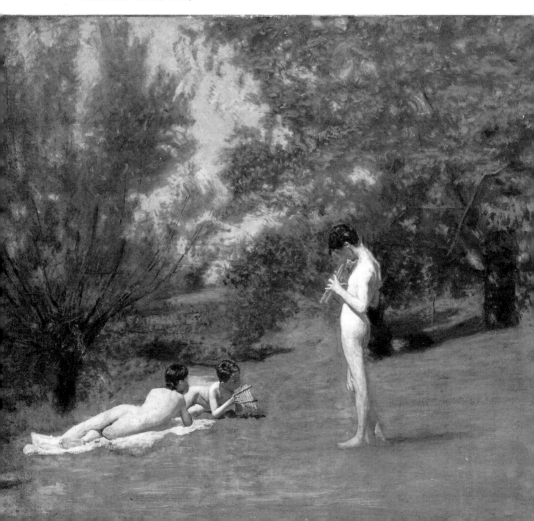

In Paris from 1866 to 1870, he settled down for the first time to draw the nude, studying under Jean-Léon Gérôme at the Ecole des Beaux Arts. He followed the Greek example of studying direct from nature rather than from the antique sculpture. His fascination with the ancient world was encouraged by Gérôme's paintings of carefully researched scenes from Roman history such as *The Death of Caesar*, and *Pollice Verso*. Though Eakins was aware of the more decorative versions of classical themes by Sir Lawrence Alma-Tadema and Albert Moore, as well as paintings by his contemporaries Thomas Wilmer Dewing and Frank Millet, Eakins favoured a much simpler, more natural style that was not decorative, anecdotal or archaeological. This view was borne out by his comment on the typical salon nude then in fashion, for which he had nothing but contempt:

> Pictures of naked women, standing, sitting, lying down, flying, dancing, doing nothing ... When a man paints a naked woman he gives her far less than poor Nature did. I can conceive of few circumstances wherein I would paint a naked woman, but if I did I would not mutilate her for double the money. She is the most beautiful thing there is—except for a naked man.[9]

Back in Philadelphia after three years in Europe, Eakins took as his subject the people and activities he saw around him which included sail boats on the Delaware, bird hunting in the New Jersey marshes and rowers practising or racing. The all-male world he often chose to paint included gymnasiums and boxing rings. Like Homer, he was fascinated by nature and landscapes.

Eakins' friendships with his students at the Academy, where he was an instructor, were as unconventional as his teaching methods. Around 1880 he acquired a 4 × 5 in. camera which he used as a way of studying the proportions and movements of the naked body. Male students were encouraged to pose out of doors in woodland glades, sometimes pretending to play the classical pipes while they were drawn or photographed. For some poses the men took up the positions of ancient statues but others were observed enjoying themselves with physical activities. *The Swimming Hole* 1883 (Fort Worth Art Museum) is Eakins' most successful naturalistic composition combining close observation of the naked male body, arranged in a careful pyramid composition. At the tip of the pyramid a youth poses, a physical and symbolic demonstration of Eakins' own homoerotic interests.

The painting's quality of wholeness and innocence is emphasised by the idyllic setting and the sheer pleasure of swimming and sunbathing in the nude. *The Swimming Hole* evokes the naked athletic comradeship of the Greek gymnasium, but with the additional sense of the relaxed

human relationships being continuous with the idyllic natural setting. Such themes relate to Whitman's poem *Song of Myself* in which physical and emotional brotherly love is a perfectly natural expression of feeling.

Despite the evident success of his teaching methods, Eakins' emphasis on the nude was not liked by conservative members of the community. Their criticisms came to a peak in 1886. Whilst teaching a women's life class he removed and refused to replace the conventional loin cloth on the male model. Told that he must be more modest in his teaching methods he resigned and set up the short-lived Art Students League with a group of his students. In the League, Eakins formed a close friendship with the young sculptor Samuel Murray. For over ten years they shared a studio, with Murray first working as his painting assistant whilst Eakins learnt from him the craft of sculpture. Later they collaborated on various projects.

Rejected by the Academy, and with the League in financial ruin, Eakins' teaching career virtually ended when he was fifty years old. Turning away from painting outdoors, he concentrated on portraits of friends and acquaintances.

One of his most famous portraits is of Walt Whitman. Murray and Eakins took photographs of the poet in his home and the painting was completed in 1887-8 (Pennsylvania Academy of Fine Arts). Whitman, shown with a fluffy white beard and long hair, looks a wise and friendly old sage. Eakins gives a clue to Whitman's homoerotic sensibilities, showing him with a fine lace edging to his collar. 'I never knew but one artist, and that Tom Eakins, who could resist the temptation to see what they thought ought to be rather than what is,'[10] said Whitman.

In 1884, when he was nearly forty, Eakins had married Susan Macdowell, one of his former students at Pennsylvania Academy of Fine Art. She was a great support to him, more or less stopping painting herself until after Eakins' death. The subjects she chose were often of women together in quiet moments, for example *Two Sisters* 1879, one sewing, one reading. Together with Eakins and Samuel Murray, Susan Macdowell shared 'a vast admiration for Walt Whitman' but refused to go to a symposium on his poetry when it meant foregoing an afternoon's painting.[11]

In the 1880s and 1890s, Eakins' painting, like Homer's was out of favour with the current fashions of the art world, but his rejection of romanticism and his unswerving and definite ideas about the choice of subject and the figure were particularly influential amongst some of the new generation of artists. These included Thomas Anschutz whose greatest work *Steel Workers at Noon* c. 1880 (private collection) shows a group of men, some stripped to the waist, relaxing and exercising, follows and develops Eakins' teaching. In turn Anschutz inspired a new generation of American artists in the first decades of the twentieth

century. The influence of Eakins can also be found in the work of George Bellows (1882–1925) in his dramatic boxing-ring painting *Stag at Sharkeys* (Cleveland Museum of Art), for example, and paintings of business men at the turkish baths.

Eakins shared a determined artistic independence, an allegiance to the new realist movement, and an understated but pervasive homoerotic element in his painting with his near contemporary Winslow Homer (1836–1910). A large exhibition of British art shown in New York in 1857 and later in Boston included three paintings by Leighton on classical themes as well as work by pre-Raphaelite artists. It was in that year that Winslow Homer, who was then twenty-one, moved to New York. He declared himself his 'own boss' and stated his determination to draw only what he saw in front of him. If he visited the British show he would have been more likely to have found inspiration in the Brotherhood's call for a return to the study of nature than in Leighton's classicism.

Homer earned a living providing illustrations for the magazine *Harpers Weekly*. They sent him to record the Civil War, an event which made a deep impression on him. After visiting the front several times he chose to

2.4 Thomas Eakins (1844–1916) *The Swimming Hole* (1893–5). Oil. 68.6 × 91.4 cm (27 × 36 in) (*Amon Carter Museum, Fort Worth*, 1990)

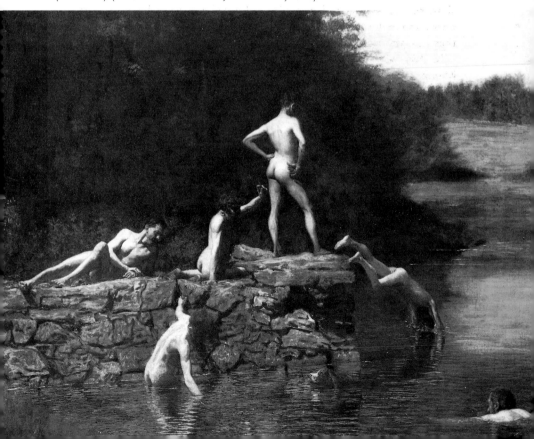

concentrate on scenes of camp life, of soldiers attempting to pass the hours of loneliness and boredom between bouts of fighting. In his book *The Great War and Modern Memory*, Paul Fussel[12] identifies the way war and sexuality are linked, particularly with regard to homosexuality. War and love, he argues, are inextricably bound together. Even the language of war, 'assault', 'impact', 'thrust', 'penetration', has strong erotic connotations, and episodes of rape and looting invariably take place against the background of violence and sexual deprivation. For some men war is a time of realisation when they become aware of their feelings for their fellow soldiers. Writers, particularly poets, have recorded such feelings. Walt Whitman, for example, was deeply impressed and moved by the Civil War, volunteering to nurse soldiers in an army hospital in Washington. He described in his poetry, as Homer did in his paintings, the ordinary and commonly shared experiences of army life.

Homer responded to the comradeship that came about in war rather than the bravery. The soldiers he paints are thoughtful and quiet with none of the heroism that Eastman Johnson (1824–1906), for example, put into such pictures as *The Wounded Drummer Boy* 1870. Set in the middle of the fighting, this work shows the young drummer boy wounded but not defeated, still bearing his drum as he is carried shoulder high by soldiers.

In contrast, Homer's *Home, Sweet Home* c. 1863 is typical of life behind the lines. Two young soldiers, resting outside their tent, are boiling a pan of water over a wood fire while listening to the regimental band play the song of the title. In spite of its heart-rending emotion, a critic writing in the art magazine *The New Path* found the picture 'too manly natural to be called sentimental'. By choosing to concentrate on the softer, more human side of the soldier's life, Homer points the contrast between the aggressive, all-male world of the war and the yearning for the quiet security of home life. The painting also hints at the companionship and closeness that can develop between men, particularly in war.

After the war Homer studied painting in Paris, his visit in 1867–8 occurring at a particularly lively time. The fifty paintings by Manet which had been rejected by the French Academy were on show while the 1867 Universal Exhibition included work by French, British and American artists as well as a collection of Japanese art. Homer, who had two of his own paintings in this show, responded to the French painters whose work reinforced his belief in his own choice of naturalist subject and style. From the Japanese art he absorbed a new awareness of composition and contrast.

In Paris, Homer shared a studio with his close friend and fellow Bostonian, the artist Albert Kelsey. They posed for a photographer,

Kelsey's arm resting on his friend's shoulder. Kelsey wrote on the back of
the photograph 'Damon and Pythias' after the friends who so impressed
Dionysius with their devotion to each other. Later Homer drew Kelsey
sitting naked on the back of a giant turtle during a holiday in the
Bahamas. The influences found in Paris gave his work a new assurance
and confidence expressed in paintings of men hunting and trapping in the
mountains, ragged-clothed children and humble scenes of farmers at
work, subjects generally ignored by American artists.

At forty-five, Homer, secretive and solitary, faced a personal and
artistic crisis and left America. In 1881 he journeyed to the tiny English
fishing village of Cullercoats near Tynemouth on the North Sea and lived
there for almost two years in a rented cottage in almost total isolation,
rarely meeting anyone. He cooked, cleaned, consumed a great deal of
alcohol and painted scenes of the local fishing community. Like his
brother's home in Maine, Cullercoats stood on a promontory jutting into
the sea, and he was fascinated by the human struggle for survival which
he witnessed in the wild and turbulent ocean. Such themes became his
regular subject matter and in them he may have found an image which
reflected his own search, his own struggle for survival.

In America Homer settled at Prout's Neck, Maine. He built a studio
and house (next to his brother) but he continued to live alone and as
self-sufficiently as possible. Three main themes occur in his paintings,
women together at work or leisure, black workers of the deep South, and
men relaxing or struggling with the sea. His paintings of women often
convey shared strength and support. A drawing of two clothed women
holding hands and playing in the sea (Metropolitan Museum of Art,
New York) is an expression of affection and evident enjoyment from
which men are excluded. *A Summer's Night* 1890 (National Museum of
Modern Art, Paris) shows two women dancing together,[13] a scene he saw
on the rocks below his studio.

Renewing his memories of visits to Virginia during the Civil War,
Homer returned and painted the negro workers, at that time a very
controversial subject. On one occasion he was threatened with physical
attack for choosing such subjects. His identification with the oppression
of the negro and American Indian enabled him to paint them without
lapsing into sentiment or the picturesque.

Visits to the Bahamas provided Homer with some of his most
sensuous images of males, often of half-naked muscular negroes,
sensitively, almost lovingly painted. Such sights were a daily occurrence
in the Caribbean sunshine and Homer renders the well-developed bodies
with ease and naturalness, giving them a solid but sensual reality. It was
as if the warm sunshine and freedom of a strange country where men
could swim half-naked without comment enabled Homer to shed some of
his own inhibitions and to respond without reserve.

The resulting oils and watercolours celebrate the physical beauty of the negro whom he shows swimming, running on the beach, fishing and so on. One of of his greatest paintings, *Gulf Stream* 1899 (Metropolitan Museum of Art), was recognised by Roger Fry, then curator of painting at the Museum, as 'one of the most typical and central creations of American art'.[14] A half-naked negro lies defiantly spread out on the deck of a small boat, its mast broken, tossed by the sea, threatened by a water

2.5 Winslow Homer (1836–1910) *The Gulf Stream* (1899) Oil. 71.5 × 125 cm (28 × 49 in) (*Metropolitan Museum of Art, New York*) and Detail

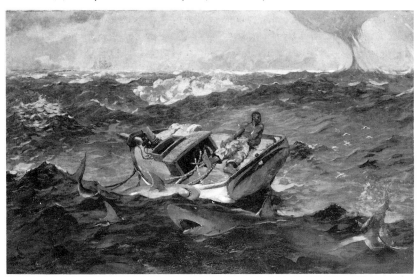

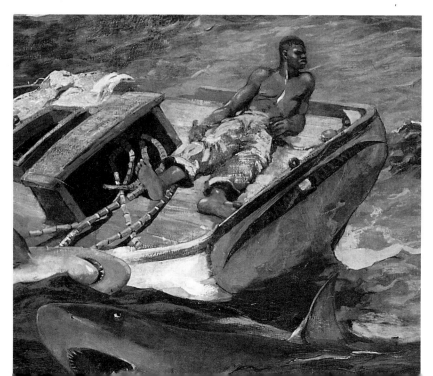

spout and surrounded by sharks. Parallels between the strengths of all of the different forces prompt the suggestion that Homer was drawing attention to the power of the muscular sailor.[15]

Homer's firm belief was in the search for truth rather than artifice. His advice to a friend was to 'try to put down exactly what you see. Whatever else you have to offer will come out anyway.'[16] A painter's emotions, Homer believed, would show themselves in an honestly painted picture without them being intentionally added. This view is particularly interesting when it is contrasted with Homer's own refusal later in life to supply biographical information to the respected art critic William Howe Downes. He said 'As the most interesting part of my life is of no concern to the public, I must decline to give you any particulars in regard to it.'[17] What that part of his life was remains conjecture.

Just as Homer, Eakins, and on occasions Sargent, had found that painting out of doors gave acceptable contexts within which to place the naked body, so artists in Britain were exploring similar opportunities. Inspired partly by the work of the French painter Bastien Lepage, a group of British painters set up an artists' colony in and around the then remote fishing village of Newlyn in Cornwall. One of these artists Henry Scott Tuke (1858–1929), settled in 1885 in Falmouth, Cornwall, an area where he had spent much of his childhood. Familiar with the unspoilt delights of the countryside and the coastline, Tuke found the position ideal. London connections could be maintained (he continued to accept commissions for portraits) and the Newlyn artistic colony was at a distance which allowed regular but not frequent contact. He could sail his boat from Falmouth Harbour and he was able to use his French brigantine *The Julie of Nantes* as an alternative home and private studio from time to time. He could also make use of the remote and inaccessible beaches as settings for his paintings.

After studying at the Slade School of Art, London, Tuke had spent the two years 1881–3 in Paris with Jean-Paul Laurens, a highly respected historical painter. With the English artist Arthur Lemon he visited Pietro Santa, a village on the coast between Livorno and La Spezia sixty miles from Florence. For a few pence, the nude, sun-browned Italian youths posed on the beach.

Tuke quickly established his reputation. Early recognition came in 1889 when the Commissioners of the Chantry Bequest purchased the large formal composition of male heroism *All Hands to the Pumps* c. 1888 (Tate Gallery, London) for £420. This ambitious canvas which contained seven carefully painted figures was completed on board the brigantine. This was his last large, classic composition. From then on he worked in the open air, painting scenes of naked and clothed youths in a naturalistic manner. When the Chantry Bequest purchased *August Blue* five years later for £525, his new style received a measure of official blessing.

August Blue c. 1893 (Tate Gallery, London) is characteristic of Tuke's *plein air* style, dealing competently with the effects of light on the body and on water. His academic training is evident in the careful composition, but the scene of naked youths bathing from a boat in crystal-clear water under bright blue skies is painted naturalistically, exuding energy and above all innocence. At the Royal Academy in 1894 its glowing colours, sparkling sunlight and healthy bodies made it a popular favourite. In contrast to the static and lifeless nudes shown by other artists, Tuke's painting was fresh and 'modern'. While artists such as Stott of Oldham had exhibited paintings at the Royal Academy of naked small boys playing on beaches, such youthful nudes so competently and freshly presented had not been seen before. Far from outraging Victorian morals, Tuke's paintings were seen as innocent and guileless celebrations of the joy and pleasure of youth, embodying all that was pure and unspoilt.

Tuke also painted other subjects, most notably portraits and watercolours of harbour scenes and sailing ships which have a delicate and almost mystical charm, but it is his outdoor scenes of youth which predominate. He painted the youths naked, engaged in healthy outdoor pursuits, swimming, diving or paddling under skies which have a Mediterranean intensity. In other pictures, clothed youths lounge in boats, lean against fences, lie in hammocks, splash in water or play in grassy fields. A poem by Tuke written in the late 1880s and published in

2.6 Henry Scott Tuke (1858–1929) *August Blue* (c. 1893–4). Oil on canvas. 122 × 183 cm (48 × 72 in) (*Tate Gallery, London*)

The Artist records his idealisation of these young men.

> Youth, beautiful and daring and divine,
> Loved of the Gods.

It is this quality of purity and respectability, free from the itch of desire, which enabled Tuke to avoid any direct suggestions of homoeroticism in his work.

In Falmouth Tuke never concealed his choice of subject matter and always obtained the permission of parents before employing his models. Early on youths were reluctant to pose and the same model was used for different figures in the same painting. *Two Falmouth Fisherboys*, exhibited as *Bathers* in 1886 in the New English Art Club used his cockney friend and model Walter Shilling for both boys. 'I am almost tired of painting the same boy but in the bathing picture I consider him quite impersonal, the vehicle of splendid flesh colour and form,'[18] he wrote. Reporting on his work, Stanhope Forbes records Tuke's problems getting models, writing that 'he had been forced to have a boy from London whom he boards and lodges. So he is painting this British youth in the style the British matron so strongly objects to.'[19]

Significantly, Tuke rarely painted the genitals of his naked figures.

2.7 Henry Scott Tuke (1858–1929) The 'no-trouser' version of *Noonday Heat* (1903) 132 × 81 cm (52 × 32 in) This painting is now in a private collection. Illustrated in an edition of *The Tatler* 1933

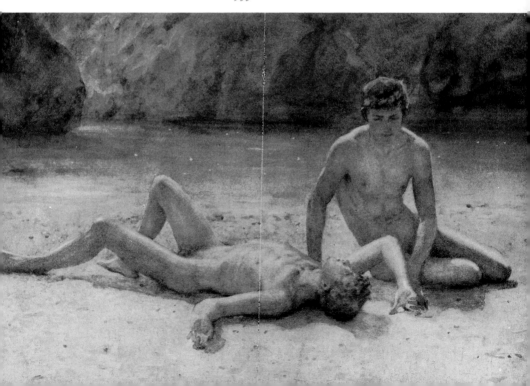

These were concealed by careful posing, or if this were not possible, they were cast in shadow.

At the request of Sydney Lomer, he did paint in the genitals in detail in one picture but promptly painted them out when the patron did not buy the work. This apparent coyness provoked Leonard Duke, another of Tuke's patrons, to ask for a 'no trousers' version of the oil *Noonday Heat* 1903. The painting shows two boys on the beach, one lying on his back wearing white-coloured, loose cotton trousers. Sitting by his side is a naked youth gazing into his eyes. The painting is ambiguous, having both an innocent reading and one loaded with sexual suggestion. It is apparently a picture of two young men enjoying the sunshine and exchanging friendly conversation; equally possible is the suggestion that the two boys have a much closer, possibly more physical relationship. Tuke's 'no trousers' version was featured in a double-spread in *The Tatler* in August 1933.

There were criticisms of his subject matter. A review in the *Cornish Echo* in 1889 of *The Diver*, a painting which shows youths diving from rocks and a boat, asked why Tuke 'does not give his attention to a more acceptable subject'. Nevertheless each year his work was shown in the Royal Academy and in 1914 he was made a Royal Academician. In 1911 he had been elected a full member of the Royal Watercolour Society.

Both before and after the First World War, Tuke had an earnest, enthusiastic group of admirers, many of whom were homosexual. Known as a 'painter of youth' he was seen to put into visual form the more open concerns of a new age.[20]

A regular visitor to Tuke's home was John Addington Symonds, one of the few homosexuals who had tried to organise opposition to the Labouchere Amendment to the Criminal Law Amendments Act 1885 and author of *A Problem in Greek Ethics*. A great admirer of Walt Whitman, Symonds had quickly recognised the homosexual theme of Whitman's poem *Calamus*. For over twenty years he was in regular correspondence with the poet, questioning him about his work and its significance. Tuke may also have been aware of the poems and the relationship between them and his paintings.

On one occasion when Tuke visited the homosexual Gleeson White in Christchurch, Hampshire, he met the writer and painter Frederick Rolfe (1860-1913), the self-styled Baron Corvo. Rolfe was currently engaged on painting a series of murals for the Catholic church. On the strength of a mutual friendship with the Falmouth timber merchant Charles Masson Fox (who received letters from Rolfe describing pederastic life in Venice), he asked Tuke for help in painting the boy figures. A poor draughtsman, Rolfe attempted to copy figures from illustrated books but the results were stiff and stylised. Within the formal religious stories, Rolfe made the men conventionally handsome and characterless and the women

pretty rather than convincing. Another attempt at religious painting at the church of St Winefride in Holywell, Clwyd, was also doomed to failure. He persuaded the local priest that a series of banners would enhance the elaborate pilgrimages the priest was staging for the holy well of St Winefride and that no payment was necessary. Rolfe cut figures out of illustrated papers and attempted to project their silhouettes so that he could draw around them. Rolfe aimed for a Gothic charm which (despite the prettiness of the youths) he did not quite achieve.

Another great admirer of Tuke was Frederick George Reynolds (1880–1932) whose handling of *plein-air* subjects and youthful nudes is equally if not more sexually suggestive than his master's. He was born in London and his father F. G. Reynolds exhibited watercolours at the Royal Academy. At the age of nineteen and with an art career planned, he sailed for Australia under mysterious circumstances and spent some years working on the land before returning to city life as an artist. He specialised in male nudes set on the sea shore or among rocks, lit by brilliant sunshine, and wrote in 1916 about the pleasures of painting the 'sports and pastimes . . . of the energies of joyous youth'.[21]

'Joyous youth' did indeed offer the male artist who was homosexual the opportunity to express homoerotic interest. The figures were usually handsome, attractive and above all, innocent, enabling both the artist and the viewer to admire from a safe distance. The subjects were also socially acceptable: 'the itch of desire' may have been suppressed but the knowing few could recognise the itch even if it could not be satisfied. For women, who had few direct Greek references, the problem of conveying love and desire for other women found other, often more subtle, forms of self-identity.

3 · Genius has no Sex

As the Empress Eugénie presented the Legion of Honour to Rosa Bonheur in 1865, she murmured 'Genius has no sex.'[1] But Rosa Bonheur was the first woman to be presented with the highest award in France and genius, whether in art or any other discipline, lay very securely in the hands of men as far as most people were concerned. Any women who wanted to develop professional careers as artists, to become in Rosa Bonheur's description 'sisters of the palette',[2] had to fight staunch opposition on many fronts. Popular opinion held that women were just not artistically gifted and that those who wanted training were merely seeking a pleasant pastime prior to marriage. There was also the view, expressed in *Art Amateur* in 1880, that women were 'too delicate ... to endure for any length of time the severe course of study' required to become an artist. As the American sculptor Anne Whitney discovered, even if recognition did seem possible, it was not enough to be an excellent and imaginative artist – you also had to be a man. Along with other sculptors she anonymously submitted designs to the Boston Art Committee for a memorial statue to the abolitionist senator Charles Sumner and they were initially accepted. When the committee found out that they had nominated a woman artist, however, the decision was reconsidered. Anne Whitney's designs were rejected and the commission was given to a man.

As well as fighting art committees, women artists had to overcome the practical problems of finding and gaining admission to reputable art schools. Financially only women who had some sort of private income or family support could pay art school fees or could make time for their studies. Some Parisian art schools charged women twice the amount asked of men. Class and social background were important determining factors in deciding which women received proper training. The obstacle

race, as Germaine Greer recognises in her book of that name, for women to become artists was complex and succeeded in putting off all but the most determined.[3]

Many women unquestioningly accepted the prevailing styles and subjects, usually chosen by men, and often competed on unequal terms for acceptance within the art establishment. Rosa Bonheur for example, was hailed as a highly successful but conventional animal painter. There were, however, other women who found their own subject matter and ways of expressing their own ideas. A group of American neoclassical sculptors learned the technique of marble carving when it was virtually a male preserve, and in their own work, as opposed to commissioned pieces, expressed their feminist and abolitionist views.

Many women found great intellectual fulfilment in the artistic profession, and on occasions a high measure of success and independence as artists. For women with feminist views, banding together in groups and clubs provided practical and emotional support where ideas could be discussed and advice sought. But as Lillian Faderman points out in her book *Surpassing the Love of Men*, women in such relationships, even where they were close physically and emotionally, would not necessarily see themselves as 'lesbian'.[4] To all intents and purposes these women identified emotionally with members of the same sex and whether this was physically expressed does not change the love and affection they felt and wrote about. Generally society saw these relationships as having no sexual content, and therefore as pure, and they could be accepted without reserve.

Not everyone viewed such attempts by women to develop truly independent artistic careers favourably. Critics did not like women imitating everything 'mannish', nor did they see it as innocent or acceptable. Female emancipation was satirised in France in the middle part of the century by artists such as Daumier. George Sand was ridiculed for wearing male clothes in a drawing by Acide Lorentz of 1842. Nor were patriotic attempts by women to fight welcomed. When the Prussians invaded France in 1870, Rosa Bonheur took up her rifle and volunteered to defend the village. The mayor restrained her saying that she was no Joan of Arc.

Criticism of female emancipation did not only come from men. Of the artist Louise Abbéma, Judith Gautier wrote:[5]

> Is this a young man? Is this a young woman?
> A goddess or a god?
> Love, fearing to commit an infamy
> Hesitates and delays its avowal.

Later in the century, in *The New York Times* of 1897, the Reverend
Parkhurst railed against such women who looked and behaved like men,
describing them as 'andromaniacs' who sought to 'minimise distinctions
by which manhood and womanhood are differentiated'.[6] Such responses
reflect the changing social climate and the growing awareness of sexual
difference. They also indicated that the independence women had gained
by the 1890s, however limited, was there to stay.

In the mid to late nineteenth century, women artists concentrated in
cultural centres such as Paris or Rome or moved towards skills within
which some measure of freedom could be found, such as that offered
within the Arts and Crafts Movement. A major exception was the
staunch individualist Rosa Bonheur. In Rome, a group of American
women sculptors centred around the powerful personality of the actress
Charlotte Cushman, while in Paris the aesthetic circle around Robert de
Montesquiou was welcoming. In Boston, America, the 'Tomboy Club'
which flourished in the late nineteenth century was an equally important
focus. Far from apologising about their unmarried state, the women
members celebrated spinsterhood and the club created the opportunity
for them to meet and talk about their interests. Close relationships
between women who lived together, often of the professional classes,
were known as 'Boston Marriages'. Many painters and sculptors formed
such relationships, and many chose to wear male attire. Rarely was the
wearing of men's clothes regarded as an indication of lesbian sexuality.
The women were merely seen as eccentric and defended their attire on
the grounds of its practicability.

Women artists' identities as 'artists' did not mean that their ideas
about female emancipation would not be expressed, but they were often
given oblique rather than direct expression. Women from classical history
who expressed individuality and independent qualities were often
portrayed. Equally themes expressing freedom, whether for women or for
slaves, were important.

The Arts and Crafts Movement, which was widespread in both Britain
and America provided an important context for rewarding creative and
skilled work for both men and women. Within the Arts and Crafts
Movement some women found a freer acceptance of their desire to learn
particular manual skills and offered artistic involvement. Mary Lowndes,
who was involved in the campaign for women's suffrage in London,
became a stained glass designer in the 1890s. Along with Christopher
Whall, she was co-founder of the stained glass firm of Lowndes and
Drury. Like Wilhelmina Margaret Geddes, another stained glass artist,
she was a lesbian. In her book *Angel in the Studio* Anthea Callen[7]
suggests that the greater self-awareness of the women as lesbians may
have increased their questioning of the socially stereotyped 'feminine'
role and the limitations which women were expected to accept.

Wilhelmina Geddes, who designed visually powerful stained glass, was trained in the An Tur Gloine (Tower of Glass) stained glass workshop and school set up in 1903 in Ireland by Sarah Purser, an artist of the Royal Hibernian Academy. Several other women were trained there.

For many women, the greatest source of inspiration was the French artist Rosa Bonheur, whose success as an animal painter of international reputation demonstrated that women could compete in a male-dominated world. Rosa Bonheur (1822–1899) was one of the most acclaimed artists of her time, taking on the academic conventions of animal painting and refining them to perfection. She not only accepted the traditions of the academy in which men totally outnumbered women, but took on many 'male' attributes in the way she lived her life. She bought her own property, wore male attire and settled down to a life-long relationship with a woman, referring to herself as 'the husband' and her friend as 'the wife'.[8]

Marie Rosalie Bonheur was born the eldest of four children in Bordeaux to the artist Raimond Bonheur and the musician Sophie Marquis. Their father, a supporter of the radical social ideas of Saint-Simonism, encouraged his family to accept this doctrine which espoused the emancipation of women and the overcoming of traditional sex roles. He taught his children the techniques of painting and, at thirteen, Rosa Bonheur was drawing at her father's side; a year later she was studying at the Louvre. Her unusual outfit earned her the title 'The Little Hussar'. As part of his belief in the Saint-Simonians, her father took up communal existence at the monastery at Merril Moutant, abandoning the children to the care of their mother. Gifted artistically and musically with a beautiful singing voice, but not physically strong, Sophie Bonheur gave piano lessons to help support her family. Sophie Bonheur's death of 'exhaustion' at the age of thirty-six, shortly after she had nursed Rosa, left Rosa with feelings of responsibility for the rest of her life and a desire to care for women who were musically gifted and in delicate health.

As a girl of fourteen, Rosa became friendly with Nathalie Micas, the twelve-year-old daughter of an acquaintance of her father's. A close friendship developed between them and when they met again a few years later a lifelong relationship developed.

Nathalie, delicate and gifted, was an artist and an inventor who excelled in the role of caring for Rosa and maintaining their home. Her paintings of cats and kittens playing with balls of wool were seen as sentimental, suitable to her role as homemaker. Anxious to protect their relationship, Nathalie often displayed jealous behaviour which was seen by their friends as part of her eccentric behaviour.

With a good grasp of the realities of the world, and adept at handling the sale of her paintings, Rosa became wealthy and successful. 'I mean',

she said, 'to earn a good deal of filthy lucre for it is only with that that you can do as you like.'[9] As a successful artist and independent woman, in 1860 Rosa bought an estate on the edge of the forest of Fontainebleau at By. The large chateau enabled Rosa to have a large and airy studio and provided a home for Nathalie's mother.

If Nathalie's given or chosen role was 'wife', Rosa's identification was very much as 'husband'. On the occasion when Rosa Bonheur received an award from the King of Spain, she claimed that Nathalie was 'as proud as the wife of an old soldier'.[10] Even since childhood Rosa preferred to wear men's clothes, an illegal act at the time unless special permission was sought. The Paris Prefect's Office granted her permission in 1857. The reason given was purely practical, that it would stop her being molested when working and be more convenient when she attended the slaughter houses, the sales of livestock and the assemblies of horse copers where she found many of her animal subjects. She insisted that her choice of clothes was only convenience and disliked meeting visitors or being photographed in male dress. It is likely that she did not want to be seen as any sort of 'freak', preferring to present herself as conventionally as possible. In fact, she usually wore men's clothes, deigning only to wear a skirt when absolutely necessary. Her outfit of full velvet trousers and floppy painter's smocks usually worn by male artists gave her a sexless appearance which on occasion gave rise to comment about the nature of her relationship with Nathalie. 'Silly, ignorant, low-minded people'[11] was her response.

Much of the couple's respectability was due to the fact that until her death Madam Micas presided over the household. Nevertheless there was inevitably gossip about Rosa's way of life. When Lady Elizabeth Butler (c. 1850–1933), the English painter of large outdoor scenes and military subjects was called 'the English Rosa Bonheur', it was a comparison she did not appreciate.

Though she maintained friendships with men she often made passing references to them suggesting that they had a limited role in her life. On one occasion she joked that the only males who attracted her were the bulls she put into her paintings.

Nathalie's death in 1889 left her desolate. Despite her critical and commercial success (one of her paintings sold for £4,200 in 1888) she was deeply depressed. An admiring visit from the young American painter Anna Klumpke who wanted to paint her portrait restored her spirits, however. Anna Klumpke had nurtured a high regard for Rosa ever since childhood when she had been given a Rosa Bonheur doll dressed in a costume of a blue smock over a finely embroidered peasant blouse, black velvet pants and patent leather shoes. The seventy-seven-year-old artist fell in love with the adoring visitor who had all the qualities she so much admired. Anna Klumpke was lame and had been so since she was a

child, she had delicate health and was gifted both artistically and musically. Rosa insisted that she give up her career and come to live with her. She also urged her to write the biography that Nathalie Micas had not lived to complete. In letters to intimate friends Rosa Bonheur referred to her as 'my wife'. Such was Rosa's love that she planned for Anna to be buried next to her and Nathalie Micas in Père Lachaise Cemetery under the tomb inscribed 'Friendship is divine affection'. Anna Klumpke's ashes joined those of the two women in 1945.

The contrast between Rosa Bonheur's academically respectable paintings of animals in which every hair and blade of grass was included, and her highly unusual way of life with an unconventional sexual orientation, expressed both her own determination to succeed as an artist and as a woman, whilst acknowledging Victorian ideas about modesty. If her choice of life partner was another woman, the format of the relationship was that of the conventional and devoted marriage. Of equal importance was her career as an artist. Her artistic and financial success placed her in a strong position to determine the way she organised her life.

Bonheur's definite views on her sexual identity prompted her to submit an account of herself as a 'contrasexual' to the Magnus Hirschfeld Institute of Sexology in Berlin.[12] She saw herself as a member of the 'third sex', as some sort of 'masculinised woman', a sexual neuter, perceiving herself very much in androgynous terms. Not conventionally religious, she did have deeply held beliefs partly derived from the Saint-Simonists. These included the mystical acceptance that saw Christ as an androgyne, with the wound in his side as an analogy of female genitalia.

Few of these ideas are immediately apparent in her paintings which are, to all intents, powerful and competent pictures of animals, usually horses, evoking their superior strength and beauty. They aimed for accuracy (they were too painstaking, some critics thought) and realism in the romantic tradition. Her work displayed little or no influence from contemporary ideas and theories about light or choice of subject matter then being discussed by the Impressionists, but took up some of the force and spirit of Théodore Géricault (1791–1824). It was he who she emulated when she visited a slaughterhouse to study the animals. Géricault, a keen horseman (he died at the age of thirty-three after a fall while riding), painted horses with a virile and energetic realism. His *Light Cavalry Officer* 1812 (Louvre) captured all the force and strength of the huge dappled horse rearing for action with the officer in brightly coloured uniform on its back.

By far the greatest influence on her was the work of the English animal painter Sir Edwin Landseer whose painting she had studied at some length at the Paris Exposition Universelle in 1855. A year later, when her painting *Horse Fair* was being shown in London, she made a

triumphant visit to the capital, meeting Landseer. If her admiration for the artist never waned (as late as 1897 she noted that he would 'remain the greatest of his kind') there is no direct evidence of his influence. His *The Monarch of the Glen* 1851 (John Dewar and Sons Ltd) of a highland stag may have inspired Bonheur's *The King of the Forest* 1878 (The Warner Collection of Gulf State, Paper Corporation, Tuscaloosa) but though she was dubbed the 'French Landseer'[13] there is little of Landseer's sentimentality in her more materialist animal observations. Unlike Landseer, the figures she painted with the animals are dwarfed by their sheer size and power, but the animals are never given the human characteristics or emotions which Landseer suggests in his work.

Rosa Bonheur's artistic success was assured when she was awarded the Chevalier de la Légion d'Honneur in 1865, the first woman artist to be so recognised. This was the year that her quarter-sized version of *Horse Fair* was finally hung in the National Gallery, London, the first painting to be shown there by a living artist. International honours were bestowed

3.1 Rosa Bonheur (1822–99) *The Horse Fair.* Oil on canvas 120 × 254.6 cm (47.25 × 100.25 in). The scene is the Marché aux Chevaux, Paris. This painting is a reduced replica, started by Nathalie Micas and finished by Rosa Bonheur, of the version in the Metropolitan Museum, New York (*National Gallery, London*)

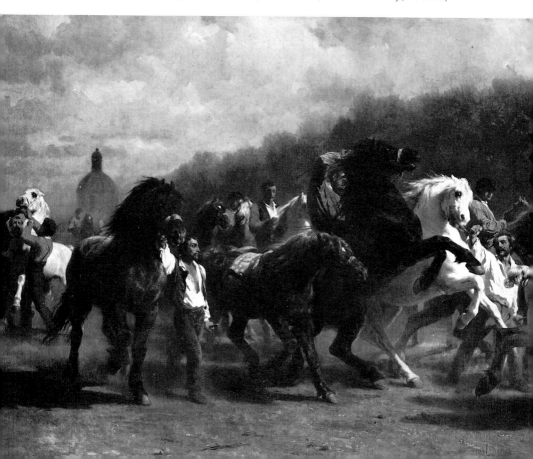

by such countries as Mexico, Belgium, Spain and Portugal; Queen Isabella II of Spain visited Rosa in 1898 and 'caught her in blue trousers and canvas jacket'.[14]

In her most famous painting, *Horse Fair* 1853 (Metropolitan Museum, New York), the large horses, proud and untamed, rear and plunge, all but obscuring the men who seek to direct them. Even contemporary critics favourable to her work observed the disproportion in size between the horses and their riders. Ruskin, whom she met during her visit to England, drew attention to her apparent indifference to the human figure, complaining that in *Horse Fair* the human faces are 'disagreeably hidden'.[15] It was not that she could not paint or draw the human figure, as her excellent drawing studies demonstrate, it was that all her interest was directed towards the animals.

After Rosa Bonheur's death, Anna Klumpke willingly took on the responsibility of caring for the estate which she had inherited and arranging a memorial exhibition. Bearing in mind Rosa Bonheur's remark that 'My private life is nobody's concern,'[16] Anna set about the biography she had agreed to do, neglecting her own painting in favour of consolidating the reputation of the famous artist.

Anna Elizabeth Klumpke was born in San Francisco in 1856. When her parents separated, the family were taken by their mother to Switzerland

where they received an education with a classical and artistic training which included instruction in French and German as well as drawing and music lessons. Anna Klumpke's artistic talents were encouraged and she eventually became an attentive and conscientious student at the Académie Julian. Despite the traditional approach of the teaching. Monsieur Julian did much to encourage the women students. 'Prepare yourselves to compete favourably with my men students,' he said, adding 'there is no reason why you should not succeed as did . . . Vigée-Lebrun, or even Rosa Bonheur.'[17]

When they met in 1887, Rosa was already aware of the success of Anna and her famous sisters, Augusta, Dorothea and Julia. Augusta was the first woman doctor in a Paris hospital doing research into paralysis. Dorothea had graduated from the Sorbonne with a doctorate in mathematical science and was a highly respected astronomer. Julia, the youngest sister, was a violinist and composer. Anna Klumpke, too, was beginning to gain a reputation as an artist and when her portrait of the feminist *Elizabeth Cady Stanton at Seventy One* 1889 (National Portrait Gallery, Washington) was much praised for its dignity, commissions followed. But her finest painting is that of *Rosa Bonheur* 1898 (Metropolitan Museum, New York) which shows the ageing artist in front of a painting in her studio at By. The relaxed and smiling figure of the artist sitting at her easel leaning slightly forward and holding a sketch is full of quiet energy and strength.

Following the death of her beloved friend, Anna Klumpke spent two years arranging a memorial exhibition and in 1908 her official biography was published in French. The last years of her life were divided between San Francisco, Boston and By. She died in 1942.

Rosa Bonheur's firm belief in the rights of women to equality of talent and success was echoed by many other women. For some she was a great inspiration, for others a less welcome heroine. Louise Abbéma (1858–1927) who lived in Paris had been hearing of Rosa's talent and fame since she was a girl and this made her determined to become 'a celebrated woman painter'.[18] Successful as a popular painter, she produced romantic images of young women fashionably dressed, holding flowers or playing the violin. These pictures were reproduced in colour and widely sold in newspaper shops. A friend of Montesquiou, she moved in the artistic circles which surrounded him. Like Bonheur, Abbéma had little interest in the radical theories of the Impressionists, preferring instead more conventional indoor subjects and portraits of friends such as *Madame Lucien Guitry* 1885. She smoked cigars and dressed in male clothes, liking them as much for their power to attract attention as for their practicability. Unlike Rosa Bonheur who wore those of everyday, Abbéma dressed as a young captain of the dragoons, wearing a large bicorned hat.

Given public acclaim (she was also awarded the Legion of Honour), she was favoured for her popular paintings, and with her flamboyant behaviour, she settled for the fashionable limelight. Indeed, with her lifelong passionate friendship with the actress Sarah Bernhardt, such fame would have been difficult to avoid. Louise Abbéma did a black and white chalk drawing of Sarah Bernhardt in 1875 and she finished her last portrait of her in 1922. The sketch portrait of Sarah is inscribed 'premiére esquisse du portrait de Sarah par son amie Louise Abbéma'. Their highly emotional relationship survived the years, with Louise Abbéma remaining a constant and reliable friend seeing her off on her journeys and welcoming her back.

When for a time Sarah Bernhardt modelled sculpture, she chose to wear the most improbable outfit, all in white, which made her the talk of Paris. It consisted of a satin blouse, neck tie, ruche, and an enormous student *lavalière* tie of white tulle. Wearing this, she allowed a photographer to take her picture: when issued as a postcard, it sold

3.2 Anna Klumpke (1856–1942) *Portrait of Rosa Bonheur* (1898). Oil (*Metropolitan Museum of Art, New York*)

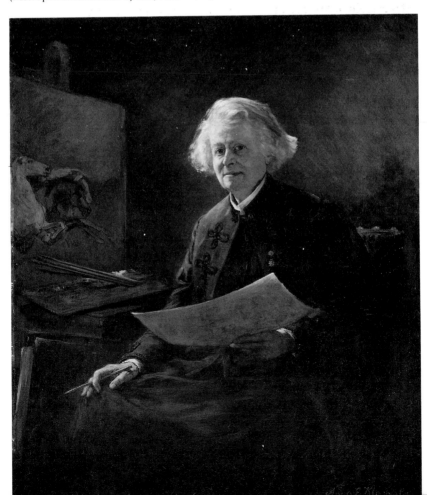

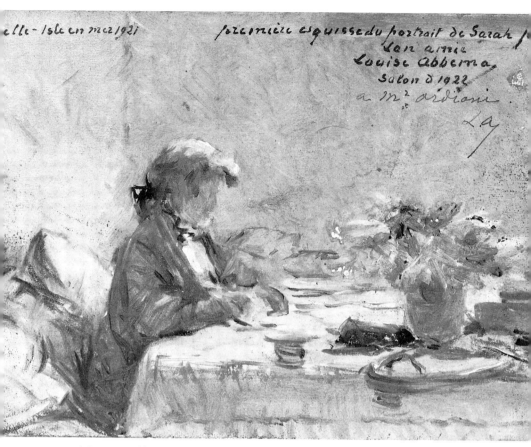

3.3 Louisa Abbéma (1858–1927) *Portrait of Sarah Bernhardt*. Oil and pastel. 15 × 21 cm (6 × 8.25 in). Inscribed Première esquisse du portrait de Sarah par son amie L.A. salon de 1922 A. M. Ordioni L.A. (*Courtesy of Sotheby's, London*)

millions of copies and was considered to be as scandalous as the short hair and men's pants of Rosa Bonheur. The long-lasting and undeniably temperamental relationship between Louise Abbéma and Sarah Bernhardt is generally given scant attention in the biographies of the actress.[19]

The acting as well as the artistic profession was one in which women could find a considerable measure of success and independence. The powerful personality of the famous American actress Charlotte Cushman, whose renowned performances included many male roles, attracted devoted female admirers, many of whom were artists.

At the centre of a group of women artists in Rome, she promoted their work among other Americans and encouraged them with advice and sometimes financial aid. This group of women, described dismissively as 'the white, marmorean flock'[20] by Henry James, had homes and studios in the capital where they studied the work of Renaissance artists and learnt the craft of sculpture.

All of the women were feminists and abolitionists and saw great similarities between the two struggles for liberation. Discussion took place on alternatives to marriage and only one member of the 'group', Vinnie Ream Hoxie (1847–1914), married. The others lived the 'eccentric life' of a 'perfectly emancipated female', as Elizabeth Barrett Browning[21] said of Harriet Hosmer, and it is these concerns which illuminate their work. They were aware of themselves as women and looked for support and guidance to other women, and this is expressed in their work.

Like their male counterparts, they accepted the contemporary vogue for neoclassical subject matter, but by choosing to show particular women from allegorical and classical history, they were able to comment on women in nineteenth-century society. Like Rosa Bonheur, they all wanted to achieve the status of professional artists and entered competitions, plied for official commissions and sought entry into respectable academies. Unlike Rosa Bonheur, their ideas about their sexual and social role as women were expressed directly in their work.

The most well-known and successful of these women Harriet Goodhue Hosmer (1830–1908), had been brought up as a boy by her father, a leading physician of Watertown, Massachusetts. Her mother, her two brothers, and her sister had all died of consumption and Dr Hosmer thought that physical exercise and the outdoor life such as only boys at that period were accustomed to take would make her strong and healthy. As a result Harriet became an expert in rowing, riding, skating and shooting; she climbed trees and made a collection of snakes, insects and other specimens of natural history. In a claypit in the garden she modelled figures of animals.

Unruly at school, in 1847 she was sent for two years to a boarding school in Lenox where she met other women who wanted to follow independent careers. Among these were the actress Fanny Kemble, and Lydia Moira Child who later wrote the *History and Conditions of Women in Various Ages and Nations*.

Harriet Hosmer was determined to become a sculptor, but because she was a woman she was not able to attend the Boston Medical School's anatomy classes. She moved to St Louis where she was admitted into the anatomy class in the medical school of the State University. The independence she established for herself was rarely questioned. Keen on adventure, she explored the lead mines of Dubuque, climbed mountains (Mount Hosmer, Missouri, is named after her), sailed on the Mississippi, and on one occasion is reputed to have smoked a pipe of peace with the chief of the Dakota Indians. At home, she set up a studio where she did marble carving, wielding a four-and-a-half-pound leaden mallet for eight to ten hours a day without any particular signs of exhaustion. One of her first pieces was a bust in neoclassical style, *Hesper* 1851–2, which with heavy drooping eyelids and hair entwined with a star and poppies

suggests the wan beauty and grace of a sleeping, or possibly dying, woman. Inspired by Tennyson's poem *In Memoriam*, she wrote that she had lost her wits over it: 'I think his Sad Hesper one of the most beautiful ideas in the English Language.'[22] It was about this time that she attended a performance of *Hamlet* with Charlotte Cushman as the prince and, deeply impressed, went back stage to meet her. A friendship was formed and Charlotte Cushman encouraged her to travel to Rome to find inspiration in the city's 'artistic air'. Rome was then considered the ideal place to study neoclassical sculpture. At the age of twenty-two, she moved to the city where she worked for seven years in the studio of the neoclassicist sculptor John Gibson. She observed his skills, sketched from his models and copied Greek and Roman drapery.

Visiting Rome in 1857, her friend the writer Nathaniel Hawthorne described her as 'a small, brisk, wideawake figure, not ungraceful, frank, simple, straight-forward and downright'. Harriet Hosmer, who dressed in 'mannish' clothes, was not entirely remembered uncritically for Hawthorne added: 'I don't quite see, however, what she will do when she grows older, for the decorum of age will not be consistent with a costume that looks pretty and excusable in a young woman.'[23]

Rome not only gave Harriet Hosmer, or Hattie as she was known, the opportunity to work with a respected sculptor but it provided the chance to be part of the literary and artistic circles of the city. She met Frederic Leighton who thought her the 'queerest, best natured little chap possible'. She thought Leighton 'very good-looking, suggestive of the young Raphael style'.[24]

Full of energy and determined to become famous, she saw marriage as a hindrance to this. For a time she lived with Charlotte Cushman (whom she described as being 'like a mother') and Emma Stebbins and led a 'wild life'. All of them believed firmly in the cause of women's emancipation. Both Charlotte Cushman and Harriet Hosmer took midnight horserides and followed the hounds with the men, leaping fences and jumping ditches, unconcerned about the fast and daring image they gave. Harriet Hosmer continued to disregard convention by driving round Rome unattended and astride a horse, to the horror of Italian society.

Artistically Hosmer took her style from that of her teacher, John Gibson, who had studied with Canova and whose great enthusiasm was for the classical Greeks. Leighton attributed Gibson's success as a sculptor to his ability to express simplicity, calm and concentration. Though Hosmer assimilated these qualities and worked in a similar classical mode, her choice of subject matter was more indicative of her own feminist views. Often the women she chose to sculpt were shown as beautiful victims, powerless to overcome the many obstacles put in their struggle for independence. Subjects included *Medusa* whose head was cut

off by Perseus as her gaze turned humans into stone; *Daphne* who had vowed perpetual virginity, and *Oenone*. This full-length sculpture, carried out in 1854–5, was of the bride deserted by Paris for Helen of Troy. It is an image of a woman as deprived and helpless which recurred often in her sculpture.

When in 1854 her father lost his money and could not afford to support her, she stayed on in Italy, determined to earn her own living. A blatantly commercial piece, *Puck*, based on Shakespeare's *A Midsummer Night's Dream*, showed a four-year-old seated on a toadstool. Its whimsicality exuded fun and merriment embodying childhood innocence. It was an enormous popular success, with copies sold to the Crown Prince of Germany and the Prince of Wales, amongst others. Altogether *Puck* made Harriet some $50,000. A companion piece, *Will o' the Wisp*, was only slightly less successful.

Harriet Hosmer's official success delighted her. When she was made a member of the Rome Academy in 1858 she wrote to a friend Cornelia Crow of her pleasure. But very aware of the jealousy the honour might bring, she was prepared to laud it to friends 'who laughed at the idea of a woman becoming an artist at all'.

In 1858 the sculptor worked on her most famous piece, a marble seven feet tall, *Xenobia in Chains* 1859 (Wadsworth Atheneum, Hartford).

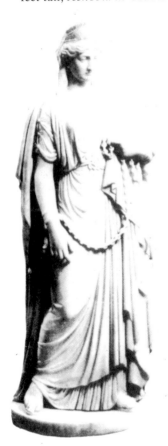

3.4 Harriet Hosmer (1830–1908) *Xenobia in Chains*. Marble (*Wadsworth Atheneum, Hartford, Connecticut*)

Monumental in conception and based on images on ancient coins, the sculpture proclaims Harriet Hosmer's identification with the proud and serious Queen of Palmyra whose military abilities and literary talents were still evident even in defeat. The statue which shows the queen bound and imprisoned yet still noble and upright was given great critical acclaim in the American exhibition of 1859 and in the Great Exhibition in London in 1862. *Xenobia* was seen by thousands of people when it toured the United States in 1864–65, making her a good sum of money. Nearly twenty years earlier the American neoclassical sculptor Hiram Powers (1805–1873) had toured his most famous sculpture *The Greek Slave* (copy at Newark Museum, Corcoran Gallery). Both statues of the full-length female figure in chains are greatly different in subject and concept. Powers' slave is a beautiful young nude female on sale in a Turkish slave market, referring to the Greek struggle for independence from the Turks. Powers explained that the nudity was essential in her plight and related to her innocence. Hosmer's fully clothed figure, though classically inspired, was a metaphor for the role of women in nineteenth-century life: hailed as a queen but deprived of power, Xenobia is a heroine and represented an image of woman very different to that shown by Powers, a man. The London *Art Journal* did not believe that the colossal sculpture could be by a woman and suggested it was by one of her workmen, a suggestion they later retracted.

Most of Harriet's life was spent in Italy and she only returned to Watertown in old age, dying there in 1908. Her final sculpture, *Queen Isabella*, was commissioned by the city of San Francisco in 1894. It celebrates the life of the woman who encouraged and sponsored Columbus in his voyage to America.

Harriet Hosmer's active participation in the Women's Movement found expression in her choice of subjects and in the way she showed them. In 1868 she wrote 'I honour every woman who has strength enough to step outside the beaten path when she feels that her walk lies in another.'[25] From 1869 she subscribed to her friend Susan B. Anthony's feminist paper *Revolution* and corresponded with her and the abolitionist and feminist Lucy Stone.

Rivalry between Harriet Hosmer and Charlotte Cushman's friend Emma Stebbins resulted in Harriet leaving Charlotte Cushman's house in Rome in 1864. Emma Stebbins (1815–1882) had met Charlotte Cushman around 1856, and 'from that time the current of their lives ran, with rare exceptions, side by side' as she wrote in her biography of Charlotte.[25] The lived together for nineteen years until Charlotte Cushman's death.

Born in New York City, Emma Stebbins had studied art in various studios before deciding at the age of forty-one that if any American woman hoped for success in the arts she must first make a name for herself in Rome. In Rome, she worked in the studio of the American

sculptor Paul Akers (1825–1861), a talented neoclassicist sculptor who was a member of the Anglo-American colony in the city. Charlotte steered touring Americans to Emma Stebbins, persuading them to place commissions. The pair visited Rosa Bonheur at Fontainebleau in 1861, where Charlotte and Rosa talked of among other things their mutual admiration for each other's work.

Emma Stebbins was awarded the important commission for a statue of Horace Mann for the State House lawn, Boston, causing some jealousy to Harriet Hosmer.[27] When the toga-clad bronze figure eventually arrived in Boston, the local press were critical, describing it as a 'mass of bad drapery' but it was paid for eventually by public subscription. A fountain *Angel of the Waters* c. 1862 for Bethesda Pool, Central Park, New York, with its allegorical figures of Health, Temperance, Purity and Peace, and its angel alighting to stir the waters, encapsulated many of the concerns of Americans immediately after the Civil War. After Charlotte Cushman's death, Emma Stebbins edited her letters and wrote her biography which was published in 1879.

Charlotte Cushman's strong personality had served as a magnet, attracting followers and admirers who shared her feminist and liberationist views. The sculptor Mary Edmonia Lewis (1843–c. 1900) who arrived in Rome in 1865 was taken up by Charlotte as her 'personal project'. In Rome, Edmonia Lewis fascinated visitors with her 'brown hands working the white marble', a fact exploited to the full in a contemporary newspaper report which describes her 'complexion and features as betraying their African origin'.[28] Born in Albany, New York, Edmonia Lewis was the daughter of a Chippewa Indian and a free black father. She was left an orphan at three but brought up in the tribal tradition of her mother and given the name Wild Fire. She had enjoyed an outdoor childhood and liked the freedom it gave. Adopted by a family who supported abolition, she was sent in 1862 to Oberlin College but a scandal in which she was suspected of poisoning two room mates forced her to leave. Supported by the abolitionist William Lloyd Garrison, she began studying with the sculptor Edmond Brackett in Boston. From the start, her abolitionist and feminist views influenced her work. 'I have,' she wrote, 'a strong sympathy for all women who have struggled and suffered.'[29] Her first success was a medallion of Colonel Robert Gould Shaw, leader of the black regiment that attacked Fort Wagner, South Carolina. On the financial and artistic success of this piece she sailed in 1865 for Rome with a letter of introduction to Harriet Hosmer. She became part of the circle of women artists around Charlotte Cushman and for a while studied with John Gibson. Her strongly held opinions continued to influence her subject matter.

Her marble *Forever Free* 1867 (James A. Porter Gallery of Afro-American Art, Howard University, Washington DC) commemorated the

13th Amendment which forbade slavery. *Freed Woman*, now lost, showed a newly emancipated slave overcome by her feelings when told she had achieved her freedom. Other pieces include *Cleopatra* (also lost) showing the queen dying, and *Hiawatha's Wooing*, based on Longfellow's poem. Charlotte Cushman was so impressed with this piece that she and a group of other Americans bought it to give to the Boston YMCA as proof that 'a race which hitherto in every age and country has been looked upon with disfavour was capable of producing work worthy of the admiration of cultivated people'.[30]

Edmonia Lewis visited America in 1873, taking with her five

3.5 Edmonia Lewis (1843/45–after 1911) *Hagar* (1875). Marble. Height 133.6 cm (52.62 in) (*National Museum of American Art: transfer from National Museum of African Art, gift of Delta Sigma Theta Sorority*)

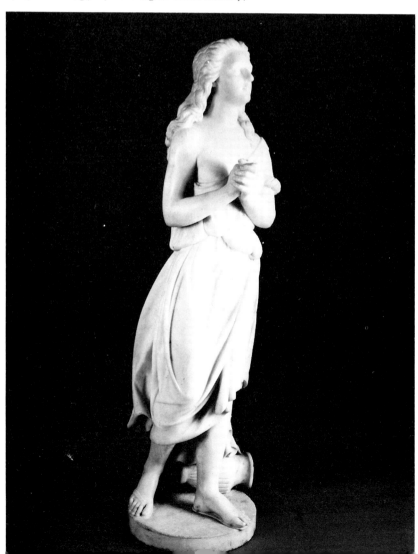

sculptures. These were shown in the Philadelphia Exposition of 1876. Soon after she disappeared from public life. The taste for neoclassical sculpture was changing in favour of a more realistic approach and little is known about the latter part of her life.

Other artists in the Rome circle included Margaret Foley (1820–1877) who had been a cameo portraitist in Boston before sailing for Rome in 1861, and Louisa Landar (1826–1923). Nathaniel Hawthorne was a great admirer of her work, writing: 'There are very admirable points about her position: a young woman, living in almost perfect independence, thousands of miles from her New England home, going fearlessly about these mysterious streets.'[31] Her portrait of Hawthorne at Essex House, Salem, Massachusetts, is one of the few pieces of her work known to exist.

One of the Rome-based artists less keen to be part of the Cushman circle was Anne Whitney (1821–1915). With the painter and poet Abby Adelaide Manning, she had formed a 'Boston marriage' which endured throughout their lives. Like Harriet Hosmer, Anne Whitney was born in Watertown but she only started work as a sculptor when she was in her thirties when she thought sculpture would be a good means of communication. For a short time she studied anatomy with William Rimmer though, like other women sculptors, she wanted to work in Rome. The Civil War delayed her departure and during this period she completed *Africa* 1864 which symbolised a race rising from slavery. Intellectual and physical freedom were recurring themes in her work as were her feminist ideals and abolitionist concerns expressed through her choice of subjects.

Managing to avoid travelling with the uninhibited Harriet, she arrived in Rome where she stayed for five years (1867–71) studying briefly with Gibson and William Story (1819–1895). Aware of the social issues of the city, she modelled *Roma*, a seated figure of an old beggar woman; the hem of her dress was decorated with allegorical portrayals of the decline of the city. The Papal court was outraged by the figure which was moved to Florence.

In America she became an instructor in art at Wellesley College but maintained her artistic output. Her failure to win the Charles Sumner competition (she wrote to her family 'It will take more than a Boston Art Committee to quench me!'[32]) did not deter her and she gained other important commissions. These included the full-length marble of Samuel Adams 1876 (Statuary Hall, The Capitol, Washington DC). Portrait heads included *Keats* 1873 (Keats' House, London), Harriet Martineau 1882 (Miss Wilson Payne Collection, Needham, Massachusetts), Adelaide Manning 1861 (Mrs S. Hince Collection, Newton, Massachusetts) and a head of Harriet Beecher Stowe.

Women artists, with much support from other women, gained

independence and were able to assert their equality to men. Rosa
Bonheur's success was an inspiration and a clear demonstration of what
could be achieved. Other women, informed by deeply held feminist and
abolitionist ideas expressed these in their art. All found great support
and strength from the 'divine affection' of other women. The example of
these women proved to be a solid basis for work with more explicitly
sexual themes painted by artists at the turn of the century.

3.6 Anne Whitney (1821–1915) *Roma*. Bronze (*Wellesley College of Art Museum,
Massachusetts*)

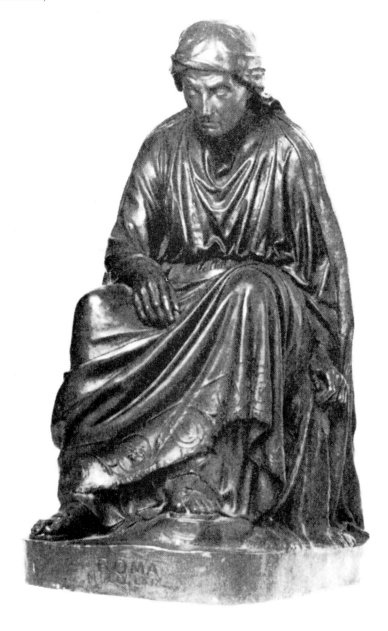

4 · Sexual Aesthetes

As male homosexuality grew more visible in the late nineteenth century its cultural manifestations became sharper and more precise, incorporating in the arts references of the Middle Ages and mysticism as well as to the Greeks. In literature the homosexual could be made a hero, even if he was defined as an aesthete or lover of beautiful things, or as a dandy doomed to disaster. His was the decadent society in which sexual and artistic pleasure went hand in hand with wealth and luxury. Oscar Wilde's *The Portrait of Dorian Gray* (1895) and Joris-Karl Huysman's *A Rebours* (Against the Grain) both showed the aesthetic dandy living a life of self-indulgent luxury. Des Esseintes, Huysman's hero, was wealthy and hedonistic, able to live a life of luxury and excess with little regard to conventional standards. Though a creation of fiction, Esseintes was based on the artist, writer and aesthete Robert de Montesquiou.

Wilde's hero Dorian Gray also lived the life of luxury, indulging in every excess without losing his handsome looks. Instead, as a result of the life he led, a portrait of him slowly changed into a picture of a hideous and deformed old man. Wilde's moral tale could almost have been a warning about his own reckless pursuit of revenge and his determination to defend his homosexual friendships and way of life. Besides Wilde's writings, which were to become notorious, other writers published poems describing the beauty and attraction of boys.

Visual artists, avoiding the explicitly erotic or crude, aimed for an expression of feeling and emotion rather than the physical appearance or activity. The introspective qualities of the aesthetic artists could hardly have been in greater contrast to the hearty, outdoor imagery of Eakins or Tuke.

What typified the work of artists of the Aesthetic Movement in France, England and America was a sensuous, dreamy, Greek-influenced luxury seen through a Renaissance gauze. Overtones of Christian morality add a note of guilt and disaster. There were no overtly masculine, muscle-bound torsos or great athletic feats depicted in their work. For the aesthetes the ideal male was young, graceful, innocent, androgynous, unspoilt by the world. This figure of perfect creation, of purity and idealism, is defined entirely by the absence of sexuality, whose existence is a denial of sexual desire and human lust. Languid, androgynous males had been painted by Burne-Jones for some years, who even when he did depict the male genitals made them so small as to be almost non-existent. Androgynous males were particularly attractive as subject matter for homosexual artists because they suggested the possibility of a public identity as a 'third sex'. By the 1890s various theories about homosexuality had been proposed by scientific and medical writers. These helped provide the basis for a homosexual identity free from guilt and the sense of sin. Edward Carpenter, socialist and pro-feminist writer, wrote about men loving men in *Homogenic Love* in 1894, while in the same year Charles Kains-Jackson questioned male stereotyping in his article 'The New Chivalry' in *The Artist*.

Leonardo's paintings, in particular *St John the Baptist* and *Bacchus* (Louvre), were seen as depicting androgynous figures and these were strongly influential on late nineteenth-century artists. Walter Pater's essay *Gioconda* published in 1869 identifies the mystery, suggestiveness and ambiguity of Leonardo's art with such phrases as 'weary eyelids' and 'the soul with all its maladies'. The poet Swinburne was deeply impressed by Pater's essay and it coloured his reading of Simeon Solomon's sexually ambiguous painting. Gustave Moreau in France and the American photographer Fred Holland Day took up similar themes.

In 1886 the French literary magazine *Le Decadent* reported that 'Man becomes more delicate, feminine and divine.' Josephin Peladan, leader and progenitor of L'Ordre de la Rose et Croix Catholique whose bizarre mixture of dandyism, occultism and aestheticism had a considerable following, also admired Leonardo's *St John the Baptist*. He encouraged the depiction of androgynous figures of intermediate sex. His novel *L'Androgyne* was published in 1891 and two years later he wrote 'Art has created a supernatural being, the Androgyne, besides which Venus disappears.'

The great expansion of interest in the visual arts in the 1880s and 1890s included the publication of many new art magazines. These often contained articles and illustrations with veiled homoerotic themes, for within the art context mildly erotic material could pass without censure. The first issue of *The Studio* (1893) carried an article on Aubrey Beardsley, while photographs by Baron von Gloeden and Frederick Rolfe

(Baron Corvo) showed naked adolescent Sicilian youths posed in classical settings.

The Artist under its editor Charles Kains-Jackson, himself a homosexual, often singled out paintings of special interest. An account in the August issue 1891 of an exhibition by the Society of American Artists in New York praised in fulsome terms H. O. Walker's *David*. The youthful figure with a sheepskin girt and a sling in his hand was shown full-length. The reviewer added suggestively that 'even Jonathan could not feel more drawn to the singularly beautiful face that the artist has depicted so well'. Earlier the same year *The Artist* had drawn particular attention to a picture of St Sebastian the Martyr on show at the Capitoline Gallery in Rome by quoting a sonnet by Frederick Rolfe which had been inspired by the painting. Articles suggest that by turning to Ancient Greece in a new spirit of naturalism artists could 'invoke the past anew in bodily beauty and fleshly form'. 'Subjects for Pictures' (*The Artist* July 1889) listed stories from Greek mythology which described relationships between older and younger men which was in effect a list of homosexual themes. After the trial of Oscar Wilde in 1895 the tone of *The Artist* became more muted and Kains-Jackson was replaced as editor.

In England the artist who most expressed the ideals and hopes of the writers and poets of the aesthetic school was Simeon Solomon (1840–1905) whose talents have partly been obscured by his arrest and conviction for a homosexual offence in 1873.[1] Solomon lived openly as a homosexual in the 1860s and early 1870s, a difficult enterprise at the height of Victorian morality. The homosexual elements in his painting became more dreamy and ethereal in the 1880s and 1890s.

Born one of eight children into an orthodox Jewish well-to-do family in the East End of London, he was encouraged to follow his career as an artist. Both his brother Abraham (1824–1866) and his sister Rebecca (1832–1886) were successful painters and on one occasion all three had work on show at the Royal Academy. Solomon worked in Abraham's studio as a boy before going to the Royal Academy as a probationer, but instead of painting genre and narrative scenes he developed a style based on the ideas of the pre-Raphaelites. His painting attracted the attention of Rossetti and in 1860 he became part of the pre-Raphaelite circle.

Solomon greatly admired the work of Burne-Jones, finding in it echoes of his own interest in androgynous males. Through Burne-Jones Solomon met the dynamic and controversial poet Algernon Charles Swinburne. Three years his senior, Swinburne was soon a dominant influence on the artist. Besides their small build and red hair, both had unconventional sexual interests, Swinburne in being beaten and Solomon in homosexuality. Eager for an education from one of the most talented writers of the period, Solomon provided Swinburne with a fond disciple; in exchange Swinburne found inspiration in Solomon's drawings. To all

intents and purposes they may have been lovers, and on one occasion the pair are said to have romped around Rossetti's home in Cheyne Walk completely naked, their antics apparently causing irritation at the disruption of work rather than outrage at their behaviour. Swinburne introduced Solomon to the writings of the Marquis de Sade and the philosophy that nothing can be unnatural, as well as to Walt Whitman's controversial *Leaves of Grass*.

Through his friendship with Swinburne, Solomon met the prominent homosexual writers Oscar Browning, at that time an Eton schoolmaster, and Walter Pater, the writer and Oxford don. Young and attractive, full of spontaneously wise and witty remarks and having a great artistic talent, Solomon was wooed and fêted. He stayed with Pater at Oxford, drawing one of the few portraits of him in existence. Browning took Solomon to Italy in 1867 to see at first hand the work of the Italian masters. Three years later Solomon made a more hasty visit to Rome, possibly to avoid any repercussions following the well-publicised trial of two transvestites, Ernest Boulton and Frederick William Park. Solomon had attended the trial and had tea with them afterwards.

During this visit to Rome Solomon wrote his insightful prose poem *A Vision of Love Revealed in Sleep*. This takes up the neoplatonic themes of his paintings and drawings and expresses an awareness of male sensuality and beauty through the visionary travels of Solomon's spirit and soul during the space of a night. Solomon's soul appears to him in *Vision of Love* as a nude man while the allegorical figure of Sleep, though male, is described as a woman. J. A. Symonds reviewing the poem in *Academy* (April 1st 1871) hinted at the exotic and unconventional nature of Solomon's theme. 'His love is not classical, not mediaeval, not oriental; but it has a touch of all of these qualities—the pure perfection of the classic forms, the allegorical mysticisms and pensive grace of the middle ages, and the indescribable perfume of orientalism.'

Throughout the 1860s Solomon's paintings of classical and biblical subjects were exhibited at the Royal Academy among other places. Walter Pater described *Bacchus* c. 1867 (Birmingham Art Gallery), painted after Solomon's first visit to Italy, as 'a complete and very fascinating realisation of the melancholy and brooding figure of Dionysus Zagreus, the god of the bitterness of wine, of things too sweet, the sea water of the Lesbian grape become somewhat brackish in the cup'.[2] Bacchus, youthful, sad and feminine, gazes sadly out of the picture, lost but hopeful, half-smiling, half-frowning, the owner of a mysterious but self-directed knowledge.

Solomon's religious paintings incorporated the contrasts so greatly admired by Swinburne of the 'deepest alliances of death and life, of love and hate, of attraction and abhorrence' and 'the subtleties and harmonies

of suggestion'.[3] The central figure in *The Song of Solomon* 1868 (Municipal Gallery of Modern Art, Dublin) has one arm linked casually with a woman on one side whilst his other arm is linked much more affectionately with a man who is kissing his hand. The biblical Solomon becomes a metaphor for the artist's own sexual tastes.

An erotic drawing on the same theme in the Victoria and Albert Museum illustrates Solomon's humour and sexual awareness. The tragi-comedy of *Bridegroom and Sad Love* suggests that marriage may be convenient but that sexual desire may lie elsewhere. It shows a beautiful naked man with one arm around the shoulders of a semi-naked bride, yet fondling the genitals of a sad-looking winged angel who has 'amor tristis' written in his hair. Skilfully drawn with a minimum of modelling, the drawing has a moral theme which is both evocative of Solomon's own sexuality and erotic fantasy.

Not everyone was well disposed to Solomon's work. Sidney Colvin's *English Painters of the Present Day* (Portfolio 1, March 1870) criticised it as apt to err 'on the side of affectation and indiscriminate sentimentalism', while Robert Buchanan in *The Fleshly School of Poetry* (1872) was much more forthright. Buchanan's attack was aimed at Rossetti, but his sideswipe at Solomon was none the less daunting in its criticism of his 'unhealthy tendencies'. 'English society goes into ecstasy over Mr Solomon's pictures—pretty pieces of morality such as *Love Dying by the Breath of Lust*', he wrote, adding that Solomon was one of those who 'lend actual genius to worthless subjects and thereby produce monsters'.

Among the aesthetic set, Solomon's drawings were popular and were placed on the walls of the rooms of more aware undergraduates and younger dons at Oxford, though they were taken down when parents or family visited. Solomon's drawing *Love Talking to Boys* (private collection), of schoolboys affectionately hugging each other while being lectured by a winged schoolboy angel, hung on the walls of Oscar Wilde's rooms at Oxford. When Lord Alfred Douglas sold Wilde's Solomon drawings after his trial, Wilde reproached him for his heartlessness.

Though Solomon's behaviour was tolerated, it was not liked. In *Five Years Dead* (1937) Bernard Falk records disapprovingly that Solomon was 'seen to lean on the shoulders of youthful male models, much in the manner of Julius Caesar'.[4] Writing to Swinburne, Solomon described his awareness that his pictures were 'looked upon with suspicion', adding prophetically 'in pecuniary and some other ways, I have had to suffer for it, and shall probably have to suffer still'.[5]

Suffer he did. On the night of February 11 1873, he was arrested in a public urinal in Marylebone, London, charged with indecent exposure among other things. Found guilty, Solomon received an eighteen month

4.1 Simeon Solomon (1840–1905) *Bridegroom and Sad Love* (1865) Drawing.
24.8 × 17.1 cm (9.25 × 6.5 in) (*Victoria and Albert Museum, London*)

prison sentence, but through the influence of family and friends, he was
released. Solomon moved out of the fashionable artistic world of Chelsea
and London's West End. A few friends supported him and tried to help
by buying pictures or encouragement. Burne-Jones later declared 'There
shouldn't be laws against immorality.'[6] Swinburne, however, immediately
disassociated himself from Solomon. Writing to George Powell (who was
homosexual), Swinburne said that it was 'impossible for anyone to keep

up his acquaintance and not be cut by the rest of the world as an accomplice'. Later Solomon became 'a thing unmentionable'[7] to Swinburne. The writer dubbed John Addington Symonds and his followers 'catamites', a derogatory name derived from the Roman version of Ganymede.

All but ruined, Solomon turned to alcohol and drugs as a form of release and to pay for them he produced numerous pastel drawings which he sold cheaply to friends and galleries. The quantity of Solomon's work in the last thirty years of his life was prodigious and the quality uneven. At their best the pictures take up and develop Solomon's most original themes in describing androgynous, epicene male figures, full of intensity and introspection. Two good examples are *Endymion* 1887 (City Art Gallery, Birmingham) showing the youth celebrated in classical myth for his beauty and *The Moon and Sleep* 1894 (Tate Gallery, London). *Endymion* is handsome with an aquiline, androgynous face and broad hips, evoking an air of mystery and sexual ambiguity. *Endymion* illustrated a poem by Keats, one of Solomon's favourite writers, and almost perfectly fits the lines:

> For on a silken couch of rosy pride,
> In midst of all, there lay a sleeping youth
> Of fondest beauty;

4.2 Simeon Solomon (1840–1905) *The Moon and Sleep* (1894). Drawing. 51.4 × 76.2 cm (20.25 × 30 in) (*Tate Gallery, London*)

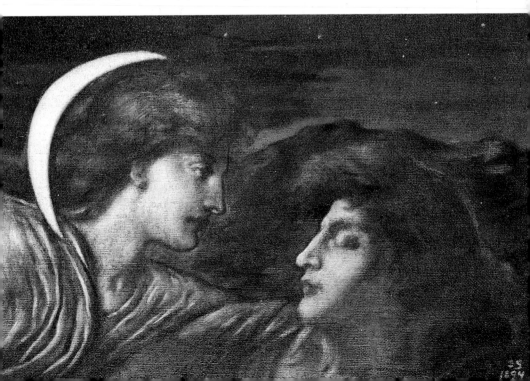

The Moon and Sleep is equally sexually ambiguous, with the two faces
locked in emotional and possibly sexual contact. Like William Blake
whom he greatly admired, Solomon was principally concerned with the
expression of spiritual qualities rather than with the representation of
external nature. Though many of the later drawings and paintings do not
have the skill of the earlier works, their vision and insight is far more
radical in its expression of sexual desires and concerns. Sombre rabbis,
Greek orthodox priests, naked or half-naked angels, lovers and
visionaries, often with faces that are 'full of morbid delicacy, like the
painting of a perfume', challenged conventional Victorian morality.[9] Even
in 1970 Solomon's painting still prompted moral disapproval. Timothy
Hilton in *Pre-Raphaelites*[10] described him as 'dissipated' and his work as
having 'an unwholesome and sexy gloom'.

Solomon's greatest artistic affinity was with contemporary French
artists associated with the decadents, many of whom shared his
admiration for the work of Burne-Jones. At the centre of the French
circle of decadents was the 'Prince of Aesthetes', the wealthy, aristocratic
and wanly handsome Robert de Montesquiou, who epitomised all that
was exquisite, refined and sensitive. As a dabbler in watercolours and an
art connoisseur he freely advised his painter friends on what and how to
paint. Amongst his circle were Jacques-Emile Blanche, Paul Helleu, John
Singer Sargent and the Spanish artist Antonio de la Gandara (1862-1917).
Montesquiou and his friend the journalist and poet Jean Lorrain (who
was homosexual) were fascinated by 'this Velasquez of the coquettes'[11]
dubbed 'La Gandara'. La Gandara was a society portraitist greatly
influenced by Whistler and his portraits of Jean Lorrain and
Montesquiou are vividly descriptive of their lives as well as their looks.

Artists within the decadent circle found the concept of the
androgynous or effeminate male highly attractive. Montesquiou eulogised
on his qualities:

> In himself the effeminate contains more than one race.
> Yes, more than one sex also.
> He is indefatigable when others are exhausted
> And deceit and anxiety only lend him strength.[12]

At the opening of the Delacroix exhibition at the School of Fine Art in
1885 Montesquiou met and fell in love with Gabriel Yturri, a tall young
man with a fine moustache, black hair and burning and expressive eyes.

While Montesquiou's sexuality became much more defined when he
established his relationship with Yturri, Gustave Moreau, one of his
friends whose painting he greatly admired, was far more of a mystery.
Moreau, something of a recluse, did not want details of his private life to
be known either during his life or at his death. There are many

indications that Moreau was á latent if not a practising homosexual. Though he had relationships with women (but never married) his close and enduring friendships with men seemed to be of greater significance. In his painting there is a distinct preference for painting handsome young men, who predominate in the compositions in size and importance. He liked to show smooth-bodied, nude male adolescents who were often put beside older, rougher looking males. For example *Tyrtaeus Singing During the Battle* celebrates the glory of Greek youths and shows Tyrtaeus 'young, feminine only in his features and of an antique beauty—a beauty, that is, serene and robust' (Moreau).[13] His heroes are usually young men and as he grew older he became fascinated with the youthful nude male which occurred with greater frequency.

Moreau's relationships with women were complex. He lived with his mother until she died and with her shared his ideas about his paintings. When she became deaf he wrote notes explaining what he was doing. Mysteriously, for over twenty-five years he had a secretive relationship with Adelaide Alexandrine Dureaux who lived in a flat near his house. Nevertheless, they did not marry however close their relationship.

The women he painted in his pictures were powerful and dominant figures from history. These included Salome, Helen of Troy, Cleopatra, Bathsheba, Andromeda, Delilah and Leda and emblemise the seductress and the Animal Woman. In Freudian terms, man is brought face to face with the fear of castration.

Moreau had little affection for women in general, writing that the female is 'in her primal essence, an unthinking creature, mad on mystery and the unknown, smitten with evil in the form of perverse and diabolical seduction'.[14] This dislike and possible fear of women was often expressed in his painting as confrontation between the sexes, giving rise to the idea that he could only like men if he disliked women. Moreau's complex attitude to sex is suggested by his comment 'the dream of sexuality is delightful; its reality is immoral and disgusting'.[15]

His attitude to his life and his art was very similar. 'I believe neither in that which I touch, nor in that which I see. I believe only in that which I do not see and uniquely in that which I sense.'[16] This approach to his work is evident when two of his life drawings of the male nude are compared with one by his friend Edgar Degas (1834–1917) who drew from the same figure at the same time. The model, in a conventional *contraposto* pose, is rendered realistically by Degas as short and squat with a firmly drawn, muscular body. In Moreau's drawing the figure appears tall and thin and more adolescent than mature, with the slender grace of an ephebe.

The son of a successful architect, Moreau, aged twenty, became a diligent and hardworking student at the Ecole des Beaux-Arts. Attracted by the orientalism and exoticism of Delacroix, he visited the painter's

studio where he was deeply influenced by the barbaric oriental splendour of such paintings as *The Death of Sardanapalus*. There he met and became a friend of Eugène Fromentin (1820–1876) who also specialised in oriental themes.

With other students or fellow artists he travelled around Italy (1856–60) looking at the work of the great masters. He studied Michelangelo's Sistine Chapel for seven and a half hours daily for two months. Deeply inspired by the work, he described Michelangelo's figures as 'arrested in an ideal state of sleep-walking',[17] adding that they 'had the self-absorption of the individual rapt in dreams'.

Moreau saw himself as an historical painter because of his fascination for myths and legendary figures, but the psychological and lyrical overtones he conferred on his paintings move them outside tradition. In such complex compositions as *Young Man and Death* 1856–65 (Fogg Art Museum, Harvard University), painted in memory of his close friend the artist Théodore Chassériau (1819–1856), and in the related painting *Jason and Medea* 1865 (Louvre) the classical themes include androgyny and diffuse sexuality. Centrally placed, Jason has similar features to the fairy spirit by his side and is almost as androgynous. His loin cloth is tied in a manner which seems to emphasise his genitals rather than to conceal them. The couple could be sisters or brothers. The critic Ary Renan, writing in the *Gazette des Beaux-Arts* 1899, observed their sexual ambiguities saying 'Memory turns back towards the androgynous attractions of a profane Sodom.'

In his will Moreau expressed the desire that 'no personal portrait or biography of him should be published'.[18] While his home and studio were bequeathed to the state and so remained virtually intact, Henri Rupp, his close friend who was made his executor, destroyed many of Moreau's private papers.

Other notable artists close to the Symbolist movement include the American-born Pinkney Marcius-Simons (1865–1909) who was taken as a child to Europe and returned only once to America. Marcius-Simons produced sentimental genre scenes and historical subjects, but under the influence of the French symbolists turned to legendary subjects and fantastic architectural designs which were shown at the Salon de la Rose et Croix. Many of the writers of the French Decadent circle responded to his dramatic, jewel-like surfaces which were influenced by Moreau's work.

The Salon de la Rose et Croix, organised in Paris between 1892 and 1897 by the French mystic and self styled 'Sâr' Josephin Peladan, attracted artists interested in the expression of mystical themes. Among these was Charles Filiger (1863–1928) who was a friend and admirer of Paul Gauguin (1848–1903). Filiger followed Gauguin to Pont-Aven, arriving in July 1888, a year after Gauguin had helped work out the formula of

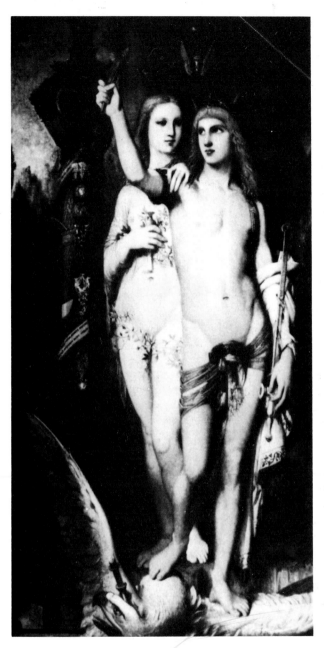

4.3 Gustave Moreau (1826–98) *Jason* (1865). Oil on canvas. 204 × 115.5 cm
(80.25 × 45.5 in) (*Louvre, Paris*)

'synthetic idealism'. This was a means by which the visual translations of symbolist thought with its mythical, mystical and dreamlike aspects could be expressed through the use of curves and areas of pure colours arranged in flat planes without perspective.

Filiger took up these ideas and became the most mystic of the painters at Pont-Aven, exhibiting small-scale paintings of saints, often rendered in what the artist called 'chromatic notations'. The circular or polygonal watercolour compositions often showed stylised heads of the Madonna or a handsome saint carried out in the style of Byzantine mosaics. The radiating compositions have some of the meditative qualities of the Hindu mandala. Biblical scenes sensitively rendered included images of young Breton men all looking very much alike and inclining towards the feminine rather than the masculine. Among his admirers were the playright Alfred Jarry who wrote an enthusiastic article about his work, and Count Antoine de la Rochefoucauld who made him a regular allowance.

From Pont-Aven Filiger moved to le Pouldu and finally settled at the Breton market town of Plougastel-Daoulas, staying in Brittany throughout the rest of his life. Increasingly he lived the life of a recluse, refusing to sell his work or to receive anyone. Like Simeon Solomon, Filiger disappeared from public view after a homosexual scandal and this may have helped prompt the delusion he suffered that he was being pursued across the Breton countryside by enemies. In *Dreamers of Decadence* Philippe Jullian[19] refers to the scandal (p. 156) and to Filiger's subsequent withdrawal from society. Suicide ended his life in Brest as an almost completely forgotten artist.

In England after the sensational events of Simeon Solomon's trial had died down, the enthusiasm for the Aesthetic Movement centred around Oscar Wilde. The work of Charles Ricketts (1866-1931) and Charles Shannon (1863-1937), two of Wilde's devoted admirers, combined classicism and aestheticism in the production of books and journals as well as paintings and lithographs. The underlying theme of homoeroticism incorporated the androgyne and the youthful male nude in an aesthetic purged of any connotations of the drama or sexual involvement of contemporary life.

The two artists met at Lambeth Art School in 1882 and formed a loving relationship which lasted throughout their lives. Both disliked the materialist values of the rapidly expanding industrial society. Neither artist was concerned with contemporary radical ideas and preferred to look back affectionately to the idealism of the Greeks and Romans as well as the Renaissance. They greatly admired the work of Leighton and it is not surprising that Ricketts was commissioned by him to carry out a drawing. Both artists frequently drew and painted each other in a style which in its treatment of colour and handling of painting owes much to

4.4 Charles Filiger (1863–1928) *Saint Jean-Baptiste* (*Private collection*)

Whistler's influence. Classical, oriental and religious themes were often their chosen subjects.

Both artists were unashamedly 'literary', preferring historical dramas and pageants to domestic scenes. All great art, they thought, was a result of intelligent study of the past. They were greatly impressed by Delacroix and by Moreau whose *Oedipus and the Sphinx* inspired Ricketts' drawing on the same theme which he did for Leighton. They also admired the work of the French artist Pierre Puvis de Chavannes (1824–1898) whose large allegorical scenes, often painted in pastel shades, had a major influence on contemporary artists. After leaving art school they visited Paris in 1887 to seek his advice on what they should do as artists and where they should live. He advised them to stay in London.

The two men were devoted to each other and to their work as artists and early on in their careers agreed to an artistic programme whereby each would support the other while they learned skills and developed their style. Charles de Sousy Ricketts, born in Geneva and taken as a child around Europe, was familiar with continental art galleries, especially those in Paris. By turns, he was an illustrator, book designer, painter, sculptor and theatre designer as well as collector, connoisseur and writer. Charles Hazelwood Shannon, painter, lithographer and engraver, was much less sophisticated, having been born the son of a village rector in Sleaford, Lincolnshire.

As students Ricketts and Shannon lived in a brown-papered room in Kennington Road, London, where they covered the walls with reproductions of the works of old and modern masters. 'Ricketts who I felt to be the most original person I had ever met, looked in those days, with his thin colourful face and long light hair, more like a dandelion pouf than anything else. He was blithe, alert and active and an extremely fast talker' was Rothenstein's[20] recollection. T. Sturge Moore (1870–1944) who was a student at Croydon Art School, remembered Shannon as 'a magnetic instructor, twenty two years old, gifted and handsome. To a boy of fifteen, Charles Hazelwood Shannon was a modern Apollo.'[21] Two years later Sturge Moore moved to Lambeth Art School where Ricketts was teaching and commented 'If Shannon was Apollo, Ricketts was Socrates and Leonardo combined.'[22]

In 1888 they took over Whistler's house in The Vale, Chelsea, moving into the fashionable artists' area of London. Here they set up a small 'artists' colony' letting rooms as workshops to Sturge Moore among others to help pay the rent. Following the vogue for small-circulation journals, they brought out their own periodicals including *The Dial* (1889–97), designed books and often collaborated on illustrations as well as doing their own painting. Some of Ricketts' most famous designs were done for Oscar Wilde. 'The Vale,' Wilde said, 'is one of the few houses in London where you will never be bored.'[23] He referred to them as 'The

Valeists'. When Wilde came out of prison, Ricketts, though not well-off, sent him £100.

From 1891 Ricketts and Shannon designed all of Wilde's books except *Salome* which had illustrations by Aubrey Beardsley. These included *A House of Pomegranates* (1891) and *The Sphinx* (1894). Ricketts considered that his illustrations for *The Sphinx* were the best he had ever done, catching the intricacies of the poetry and its note of perverse mystery. Wilde commissioned Ricketts to design a private edition of *Silverpoints* (1893) written by his protégé John Gray. Though a keen admirer of Ricketts' work, Wilde was also aware of the self-contained air of the house and the inward-looking quality of their art.

While Shannon concentrated on producing lithographs, woodcuts and paintings, Ricketts ran the publishing and book production business. He also managed The Vale Press, which they set up in 1896, producing tasteful and scholarly books. In his paintings, lithographs and drawings, he often showed long, lean and androgynous men, their thin elongated faces looking very much like idealised images of Shannon. A good example is his woodcut illustration 'Neptune quells waves to stay rash Destiny' for *Hero and Leander* (c. 1894) which celebrates the androgynous beauty of the male in a dramatic, well-organised

4.5 Charles Ricketts (1866–1931) and Charles Shannon (1863–1937) *Hero and Leander*. Neptune quells waves to stay rash Destiny. (1894). Woodcut illustration

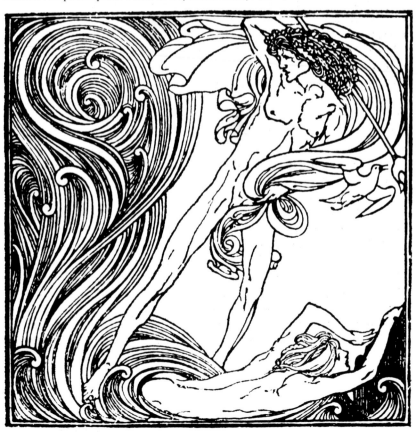

composition. Religious subjects, *The Descent from the Cross*, *The Good Samaritan*, *Christ Before the People* and *The Resurrection*, all include slim, sensual males as did subjects such as *The Death of Montezuma*, *The Assyrian God* and *Eros and Anteros*.

Ricketts and Shannon were well-suited. Shannon—handsome, tall, reticent and serene—'had an energetic sturdiness in all his ways', with a face that 'just perceptibly reflects something of the conflicts between the love of the voluptuous and the love of the austere'.[24] In contrast, Ricketts was a constant talker with a characteristic pose in which 'his head was thrust forward, brow drawn over the intense and eager eyes'. Between the two men 'existed the most marvellous human relationship that has ever come within my observation, and in their prime each was the other's complement', wrote their great friend Thomas Sturge Moore.[25]

While rehanging a large painting after an exhibition at his home town of Lincoln, Shannon met with a tragic accident. He fell from a stepladder, striking his head on a marble pavement in the entrance hall. For several weeks he hovered between life and death before making a physical but not a mental recovery. Ricketts, devastated by Shannon's accident, did not undress or go to bed for four days and nights and sold part of their collection to raise funds for proper nursing. Exhausted, Ricketts died in 1931. Shannon lived for six more years.

Throughout their lives Ricketts and Shannon had many close friendships with homosexual men and women and they were in all respects assumed to be a homosexual marriage. Among their friends were the artists Glyn Philpot and Vivian Forbes (whose work is discussed in Chapter 9) and 'Michael Field'[26] whom they met in 1892. Yet despite all appearances they were reluctant to acknowledge their homosexuality. On one occasion when J. A. Symonds spoke to them about it Ricketts was so affronted that he is reputed to have shown him the door. Shannon's friendships with other men and women caused concern to Ricketts, yet their devotion remained. Ricketts, who was almost exclusively homosexual, was the more complex, gifted and versatile of the two. He offers a view of his sexuality through his work which suggests that the physical act of sex was of little importance to him. His idealised androgynous male figures offer a withdrawal from the crude and vulgar expression of the sexual act in favour of a more ethereal one. Such an attitude would also be confirmed by the denial of the homosexual nature of their relationship. An exhibition of Charles Ricketts and Charles Shannon (Orleans House Gallery, Twickenham, 1979) was subtitled 'An Aesthetic Partnership'[27] identifying both their shared artistic life and the spiritual and emotional quality of their relationship.

In contrast to the restrained and cautious life and work of Ricketts and Shannon, the drawings, designs and life of Aubrey Beardsley (1872–

1898) are even more spectacular, innovative and challenging. In his short but dramatic career of six years, Beardsley not only developed a precise linear style of drawing and composition which influenced his contemporaries and had a significant effect on subsequent generations of artists and illustrators but he also questioned conventional sexuality by introducing and celebrating sexual excess, often with the hermaphrodite much in evidence. Traditionally the hermaphrodite embodied in one person the ideal union of male and female, combining sexual organs of

4.6 Aubrey Beardsley (1872-98) *The Hermaphrodite*: Illustration for Oscar Wilde's *Salome*, as it was published in London.

both sexes. The pre-Raphaelites, Burne-Jones, Simeon Solomon, and to some extent Ricketts had expressed this idea through the androgyne, a Christian rather than a pagan interpretation. For Beardsley, who questioned and often ridiculed the 'male' and 'female', such figures did not go far enough in exploring the ultimate in non-conventional sexuality. Such an image is intrinsic to Beardsley's own complex sexual make-up in which he saw both male and female combined since he desired sexual relationships with women and men. His closest and most intense emotional, and possibly sexual, relationship was with his sister Mabel who was born almost a year to the day before him. It is thought that he was the father of the child which she miscarried in 1892.

From an early age he suffered poor health and as a result spent much time alone, drawing and pursuing his own ideas. In his work he created a world of his imagination, an exotic and fantastic refuge from the awfulness of feeble health. Yet despite his lack of physical strength he became a well-known social figure, was well read and had an almost obsessional capacity for work, producing impressive quantities of detailed drawings in a few working years. Beardsley had little academic training (he attended evening classes at the Westminster School of Art) and never drew from life. At the age of twenty, taking the advice of Burne-Jones, he left his job as a clerk in the Guardian Insurance Office to make art his career.

At this time, 1892, he met Robert Ross (1869–1918), the co-director of the Carfax Gallery. Well-known to the police as a homosexual for his Piccadilly importuning,[28] Ross was at the centre of a group of artistic homosexuals in London and a close friend of Oscar Wilde. Wilde and Beardsley did not become friends. When Beardsley was painted in 1893 by Jacques-Emile Blanche as a fashionable dandy, the picture was described as 'a harmony in brown and silver'. Wilde, however, referred to Beardsley as a 'silver hatchet'. Beardsley illustrated only one of Wilde's writings, Salome (1894) and this contained a caricature of Wilde as the moon in the frontispiece.

Beardsley's first commission, from J. M. Dent, was to illustrate Malory's Morte d'Arthur, published 1893–4. In it he established his basic style of strongly contrasted areas of black and white with fine linear drawing reflecting a Japanese influence in the division of the space. Elaborate decorative patterns and the ornamental quality of his linear rhythms came to epitomise the decadent spirit. The chapter headings for Morte d'Arthur were hermaphroditic in character. Though these were well received, it was the illustrations for Wilde's Salome that made him famous. The unrestrained illustration included naked figures, hermaphroditic men, ugly, deformed dwarfs and sinister women.

In 1894 Beardsley was invited to become art editor of the notorious The Yellow Book published by Arthur Lane. His illustrations confirmed

his reputation as a brilliant and innovative artist and brought his work to the attention of a huge audience. Contributions from noted writers (but not Oscar Wilde) defined it as avant-garde and original. Lane was circumspect in what he would allow to be published and he banned Beardsley's drawing *The Toilet of Salome* which showed men and women masturbating.

His editorship was shortlived. When Wilde was arrested he was reported to have been carrying a yellow book and this was assumed to have been *The Yellow Book*. Panic ensued among Arthur Lane's other authors who threatened to withdraw their work unless Beardsley was dismissed. After the Wilde conviction the homosexual circle around Ross broke up as men faded into the background or crossed the Channel to escape any possible prosecution. Out of a job, Beardsley strangely moved into the rooms Wilde had occupied. He was befriended and helped by Marc André Raffalovich (1864–1930), a wealthy Russian who had arrived in London in the early 1880s. Raffalovich had enticed the poet John Gray away from Oscar Wilde (Gray had been the model for *The Picture of Dorian Gray*) and so confirmed their animosity. Raffalovich showered Beardsley with gifts and gave him an allowance of about £100 a quarter.

The only commissions came from Leonard Smithers (1861–1907), a publisher of high-class pornography, for illustrations for a new magazine, *The Savoy*. The drawings included a woman with a riding crop and a cherub about to urinate on *The Yellow Book*. His drawing *The Abbé* (published in the first issue of *The Savoy* in 1896) illustrates his own story 'Under the Hill'. It is something of a self-portrait in manner if not in exact likeness. The Abbé, a name chosen for its similarity to his own initials, is ornately and splendidly dressed, an epicene and luxurious figure in an exotic setting.

Though ill and weak and exhausted from tuberculosis, Beardsley still managed to work. In an attempt to regain his health he moved into Jacques-Emile Blanche's studio in Dieppe in 1896 and later to Menton in the South of France. Still he worked, pouring out brilliant and innovative drawings. Some, like the *Lysistrata* series were explicit in the sexual details they showed and were bought by collectors more attracted by their pornographic than by their aesthetic qualities.

A mysterious postscript to Beardsley's life is Walford Graham Robertson's portrait of Beardsley's sister Mabel painted after Beardsley's death. She is shown with short hair, well-groomed and in male dress virtually identical to the clothes worn by Beardsley, in the style which identified him as the dandy of his time. There is a suggestion of cross-gender dressing in which brother and sister exchanged roles.

The ideas of the Decadents found a response in America. The work of Whistler was greatly admired and Oscar Wilde's lecture tour in 1883

served to publicise the ideas of the Aesthetic Movement. He was met by large and enthusiastic audiences anxious to see and hear about 'Art for Art's sake'. Montesquiou's visit some years later was equally successful: he gave 'interviews' for which a charge was made. Artists such as Robert Newman (1827–1912), Arthur Davies (1862–1928) and Elihu Vedda (1836–1923)[29] painted women and men in long, flowing robes in a meditative, dream-like style. Their spiritual, dreamy qualities are especially evident when compared with the worldly, lusty 'Gibson Girls' then so much in vogue.

In Chicago, a much more adventurous city than New York in the 1880s and 1890s, a short-lived publication called *Chap-Book* imitated the style and make-up of *The Yellow Book*. The artist Will H. Bradley who had studied the work of Dürer and Botticelli was employed to provide illustrations in the style of Beardsley. But the artist who identified and celebrated all the artistic and sexual qualities of the European decadents and aesthetes was the wealthy photographer and publisher Fred Holland Day (1864–1933).[30] Through the publishing house he owned with Horace Copeland, Copeland and Day (1893–1899), he acted as co-publisher with Arthur Lane for *The Yellow Book*. He made regular and extensive visits to Europe, meeting his heroes Oscar Wilde and Aubrey Beardsley.

During their partnership in the 1890s, Copeland had advised Day to be cautious in his friendship with Beardsley, but fifteen years later he felt able to throw off any restraint. Later Copeland wrote explicit letters to Day about his love affairs with young men. In one letter he expressed his doubts about visiting Day with his lover as he doubted whether Day would take to him. There are also strong implications in his letters that he and Day shared the same interest in young men. Unfortunately Day's letters to Copeland have disappeared and Day did not, as far as is known, document his homosexual activities.

Day's closest physical relationships were with young men, many of whom were immigrants whom he helped and befriended. Many posed as models for his photographs. The Syrian immigrant Kahlil Gibran (1883–1931) met Day when he was thirteen, parentless and without funds. Day provided him with an education and photographed him in exotic costumes. Gibran later became an artist producing visionary paintings and drawings influenced by Blake, Beardsley and Burne-Jones.

Another model, Nardo, an Italian from Chelsea, had been picked up by Day on a 'charity excursion'. Photographic studies picture Nardo naked in a wide variety of classic Greek poses. In a letter to Day, Nardo refers to their close relationship and their friendship. Though married, Nardo became sexually involved with Herbert Copeland. Problems of Day's and Copeland's sexual desires for working-class men were voiced in a letter when he asked if it were 'right to adopt those of another class than our own'.

4.7 Fred Holland Day (1864–1933) *On the Glade* (c. 1905). Triptych, platinum.
19.5 × 23.8 cm (7.67 × 9.37 in). A youthful male figure embraces the Herm of Pan
(*Royal Photographic Society*)

Regarded as one of the world's leading photographers of the time, Day was an equal and rival of Alfred Stieglitz. As an exponent of photography as a fine art Day pursued new and controversial imagery. He was one of the few Americans to be elected to the highly regarded Linked Ring Brotherhood in England who were dedicated to the idea that photography was a fine art. Day set up the 'New School of American Photography' and introduced the work of its members to audiences in the United States and in London and Paris.

His fascination in the beauty of the young male body was expressed in sensual, atmospheric soft-focus studies which called on classical, religious and allegorical themes and conventions. Such images often shocked and outraged the public. For his series *The Crucifixion* he hired friends to pose as Roman soldiers while he, starved and emaciated, played the part of Christ on a specially built and imported Syrian cross. After spending days rehearsing and finally arranging the tableau, Day operated the remote control shutter release from his position on the cross. One study for *The Crucifixion*, a full-frontal view of a naked man, caused uproar when exhibited in Boston for its profanity and its flaunting of the rules of propriety.

Day also posed for a series of close-up views for the *Seven Last Words of Christ*. Wearing a savage looking crown of thorns his thin, long face and dark beard expressed the agony and the pleasure of the final hours. By selecting this particular religious theme Day confronted ideas of what was acceptable for the photographer but was undeterred by the views of his critics who thought the figures far too real for the spiritual qualities they were meant to express.

After a disastrous studio fire in 1904 which destroyed practically all his prints and negatives, Day abandoned religious themes in favour of pagan subjects many of which had a powerful homoerotic quality. Nude youths or adolescents were posed in woodland glades often with a garland on their heads or bearing such classical props as a shepherd's cloak or a lyre. One youth was photographed embracing the herm of Pan, a symbol of the penis and fertility. The idea was probably based on a Beardsley drawing. Day's technique of using a soft, misty focus gives his images a romantic mysticism which is both sensual and erotic.

Throughout his working life, Day continued to bring the same element of sensitivity to all his photographs, especially those of women. These were particularly successful in describing what the sitters were like as well as how they looked. He wanted an atmospheric and emotional content and was not interested in reportage or documentary work. His rivalry with Steiglitz and the destruction of his life's work in the studio fire diminished Day's reputation and around 1915 he ceased serious photography. For the last sixteen years of his life, a virtual recluse, he lived in his bedroom swathed and swaddled with shawls and blankets for

a variety of real and imagined illnesses. He was largely forgotten and ignored by the new generation of artists and photographers.

The introspection, the veiled homoerotic imagery, the concern of artists to seek out a public identity, used art itself as a subterfuge. It is difficult to think of a more suitable means. The ideals of the ancient Greeks had not yet been replaced by modernism or formalism, but dramatic changes lay on the horizon, for the dawn of a new century saw ideas and imagery move from classical concerns to ones which touched more closely on the daily lives of women and men; the opportunities for fresh beginnings could not be ignored.

5 · The Soul Identified with the Flesh

The diverse range of images of women created by artists who were lesbian in the last decade of the nineteenth century and the first decades of the twentieth century was an integral part of the widely differing attitudes towards female homosexuality. Artists could, as one writer put it, give physical expression to emotional desire when 'the soul is identified with the flesh'.[1] Though lesbianism was not forbidden by law, this was not because it was officially condoned but because legislators were reluctant to accept that it could exist and they feared that discussion would draw attention to it. Generally lesbian relationships were regarded as a last resort when a husband failed to materialise, while a more knowing but equally oppressive view was that it was 'a passing phase'. Others saw it in terms of Freud's theory of 'arrested development' which could be remedied either by a 'good man' or the more fashionable practice of psychoanalysis.

Public displays or expressions of lesbianism met with various degrees of disbelief or disapproval. In 1907, when Colette embraced her real-life lover, the Marquise de Belboeuf ('Missy'), at the climax of their performance in the pantomime *Rêve d'Egypte*, the kiss was of such explicitness that the entire audience rose in uproar. A police injunction was imposed to prevent further performances. Lesbian circles flourished in Paris, Florence and Capri in the early decades of the century, while 'sympathetic' groups such as the Bloomsbury circle of writers and intellectuals in London offered support. Both male and female homosexuals still saw ancient Greece as a model society in which same-sex love could be freely expressed. Bloomsbury, for example, dubbed lesbians 'Sapphists', after the sixth-century BC poet who lived on the island of Lesbos, inspiring the writers Natalie Clifford Barney and Renée Vivien to take adjacent villas on the island of Lesbos, gathering around

themselves a group of women such as Sappho had done. The experiment, though short lived, demonstrated the mood of the time.

Many women found it much easier to express their sexuality both as women and as lesbians away from the confining and defining attitudes of their homes and families, building creative lives in other countries, particularly in Europe. Frances Hodgkins came to Europe from New Zealand and spent much of her time attempting to survive financially. In contrast, women with wealthy backgrounds such as the American Romaine Brooks could afford to lead eccentric life styles and to cultivate their art with little regard to sales of their work. The cultured air of Europe nourished and sustained the relationship between Ethel Sands and Nan Hudson, two wealthy American artists who set up a smart and fashionable home together in Chelsea, London. For the English artist Gwen John, however much she had enjoyed London as a student, the attractions of France were greater. Away from the overpowering flamboyance and ostentatious success of her younger brother Augustus, she was able to live the life of a recluse, developing her highly private painting.

Finding like-minded friends and setting up a base from which to work was an important part of establishing an identity both as an artist and as a lesbian. Dora Carrington, Dorothy Hepworth, Patricia Preece and Ethel Walker found this in the artistic circles in and around London, but the establishment of their independence was still important. Gluck (Hannah Gluckstein) and Dora Carrington, for instance, left their solid middle-class families as early as possible and both dropped their defining 'feminine' names in favour of single, less gender-specific titles.

With little or no lesbian visibility in art, save for images painted by men for men such as those by Courbet and Toulouse-Lautrec, artists who were lesbian were forced to call on their own experiences. This is exactly what the American Alice Austen (1866–1952) did at the turn of the century. Responding to the magic of the camera and its newness, she photographed her friends and her lover, producing images of lesbian life which even today seem remarkably explicit. Taking a documentary, almost journalistic approach, Alice Austen had much in common with the photographer Frances Benjamin Johnston (1864–1952). Johnston worked as a photo-journalist in Washington DC, becoming known for her portraits of eminent women who included Alice Roosevelt, the wives of the Presidential Cabinet and the feminist Susan B. Anthony. She was the only woman delegate at the Third International Photographic convention in Paris in 1900. Like Frances Johnston, Alice Austen had financial security and travelled widely. Both photographers were fascinated by the precision and detail the camera could produce, unlike Fred Holland Day (see Chapter 4), whose misty-eyed compositions aimed for romantic rather than realistic effect. Equally they did not respond to the style of

Gertrude Kasebier (a close friend of Holland Day) whose studio portraits of mothers and children aimed for the 'mystical essence' of motherhood.

As well as photographing friends, Alice Austen photographed women workers, Indians and blacks, coal miners and other manual workers. She took her cumbersome and heavy photographic equipment to New York to record the city's immigrants, such as street sweepers, rag pickers and pedlars, the Irish postmen and the women who stood at market stalls or walked barefoot in the streets. She published some of these in a small portfolio *Street Types of New York*.

Alice Austen's background, like that of Rosa Bonheur, was centred on her mother. Shortly after she was born her father returned to London, his home town, never contacting his family again. Bitter and angry, her mother returned to her parents' home on the east shore of Staten Island, dropping her married name in favour of her maiden name. Though the only child, Alice Austen was encouraged to develop her sporting abilities and her mechanical skills. One uncle gave her a camera and another showed her how to develop the negative images on the glass plate and how to make prints. By the time she was eighteen Alice Austen was taking excellent photographs. An impressively posed photograph of 1886 shows Mrs Cocroft, who did the housework for the Austen family, surrounded by her eleven children, one of whom is a baby in her arms. The children, sturdy and confident, neatly dressed in white smocks are shown standing in the branches of a tree, a far cry from the careful romantic idylls of other contemporary photographers, or from the idealised Little Lord Fauntleroy image created by the writer Frances Hodgson Burnett.

In other photographs Violet Ward, a friend since childhood, is shown with her unnamed female lover. An enthusiastic cyclist, Violet Ward adapted the bicycle to make it easier for women to ride. Bicycles were regarded as a vital part of women's emancipation and despite the Boston Women's Rescue League which warned that thirty percent of all 'wicked women' had at some time been bicycle riders, thousands of women bought the lady's bicycle which had no cross-bar. Alice took photographs for Violet Ward's book *Bicycling for Ladies* published in 1896. Their friend Daisy Eliot, a gymnast, was the model.

An amusing series of photographs illustrates the humour of Alice and her friends. One shows three of them in bed at a 'slumber party' with Alice Austen operating the concealed camera release. The three women appear again with moustaches and full male clothing in another photograph. 'Maybe we looked better as men,'[2] commented Alice Austen. A third photograph shows her with the minister's daughter both posed in corsets with long flowing hair and smoking fake cigarettes.

During her summer holiday in 1899 Alice met Gertrude Tate, the woman with whom she was to share her life and work for over fifty

5.1 Alice Austen (1866–1952) *Violet Ward on her porch with a friend*. Photograph (*Staten Island Historical Society*)

years. Gertrude Tate, then twenty-eight, was a kindergarten teacher and dance instructor recuperating from typhoid fever. They spent summers together in Europe, but it was not until 1917 that Gertrude Tate overcame her family's objections to her 'wrong devotion'[3] and she moved

from Brooklyn to Alice Austen's home on Staten Island.

The 1929 collapse of the Stock Market virtually ended Alice Austen's work as a photographer. Film was expensive and she had no income. They sold their possessions, rented out rooms, even opened a tea shop but, still unable to meet mortgage repayments, they were forcibly evicted in 1945. Many of Alice Austen's 7,000–8,000 negatives were lost or destroyed. Fortunately, when the contents of the house were being disposed of a member of the Staten Island Historical Society spotted the plates and some 3,500 of them were saved.

For a time both women shared a small apartment, but in 1950, ill and without funds, they were forced to separate. Alice, then eighty-four, was put into the Staten Island poorhouse while Gertrude Tate went to live with her married sister. Fortunately Oliver Jensen, came across the Austen plates in the Staten Island Historical Society archives and then found that the photographer was still alive. Publication rights for the photographs raised sufficient money to enable Alice Austen to move to a nursing home. During the last few months of her life she was interviewed on television and met many of her old friends again. She died in 1952. Gertrude Tate survived her by ten more years.

Few women felt as confident in recording their lives as Alice Austen. Most were more circumspect, taking up the post-Impressionist use of light and colour for quieter, more conservative images of women. Nan Hudson chose intimate domestic scenes, while Ethel Walker painted more flamboyant and openly celebratory images of female beauty. Gwen John's work invokes the quieter introspective qualities of women and it is their aura as well as their beauty which reverberates in her paintings.

None could match the outspoken, sometimes cruel images of lesbians painted by Romaine Brooks (1874–1970). An active member of the openly lesbian circles of Paris, Capri and Florence, Romaine Brooks portrayed that society as well as producing androgynous images of women in a style close to that of the Aesthetic Movement. Her views on lesbianism were as forthright as her painting. Even though her vast wealth protected her style of life, she was aware of the need for images of lesbians which did not caricature or sensationalise. She did not, for instance, like *The Well of Loneliness*, though for reasons which were the opposite of the general outcry. She thought the book gave a trite and superficial portrayal. Neither was she overfond of the book's author, partly because she did not like the way she was portrayed as Venetia Ford, the artist in Radclyffe Hall's novel *The Forge*. The two women maintained, however, a polite friendship centred around Natalie Barney's Paris *salon*.

Four years before *The Well of Loneliness* was published, in 1924, Romaine Brooks had painted a merciless portrait of Radclyffe Hall's lover Una, Lady Troubridge (Smithsonian Institution) who was a

competent artist in her own right.[4] In later years Romaine Brooks discounted the painting, claiming that it was a joke. Its remorseless exposure of its subject was thought to be too outspoken, and the painting was not shown in Brooks' London exhibition. The portrait's clear description of the wealthy, confident, aristocratic, 'mannish' lesbian is unmistakeable. For the portrait Una, Lady Troubridge, tall, slim and elegant with short-cropped hair, chose to wear a high-necked white starched shirt and cravat, a black jacket and dark trousers, with a monocle held in one eye. In front of her in pride of place are her two champion short-haired dachshunds, a present to her from Radclyffe Hall.

The painting makes an interesting comparison with Romaine Brooks' self-portrait (Smithsonian Institution). Both show aristocratic wealthy women wearing male attire, but whereas Una, Lady Troubridge gazes directly out of the frame confident and assured, Romaine Brooks appears less open and almost evasive. The tall dramatic hat she wears is placed low on her forehead so as to cast a shadow over her eyes, concealing half her face. We are permitted only to see part of her. Behind stretches a ruined castle, a suggestion that her life is neither happy nor successful. Family fortunes provide her with the means for a luxurious life style but they have not necessarily ensured happiness or security.

She was born Romaine Mary Goddard, into an enormously wealthy but unhappy family; the scars of a traumatic childhood and emotional neglect never left her. Her mother, eccentric and slightly sadistic, was deserted by her father before she was born. Different times of year were spent in a succession of large houses avoiding her mother and brother Max as much as possible. She studied art in Rome from 1896 to 1897 and three years later rented a studio on the island of Capri, then a haunt for artists and the sexually unconventional. A series of brief affairs, including a short-lived marriage to John Ellington Brooks, a homosexual who had fled England after the trial of Oscar Wilde, did little to ease her unhappiness. Though her marriage was not a success, it gave her the opportunity to take a new name.

On the death of her mother and brother in 1902, she inherited the vast family fortune and was financially free to travel around Europe. Eventually she settled in Paris where she was strongly influenced by the aesthete Robert de Montesquiou. She designed his apartment in the muted colour scheme of black, white and grey that she used in her paintings.

Romaine Brooks' work falls into three main groups, portraits (of friends rather than commissions), the thematic paintings of young androgynous women, and the 'stream of consciousness' line drawings. Androgyny and hermaphroditism were recurring themes in the work of the aesthetic artists including Brooks' friend Gabriel d'Annunzio. In his notorious stage production *The Martyrdom of St Sebastian* for which

Debussy wrote the music and Leon Bakst provided the designs, the dancer Ida Rubinstein played the role of St Sebastian as an hermaphrodite. Romaine Brooks' painting *The Masked Archer* (1910–11) was inspired by this and shows a naked woman (a portrait of Rubinstein) bound to a stake being shot at by a tiny dwarf-like archer, d'Annunzio in thin disguise.

All Brooks' female nudes have a particular idealisation of the body which is as much an expression of spiritual qualities as of flesh and blood. The pale, wan and bloodless nudes with small immature breasts, no pubic hair and a slim body have the shape more of boys than girls. Their nakedness, which combines eroticism with symbolism, gives them a particular sensuousness but it is one remove from mortal and physical desire. Like Gwen John, Romaine Brooks gave her female nudes thin, slim, underfed bodies. It is of such paintings that a contemporary reviewer observed that it seemed as though 'the soul is identified with the flesh'.[5]

The Crossing (Le Trajet) c.1911 (Smithsonian Institution) again uses Ida Rubinstein as a model and shows her naked, pale and ethereal lying on a sort of white wing which bears her on a mysterious voyage in a black void. The pitifully thin body and the trailing black hair could suggest death or ecstasy. The large canvas with its air of tragedy and sadness is a powerful *tour de force* in which colour, mood and sensuality are successfully combined.

5.2 Romain Brooks (1874–1970) *The Crossing (Le Trajet)* (1911). Oil on canvas. 115.2 × 191.4 cm (45.37 × 75.37 in) (*National Collection of Fine Arts, Smithsonian Institution, Washington DC*)

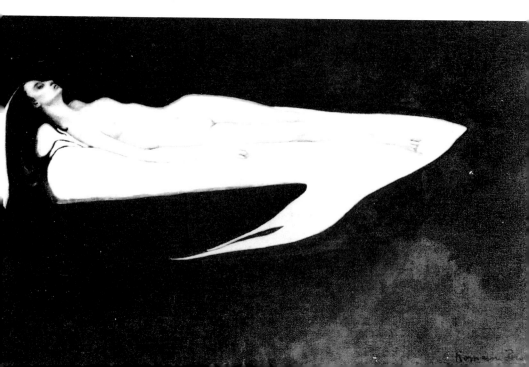

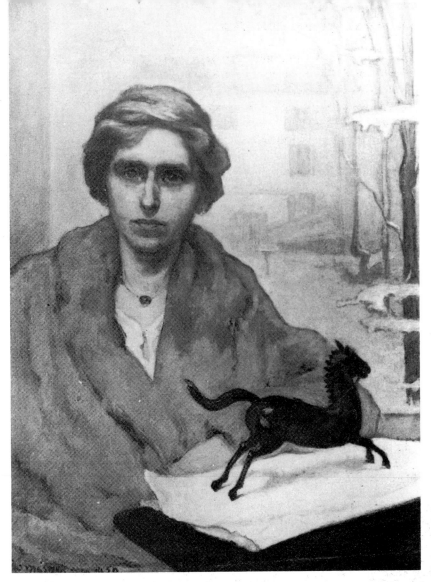

5.3 Romaine Brooks (1874–1970) *Miss Natalie Barney 'L'Amazone'* (1920). Oil on canvas. 86 × 65 cm (33.9 × 2?.6 in) (*Musée Carnavalet, Paris*)

Romaine Brooks' relationship with Natalie Clifford Barney (1877–1971) was a vital and enduring friendship against which brief affairs took place. They met around 1915 at Natalie Barney's *salon* in the Rue Jacob and became lovers and friends for over forty years. The portrait of Natalie, subtitled *L'Amazone* 1920 (Musée Carnavalet, Paris) painted the same year that Romaine was awarded the Legion of Honour, is typical of her skill as a portrait artist. Not only is it a tribute to her lover's strength and intellect but it is a commentary on her interests and

emotional state. Swathed in furs, Natalie gazes confidently but sensitively out of the picture. She is set against the backdrop of a wintry garden scene at her home on the Rue Jacob. On the table in front of her is a riding crop, and placed on top of a folded sheet of paper is a model of a galloping horse, references to her skills as a writer and as a horse woman – hence the title of the painting, *L'Amazone*. The cold, frosty winter scene in the garden implies Natalie is outwardly cool while its whiteness relates to her purity and to her interest in androgyny and hermaphroditism. The furs she wears and the soft smile suggest that within she is warm and caring.

This frankness is typical of most of Romaine Brooks' portraits. Using conventions employed by Bronzino amongst others some three hundred years earlier, she loads her paintings with information and comment. Emblems such as models of animals or particular settings often revealed more about her sitters than they liked. Such frankness alarmed and often annoyed them. It was not without reason that d'Annunzio whose portrait she painted twice described her as 'the thief of souls'[5] for her ability to penetrate beyond appearance and reveal the traits of her sitters' characters.

A series of semi-abstract line drawings carried out in the 1930s was a move away from direct depiction of her world and the people in it to a more inward, more personal but more obscure style. Like the work of the surrealists, these freely done continuous line drawings were attempts to tap the subconscious mind and let it guide the hand. The resulting drawings, intense and introspective in their search for expression, have something of the quality of caricature. In some, hermaphrodite figures can be recognised being engulfed by others which are larger but equally diffuse, amorphous and ghost-like. The drawings were part of an important 'search' for Romaine who described them as aspiring 'to a maximum of expression with a minimum of means'.[7]

In the late 1940s Natalie Barney took the writer Truman Capote to the studio of her 'beloved friend, Romaine Brooks'.[8] The room was filled with paintings produced over a period of fifty years. In the post-war years there was little interest in Romaine Brooks' paintings and it was not until her retrospective exhibition in America in 1971 that her work again received serious consideration. Much the same fate befell the English painter Hannah Gluckstein (1895–1978). Her paintings of herself and her friends completed in the 1920s and 1930s were totally out of favour in the post-war years. In fact she deliberately kept out of the fashionable art world, not wanting to be thought of as an object of ridicule.

Like Romaine Brooks, Hannah Gluckstein (or Gluck as she was to insist on being known) was born into a wealthy family which she was determined to leave as soon as possible. She also explored themes of

androgyny and unconventional sexuality in her paintings. Like Romaine Brooks', her paintings were not merely about taking up fashionable styles but searching for a personal statement which would relate to her own experiences and understanding. But, unlike Brooks, Gluck was less attracted to the lesbian circles of the international set and preferred a quieter, less social life.

Born in London, Gluck was a daughter of Joseph Gluckstein, one of the founders of the Lyons & Co. restaurant chain. Like her American mother, she was a talented musician and this was to have been her career until she was deeply impressed by the sight of a painting by Sargent, his portrait of the violinist Joachim. From then on her ambition was to become an artist. Though she had spent 1913–16 at St John's Wood School of Art in London, this was mainly to please her parents rather than from her own choice. She spent some weeks in Cornwall near the artists' colony of Newlyn where she met and was encouraged by artists

5.4 Gluck (1895–1978) *Medallion* (c. 1937). Oil on canvas. 27.9 × 33 cm (11 × 13 in) (*Fine Art Society, London*)

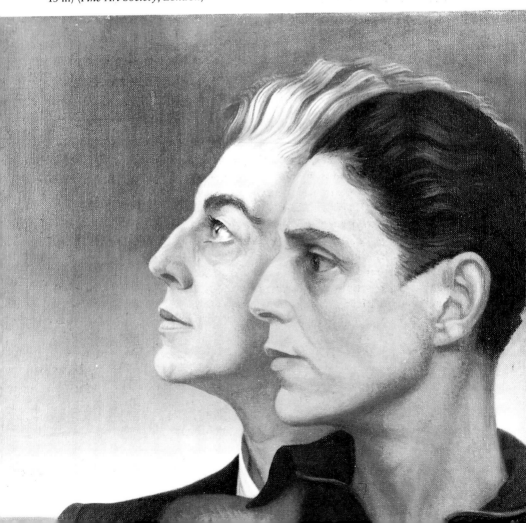

including Alfred Munnings, Dod and Ernest Proctor and Laura Knight.

In London she felt she must escape from the conventional reins of her family who thought that an acceptable marriage was her rightful aim. With little more than pocket money she left home. Able to express her own personality, she cropped her hair, wore male clothes and insisted on being known only as Gluck. Gordon Selfridge let her have a studio in his

5.5 Gluck (1895–1978) *Self Portrait with Cigarette* (1925). Oil on canvas. 25.4 × 20 cm (10 × 8 in) (*Fine Art Society, London*)

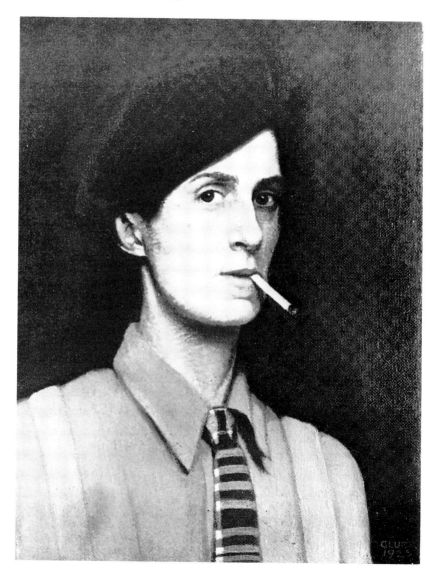

famous London store and for a time she did 'instant' sketches of customers.

Gluck's paintings explored an eclectic choice of subject matter which included still life, dancers in the theatre, vaudeville acts, fish, flowers, and the boxing ring, as well as androgynous figures. She painted delicate portraits of 'ephebes', many set in North Africa. She also enjoyed painting portraits. All have little colour and use strong greys, blacks and whites to model the features and give the works a powerful dramatic quality. Like Romaine Brooks with whom she was friendly, Gluck was concerned with accuracy rather than with any flattering picture of the sitter. This honesty was apparent in the 1920s when the two formidable artists agreed to paint each other's portrait, with Romaine Brooks coming to Gluck's studio in Tite Street, Chelsea. Romaine Brooks' portrait of the artist twenty years younger than herself, *Peter – a Young English Girl*, is both explicit and insightful. Gluck's strong, sensitive face with its close-cropped hair, collar, tie and belted jacket describes a young fashionable lesbian who is given a name which was used by both men and women. Romaine Brooks was less keen to pose. She arrived late in the afternoon when the light was fading and Gluck was only able to block in a large canvas. Romaine, who always pictured herself long and slender, did not care for Gluck's image and never returned. Only a photograph remains of the sketch, for subsequently Gluck used the canvas for another painting.

Exhibitions of Gluck's work were held at the Fine Arts Society, London, in 1926 and 1937 and then not until 1973, followed by a memorial show in 1978 after she died. The huge gap of thirty-six years demonstrates how her work was 'out of fashion' and it was only in the 1970s that the paintings were again given serious attention. In the 1950s for instance, so disillusioned was she that she destroyed several early self-portraits showing herself dressed in trousers, cap and cloak since in middle age she came to resent the curiosity shown in the more sensational aspects of her life.[9] In the repressive mood of the late 1940s and 1950s it is not surprising that Gluck should have disliked being made to feel a freak and an object of curiosity.

The images of women that Romaine Brooks and Gluck painted were depictions of their own interests and of the society in which they lived which included the openly lesbian circles. Images of women painted by other lesbians were more conservative and cautious, reflecting their reluctance to identify their relationships as lesbian. Ethel Sands (1873–1962) and Anna Hope Hudson (1869–1957), known as Nan, were in contrast highly discreet in their lives and in their art. Though they lived together as a couple for over sixty years, they never saw themselves as lesbians, though they were thought of as such by their friends. Lytton Strachey described Ethel as 'an incorrigible old sapphist'[10] in 1913, while

in later life Nan was given the nickname 'Man'. In a letter to Vanessa Bell, her sister Virginia Woolf reported that Nan Hudson thought that people took her for a sapphist. Keen to find out if this was accurate, Virginia Woolf added that she almost got Nan to admit that she 'had once or twice, on a pale May night, embraced Ethel'.[11] Their friend the artist Walter Sickert flirted endlessly with Nan.

The two women, both American, had met whilst studying art in Paris. Both were independent financially and had ambitions as artists preferring to make England rather than America their home. Each found in the other qualities that she did not herself have. Their letters testify to their deep and passionate devotion which emphasised the emotional, tender and caring aspects of their relationship. Whether or not their relationship was sexually expressed both were anxious to avoid being thought of as lesbians. On one occasion in the 1920s when Ethel wrote to Nan describing a new outfit of dark blue rep with a white satin tie, she added that 'it wasn't that way'.[12] Both women had many homosexual friends and were generally accepting and uncritical of others' tastes. But for them it was important that society accepted their friendship rather than giving it a label.

They were as conservative in their art as they were cautious in their lives. They withdrew for example from the radicalism of Roger Fry's post-Impressionist exhibition of 1910 but identified with a more modified version of English post-Impressionism. In Paris the two artists were influenced by Edouard Vuillard and Pierre Bonnard and in London they became great admirers and friends of Walter Sickert. Both women painted scenes of intimate interiors influenced strongly by the Sickert style of English post-Impressionism. Unfortunately in the Second World War their two houses were bombed and many of their paintings were destroyed.

Ethel Sands' chosen subject matter, of intimate domestic interiors with such titles as *Femme au Lit* and *Le Cabinet de Toilette* were generally sympathetically received and they were praised by Roger Fry for their quiet and 'feminine' qualities. Nan Hudson also did interiors and some genre pictures but gave up painting for many years, returning to it later to do more precise, softer coloured watercolours, often with architectural interest.

Though both were friends of Sickert, often showing paintings in his studio in Fitzroy Street, they were excluded from membership of the Camden Town Group. Set up in 1911 as a response to the conventionalism of the New English Art Club (NEAC) membership was limited to sixteen fully professional artists, all of whom were men. The limits were designed partly to exclude the two women who were not thought to be sufficiently serious. Despite these setbacks they showed their paintings at the Carfax Gallery (which had been opened in 1898 by

the painter and archeologist, John Fothergill, to show the work of younger artists), the Goupil and the NEAC. Both women lived well into their eighties, though their art was disregarded by the new generation of post-war artists and their social circle dwindled as their friends died and fashions changed.

Two friends of Ethel Sands and Nan Hudson, Dorothy Hepworth (1898–1978) and Patricia Preece (1900–1971) painted in a similar style but lived more openly lesbian lives. The two artists met in 1917 whilst students at the Slade School of Art, London, and established a life-long relationship in which their artistic careers merged and their work was presented under one name. Both artists were well thought of at the Slade and both disliked students who were there merely to pass the time before marriage. Each wanted to make painting her career. Professor Tonks had a high opinion of Hepworth, while Roger Fry and later Clive Bell and Duncan Grant lauded Preece's work.

After the Slade they shared a studio in Gower Street, London, until Roger Fry persuaded them that their work would benefit from a period of study in Paris. For four years they lived and studied there, with Hepworth enrolled at Colarossi's studio and Preece at the studio of the more experimental André L'hôte. They returned to England in 1925 and after moving from one place to another settled in 1927 in Moor Hatch Cottage, Cookham, a village Preece had known in childhood. Neither had any income and when the cottage came up for sale Hepworth's father bought it and gave it to her. Patricia Preece had wanted to live in London but thought that because of Hepworth's health a country home would be more suitable.

Dorothy Hepworth, described as wearing 'masculine clothes' and as a 'private person' was totally devoted to Preece and stayed loyal to her throughout Preece's involvement with Stanley Spencer.[13] She also proved to be the more committed artist although under unusual circumstances.[14] They were friendly with Duncan Grant who wrote a catalogue introduction to the 1936 Lefévre Gallery exhibition. Their principal subject was the human figure often presented with an intimate and domestic feeling. Paintings such as Seated Nude by a Washstand are both appealing and innocent. Early on in their relationship the two women came to an agreement whereby all their works were signed 'Patricia Preece', though it is likely that Hepworth did most if not practically all of the painting. The work left in the cottage after Hepworth's death in 1978 revealed that all were signed 'Patricia Preece'. A few seemed to be by a different hand and these are thought to be by Preece herself. However, whenever they showed their work it was Preece who dealt with art galleries and who attended the private view.[15]

To all intents and purposes they acted and presented themselves as one person. Patricia Preece's liaison and eventual marriage to Stanley Spencer

(1891–1959) did not seem to change their relationship significantly. Spencer met Patricia Preece in 1929 in Cookham and fell in love with her. She responded and eventually agreed to marry him. He ignored Hepworth, dismissing her as having no feelings saying that she 'could only find human beings awfully good models to draw'. In contrast he saw Preece as having a 'hunger and thirst' for real life.[16] Equally Hepworth had little time for him and advised Preece against the marriage. On May 25 1937, Spencer's divorce from his wife Hilda was made absolute and four days later he married Preece. By this time she had virtually lost interest in the marriage and the day after the ceremony, having banned Spencer from the cottage, left with Dorothy Hepworth for a painting holiday in St Ives. Spencer followed, but though they all stayed in the same cottage the marriage was not consummated and they never lived together.

'Patricia Preece' had a major exhibition in 1936 (with an introduction by Duncan Grant) and again in 1938 at the Leger Galleries in London. Writing in the introduction to this later show, Clive Bell noted that two years earlier there had been an 'excessive insistence on the rugged individuality of the model' whereas in 1938 the 'moral qualities are no longer in the shop window but in the texture of the painting'.[17] Given the traumatic events of 1937 in their lives, such a change is not surprising.

Dorothy Hepworth's devotion to Patricia Preece and her willingness to take her name and give her art to her is similar to the love Dora Carrington (1893–1932) had for Lytton Strachey. Through Strachey Carrington became associated with the Bloomsbury group and enjoyed participating in open discussions of sexual interests. Attracted to men and women (she described her sexuality as 'hybrid'),[18] the problem for her was sustaining relationships whoever they were with.

As a child Carrington enjoyed a close and admiring friendship with her father, enjoying his liberal and radical views; in contrast her mother seemed unduly fussy and conventional. At seventeen she enrolled at the Slade School of Art where she was recognised as one of the most talented students of her year. She became interested if not involved in the ideas of the suffragettes and began to question her role as a woman. She bobbed her long hair and generally sought to obtain as wide an education as possible. But one aspect of herself which she never came to terms with was her dislike of her womanhood. 'You know how much I always hated being a woman', she wrote.[19] In her letters she often referred to menstruation, a phenomenon which she described as filling her 'with such disgust and agitation'.[20] In 1915 she met Lytton Strachey who was homosexual and fell in love with him, starting a relationship that was to dominate the rest of her life. Contact with him and the Bloomsbury group further extended her education but she was not encouraged as a

5.6 Dorothy Hepworth (1898–1978) *Drawing of Patricia Preece*. Pencil. 25.4 × 30 cm (10 × 12 in) (*Private collection*)

painter by the important critic and writer Roger Fry.[21] In fact one of her continual battles was to interest her friends in her work sufficiently to receive support and encouragement as well as constructive criticism.

Though she lived with and cared for Lytton Strachey (they set up home together first in Tidmarsh Hill, Pangbourne, from 1917 to 1924 and then at Ham Spray in Wiltshire), she continued to have relationships with other men and women. In the mid-1920s she had a sexual relationship with Henrietta Bingham, the daughter of a judge who was later made US ambassador to Britain. The difficulties of a relationship with a woman seemed to be just as acute for Carrington as a relationship with a man. Writing about her affair with Henrietta in a letter to Gerald Brenan with whom she had fallen in love earlier, she speculated on the differences between loving women and loving men. Carrington explained that she felt no shame at the ecstasy she found with Henrietta but thought that if she was completely 'sapphic' such relationships would be less problematic. Later her feelings for Julia Strachey were just as intense and surrounded by complexities. Carrington's portrait of Julia, painted in 1928, ably echoes some of the qualities Virginia Woolf suggests in her description of Julia as a 'gifted wastrel'.[22]

5.7 Carrington (1893–1932) *Lytton Strachey* (1916). Oil. 68.6 × 73.6 cm (27 × 29 in) (*Private collection*)

A dense and detailed painting *The Mill at Tidmarsh* 1918 exemplifies the closeness of her art and her life. The Mill was the first home she shared with Lytton Strachey and she devoted herself into making it a home. The imaginative and colourful use of paint and the detail with which the subject has been observed and recorded reflects the intensity of her time at the Mill. Local landscapes and portraits of friends have a similarly vivid and lively strength.

E. M. Forster (National Portrait Gallery, London), *Gerald Brenan* and *Samuel Carrington* (a picture of her father) which were all painted at this time are incisive images of the sitters' characters. One of her finest portraits *Lytton Strachey* 1916 (private collection) is an expression of the passion and devotion she felt for the writer. He is shown in profile lying down in a moment of rest, reading. The portrait shows only his head and delicate extended hands and each detail, each brushstroke, describes him as sensitive and thoughtful rather than as the sharp, acid wit of society.

In 1931 Lytton Strachey fell ill and died of an undiagnosed cancer, leaving Carrington desolate and lonely. Despite close and caring friends, she died by her own hand a few months later.

If Carrington's talents as an artist were overshadowed by her relationship with Lytton Strachey and a group of people more concerned with literary rather than with artistic accomplishment, Gwen John deliberately kept her skills to herself, concealing rather than exhibiting them. Like Carrington, Gwen John (1867–1939) had passionate feelings for women and men into which she poured much emotional energy. Yet she spent most of her life protecting her independence and painting principally for herself. Gwen John was a recluse who avoided contact with people other than her close friends and was only prepared to spend time with the man and women she loved.

Born Gwendoline Mary John in Pembrokeshire in Wales, she eventually managed to persuade her father, a solicitor, to send her to the Slade School of Art along with her brother Augustus. At the Slade she established close relationships with women students, some of which were to survive most of her life. Like her brother before her, in her second year she won the drawing prize. With two other female students she moved to Paris in 1898 and despite financial difficulties enrolled at the newly opened Académie Carmen. Unlike the Slade, the emphasis there was on painting rather than on drawing and Whistler taught her once a week. From him she learnt how to build up a figure in a sensitive series of washes and this, together with an awareness of post-Impressionistic handling of the effects of light, was to form the basis of her painting style.

To help her survive financially she worked as an artist's model. In 1903 she was introduced to Rodin to pose for *Whistler's Muse*, an ironic subject given her own admiration for the American artist. A plaster cast

of the work remains in The Rodin Museum, Paris. Rodin, then sixty-three, found her enormously attractive and the two became lovers. She regarded herself as Rodin's true wife, his muse in life and in art. Despite the ending of their physical relationship, she continued with this belief until his death in 1917.

Before meeting Rodin she had had flirtations with women and men, developing a strong attachment for Dorothy McNeil (known as Dorelia). They had set out to walk from Bordeaux to Rome and *en route* an innkeeper's wife had fallen in love with Gwen John, even following her to Paris.[23] Later Augustus John's wife Ida and his lover Dorelia fell in love and ran away with his children to Paris to be with her. In the 1920s Gwen fell as passionately in love with Véra Qumançoff as she had done earlier with Rodin. She told Véra that she loved her 'as she loved flowers, ... so much that she dared not look into her eyes'. Though her devotion was not reciprocated, she showered Qumançoff with gifts of drawings and paintings. Eventually Véra banned her from visiting her home and paid no attention to the growing collection of art she had been given. It is unlikely that their relationship had physical expression.

Though lesbians found Gwen John attractive (she often posed for women artists who were openly lesbian), she was never attracted either physically or emotionally to them. Clearly she did not see herself as being lesbian nor did she identify with them. Yet apart from Rodin who was over thirty years older than she, it was only with women that she felt any deep spiritual and emotional attachment. Men seemed to intimidate her and she had little contact with them. She even avoided meeting John Quinn, her understanding and generous patron from the United States. It was only with women and children she felt relaxed and confident and these were her favourite subject matter. Like Goya she liked to paint her models with and without clothes, studying them in very different ways. For example in 1909 her friend Fenella Lovell was painted dressed and nude. The vulnerable body was skinny and fragile but the face strong and forceful. All the women she painted appeared as thin and pale and it was clearly a 'type' to which she was attracted. It may well have been how she looked herself, so undernourished did she become. But compared with paintings by Romaine Brooks her women are more naturalistically coloured and less dramatic in presentation. Drawings and paintings of nuns (she converted to Catholicism), women in churches, young girls, portraits of women friends and female models as well as self-portraits far out numbered the views of empty streets seen from her window, flowers and her beloved cats. On the rare occasions when she was asked to paint men the stilted studies were made from squared-up photographs.

Gwen John's only solo exhibition, at the Chenil Gallery, London, in 1926, came at the end of her most productive period and confirmed her

5.8 Gwen John (1876–1939) *Dorelia by lamplight, at Toulouse 1903*, Oil on
canvas 54.6 × 31.8 cm (21½ × 12½ in) (*Courtesy Anthony d'Offay Gallery*)

reputation as a major twentieth-century artist. She painted slowly, working for weeks or months on a single picture, in either gouache or watercolour, achieving a penetrating, quiet intensity. This effect is heightened by the pale, cool overlapping strokes of paint which build up the painting layer by layer which suggests that she was as concerned with the emotional state of the sitter as with outward appearance.

For the last eight years of her life, with the ending of her friendship with Véra Quamançoff, she lived the life of a solitary recluse. With the proceeds of her exhibition at the Chenil Gallery she bought a plot of land with a shed on it, at Meudon on the outskirts of Paris, surrounding it with a wall to create her own world and to keep out the inquisitive or curious. Visitors were actively discouraged and to some she would not even unlock the door. With only her cats for company and at times eating very little, she became so weak she could hardly stand. She preferred to feed the cats. When war was declared, the thought of remaining for a second time in a war-torn country proved too much and in 1939 she travelled to Dieppe hoping to embark for England. On the way she fell ill. Poverty stricken and unrecognised, she died and was buried in an unidentified pauper's grave.

In contrast to the pale sensitivity and delicacy of the women that Gwen John painted, alone and withdrawn from the world, the women that Ethel Walker chose were robust and healthy, exuding well-being and vigour. Born in Edinburgh the daughter of a Yorkshire father, Ethel Walker (1861–1951) was very much a social artist, having a studio in Cheyne Walk, London, and taking an active part in the artistic life of Chelsea. Inspired by a collection of oriental art which she saw in Edinburgh in her twenties she decided to train as an artist. Two years at Putney Art School was followed by a period at Westminster and Slade School under Professor Frederick Brown. She visited Spain with her friend Clare Christian whom she had met at Putney and who was also a painter. She was deeply impressed by Velasquez' mixture of realism and myth and the influence of the Spanish painter is often evident in her work. On the way back to England she stayed in Paris, where George Moore introduced her to the work of the Impressionists. He later incorporated the two women into his novel *Hail and Farewell* as Florence and Stella.

The two women settled in Pulborough, Sussex, before taking a house in Cheyne Walk in 1898. Unfortunately it was a short-lived arrangement. In 1900 Clare Christian visited Ireland where she met and married an Irishman, dying shortly afterwards in childbirth. Deeply upset, Ethel Walker gave up the house but later returned to Cheyne Walk to take the first floor at number 127, using the large space to live, work and entertain surrounded by her painting and her dogs.

After her portrait *Angela* had appeared in the 1899 exhibition, Ethel

Walker was elected the first woman member of the New English Art Club. Both in subject matter and treatment it was characteristic of her most successful work. Impressionism was not generally accepted at the time and her adaptation of its basic principles won her great praise. She was to become recognised as a leading exponent of the style in England, though not in its 'purist' form. Her more muted use of colour was nearer the style of Whistler than Monet but she achieved a lightness and brilliance very much in tune with the 'new age'. Angela, the girl of the title, wears a white dress and is painted in a non-fussy, rugged style which combines a typical element of realism with a visionary quality. 'It was the freshness and sparkle of young girls which pleased her most, and it was these that she painted most often,' noted the *Dictionary of National Bibliography*.

5.9 Ethel Walker (1861–1951) *Two Female Nudes* (c. 1920). Oil on canvas. 76 × 63 cm (30 × 25 in) (*Blond Fine Art, London*)

Women, Ethel Walker's favourite subject, were shown in precise and carefully observed nude drawings and paintings and in portraits, all of them a celebration of the female form. 'She painted women as though they were flowers', noted T. W. Earp in the 1952 Tate Gallery Exhibition Catalogue, adding that they convey 'the enthusiasm of the painter's response to her subject'. Writing to a friend Grace English, who was also an artist, Walker described a model as having 'no make-up, such lovely naturally curling golden hair. Like a Botticelli angel, with beautiful features and expression, and a nice long neck.'[24] An early female nude *The Silence of the Ravine* 1916 (Courtauld Collection, London) provides a magnificent example of her skills and interests. The nude, though reclining voluptuously on cushions, is posed to suggest restlessness and movement rather than inactivity. With eyes cast down, the model has an oriental look, while behind a large and full arrangement of flowers suggests nature and naturalism. It is a highly seductive painting.

Fascinated by various philosophies and religions, in particular those of the East, and by the scientific and mystical teaching of Emanuel Swedenborg, Ethel Walker gave them direct expression in some of her more ambitious paintings. *Zone of Hate* (1914-1915) (Tate Gallery, London) was painted at a time when she believed evil forces dominated the world. This contrasts with *Zone of Love* (c.1930-32) (Tate Gallery, London) in which the soul is represented as a young girl just awakening. She was particularly resentful of her work being placed in a special category because she was a woman. Commenting on a review of her exhibition at the Lefevre Gallery, London, 1939, she wrote 'Because I am a woman I have to be patronised it seems with a sea of futilities and adjectives.'[25] In 1940 she was elected as an Associate of the Royal Academy and three years later made a Dame of the British Empire. She continued to draw and paint, a figure in the post-war period very much from an earlier time. A catalogue entry describes her as a 'tiny wiry woman' who 'was dressed in what was then considered as severe tailored costumes with shirt and tie and felt hat'.[26]

Frances Hodgkins (1869-1947), like her near contemporary Ethel Walker, was equally determined to pursue her own ideas and styles but from a very different perspective. Stylistically and socially she was a 'loner', identifying with no popular genre and her life was as an enduring bohemian and as an artist of the twentieth century. She was, for example, reluctant to stay for long in the artists' colonies of England or Europe and frequently moved around, settling only for short periods.

Frances Mary Hodgkins was born in Dunedin, New Zealand; her father, a solicitor, was an enthusiastic painter and taught her how to use watercolours. By careful saving she was able to gather sufficient funds to sail to Europe, arriving in London in 1901. In the strange and alien city she was glad of introductions to other New Zealanders. Dorothy

Richmond (1861–1935), an artist eight years her senior who had studied at the Slade School of Art (1878–1880) was a sympathetic friend. Together they travelled around Europe with Dorothy Richmond prudently equipped with a rubber bath, able to speak several languages, to arrange tickets and to haggle with landlords. They went to Provence and the Italian Riviera, brewing up billy tea and drawing and painting. At this time she made another friendship with an artist, Rosamund Marshall, which lasted many years.

Paintings were hard to sell. After a rejection from the New English Art Club, the forthright Dorothy Richmond wrote in her diary 'D–'em and B–'em for dunderhead idiots'.[27] There were some successes. A painting which Hodgkins completed in Morocco was shown at the Royal Academy and admired by the Fine Art Society who invited her to put similar pieces in their gallery in Bond Street.

After two years in Europe Hodgkins returned to New Zealand with Dorothy Richmond. Richmond stayed and established her reputation as a painter, sitting on the Council of the New Zealand Academy of Fine Art until her death. Frances Hodgkins became engaged to a man she hardly knew, but the improbable relationship did not last and, though comforted by Dorothy Richmond, she decided to return to Europe.

In Paris she gained recognition as a watercolourist and for a time taught at the Académie Colarossi, the first and only woman on the staff. In 1911 she opened a school of her own, teaching the skills of watercolour mainly to women, and she continued to hold such classes for many years. A watercolour *Rosamond* 1909 (Ewing Collection Melbourne University Union) typical of her style at this time, commemorates her friendship with Rosamond Marshall. The 'little Princess', as she called Rosamond,[28] is shown preparing the salad for dinner. The domestic scene is formally composed yet intimate in feeling.

The outbreak of the war prevented travel and grudgingly she settled in a ramshackle studio in St Ives before moving again around Europe. Under the influence of the two young, enthusiastic artists Cedric Morris and Arthur Lett Haines (whose work is discussed in Chapter 7), she became more involved in the work of contemporary French artists and began to integrate their ideas in her own painting. Morris also encouraged her to paint in oils. Through her friendship with Morris and Haines she was later introduced to members of the new generation of *avant garde* artists and for a time she became a member of the Seven and Five Society, a progressive and advanced group of radical artists.

It was a period of exploration and experiment in Hodgkins' art in which the tight handling of paint and composition gave way to a freer, lighter approach. Some idea of the change in her work is suggested by a comparison of the fussy detailed academic approach of *Rosamond* with the simpler and more direct style of her portrait of Hannah Ritchie and

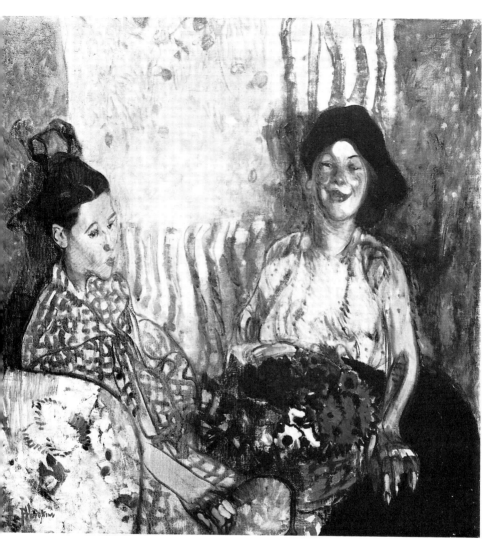

5.10 Frances Hodgkins (1869–1947) *Loveday and Anne: Two Women with a Basket of Flowers* (1915). Oil on canvas. 67.3 × 67.3 cm (26.5 × 26.5 in) (*Tate Gallery, London*)

Jane Saunders in *Double Portrait* c.1922–5 (Hocken Library, University of Otago, Dunedin).

Hannah Ritchie had regularly attended Hodgkins' art classes until she was appointed to the staff of Manchester High School for Girls where she met and became friends with Jane Saunders. These two friends arranged for Hodgkins to hold art classes in Manchester where she lived from 1922–6. In Manchester she was fascinated by working class women

and had 'artistic yearnings to paint Lancashire mill girls'. 'Some of them were raging beauties,' she wrote.[29]

An exhibition of her oils, watercolours and drawings at the Claridge Gallery, London, in 1928 was enthusiastically received, and it was the success of the show that prompted her membership of the Seven and Five Society. She was in her late fifties while most of the other members were thirty years her junior. Because she associated herself with the young it was assumed that she too was the same age and the belief persisted for many years. Until the late 1920s a wig concealed her thinning hair and she was reluctant to be photographed, even by Cecil Beaton, other than by close friends for their own personal enjoyment. The desire to be kept out of the public gaze may have been partly because she did not want to be looked upon as a freak curiosity.

Recognition of the originality of her work by Arthur Howell at the St George's Gallery and later the Lefevre Gallery ensured her some regular income, but her success when she was in her sixties came too late to fundamentally change her way of life. Her restlessness remained and she moved around the remote and unspoilt parts of Europe. In 1940 she was one of the five British painters selected to have work exhibited at the Venice Biennale Exhibition which war prevented happening, but still she lived in relative poverty and hardship.

Her last years were spent with her friend Amy Krauss in Corfe Castle, Dorset, and she lived to see a highly successful retrospective exhibition of her work at the Lefevre Gallery, London, six months before she died in 1946.

The challenge of a new life and a new art that were eagerly taken up by artists, including Romaine Brooks and Gluck, found a very different response in the work of more conventional artists. Ethel Walker's loving celebratory images of women which showed their beauty and glowing health were in great contrast to Brooks' and Gluck's more introverted work which pushed at the boundaries of what was and what was not acceptable. Their pioneering images had to wait fifty years before they could be safely admired again. The diversity of images and life style, pursued so independently, was taken up by other women some of whom were prepared to push their ideas further.

6 · The Sexual Code

'The act male homosexuals commit is ugly and repugnant and afterwards they are disgusted with themselves. They drink and take drugs to palliate this, but they are disgusted with the act and they are always changing partners and cannot be really happy.' Gertrude Stein's unsympathetic and bigoted view of male homosexuality, written in a letter to Ernest Hemingway,[1] is even more surprising given that her fashionable *salon* in Paris included many homosexual men, some of whom were close friends. Indeed it is she who is credited with the first use in literature of the word 'gay' to denote homosexuality. Her view is an even more damning critique of male homosexuals when compared with her idealistic view of lesbians, and by implication her relationship with Alice B. Toklas, which is the exact opposite. 'Women,' she wrote, 'do nothing that they are disgusted by and nothing that is repulsive and afterwards they are happy and can lead happy lives together.' Nevertheless her opinion did identify some of the difficulties homosexual men faced in seeking to lead 'happy lives' and also reflected many of the prejudices and oppressive attitudes of society.

With her lover Alice B. Toklas, Gertrude Stein observed and took part in the emotional and intellectual life of the artistic circles of Paris for nearly thirty years. As a keen and enthusiastic admirer of the *avant garde*, she knew the artists and purchased their paintings. At her Saturday evening *salon* artists, writers and intellectuals met, and her appartment at 27 rue des Fleurs became a mecca for visiting Americans many of whom found it an excellent introduction to Parisian society. Homosexual men found the more sophisticated attitudes to sexual taste of the French capital liberating, and inhibitions which were crippling at home seemed insignificant when sexual pleasure could be sought and enjoyed more openly. Paris also had the advantage of well-established

homosexual and artistic subcultures which often mixed. Gertrude Stein's *salon* offered a respectable and stimulating half-way house between the more discreet homosexual world and conventional society.

In America Mabel Dodge, a friend of Gertrude Stein, led similar *salons* in New York and in New Mexico. In a more modest way these also served to provide an artistic ambience in which less conventional sexualities were accepted.

Literary magazines including *Contact* edited by the bisexual Robert McAlmon, served as a forum for serious criticism of art, literature and sexuality. New galleries opened to promote and sell the work of radical artists exploring contemporary styles. In New York the Macbeth Gallery, founded in 1892, concentrated on the work of American artists, while Stieglitz' 291 Fifth Avenue Gallery, opened in 1908, and the Daniel Gallery (1913), showed paintings and photographs by artists from America and Europe. Major exhibitions in London (Roger Fry's *Post-Impressionists*, 1910 and 1913) and New York (the Armory Exhibition, 1913) were surveys of the new developments in French painting, both of which served to introduce this work to countries which were far more academic and traditional in their approach.

Against this artistic and cultural background limited expression of homosexuality was possible though various elaborate 'codes' of sexual self-presentation were used by artists to describe their complex feelings and to create homosexual images.

Without any established visual forms to use, painters looked to literature, in particular to the writings of Oscar Wilde and Huysmans' *A Rebours*. Charles Demuth read and re-read the French novel and even recommended it to his friends. The hidden life of the book's hero des Esseintes confirmed the homosexual as someone 'beyond nature', doomed to the night and the insatiable search for sensual satisfaction. Exotic plants and flowers, the vaudeville and the circus are used by Huysmans in the novel as vehicles for excess and sensuality.

Experiments to find a suitable form of self-presentation also embraced the contemporary vogue for amateur Freudian psychology and the pervasive search for the 'phallic symbol'—all themes which occurred in the painting of Charles Demuth. Demuth was also influenced by the ideas and work of his friend Marcel Duchamp (1887–1968) whose radical linking together of sexuality and art had outraged many when his painting was shown in America. Duchamp, who arrived in New York in 1915, had already established his reputation with his notorious painting *Nude Descending a Staircase* 1912 (Philadelphia Museum of Art)— exhibited in the Armory Show. The nude, probably a self-portrait, expresses the vibratory movement of the body in such a way that in Freudian terms it could be seen as representative of the pulsating strength of the erect penis. Much the same questionings were evident in

Duchamp's more subtle ready-made, the men's urinal, given the innocent, coy title *Fountain 1917*. The object combined humour, discomfort and subtle eroticism. By taking such a vital item of men's room furniture and placing it on public show Duchamp was making reference to the private functions of the male body. In Freudian terms the rounded, concave structure of the bowl could be seen as representative of the female sexual organs and so referred to the penis as much by its absence as by its presence. The *Fountain* had one other implication for homosexuals, which was that urinals have associations with men's public lavatories, places often used for homosexual contacts.

Such a blatant expression of sexual interest would have been unlikely from homosexual artists, but in the contemporary atmosphere some elaborate and some more direct forms of self-presentation were worked out. For Demuth, who had a private income, it was not so necessary from an economic point of view to sell work and he felt able to experiment with a range of sexual codes. His explicitly erotic paintings could be reserved for private customers. This luxury was not possible for Marsden Hartley, who relied on sales of works for his income. He swathed his feelings for his lovers in a complex and deeply encoded imagery combining spiritualism, astrology and numerology rather than psychological theories. J. C. Leyendecker used the medium of advertising to create the perfect masculine all-American male.

Few of the artists felt free of feelings of guilt at being homosexuals and their work often expressed the complexities of their emotions. Some artists such as Maurice Prendergast could not or did not want to deal directly with their sexuality in their art. Prendergast painted images of pretty women which in their unreality convey disinterest, a refusal to accept women as anything other than pretty, empty-headed and frivolous.

It was not paintings by Prendergast that the art critic Henry McBride had in mind when he wrote the article 'An Underground Search for Higher Moralities' (New York *Sun*, Nov. 15 1917). He took artists to task for spending time in disreputable night clubs where 'races of various colours mingled, danced and drank', making this their subject matter. The paintings may have been good, but for him the subject and the 'search' involved probed too deeply into the personal and sensitive side of life. But it was in just this sort of 'low-life' that male homosexuals were likely to make sexual contacts as well as to find some recognition and acceptance from a supportive group of men and women whose friendship was uncritical of their sexuality.

For Charles Demuth it was in such places that he felt at home and his paintings of these bars and clubs have a sharpness and edge which suggest some of the mixed pleasures they offered. Throughout his life, Demuth's changing response to his homosexuality was poured into his art, finding a more direct expression in his paintings after his return from

Paris in 1914. Five years earlier in 1909 he had met Robert E. Locher, a handsome and debonair theatre and interior designer and architect and they formed a long lasting homosexual relationship. It was to Locher that he left the bulk of his paintings on his death.

Charles Henry Buckius Demuth (1883-1935) was born an only child in Lancaster into a prosperous, well-off family. After the death of his father in 1911, his close relationship with Augusta, his mother, strengthened and his permanent home was with her. It was a complex relationship. While he gained strength from her energy and determination, he was wary of her overwhelming protectiveness, describing her on one occasion as 'a ship under full sail' and 'Augusta the Ironclad'.[2] Dark complexioned, with large, deep, intense eyes, one of which had a cast, and with a pronounced limp (after an injury at the age of four), Demuth was nevertheless considered something of a dandy and man about town.

Two years were spent at Franklin and Marshall Academy (1899-1901) before he went to the Drexel Institute. Here he made friends with the poet and writer William Carlos Williams (then training to become a doctor) who remained a life-long friend. Further study at the Pennsylvania Academy of Fine Art, Philadelphia, brought him in contact with amongst others Thomas Anschutz and William Merritt Chase. But the constant talk of what was happening in the art world of Paris stirred his imagination and at the age of twenty he made the first of several visits to the French capital.

During a second visit in 1907-8 he met Picasso and Matisse, but it was the sixteen-month period spent there in 1912-14 that was to make the deepest influence. He attended various life classes and through his contact with Gertrude Stein he became familiar with the work of French artists. Equally important was his friendship with Marsden Hartley. Both were fascinated by the ideas of the Fauvists and Cubists, though they were slow to realise the relevance to their own work, and both had ambitions to write as well as paint. They also enjoyed the homosexual life of the city and with the sculptor Arnold Rönnebeck travelled around Europe, visiting London, Berlin and Hamburg. Rönnebeck, who lived in Berlin, modelled heads of Demuth, Hartley and McAlmon and later became director of Denver Art Museum. Demuth, fond of drink, gained a reputation as something of a *debauche* and a socialiser. He was friendly with Edith Sitwell, the artist, writer and lesbian Djuna Barnes, and Carl van Vechten, (1880-1964) a homosexual and at that time music reviewer for the *New York Times*, later a distinguished photographer.

After sixteen months in Europe, Demuth returned in 1914 to be met by his mother, his Aunt Kate and his friend Robert Locher. Demuth, now thirty-one, entered his most productive period. He spent regular periods with his mother at Lancaster. He took a studio at 45 Washington Square South, New York, and he enjoyed the homosexual life of the city. He

was also a frequent visitor to the small, picturesque fishing port of Provincetown, where he could observe the United States Navy. Demuth's painting which included abstraction and figurative work, showed a strong understanding of pictorial form taking from Cézanne a reluctance to create illusory space, concentrating instead on the sense of the flattened picture plane. Homoerotic themes, sometimes explicit, at other times more veiled, were incorporated into his work.

The questioning of meaning and significance fascinated Demuth. While he liked to paint a subject so that it had a literal meaning, he also liked it to serve as a reference point for other interpretations and to be seen in Freudian terms as 'symbolic'. In fact Demuth made use of the metaphor rather than the symbol and subjects ranged from acrobats doing sexually suggestive hand stands, erotic arrangements of bowls of fruit to his favourite subject, sailors. In the company of Duchamp and Hartley, Demuth was a frequent visitor to such clubs as the Golden Swan, known as the 'Hell Hole', Jimmy the Priest's, and Little Savoy. He painted sleazy bar-room scenes in watercolours such as *The Drinkers* 1915 (Columbus Gallery of Fine Art, Columbus, Ohio) in which some sort of casual, possibly sexual transactions are taking place. The effeminate gestures of the men and the earnest, penetrating eye contact of the barman and the customer suggest homoerotic overtones of a gay bar.

A more straightforward and factual representation of the homosexual world is in his watercolour *Turkish Bath Scenes with Self-Portrait* 1918 (private collection). The all-male world of the Turkish Bath is apparently described in a dead-pan way with little to indicate that the relaxed group is a homosexual meeting. The 'Lafayette' baths, popular with Demuth, was a well-known homosexual haunt and was later raided by the police.

He took up ambiguity of meaning and heavy use of symbolism in his watercolours of still life, studies of flowers, plants and fruit. Amidst the convoluted compositions and sparkling colours some objects are given phallic shapes and placed in position with other objects so as to suggest genitals. The washes of colour and the 'natural' forms contrast with the menacing overtones of the imagery. They are to all intents and purposes the exotic fruits enjoyed by des Esseintes. In his autobiography William Carlos Williams[3] describes how Demuth made no secret of his fascination for the similarity between the forms of the flowers and the male genitals. Half-concealed genitalia also appear in watercolours painted during a visit to Bermuda. In views of the town human limbs can be identified among the trees. Such paintings were unlikely to have been those seen by a reviewer in 1918 who observed that in Demuth's painting there was a 'lack of striving for more solid and masculine attributes'.[4]

Around 1920 Demuth started to suffer attacks of a disease, later diagnosed as diabetes, which left him weak, emaciated and depressed. Undeterred he visited Europe in 1921, staying briefly in London before

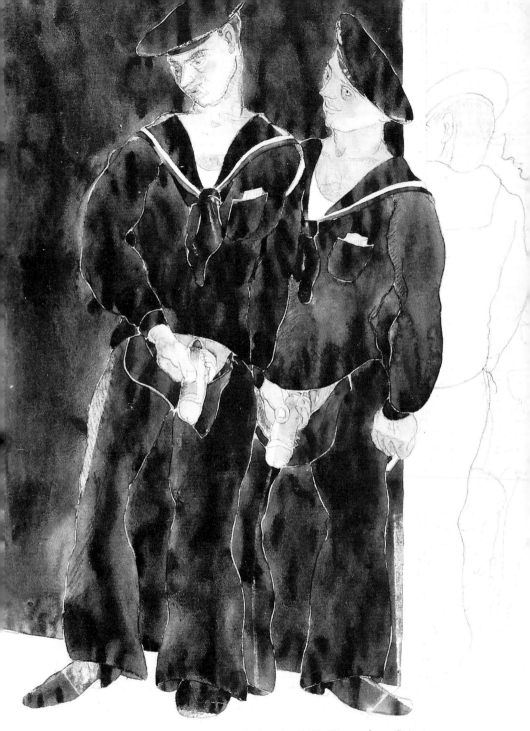

6.1 Charles Demuth (1883–1935) *Two Sailors* (c. 1930). Watercolour (*Private Collection*)

moving on to Paris to spend time with Robert Locher. The newly developed insulin treatment improved his health, but he was physically less strong and less confident. There were also changes in his style of painting. The figurative studies continued, some more boldly and suggestively referring to sex. In addition he started doing more abstract and flattened compositions which included factory buildings, often with rays of light or energy dividing up the sky like searchlights. Sexual innuendo continued in figurative scenes of vaudeville, the circus and sailors. The handlebar of the bicycle appears suggestively between the legs of the cyclist in *Vaudeville-Bicycle-Rider* 1919 (Concoran Gallery of Art).

In the watercolour *Two Sailors* c.1930 the men are urinating or possibly masturbating. Demuth leaves this unclear. There is similar ambiguity in *Four Male Figures* c.1930 (pencil and watercolour) in which four men have begun to strip in a forest or a park. The lumpy, inexpert drawing of the figures is particularly crude when compared with earlier work. A pencil drawing *Two Figures in a Bedroom* of much the same time is almost completely carried out in the neoclassical style of line drawing and recalls the drawings of Jean Cocteau both in style and treatment. One man lies naked on the bed and the other wearing a sailor's hat sits on the edge of the bed either dressing or undressing. There is little doubt that this is either a pre- or post-sexual encounter. The loose drawing and odd anatomy with the cartoon-like face suggest that this was not intended as a serious study.[5]

One of his most amusing comments on the homosexual art scene is the watercolour of an invented situation based on Robert McAlmon's novel *A Distinguished Air* 1930 (Whitney Museum of American Art). Set in a fashionable art gallery, a group view an exaggerated version of Brancusi's phallic sculpture *Mlle Pogany*. The sexuality of the group is ambiguous but their sexual appetites are sharp. A man casts a lustful eye over a sailor whose arm is around a person whose gender is unclear. The sailor gazes at a woman wearing a low-cut dress holding a small fan in front of her crotch. The campness, the humour and the clearly stated diversity of the sexual interests was rarely expressed with such explicit detail. Even in 1950 this painting was deemed too controversial to be included in Demuth's retrospective at the Museum of Modern Art.

Demuth's health continued to fail, despite his mother's energetic care. Occasionally he stayed at Provincetown, as fascinated as ever by the sailors and the naval ships. Plans to make another visit to Paris were

6.2 Charles Demuth (1883–1935) *Distinguished Air* (1930). Watercolour. 35.6 × 30 cm (14 × 12 in) (*Collection of the Whitney Museum of American Art, New York. Gift of the Friends of the Whitney Museum of American Art, Charles Simon and purchase*)

never fulfilled, for in 1935 at the age of fifty-one he suddenly died, probably because of his decision to stop taking insulin.

A major part of Demuth's struggle was against bad health and an overcaring mother, but for Marsden Hartley (1877–1943) it was much the opposite both in his art and in his life. Where Demuth looked for physical beauty and sexual attraction in conventional stereotypes such as sailors, Hartley was more interested in finding spiritual fulfilment. His great attachment to particular places and deep love for men inspired some of his finest paintings. He found spiritual fulfilment in the massive, overpowering strength of mountains, one of his favourite subjects, in the writings of Emerson, Whitman and Thoreau, in folk art, in conventional religion, and in the idealised love of individual men. With no supportive base and without funds, Hartley was continually searching for financial security and a home. In the final years of his life his bad health was as much a result of poverty as neglect. At various times he lived in Provincetown and Gloucester in New England, Maine, New York, New Mexico, the Bahamas and Nova Scotia, as well as spending long periods of time in Europe.

Though Hartley rarely wrote about his homosexuality, there is in one of his late Whitmanesque poems a confirmation of his desire for total, almost God-like fulfilment. The poem refers to the need for male love in which he can feel 'the sacred fire' and 'unalloyed desire'.[6] This need, this craving, was for an involvement which would possess mind and heart as well as body. The search did not preclude physical desire; the artist Oswald Blakeston remembers being solicited by Hartley in a Parisian café in the 1920s and William Carlos Williams in his autobiography describes the occasion when he rejected Hartley's sexual overture.

Hartley remembered his childhood as 'vast with terror and surprise'.[7] He was born in Lewiston, a mill town on the Androscoggin River, the youngest of nine children. The family were poor; his father, a cotton spinner from Lancashire, England, earned barely enough for them to survive, and when his mother died when he was eight, the family split up. At fifteen he had to leave school to work in a factory.

Intensely private and withdrawn, Marsden collected natural objects, finding in them a source of beauty and a stimulus to his imagination. Eventually he was given a scholarship to study at the Cleveland School of Art. This was against the wishes of his father who considered him a failure for entering the art profession. In 1899, supported financially by Anne Walworth, a trustee of the Cleveland School of Art, he enrolled at the New York School of Art (the Chase School), studying under William Merritt Chase, and then at the less expensive National Academy of Design. In 1904, his grant at an end, he worked as an extra with Proctor's Theatre Company. While on tour in Philadelphia he met Horace Traubel who had been a companion and biographer of Walt

Whitman. Traubel, then editor of *Conservator*, a political-spiritual newspaper, fell in love with the earnest young man and the two remained friends until Traubel's death in 1919. Through him Hartley became familiar with Whitman's ideas and was introduced to a predominantly homosexual community of radicals, many of whom shared his mystical and spiritual beliefs. His painting *Walt Whitman's Home 328 Mickle Street, Camden, New Jersey* c.1905 (private collection) indicates his enthusiasm for the poet.

Inspired by reproductions of the Italian Divisionist painter Giovanni Segantini, Hartley adopted the technique of using short paint strokes to build up a picture. This 'stitch' convention enabled him to capture the spiritual and mystical qualities of landscape and to express his belief that nature 'was never the same two consecutive moments'.[8]

In their celebration of the textural quality of paint and their bright colour, his work has a stylistic connection with that of Maurice Prendergast whose paintings he may have seen in Boston. Through his friendship with Prendergast, Hartley's paintings were brought to the attention of the progressive art group 'The Eight'. Some members responded enthusiastically, others found the paintings' mysticism overpowering. Alfred Stieglitz was sufficiently impressed to show them at the 291 Fifth Avenue Gallery in 1909.

At this time he was introduced to and greatly admired the work of Albert Pinkham Ryder whose dark mysterious sea-scapes combined the spiritual, romantic and primitive qualities which he sought. Expressive, intense and sombre, the paintings captured Hartley's feelings of isolation and loneliness and he visited Ryder in his studio on 15th Street. Hartley in a period of depression and poverty painted 'solely from memory and imagination'.[9]

At 291 Gallery Hartley came into contact with paintings of Matisse, Picasso and Cézanne and decided to visit Paris. Supported financially by Stieglitz, he arrived in April 1912. At the artists' cafés such as the Dôme and the Rotonde he met painters and writers and visited Gertrude Stein's Saturday evening *salons*. Like Demuth, Hartley found a new sense of freedom and liberation in the more accepting air of Europe, particularly with the group of Germans who gathered at the Restaurant Thomas on the Boulevard Raspail. The mystical aspects of German art proved a more powerful influence than French art. Through Rönnebeck and his cousin, the handsome and gentle Karl von Freyburg, Hartley was introduced to the work of German artists. He was particularly drawn to the new magazine *Der Blaue Reiter*, published by the Russian artist Wassily Kandinsky who was then living in Germany, which echoed his own spiritual interests.

In 1913 he moved to Berlin and felt at ease in the male-oriented city, in the pageantry of the Imperial German culture and in the well-

established homosexual subculture. Writing to Stieglitz, Hartley said that he 'lived rather gaily in the Berlin fashion—with all that implies. . . .'[10] His major emotional involvement was with the handsome, twenty-four-year-old Lieutenant von Freyburg, and he described his friendship with him and with Rönnebeck as 'a beautiful triangle'.[11] He later described von Freyburg as 'the one idol of my imaginative life'.[12] Inspired by these emotional involvements, with the mystical theories of Kandinsky and with the homosexual life of Berlin, his paintings took on new compositional and spiritual strength and intensity referring to his style as 'Cosmic Cubism', 'Intuitive Abstraction' and 'Subliminal Cubism'. His paintings incorporated emblems taken from the bustling life of the city and included military imagery such as epaulettes, helmets and uniforms. From his study of numerology and mysticism he also drew on the symbolism of numbers, colours and shapes such as stars, moons and suns. Though still expressionistic in feeling, the abstract compositions embodied emblematic themes in a more pattern-like symmetry.

The death of von Freyburg in action in October 1914 threw his life into tragedy. In his profound love for von Freyburg he saw embodied elements of the masculine ideal which led him to consider their relationship as a spiritual marriage worthy of worship. This devotion was expressed in one of his most successful paintings, *Portrait of a German Officer* 1914 (Metropolitan Museum of Art) which incorporated direct but encoded references to von Freyburg. These included the figures '24', the age at which von Freyburg was killed, his initials, '4', his regimental number, the feathers worn in his helmet as one of the Kaiser's Royal Guards, the Iron Cross and the spurs and tassels of the Guards' dress uniform. The numbers '8' and '9' included in the composition have numerological significance, referring to cosmic transcendence and regeneration.

Similar references occurred in a later painting, *Eight Bells' Folly, Memorial to Hart Crane* 1933 (University Gallery, University of Minnesota, Minneapolis), completed in response to a similar tragedy. Hartley met the poet briefly in Mexico and established an immediate rapport. Both men were anxious about their homosexuality, both were artists and Crane openly spoke of his fear that he had nothing to say as a writer. Shortly after their meeting Crane, then thirty-three, committed suicide by jumping overboard from a boat. In the painting the figure '8' occurs, as does the eight-pointed star, a moon, a sun, and '33', Crane's age.

Forced to return to America, Hartley's misery was made worse by rampant anti-German sentiment. Unable to paint any German pictures, he abandoned military subject matter in favour of more neutral still-life groups and two-dimensional expressive portrait compositions. He spent the summer of 1916 in John Reed's home in Provincetown where

6.3 Marsden Hartley (1877–1943) *Portrait of a German Officer* (1914). Oil on canvas. 68.25 × 41.2 cm (26.8 × 16.2 in) (*Metropolitan Museum of Art, New York: The Alfred Stieglitz Collection*)

painters, writers and actors from Greenwich Village gathered, among whom was Carl Sprinchorn, a painter who became one of his closest friends. Hartley went to Bermuda with Demuth and, like him, took up the crude sexual symbolism and innuendo of particular arrangements of fruit and flowers. 'A cold and ferocious sensuality seeks to satisfy itself in still-lifes, with their heavy, stiff, golden bananas, their dark, luscious figs, their erectile pears and enormous breast-like peaches' was Paul Rosenfeld's critical comment in *The Dial* December 1921.

In New York Hartley became friendly with Robert McAlmon, handsome, energetic and intelligent, who worked as a nude model for art classes at Cooper Union. Hartley introduced McAlmon to William Carlos Williams and Djuna Barnes. In his autobiography Williams recalled Hartley's sexual loneliness and isolation, commenting that his life had been 'a torment which painting alone assuaged'.[13]

Desperate to return to Europe, in 1921 Hartley auctioned his paintings, raising sufficient financial resources to move to Berlin. The city was even more decadent with an 'air of abandon'.[14] Life was 'at the highest pitch of sophistication'.[15] His reputation as an *avant garde* artist was still respected, though he now painted still lifes and landscapes based on those he had seen in Mexico. Encouragement also came from Rönnebeck whose studio he shared. In 1930 he returned to America to one of the most difficult periods in his life. Unable to raise sufficient rent to pay for the storage of his work, on his fifty-eighth birthday he destroyed over a hundred paintings and drawings.

The search for a cheap and unspoilt place to live took him in 1935 to Nova Scotia and the small fishing village of Blue Rocks. Here he met the Mason family who once again offered him contact with human nature that seemed untouched and unspoiled by contemporary values. Hartley was greatly impressed by their calm spirit, their direct simple existence and by their handsome sons. A warm embrace from Alty, thirty-one years old, weighing 210 lb, with a mop of jet black hair which stood on end, rekindled his sexual interest. Attracted physically and emotionally to the family, he was invited to move into their home. The peaceful atmosphere and their quiet dignity made him feel wanted in a way he had never before enjoyed and renewed his enthusiasm for life.

Alty, magnificent and sexual, seemed to embody all the unaffected qualities of the perfect male and he seemed to be equally attracted to Hartley. In an autobiographical story *Cleophas and his Own*, Hartley wrote of Alty that 'he will give as much love to a man as a woman'.[16]

6.4 Marsden Hartley (1877–1943) *Adelard the Drowned, Master of the Phantom* (1938-9). Oil on board. 72.4 × 56.5 cm (28.5 × 22.25 in) (*University Gallery, University of Minnesota, Minneapolis: bequest of Hudson Walker from the Ione and Hudson Walker Collection*)

Again his happiness was short-lived for in bad weather Alty and his brother Donny and cousin Alan were drowned in a North Atlantic storm. Deeply upset, Hartley stayed with the Mason family mourning their loss. It was some two years before Hartley dealt with the incident and its emotional trauma in his painting, with a series of archaic portraits of the Mason family rendered in a direct, figuratively expressive manner. They have all the strength, power and sensitivity of the more abstracted portrait of Karl von Freyburg. *Adelard, the Drowned Master of the 'Phantom'* 1938-9 (University Gallery, University of Minnesota, Minneapolis) is a portrait of Alty. His huge body fills the canvas with calmness, strength and peace. The strong face of the man and his black hair is contrasted with a rose placed behind the ear which gives it an erotic ambiguity. Though Alty often wore a rose behind his ear, the portrait recalls Caravaggio's *Boy Bitten by a Lizard* (National Gallery, London).

None of these portraits aimed at a naturalistic rendering but sought instead for expressive spiritual qualities. Other portraits included those of Albert Pinkham Ryder, John Donne, and a French-Canadian light heavyweight boxer. In *Madawaska Acadian Light-Heavy* 1940 (private collection) the naked muscular body of the boxer recalls the beauty of a Greek statue and carries a phoenix-like motif formed from the hairs on his chest and stomach. A similar interest in musculature is found in *Canuk Yankee Lumberjack at Old Orchard Beach, Maine* 1940-41 (Hirschorn Museum and Sculpture Garden, Smithsonian Institution).

As his health continued to deteriorate, poverty and constant moves in search of security and a low cost of living did little to help. Publicly he avowed that his chosen subject matter was of little interest to him — 'it is well done, or it isn't',[17] he said on one occasion — yet his subject matter and its emotional content were quite clearly of central importance to him as an artist. It is a dilemma he never satisfactorily resolved but it reflects his own mixed feelings about his homosexuality and its constant force as subject material. Significantly he shared a studio in New York with his friend the photographer George Platt Lynes (see Chapter 9) who faced similar problems. Hartley died in 1943 just as his reputation was again growing and the long-due recognition forthcoming.

Marsden Hartley's reluctance to acknowledge his personal life in his painting was echoed in the work of the Californian artist Rex Slinkard (1887-1918) whose paintings were brought to his attention by Carl Sprinchorn. Slinkard seemed to Hartley to combine in his work a visionary quality unspoilt by western civilisation. Hartley idealised him as a 'Western ranchman and poet painter'[18] who was also involved as much emotionally with men as with women. Slinkard, born in Indiana, spent his youth on a ranch in California making visits to Mexico with his father to buy and sell horses. In 1910 he was elected director of the

Art Students League, Los Angeles, but in 1913 he was forced by economic circumstances to return to his father's ranch. Serving in the war, he caught pneumonia and died in 1918.

Letters by Slinkard published in *Contact* speak of his art, his interest in contemporary paintings, and his love for Carl Sprinchorn. His paintings, symbolic and lyrical, have a youthful exuberance combined with a sense of reverie. In *Contact* no. 3, he wrote 'Imagination—that's the thing I can paint with. I am lost without it.' One of his most successful works *Young Rivers* shows horses, figures and deer in a partially dissolved landscape, suggesting an ethereal ideal of man at one with God and Nature. A similar evocation of the organic spirit is found in *My Song* c.1915 (Stanford University Museum of Art), a picture of formal figures rendered in tones of blue.

A friend and older contemporary of Hartley's was the Boston painter Maurice Prendergast (1859-1924). There is little evidence of his sexual preferences in his frothy scenes of fashionable women shown either promenading by the sea shore or sitting in parks painted in a colourful impressionistic style. They almost seem in their unreality to represent a withdrawal from the conflicts of life into the representation of a conventional, pretty world of politeness and perfection. His art, exuberant, lively and colourful, was thought sufficiently radical for him

6.5 Rex Slinkard (1887–1918) *Young Rivers* (c. 1915–16). Oil on canvas. 96.5 × 130 cm (38 × 51.5 in) (*Stanford University Museum of Art, Stanford, California*)

to be a part of 'The Eight'. Described as a 'confirmed bachelor, a shy and retiring artist',[19] he always seemed to be the spectator, never the participant. He often quoted and heeded the passage by Rudyard Kipling *In the Pride of His Youth*:

> If a man would be successful in his art, art, art,
> He must keep the girls away from his heart, heart, heart.

Prendergast's solidly middle-class and respectable women seem remote from the realities of life. The paintings are suggestive of a carefree holiday existence without any of the usual problems of life. This depiction of women as attractive, joyful but unreal shows influence from Pierre Bonnard and Edouard Vuillard but in the way they describe women as pretty and decorative they also relate to the work of such French *rococo* artists as Boucher and Watteau.

Equally important is the impression that Prendergast painted women as unreal because that was the way he saw and experienced them. Even in his sketch book his quick drawings repeat the same light-hearted view. Charles Condor, whom he met in Paris, also showed pretty women and he may have influenced him. Yet the carefree life he painted could not have been further from his own experience.

Maurice Brazil Prendergast was born in St John's, Newfoundland, two years before the family moved to Boston. Whilst still at school he got a job with Loring and Waterhouse Dry Goods where he was fascinated by the colours of the different cloths and arranged them as women's dresses over mannikins which he would then sketch. In 1886 he and his brother Charles travelled to Europe, working their passage on a cattle boat. A brief stay in Paris was sufficient to prompt a longer visit and in 1891 he returned for a three-year period.

In Paris he studied at the Académie Colarossi and the Académie Julian with Jean-Paul Laurens. Through his friendship with the Canadian painter James William Morrice (1865-1924) he met the British circle of artists and writers associated with *The Yellow Book*. Prendergast and Morrice made a surprising friendship, for both were very different. Morrice, outgoing and lively, was fond of alcohol and contrasted with Prendergast who was quiet and withdrawn.

Prendergast went to Brittany on summer visits but he found little interest in the dull, granite landscape. He was, however, deeply impressed by Gauguin's spiritual belief, taken up and developed by the Nabis, that form resides not in nature but in the imagination and that colours exist to be used in their symbolic purity and for their decorative value.[20] It was a philosophy that Prendergast was to practise in all his work. His style, once developed, varied little. He produced watercolours and oil paintings of highly coloured spectacles of crowds of

women, ever youthful, in carefree groups enjoying themselves at fashionable seaside resorts or in old cities, all wearing voluminous gaily-coloured costumes of many hues and patterns. Titles such as *The Pretty Eight Girls by the Sea* confirmed their light and non-controversial content. After a visit to Europe in 1909-10 he began to paint nudes which reflect the influence of Puvis de Chavannes, though all literary associations were avoided.

In America he lived with Charles his younger brother at Winchester, Massachusetts, several miles from Revere Beach where he set many of his watercolours. A further visit to Europe followed in 1898-9 and on his return he was introduced to the artistic and social community of New York. He had sixteen paintings in the 1908 'Eight' show at the Macbeth Gallery and five watercolours in the Armory show. Increasing deafness and ill-health rendered him bedridden for some years and he died in 1924 after a long period of being unable to paint.

The influence of the Parisian scene was not, as many artists found, restricted to the learning of new styles or techniques, but was also an opportunity for many sorts of self-discovery and exploration, impossible in the confines of home and family. This was the particular experience of Russell Cheney (1881-1945) and J. C. Leyendecker. Like Prendergast Cheney studied in Paris under Jean-Paul Laurens at Académie Julian but at that time he had not realised that he was homosexual. He was born the eleventh and youngest child of a well-to-do family in South Manchester, Connecticut, and followed his brothers to Yale, graduating in 1904. Keen to become a painter, he eventually enrolled at the Art Students League, New York, before spending three years in Paris.

A studio was created out of a converted barn at his parents' house in South Manchester where he painted landscapes and interiors in the style of American Impressionism. Despite exhibitions of his work in New York and the development in his paintings of a 'Fusion of Impressionistic handling of light with Post-Impressionistic solidity of form and weight of modelling'[21] he could not dispel his growing disenchantment, his feelings of lethargy and a black cynicism. Within the confines of his large family he felt unable to produce anything worthwhile. Persuaded by his friends to visit Venice, he travelled on the ocean liner 'Paris' where he met Francis Otto Matthiessen who was returning to Oxford. The two immediately fell into a friendly intimacy and after a few days it was obvious to Matthiessen that the one subject about which they had not spoken was that of sex. Matthiessen, nervous and hesitant, spoke of his homosexuality to which Cheney replied, 'My God, fellow, you've turned me upside down. I'm that way too.'[22] Matthiessen had already recognised his own homosexuality, but for Cheney it was a new realisation and the beginning of a relationship which was to give both of them a new meaning to life. As Matthiessen wrote about himself, he had found 'a love more complete and sacred than any I had dreamed'.[23]

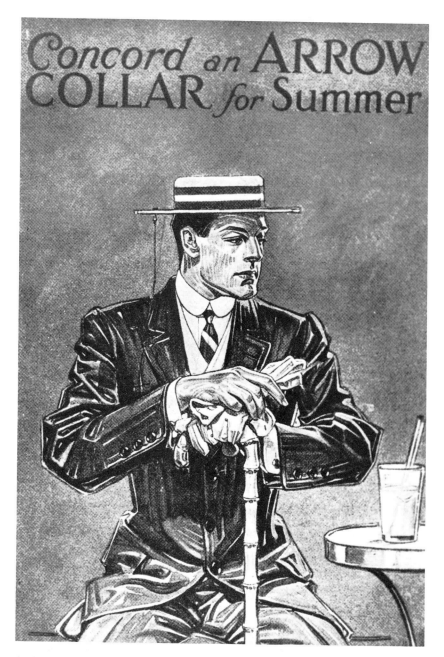

6.6 J.C. Leyendecker (1874–1951) *The Arrow Collar Man*. Advertisement for the concord style collar 1910. Charles Beach was probably the model.

Cheney's work took on a new power as he recognised that painting involved 'pure emotional expression'.[24] He spent Christmas touring the hill towns of Italy and travelling as far south as Taormina before settling at Cassis in the South of France. In New York he painted from models, struggling in his work for a sense of personal independence. He painted male nudes and portraits of friends and acquaintances who included Katherine Hepburn, Marcia Davenport, and the poet Phelps Putman. 'Sooner or later,' he wrote at the age of forty-seven, 'my personality and my job will meet.'[25] Undoubtedly this happens in his portraits. The portrait of Fred Hoen, one of the two brothers who ran a small store and garage near Santa Fe where he stayed, powerfully conveys his understanding and admiration. The sheer strength of the man who is shown sitting at a table in the kitchen is expressed through the tanned face and neck and the large working hands. Likewise the portrait of a young German journalist, Burkhardt Melhorn, a friend with strong anti-Nazi convictions, has the same sense of admiration. Cheney described Melhorn as a 'solitary and very quiet guy, but a passionate sort of intelligence held down'[26] and the portrait painted in 1931 shows the young man gazing directly out of the frame wearing a blue jersey.

Kittery, Maine, was his home for the last fifteen years of his life. Portraits of local people and pictures of the countryside contained an element of stylisation as he consolidated and developed his ideas. He died in 1945 and two years later Matthiessen wrote a book about Cheney as his tribute to 'the closest personal relationship of his life'.[27]

When Joseph Christian Leyendecker (1874–1951) visited Paris to study it was not so much the work of the fine artists that stirred him but the graphic posters of Jules Cherèt, Toulouse-Lautrec and Mucha which were plastered around the city. Cherèt had been awarded the Legion of Honour in 1889 for 'creating a new branch of art by applying art to commercial and industrial painting'.[28] The thriving American economy suited Leyendecker's skill as a graphic artist and he was soon to become one of the leading commercial artists of the day.

Leyendecker was born at Montabour, a tiny village on the Rhine in south-west Germany. The family emigrated to America in 1882 and settled in Chicago, where his father worked in a brewery. At sixteen Leyendecker became an apprentice at J. Manz & Co, a Chicago engraving house, and attended part-time classes at the Chicago Art Institute. By careful saving, Leyendecker was eventually able to travel with his young brother Frank to Paris for full-time study. On their return they opened a studio in Chicago where Leyendecker rapidly established a reputation as a skilled and innovative artist. He did his first cover for the *Saturday Evening Post* in 1889 and over the next forty years carried out over three hundred such covers. Eventually he was able to support his parents and his sister Augusta in a house with several servants and a car.

Leyendecker's life changed when he met and fell in love with a Canadian, Charles Beach, who came to model for him. Beach embodied all the qualities he expressed in his advertisements and cover designs. He was tall, powerfully built, handsome and well-dressed and 'looked like an athlete from one of the Ivy League colleges'.[29] Beach became the model for the Arrow collar man, advertising detachable shirt collars. The advertisement was a huge success and by 1918 sales had risen to $32 million. The Arrow collar man achieved national recognition and became a byword for the debonair, suave, handsome male equal as a stereotype to Charles Dana Gibson's Gibson Girl. Thousands of love letters were written to him and he became the standard against which all other men were judged. In F. Scott Fitzgerald's 1929 story 'The Last of the Belles' an ideal man is referred to as having a 'Leyendecker forelock'.

Charles Beach met Leyendecker in 1901 and their relationship lasted fifty years. Norman Rockwell in *My Adventures as an Illustrator* remembered Beach as being 'tall, powerfully built and extraordinarily handsome'[30] though his account of their relationship was more than tinged with jealousy. Rockwell also describes Beach as a parasite who had a bad effect on Leyendecker. Beach virtually became Leyendecker's manager; he hired the models, arranged fees and commissions, and ran the house. Family disagreements in the early 1920s resulted in Frank and Augusta moving out of Leyendecker's house. Frank, overshadowed by his brother's success, was depressed and ill and died in 1924. Beach lived with Leyendecker until his death in 1951.

Little of these personal tragedies and dramas were reflected in Leyendecker's work. His designs remained in great demand both for magazine illustration and for advertising until the 1940s when styles changed and the different needs of publishing called for new faces and new images. The move away from realism towards abstraction also had its effects on the new styles. Leyendecker created the ultimate masculine image whether it was within typical male occupations such as air pilots, soldiers, sailors, footballers, athletes, rowers and labourers, or merely smart men about town. Without exception, all are broad-shouldered and powerful, the epitome of health, strength and social standing. Power is conveyed in all parts of the body and the modelling round the genitals always carries a suggestion of the form beneath. There is also an improbable romantic air in the work, sometimes carried to sentimental excess. Naked and chubby bodies which adorned *Saturday Post* covers suggested innocence and hope but carried an air of physicality which is both naughty and daring.

Some of Leyendecker's most sexually suggestive images are in his advertisements featuring groups of figures in which men address themselves to each other whilst ignoring the women. A 1910 Arrow collar advertisement shows two men sitting beside a woman playing with

a dog. The men cast admiring glances at each other, indifferent to the less well-detailed figure of the woman. They could be admiring each other's detachable collars, but there is an ambiguity about their look which seems to be much more about eye-to-eye contact than eye-to-collar. Much the same sort of scenario appears in a 1918 advertisement which is set on the deck of the SS *Leviathan*. It features a woman, two soldiers and a sailor. She looks at one of the soldiers who looks at the other soldier. The sailor looks on at the episode. Again, while the clothes are well displayed, the scene has an ambiguity which offers a variety of readings.

The clean all-American Ivy League elegant men that Leyendecker painted, with their superior, all-knowing air of confident homosexuality, the blatantly homoerotic work of Demuth, and the spiritually intense portraits by Hartley were, in their very different ways, moving towards an expression of self-identity and affirmation. Guilt, uncertainty, and the need to shield the details of their private life were in conflict with the desire to be open and clear. The battle between the private and the public, the secret and the exposed, only just beginning, was to be taken up by other artists determined to break down the barriers.

7 · Breaking Out: Private Faces in Public Places

The conflict between the 'private' and the 'public' is a problem for all artists: while all art is about 'life', not all experiences and feelings can be told. The complex process of ingestion and regurgitation of experience before it can be expressed takes time and often courage to challenge restricting conventions. Most of us are brought up to accept that ethical and moral values pre-exist and cannot change. The realisation that these values can be challenged or that they may not even exist and that individuals either alone or collectively can construct their own, offers the artist a wealth of possibilities. Some retreat and use their art as a means of escape; others seek to use art as a means of challenge, an opportunity to state the absence of a given set of values. In London the Bloomsbury group of intellectuals, writers and artists, which included artists Duncan Grant and Stephen Tomlin, and the critic Roger Fry challenged the conventions and traditions of art and the values of society, while in France Jean Cocteau was part of a movement which demanded that homosexuals should not merely be tolerated but given equality.

In the early decades of the century, scientists and doctors as well as writers and artists were questioning definitions of sexuality. The English philosopher and poet Edward Carpenter found a positive identity for his homosexuality in the poems of Walt Whitman and he wrote enthusiastically and fully about 'homo-genic' love. In 1897 Dr Magnus Hirschfeld had founded the Scientific Humanitarian Committee, the first homosexual reform organisation in Germany. His theories had far-reaching effects and were seriously discussed not only in Germany but also in the United States and England where he travelled to speak about his theories of the 'intermediate type' of male and female homosexual. His research attracted widespread, if limited, support.

In England the poetry, writing and life style of Edward Carpenter, in

particular his book *Homogenic Love and its Place in Society* (1894) inspired writers who included E. M. Forster and the artist C. R. Ashbee (1863–1942). Enthused partly by Carpenter's theories, Ashbee founded his Guild of Handicraft in Whitechapel, London, at the end of the nineteenth century. Like many others it was modelled on the mediaeval guilds of England and the craft guilds of the Italian Renaissance. What set his apart was the adaptation of Edward Carpenter's socialist and homogenic theories which suggested that virtue lay in simple things produced by honest toil in the companionship of 'comrades'. Carpenter thought that a new society could come about by the endeavour of the working man, and equally significantly he had a great belief in the reforming value of comradeship.

Ashbee's own homosexuality found expression in Carpenter's ideas of 'homogenic love', an almost mystic condition in which sexual urges were somehow transformed into the purer love of comrades working together in the common cause. Ashbee selected his Guildsmen not only on talent and ability but also because they seemed more responsive to homogenic feelings. All worked together in a variety of crafts including furniture making, jewellery and printing, making objects mostly to Ashbee's own designs. Any homogenic expression was in the making rather than in the design of the work.

The personal search by homosexuals for some sort of public identity, for an art around which a sense of their own sexuality could be centred, was given a tremendous boost by the work of the Russian impresario Diaghilev. Not only did he transform the structure of ballet itself, giving the male dancer as much importance as the ballerina, but he involved writers, artists and musicians in new productions many of which explored aspects of sexuality. Also he made little secret of his own homosexuality.

Some writers even saw Diaghilev as establishing ballet as a respectable homosexual art form. Anatole James, writing in the *International Journal of Sexology*, vol. VIII, no. 1, on 'Homosexuality and the Artistic Profession' wrote:

> From the very outset, the Russian Ballet appealed enormously to most homosexuals. There was something in its sensuousness and gorgeous colouring that made a tremendous appeal. Whenever the Ballet was in London the theatre was crammed with homosexuals, and soon its appeal spread to the humble class of would-be 'artistic' males.

Diaghilev's work provided a focus, a respectable centre for the interests of the 'artistic' man, a typical euphemism for homosexuals. Ballet was no longer merely sweet and romantic but was suffused with

new life and vigour. In 1913 Diaghilev's new ballet *The Rite of Spring*, with music by Stravinsky, outraged Parisian audiences by its suggestions of homosexuality and Diaghilev was accused of corrupting the youth of France. Unperturbed, Diaghilev enjoyed the publicity.

Jean Cocteau was a constant companion of Diaghilev whom he met in 1910. He put on his own ballet a few years later. Picasso designed the sets, Satie wrote the music, and Massine the choreography. The ballet *Parade* received its premiere in 1917 but was not a success.

Cocteau (1889–1963), poet, writer, film producer and artist, was at the head of a group of people attempting to grapple with modernism in both its artistic expression and its choice and handling of subject matter. Cocteau's most impressive public statement about his own sexuality and condemnation of society's generally repressive attitudes to homosexuality is in his book *Le Livre Blanc* (1928).[1] His reluctance to acknowledge authorship was as much an indictment of the contemporary attitudes towards homosexuality as his own reluctance to publicly proclaim his sexuality.

Le Livre Blanc, a semi-autobiographical homoerotic story that is both tragic and insightful, describes a youth's love affairs with a succession of boys and men in the early part of the century. The book's final plea for acceptance rather than mere tolerance of homosexual love is heartfelt and moving and was central to Cocteau's philosophy. When the book was published again two years later in 1930 a series of explicit homoerotic illustrations were included by Cocteau showing the 'type' of man he found attractive, drawn in a crisp, linear style with which he came to be identified.

Like many others, he idealised the men he created. Their handsome Greek-looking profiles, thick curly hair and well-built muscular bodies depict physical perfection. These men are without doubt 'masculine' and 'virile', with faces that seem mere masks to a lustful desire for sexual pleasure. In their crisply drawn, assured, continuous outline they suggest the odour, attractions and rough masculine sexuality of sailors, soldiers and labourers.

These demi-gods, so effortlessly and lovingly drawn by Cocteau, are the fantasised images of a well-developed subculture. Other drawings by Cocteau, all of which use the continuous line, produced for private enjoyment rather than for exhibition or publication also described the same idealised 'types' of masculine, well-modelled young bodies, often implying a lack of sophistication but which are more explicit in their homosexual content. Similar figures, though not in explicit homoerotic situations, occurred in other visual works, as for example in his murals in the church Notre Dame de France, Leicester Square, London, 1960.

Cocteau made his first public appearance in 1907 when he was seventeen, in a group of people around the actor Edouard de Max, a

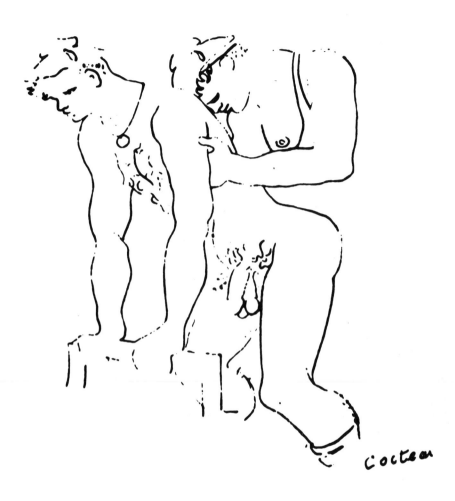

7.1 Jean Cocteau (1889–1963) Drawing (attributed to Cocteau) © DACS, London 1993

flamboyant homosexual. Other friends included Robert de Montesquiou, Proust and André Gide. From his youth Cocteau seemed determined to make his homosexuality the centre of his life, directing to it a great part of his creative energy. He was born in Paris to a father who was a stockbroker but whose passion was painting, and an aristocratic mother who doted on him. At school he developed an infatuation for a fellow pupil, Pierre Dargelos, whom he saw as a shameless unsophisticated beauty. This friend who represented both desire and perfection was reincarnated in later works including *Orphée*, *Les Enfants Terribles*, *Le Sang d'un Poète*, and *Le Livre Blanc*. As a youth Cocteau ran away to Marseilles where he took drugs and for the first time had homosexual relations. The dramatic event proved almost too much even for the extrovert Cocteau, for he hardly ever referred to the episode. However, it set the pattern for dramatic events in his life.

After the war, Cocteau met and fell in love with Raymond Radiguet, who was then fifteen, and formed a relationship which was to serve as a model for many of his subsequent love affairs. Handsome and intelligent, the young poet had a well modelled face with a Greek profile which matched Cocteau's ideal. Radiguet had been helped by the artist and writer Max Jacob who introduced him to Cocteau. Much to Jacob's surprise they became inseparable, going everywhere together and sharing their common interest in poetry and art and collaborated on a play. Radiguet's novel *Le Diable au Corps* made him an overnight celebrity, much sought after by women and men. Cocteau's jealousy resulted in many angry scenes. A pen-and-ink drawing by Cocteau of 1922 records Radiguet's sensual lips, his youth, his large eyes and his general air of introspection. Radiguet's tragic death in 1923 of typhus plunged Cocteau into deep despair.

Cocteau started smoking opium at this time and the drug-taking continued on and off for some years. A series of thirty drawings completed in 1924 captured his mood of uncertainty. Given a punning title, *The Mysteries of Jean, the Bird-Catcher* (oiseleur, or bird-catcher, means 'phallus' in French slang) each drawing shows a different Cocteau; the handsome sailor, the angel, the philosopher, the poet, and so on, all searching for a 'true' voice, a 'real' image. They are amongst the most moving of all Cocteau's drawings.

Homosexuality and opium became for him a way of life; he sought to make it *chic*, drawing into his circle other artists who at some point fell under his influence. The English artists Christopher Wood and Francis Rose, and to a lesser extent Cedric Morris and Lett Haines, paid court at some time, as did Max Jacob and the artist and designer Christian Bérard.

In later life Cocteau courted respectability and success. In 1955 when Colette died, he took her place at the Académie Royale de Belgique and was elected to the Académie Francaise. Unlike his friend Jean Genet,

Cocteau did not deal specifically with homosexuality in his public work, preferring instead to use wider classical references which seemed to deny rather than to welcome sex. While carefully presenting a respectable face to the public at large, Cocteau produced explicit homoerotic drawings for private circulation only. Among friends he argued the case for homosexual emancipation, saying that homosexuality was part of the 'natural order'[2] and was part of the vast machine in which nature strove to maintain an equilibrium. If society in general had made few strides in understanding and accepting homosexuality as 'natural', there was a strong underground movement putting forward this view.

Seen by some as a leader, Cocteau was hated and despised by his one-time associate André Breton precisely because he was homosexual. Breton's dislike and distrust of homosexuals extended to other artists, most notably the writer René Crevel, the only self-proclaimed homosexual in the surrealist group, who was given a mock trial for his sexual tastes.

Other artists, though drawn to Cocteau and benefiting from his outspoken attitudes, could not respond so positively to his radical views. Max Jacob (1876-1944), artist and writer, considered that the cross he had to carry through his life was being born a Jew, being homosexual, and being a practising Roman Catholic.[3] Jacob was very much part of the *avant garde* artistic group in Paris, at one time sharing a flat with Picasso. The two young artists met in 1901 when Picasso was starting his so-called 'blue period', and continued their friendship, later working together on Cocteau's *Parade*. Jacob's dark, sombre water colours (views of Paris in thick gouache paint) were less well-known than his poetry.

It was Max Jacob who introduced the English artist Christopher Wood (1901-1930) into Cocteau's circle. Attracted by Wood's good looks, his simplicity of style and his unspoilt youth, Cocteau offered this handsome and talented artist patronage and excitement. 'Kit' Wood, who was sexually attracted to both women and men, combined in his life and painting the contrasting qualities of sophistication and naivety. To many he appeared to be a handsome young man about town, sociable and carefree, but he was also a dedicated painter whose creative anguish was full of secret passions and torments which often led him to retreat into a private existence.

John Christopher Wood was born at Knowsley near Liverpool; his father was a doctor on the Earl of Derby's estate and Wood was sent to Marlborough to be educated. After only one term a blood disease confined him to bed for long periods and left him with a permanent limp. With his father away in the 1914-18 war, he developed a close relationship with his mother and it was she to whom he constantly wrote. Letters to her described his feelings and social activities and attempted to hint at the nature of his relationship with his lover Gandarillos.

During his illness Wood had developed his skill at drawing and eventually he started studying architecture at Liverpool University. By chance he met Augustus John who praised his drawings and suggested that he take up painting seriously. Encouraged by the admiration, Wood moved to London where John introduced him to Alphonse Cahn, a wealthy collector and patron of the arts. Cahn took him to Paris to study where he enrolled at the Académie Julian.

Within a month he had been introduced to the wealthy Chilean diplomat Antonio de Gandarillos and they became lovers. Gandarillos, quick and lively, introduced Wood into Parisian society and they travelled around Europe and North Africa.

Anxious to find his own voice as an artist, but unable to resist the temptations of a full social life, Wood tended to experiment with any style that caught his attention. In all his work there is a direct freshness whether it is in the interior of a bedroom in which a naked figure is washing at a wash stand (for which the model was Francis Rose) or in his portrait of Gandarillos painted in 1926. Gandarillos, whom he described as 'a chattering, charming, childish and always cheerful small monkey'[4] is shown in a fluffy bow-tie and patterned jersey, holding a cigarette. Sophisticated and calm, the diplomat gazes straight out of the picture with a confident and almost bold defiance. Gandarillos introduced Wood to opium smoking, and Cocteau, still in mourning for Raymond Radiguet, encouraged him. It was a habit which was to disturb Wood's mind and contributed to his death in 1930.

In 1926 Serge Diaghilev invited him to design sets for *Romeo and Juliet*. An impressive group of designs were produced for the unrealised all-English production which was to have been conducted by Wood's friend the English composer Constant Lambert. Wood's portrait of Lambert, painted in 1926 (National Portrait Gallery, London) shows the sitter serious and quiet, carefully posed. It is in contrast to the much more intimate full-length nude study of Lambert, *The Composer* (Towner Art Gallery, Eastbourne) in which the musician looks wistful and anxious as he lies on his side, pen in hand. Behind him, looking on, is the figure of another young man.

Painting, social commitments and drugs presented Wood with many conflicts. Problems about his 'style' were partly resolved when in 1926 he visited St Ives in Cornwall with the painters Winifred and Ben Nicholson. Here the simplicity of the life, the rhythms of work of the fishermen and the unspoilt village offered peace and the opportunity for reflection. In the quiet lull of St Ives his style simplified and strengthened. Always an able draughtsman, he now concentrated on scenes and portraits in the fishing village, all painted in strong colours and with a deceptively simple directness. He joined the London Artists Association and the following year showed paintings with the Five and Seven Society in London.

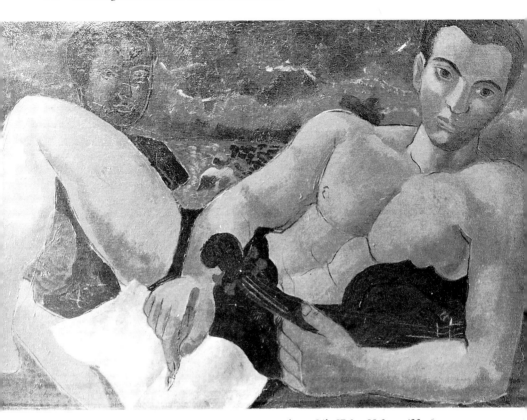

7.2 Christopher Wood (1901–1930) *Constant Lambert.* Oil. 57.3 × 89.3 cm (23 × 36 in) This contrasts with the more conventional three-quarter length clothed portrait of the musician in the National Portrait Gallery, London, painted in 1926 (*The Towner Art Gallery, Eastbourne*)

Back in France, he was soon caught up in the turmoil of relationships and extensive opium smoking. In a self-portrait in 1927 he chose to show himself as a serious artist, brush in hand, paints on the table by his side. Behind him stretches a French townscape, dark and slightly forbidding, placing him in an urban rather than an intimate setting. His look, though serious, has a note of playfulness, a hint that everything is not quite as it seems.

Though his relationship with Gandarillos continued, it was interspersed by love affairs with women, including Meraud Guinness. Opposition from her family prevented them from marrying. Later he met the 'hauntingly beautiful' Frosca Munster, a Russian émigrée, and she became his last and most devoted mistress. His nude portrait of her, *The Blue Necklace* 1928 (private collection), catches her strength and power. The solidity of the body reflects the influence of Picasso.

By 1929 opium smoking was dominating his life and, unlike Cocteau,

he did not, or could not, take a cure. Separation from Gandarillos deprived him of direct access or funds to purchase the drug and more and more he came to use dross, or once-smoked opium which induced dangerous and poisonous dependence. Towards the end of his life he was eating opium.

Pictures of this period, often painted in cheap household oil paint, are bright in colour and bold in composition. Fishermen, families, boats, houses and harbours were favourite subjects and many have a heightened sense of reality. *The Sleeping Fisherman* 1930 (Laing Art Gallery, Newcastle), completed shortly before his death, shows a handsome, half-naked sailor asleep on the beach. Behind him the dark cliffs loom menacingly above the strong but vulnerable figure. In its implications of encroaching doom the painting suggests the darkening and dimming of Wood's own life. Paintings were completed in a tremendous surge of feverish activity and intensity, 'almost two a day' he wrote to Winifred Nicholson.[5]

Semi-delirious with opium poisoning, Wood travelled to England in August 1930 with a loaded revolver in his pocket. He was under the impression that he was being followed by secret agents. After having lunch with his mother and sister on Salisbury railway station he either fell or threw himself in front of the London express train.

'It was clear,' wrote Alan Bowness in the catalogue to Christopher Wood's exhibition at Kettle's Yard, Cambridge, in 1974, 'that he was trying to break his addiction to drugs, and that his emotional life – especially his relationships with his girlfriends, boyfriends and with his mother – was hopelessly entangled.' Wood's high-speed living, his desire to experience to the full relationships with men and women contrasted or complemented his urge to paint and to seek out a voice of his own. The energy in his paintings, their animation, their speed, reflect his restlessness. Stylistic influences from Utrillo and most particularly Picasso and finally his own 'sophisticated naive' style move at a tremendous pace. As Ben Nicholson said, 'Why write about his life – it is all there in his pictures.'[6]

The circle around Cocteau also included in the 1920s and 1930s the flamboyant English artist Sir Francis Rose (1909–1976). In his autobiography *Saying Life* (London, 1961) Rose records the life of the artistic community centred around Cocteau at the Welcome Hotel, Villefranche, in the south of France. Rose, himself of aristocratic birth, was a colourful character and a dedicated if uneven painter. In his autobiography there are vivid descriptions of the artists he knew which are highly romanticised if not fictionalised. There are, however, some sharp pen-portraits of Cocteau, Bérard and Christopher Wood. He described Wood as 'the most serious painter of the time'. The two painters became friends at Treboul where he posed for Wood. In the

1920s Rose visited Germany and describes in the book the heavily homosexual air of the cities. It was, he said, 'impossible for a young man to go out in the centre of Berlin without being accosted'.

The book's principal interest is its spirited defence of homosexuality and a plea for the decriminalisation of the law in Britain. Without ever discussing his own homosexuality, Rose's argument is clearly based on his experience. In the early 1970s Francis Rose was a frequent visitor at Gay Liberation Front meetings in London, often to be seen exotically dressed and with a parrot perched on his shoulder.

Without any formal art training other than private lessons with Tonks and other artists in the early 1920s, Rose experimented with different styles and themes. He travelled around Europe, painted portraits of friends including Isadora Duncan, and in 1929 did theatre designs for Diaghilev. Later he designed the costumes and scenery for Lord Berners' ballet *Cupid and Psyche*, which was to have music by Constant Lambert. His great admirer was Gertrude Stein whom he met in 1931 and who had nothing but the highest praise for what seemed to everyone else mediocre, if flamboyant, talents.

In England the artists and writers who formed the Bloomsbury group in London discussed questions of sexual taste and were accepting of male and female homosexuality, even if this was against a gossipy and curious interest which tended to play down differences. At least lesbians, by being referred to as 'Sapphists' were ascribed with feelings and emotions as well as particular sexual interests. Men's homosexual activities by being labelled as 'buggers', or being 'sodomitical' were separated from emotional concerns. The implication that all men, no matter whether hetero or homosexual, had the same emotional needs made the expression of homosexual feeling difficult. Even this limited form of acceptance was confined to the close circle of Bloomsbury friends.

Duncan Grant (1885-1978) recognised the specialness of membership of the Bloomsbury group when he complained to his lover Maynard Keynes that while he could be open about his homosexuality within the group he had to hide it from most people. Brought up by his uncle and aunt, Sir Richard and Lady Strachey, in their London home, he came into contact with his cousin Lytton Strachey, who was homosexual, at an early age. There never seemed to have been particular difficulties in his acceptance of his homosexuality or in its expression in many of his paintings. From 1902 to 1905 he studied at the Westminster School of Art, afterwards moving to Paris where he enrolled at Jacques-Emile Blanche's school, La Palette, Paris and copied paintings at the Louvre.

Lytton Strachey, who fell in love with the handsome and talented artist, described him in 1905 as having a face of 'the full aquiline type, with frank grey-blue eyes, and incomparable lascivious lips'.[7] A year later Grant was copying the angels in Piero della Francesca's *Nativity* in the

National Gallery, London, when he was spotted by the artist Maxwell Armfield. So impressed was Armfield by Grant's good looks that he introduced himself and for a brief time the two were lovers. Grant found the precise, slightly old-fashioned attitudes of Armfield did not suit his expansive, exploratory mood and they soon drifted apart.[8]

This same absence of experiment and exploration resulted in Grant's staying only a short time at the Slade School of Art in London. After the excitement and enthusiasm of Paris, London art schools seemed out of touch and lifeless. With Maynard Keynes, Duncan Grant travelled around Europe, visiting Italy, Greece and Turkey. Slowly he began to establish his own style of freely interpreted figurative compositions with the use of bold adventurous colour, classically derived compositions and sharply observed portraits.

In 1911 Duncan Grant, who was still assimilating influences from the early Italian Renaissance painters as well as Picasso and Matisse, worked on his first major commission. Along with other artists, he collaborated on a series of murals for the refectory of Borough Polytechnic in south London. His two mural panels *Bathing* and *Football* (Tate Gallery, London) are impressively carried out, imaginatively conceived and celebrate the strength and beauty of the male form. *Bathing* in particular is a study which gives the figure an idealised, god-like beauty and this quality of adoration is one which was a recurring theme in his paintings and portraits of men. Both panels have the frieze-like composition of

7.3 Duncan Grant (1885–1978) *Bathing* (1911). Tempera on canvas. 228.6 × 306.1 cm (90 × 120.5 in) (*Tate Gallery, London*)

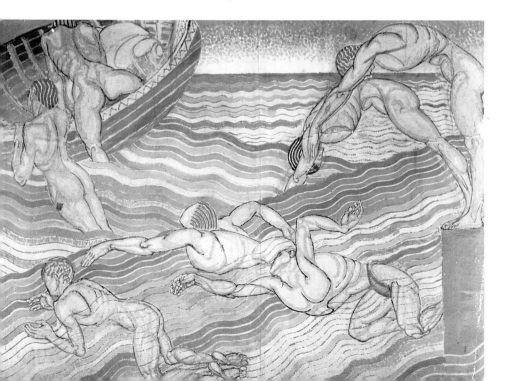

much Greek art. *Bathing* shows the progress of a naked man diving, swimming, and eventually climbing into a boat in the manner of several exposures of a film. The man's well-proportioned, muscular body is stylised and the whole painting has the feel of a Byzantine mosaic. It is significant that in 1911 Grant had visited Ravenna to see the early mosaics.

Reviewing the murals in *The Spectator*, the art critic identified the influence of the Italian artist Signorelli and hinted at the celebratory quality of the male form. 'When all is said, the effect of the whole gives an extraordinary impression of the joys of lean athletic life,' he wrote. In contrast, the critic of *The Times* was less appreciative of the freedom and delight expressed by *Bathing* which he thought could have a 'degenerative influence on the children of the working classes'.[9]

The figures in *Football* lend themselves less satisfactorily to the stylisation that Grant adopted, and appear stiff and modern by comparison with the flowing figure of the bather. Studies of the male nude occurred in other works at this time. On a chest now in the Charleston Collections, produced by the Omega Workshops, a male nude swimmer with a fully modelled torso covers the front. The images became more graphic, more explicitly homoerotic, in a series of pen and ink drawings of nude wrestlers in the early 1920s. These were done subsequent to a visit to a wrestling match in the East End of London. This subject, with its physical involvement of two semi-naked males, was

7.4 Duncan Grant (1885–1978) *Two Wrestlers* (c. 1920–24). Pen and ink wash. 17.8 × 22.8 cm (7 × 9 in) (*Anthony d'Offay Gallery, London*)

one often chosen by artists to convey feeling and emotions which cannot be expressed directly. Other artists, notably Francis Bacon and Keith Vaughan, also showed wrestling male figures with similar sexual overtones.

Later in life, Grant filled notebooks with drawings based on photographs in magazines and books of the male nude. The drawings of the male figure contrast strongly with his paintings and drawings of figures on classical themes. In *Venus and Adonis* 1919 (Tate Gallery) a theme of idealised love which recurred in many of his paintings, the woman is huge and rounded and recalls the style of Picasso. Her lingering gaze to a far distant figure of Adonis has sad overtones. Sir Kenneth Clark noted Grant's concern with 'the earthly adventures of amorous gods'[10] which was taken up in such themes as Leda and the swan, Europa and the bull, and Psyche and Amore. The idealised love and passions they describe can never be fulfilled and it is this tinge of melancholy that suggests that love, though an important driving force, can never have the life-enhancing qualities ascribed to it by myth.

This philosophical view was reflected in his relationships. Throughout his life the admiration and fulfilment he found in his male lovers was often expressed in the portraits he painted of them. These love affairs were set against his major relationship which was with the artist Vanessa Bell; they lived together from 1913 until her death some fifty years later, and this intense, deep, but in many ways confining relationship formed the background to his more passionate and certainly more sexually fulfilling relationships with men.

Duncan Grant and Vanessa Bell made their home at Charleston, an old farmhouse near Firle in Sussex. Complex interpersonal relationships resulted with Grant having love affairs with men, he hoped with Vanessa's approval.[11] During his affair with David ('Bunny') Garnett (who later married their daughter Angelica) both artists painted his portrait. Vanessa Bell showed a short, stocky, rather ordinary man while Grant completely idealised him, giving him a god-like quality. This 'interpretation' of the model is also evident in his portrait of Lytton Strachey of 1911 (Anthony d'Offay Gallery). It shows a foppish, intense, bearded character. Its coolness is particularly evident when compared with Carrington's portrait of Strachey (see chapter 5) painted five years later.[12]

Vanessa Bell and Grant produced designs for Roger Fry's Omega Workshop and both worked on mural commissions for Maynard Keynes, Ethel Sands and Nan Hudson among others. Other artists who were associated with the Omega Workshop included Alvara Guevara (1894–1951) and Edward Wolfe. A handsome and dashing Chilean whose good looks and openness attracted both men and women, Guevara's anglophile family insisted that he (and his nine brothers and sisters)

should have an English governess and he was sent to an English school in Chile. Fluent in English, German and French as well as Spanish, Guevara arrived in England in 1910 intending to study wool manufacturing (the source of the family fortune) at Bradford Technical College. However, he preferred painting and drawing and attended evening classes at Bradford Art School. Here he was awarded a scholarship to study at the Slade School on the strength of his illustrations for Shakespeare and Bunyan.[13]

At the Slade (1913–1916), where he became known as 'Chile' though still dressed in formal English suits, he enjoyed the freedom of the school and was likely to greet both men and women with kisses. Whilst still a student Guevara started to experiment sexually. Prostitutes, though readily available, carried the dangers of venereal disease (which he was rumoured to have contracted), while he thought men did not and he experienced many casual contacts with young tradesmen and errand boys. He had a sustained relationship with Michio Ito, a Japanese dancer. Because of his masculine manner and powerful body (Guevara had learnt to box in Chile and he kept up the sport), everyone assumed he was heterosexual and he did little to make his sexual tastes known to anyone but his lovers. As well as having a reluctance to be open about his sexual tastes, Guevara also held conservative views with regard to social behaviour, despite his flamboyant and extrovert character. He did not, for instance, want his sisters to meet the artists Betty May and Nina Hamnett because of their emancipated views, nor did he approve of the open discussion of buggery that took place in front of women and men at various Bloomsbury social occasions.

The contradictions in his attitudes to sexual freedoms were also expressed in his attraction to working-class youths and to smart, intelligent and elegant women such as Nancy Cunard and Edith Sitwell. Walter Sickert had introduced him to the pleasure of swimming at the London swimming baths and Guevara was a frequent visitor, admiring the glistening and shiny bodies of the half-submerged swimmers in the shimmering water. He often worked there, drawing figures in and out of the water as studies for oil and water colours. The vulnerable bodies were often painted in a slightly abstracted manner and prefigure a style that was later developed by Keith Vaughan.

In the mid 1920s he travelled to Paris with an introduction from Edith Sitwell to Gertrude Stein, also becoming involved with the social group around Cocteau, Gandarillos and Christopher Wood. Wood's affair with the painter Meraud Guinness had by then been brought to an end by her family and Guevara, entranced by her beauty, persuaded her to marry him in 1929.

Though it was not a successful marriage, their friendship remained until his death in 1951. Unfortunately the majority of Guevara's paintings

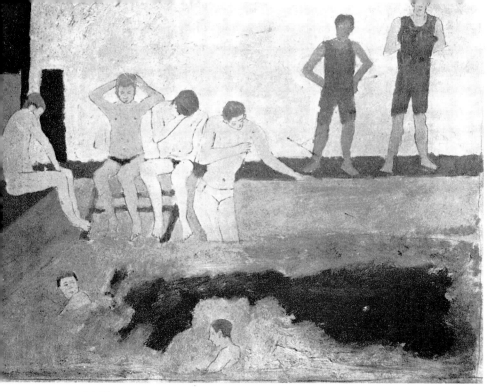

7.5 Alvaro Guevara (1894–1951) *The Shallow End* (1916–17). Oil on board. 44.4 × 57.1 cm (17.5 × 22.5 in) (*Colnaghi, London*)

were destroyed in the war and shortly afterwards illness prevented him from painting again. He died at the age of 57.

Edward Wolfe (1897–1982), mercurial and adaptable, was a South African artist whose introduction to the Omega Workshop brought him into contact with many artists, including Guevara and Grant. Much of Wolfe's success as an artist was due to his ability to combine in his painting the influence of his unusual and exotic African background with an appreciation of the dramatic qualities derived from his interest in the theatre. As a child in South Africa he worked in a travelling theatre company until his voice broke. His intention in London was to train as an actor rather than as an artist. A scholarship, however, took him to Regent Street Polytechnic School of Art and he decided that he wanted to train seriously. A year later he was a student at the Slade School, making contact with Nina Hamnett, Roger Fry and the Omega Workshop.

For the following twenty years, Edward 'Teddy' Wolfe travelled, settling for a year or so before moving on to explore another country. In 1922 he rented a studio in Montparnasse, Paris, and later travelled to

Spain, Florence, Rome and Morocco. But London was his regular base and it was here that he showed his paintings (a one-man exhibition at the London Artists' Association in 1930) and got commissions for costume and set designs. In 1967 he was elected an ARA, the same year that the Arts Council in England showed his work.[14] From the end of the 1950s he settled in a studio in Rotherhithe by the Thames in London and lived there until his death in 1982.

If the Bloomsbury group's 'official' painters were Duncan Grant and Vanessa Bell, its 'official' sculptor was Stephen Tomlin (1901–1937). Usually known as Tommy, he was born the youngest son of Lord

7.6 Edward Wolfe (1897–1982) *PC 77* (c. 1927). Oil on canvas. 107.6 × 78.1 cm (42.2 × 30.75 in) (*Tate Gallery, London*)

Justice Tomlin and studied at New College, Oxford, before taking up sculpture. He was a pupil of Frank Dobson for two years before moving out of London in 1926 to set up his own studio. Talented and intellectually able, Tomlin was also deeply melancholic and obsessive. This contrasted with an uncontrollable impetuousness and boisterous energy. Though married to Julia Strachey, he was also closely involved emotionally with men and women including Lytton Strachey and Carrington. The complexities of their emotional entanglements did not deter him. Tomlin, bisexual, seduced both men and women in a bravura attempt to demonstrate his attraction. As a result he would be overwhelmed with guilt and beg forgiveness from his wife. For a year or two the marriage was sustained until bouts of depression, heavy drinking and sexual infidelities brought about the final separation in 1932. In his last years he formed a relationship with a working-class man known as 'H' who served in a haberdasher's shop in Holloway, London. That this man was known only by a cypher and was not given his proper name suggests the difficulties of the relationship.

A photograph in *Vogue* (November 1925) shows Tomlin standing by the side of a kneeling figure. His good looks, dark floppy hair and carefully tied neck scarf suggest a romantic image of confidence and sensitivity and do not hint at the dark side of his nature. Some of this depression and despair is expressed directly in *The Sluggard's Quadrille*, a black reworking of Lewis Carroll's *Lobster Quadrille*.[15] A sculpture commissioned by Lytton Strachey for Ham Spray does have a bizarre note of black comedy. The subject is the episode in Rabelais when Pantagruel wipes his backside on the neck of a goose. The balletic grace of the statue gives the piece a bizarre unity. The features of Pantagruel resemble those of Nijinsky.

Commissions from Bloomsbury friends varied in their success. A portrait of Henrietta Bingham gave her a short neck and a heavy jaw, creating a pudding-like quality. In contrast, the sensitively modelled head of Angus Davidson c. 1924–5 has a long elegant neck, with a suggestion of graceful movement. A portrait of Lytton Strachey of 1928 (Tate Gallery, London) was described by the sitter as 'a highly impressive, repulsive and sinister object'.[16] By far his most successful work is his portrait bust of Virginia Woolf 1931 (National Portrait Gallery). A reluctant sitter, she disliked being stared at, yet Tomlin catches in the head the fineness of her features, the quivering sensitivity and the strength of the great writer.

7.7 Stephen Tomlin (1901–1937) *Lytton Strachey* (1928–30). Bronze. Height 45 cm (18 in) (*Tate Gallery, London*)

The two artists Cedric Morris and Arthur Lett Haines ('Lett') spanned the artistic circles of London and Paris, spending time in both cities in the 1920s. They met at the end of the First World War when Cedric was thirty and Lett twenty-six, and formed a relationship which was to last until their deaths. Though both had military careers planned for them and had served in the war, each wanted to become an artist. Temperamentally and artistically they were very different; Morris painted the natural world very much as he saw it and was quiet, intuitive and single-minded in his determination to paint. Haines, as an artist, was much more concerned with the imaginative in art and as a personality was more complex and 'difficult'.

Cedric Lockwood Morris (1889–1982) was born in Wales and educated at Charterhouse. Family plans for a career in the army were thwarted when he failed the entrance exam and a period of restless travel followed in which he worked as a hired man on a ranch in Canada and studied singing at the Royal College of Music before deciding on a career as an artist. In Paris he enrolled for a short time at the Académie Delacluse, then reckoned to be one of the most reactionary *ateliers* in Paris. His stay there was cut short by the onset of the First World War and, though he spent time in the Artists' Rifles, he was forced to leave due to partial deafness.

The meeting with Lett Haines and their subsequent relationship gave his life new form. In 1925 Cedric Morris wrote to Lett acknowledging that it had been through him that he had sprung to life and that he had been 'asleep'[17] before they had met. Together they went to Paris and it is here that his serious training as an artist started. He explored various styles from abstract works to the more naive style of the Italian primitives. Paris society also influenced their work, as did their friendship with Gertrude Stein and Jean Cocteau. Visits were made to Treboul, Brittany, where they became friendly with Christopher Wood, and the influence of Morris can be seen in Wood's paintings. Morris's *The Dancing Sailor* 1925 (Collection Miss Mary Rose Wakefield) of a bare-chested sailor dancing in a field of cows in front of a bay crowded with sailing boats has a subtle homoerotic quality.

In London in the late 1920s they took a studio in Bloomsbury and Morris was elected a member of the Seven and Five Society (so-called because the original group founded in 1919 was made up of seven painters and five sculptors). By 1926 the society was still small but their exhibitions were regarded as some of the most progressive of the time.

Morris, who felt much more at home in the country, regularly travelled to Gower in South Wales and finally settled in Essex. With Lett

7.8 Sir Cedric Morris (1889–1982) *Self Portrait* (1930). Oil on canvas. 72.7 × 48.9 cm (28.5 × 19.25 in) (*Trustees of the National Portrait Gallery, London*)

Haines he set up the East Anglian School of Painting and Drawing in 1936 at Dedham. After a fire in 1939 the school moved to Benton End, Hadleigh, in an old house with a walled garden. There was little formal teaching and students who had to have enthusiasm as well as talent were encouraged to follow their own ideas as long as they were 'sincere'.

The naive, almost simplified directness of Morris's painting of the natural world combines his own approach with a particularly English adaptation of the ideas of post-Impressionism. Though aware of and influenced by the ideas of Roger Fry, Morris was bored by formal and painterly problems on their own. His use of strong colour and bold form was not intended to suggest naturalism but a heightened slightly surreal quality. The erotic qualities of flowers, in particular of the iris, intrigued him, though he never loaded his paintings of them with psychological or sexual overtones such as can be seen for instance in the work of Charles Demuth (see chapter 6).

It was, however, for his portraits that Morris gained his greatest reputation. Raymond Mortimer is reported as having described them in 1939 as 'not speaking but shrieking likenesses'.[17] In them he did not attempt a photographic impression but by a subtle blend of exaggeration, caricature and simplification caught the spirit and appearance of the sitters who seemed almost to be exposed by the bold descriptive painting. His list of sitters spanning the 1920s, 1930s and 1940s include a whole group of artists, writers and so on, many of whom were homosexual. These included Angus Davidson, Frances Hodgkins (1922), John Banting (1923), Angus Wilson (1940), Anthony Butts (1936) and Rupert Doone. A portrait of Lett (collection of Mr and Mrs Aidan de la Mare), painted in 1925, shows his friend in front of a map of Morocco, but most were set against a plain, empty background.

Like Morris, Arthur Lett Haines (1894–1978) had a career planned in the army; he attended the Royal Military Academy, Woolwich, London, and by 1913 he was a professional soldier. When he first met Cedric Morris at the end of the war he was living with Aimée, his second wife. Morris moved in with them until a few months later they settled in Cornwall and Aimée went to America. From then on the two artists lived together until Lett's death in 1978. Lett Haines was less well-known as a painter than Morris partly because he took the decision to help and support his lover. His influence upon Morris, particularly during the formative years of the 1920s was profound.

While Morris's paintings were intuitive and concerned with the natural world, Lett Haines' work was more psychological and often erotic, with influences taken from Beardsley as, for example, in an early work *The Poems of 'Orisons of Sunnara'* (1916) and Picasso. The greatest influence was undoubtedly that of the surrealists. In his free treatment of organic form, the menacing fantasy element was conveyed. This was expressed in small sculptures such as *Cyclops*, or indirectly in paintings dealing with

7.9 Arthur Lett Haines (1894–1978) *The Poems of 'Orisons of Sunnara'* (1916).
Watercolour. 29.8 × 22.8 cm (11.75 × 9 in) (*Redfern Gallery, London*)

the relationships between humans and animals. *Boy Mounting Lion* has a
disturbing erotic quality as well as elements of fantasy.

After the war the paintings of both Morris and Lett Haines were out
of fashion. Though their art school continued to attract students, they
had few exhibitions. Morris devoted more time to his cultivation of
plants, leaving Lett Haines to administer the school. In the post-war
years homosexuality was seen as an appalling perversion and this attitude
would not have encouraged either Lett Haines or Morris to make
'public' their 'private' lives. The separation had to be maintained.

8 · The New Woman

The end of the First World War brought new opportunities for women to follow their own careers and gave greater freedom to explore and express their sexuality. During the war many women had had to take over much of the work and responsibilities of men. Though at first forced, this emancipation turned into conscious self-liberation for many women. In several European countries women gained the right to vote and there were campaigns for birth control and generally broader attitudes to questions of sexuality. The New Woman was born, whose progressive identity often involved having short hair, wearing slacks, ties and shirts, and smoking cigarettes. If the reality of social and economic equality was still far off, at least it could be implied by outward appearance. Images of the New Woman were drawn by artists including Djuna Barnes, Tamara de Lempicka, and Jeanne Mammen.

Before the war some lesbians had donned male outfits as part of a statement of sexual and social identity. After the war such an appearance was more easily accepted when it carried with it elements of fashion. While such a fashion made a particular lesbian identity more difficult to define, its lack of controversy attracted a wide range of women once it was no longer specifically associated with lesbianism. A more public visibility was expressed. Lesbian clubs flourished in Paris and Berlin in the 1920s and 1930s and in Berlin there were two lesbian journals, *Die Freundin* (The Girlfriend) and *Frauenliebe* (Woman Love). Images of lesbians appeared, for example, in the magazine *La Vie Parisienne*, 1 November 1934.

A few women saw themselves as lesbians and felt neither shame nor remorse. In her autobiography Natalie Barney wrote, 'I consider myself without shame; albinos aren't reproached for having pink eyes and whitish hair, why should they hold it against me for being lesbian? It's a

question of nature; my queerness isn't a vice, isn't "deliberate", and harms no one.'[1] But many lesbians did not identify with this view and saw their sexuality as relating very much to themselves. 'I'm not a lesbian. I just loved Thelma,'[2] was Djuna Barnes' simple summary of her sexuality nearly fifty years after her relationship with Thelma Wood ended in 1931. She saw the relationship as something special to them rather than as part of any corporate identity. Public attitudes were slow to change. At the outbreak of the Second World War Djuna Barnes travelled to Arizona to see her friend Emily Coleman, who had married a cowboy. Though she took an instant dislike to him, she was even more horrified by his total ignorance of lesbianism.

Even in 1984 the writer of a BBC radio programme *The Ladies of Llangollen* thought it would not be right to speculate on whether the love between the two women was physically expressed. The implication was that physical expression would 'mar' a perfect spiritual and emotional union and to enquire whether such a love was sexually fulfilled would be somehow indecent. Just as it seems inconceivable that such questions should be dismissed today, so in the 1920s and 1930s it was inconceivable that such questions about these women could be asked. However, even over the space of ten or fifteen years attitudes towards lesbianism had changed. In the 1920s bars were quiet and discreet, while in Paris in the 1930s such bars as Le Monacle and Le Sphinx were noisy and aggressive. After the war, any discussion of lesbianism seemed impossible.

Typical of the more 'knowing' mood of the time was the fact that writers including Djuna Barnes, Compton MacKenzie and Radclyffe Hall wrote novels with lesbian themes. However the great moral outcry which greeted Radclyffe Hall's *The Well of Loneliness* (1928) indicates the taboo such subjects carried. James Douglas of the *Sunday Express* thundered: 'I would rather give a healthy boy or a healthy girl a phial of prussic acid than this novel. Poison kills the body but moral poison kills the soul.' In America a judge declared the book 'anti-social and offensive to public morals and decency'.[3]

Many lesbians; however were critical of the conventions and posing often involved in being openly lesbian. Djuna Barnes often used biting satire and humour to point out that women in her circle could be crude and vulgar as well as sensual and loving. But in the supportive, accepting atmosphere of a cosmopolitan city such as Paris, artists could affirm images of their sexuality as they experienced it. It was here that the Polish émigrée Tamara de Lempicka produced images of the New Woman who was perfectly stylish, wealthy, desirable and desired, and very much in command of her own life.

In the 1930s the city attracted the Argentine-born artist Leonor Fini who worked with the surrealists. She produced startling images of

woman as goddess and witch. Marie Laurençin, after her involvement with the cubists in Paris, established her own quiet but sensitive style of images of young girls and women.

Throughout the 1920s and 1930s Paris was a good address to have. For Americans the favourable exchange rate enabled them to enjoy a reasonable standard of living, and in the 1920s when the German mark collapsed the dollar maintained its value. But its greatest attraction was the opportunity for a rich cultural and social life in which the New Woman could blossom. For the American artist and writer Djuna Barnes (1892–1982) the first struggle on leaving home was to provide an income for herself and for her mother. In Greenwich Village, New York, around 1911 she was undecided whether to become an artist or a writer. For a short time she enrolled for drawing classes at the Pratt Institute, Brooklyn, and later at the Art Student's League, but at neither school did she stay long. Her ambition to succeed coupled with her need to earn money led her to do freelance illustration for the *Brooklyn Daily Eagle*. She became a highly successful journalist including her own illustrations in some of her pieces, carried out in a flat linear style inspired directly by Beardsley. Not only do they take up his use of plain areas contrasted with continuous and broken lines but have within them the same 'decadent' feeling. For one notable journalistic assignment she agreed to be force fed like the suffragettes in England, to experience the horror for herself. But however much she sympathised with the Women's Movement, she did not join it, preferring to retain her independence and the freedom to comment.

Barnes' first publication *The Book of Repulsive Women* (1915) had eight poems and five drawings all expressing, though indirectly, a concern with lesbianism. It was one of the first modern literary works to deal with the theme of woman's 'bitter secret' even though it was never named directly. For a brief period Barnes was married and had affairs with other men and some women, and it was not until she moved to Paris after the First World War ended that she began her love affair with Thelma Wood. Their relationship, passionate and intensely domestic, lasted until 1931.

In Paris Barnes moved directly into the lesbian circles centred around Natalie Barney. She met though did not become a friend of Gertrude Stein and got to know Marsden Hartley, Carl van Vechten and Marcel Duchamp amongst others. Thelma Wood arrived from the United States in the summer of 1920 and from 1923 she and Barnes lived together. It may have been because of her relationship with Wood, a sculptor, that Barnes concentrated on writing and illustrating her works with her own drawings. She only began to paint when their relationship was over.

The twenty-two pen and ink drawings for *Ladies' Almanac* (1928), anonymously published by 'a lady of fashion', chronicle and celebrate the

life of Evangeline Musset told in the calendar and zodiac form. The drawings, based on some old French almanacs she discovered, look like wood prints and are without perspective and depth. They express a mood of melancholy, spiced with satire and sometimes coarse humour. In *April*, a woman crouches, sadly meditating on loss and death whilst urinating. Despite the satire and humour, Barnes presents the lesbianism of her Parisian friends as cosmopolitan *chic*. There is no hint of tragedy or disaster.

Ryder, Barnes' novel published at the same period, is altogether more bawdy and earned the epithet 'a female Tom Jones'. The illustrations reflect the vulgarity of the action. An opera singer, straining to reach the top note, urinates with the effort. A more ambitious drawing with

8.1 Djuna Barnes (1892-1982) *Kate Careless*. Drawing in *Ryder*.

overtones of myth and ritual shows a woman with animal breasts and with the legs of a horse, lying on the ground about to be ravished by a mysterious beast with a ram's head.

With the ending of her ten-year-long relationship with Thelma Wood she moved for a period to England. Almost in defiance and as an assertion of her freedom to paint, she started working on large portraits of her friends. A five-feet-tall portrait of Alice Rohrer *Portrait of Alice* shows a thin, standing figure with hair pulled back from the face and piled on the back of her head. The tall, painfully thin figure looked very much like Barnes, who as this time weighed only 126 pounds fully clothed. A portrait of Emily Coleman, *Madam Majeska*, is almost a dark silhouette. Painted in harsh yellow and gold, the figure which shows only the head and shoulders was described by Barnes as looking like 'a divine monkey'.[4]

Barnes' most important literary work, *Nightwood*, was based indirectly on her relationship with Wood. It was written over several years and when published in 1937 it was not received with enthusiasm. Writing in *New Masses* (4 May 1937) Philip Rahr saw *Nightwood* as describing only a tiny ingrown clique of intellectuals 'in which the reciprocal working of social decay and sexual perversion have destroyed all responses to genuine values and actual things'. Alfred Kazin in the *New York Times Book Review* (7 March 1937) described the characters as 'freaks'. The review reflects the unsympathetic attitudes of the time.

Forced to leave her beloved Europe and to return to America at the outbreak of the Second World War, Barnes eventually settled in the small flat in New York where she was to live for over forty years. Without income, she was eventually provided with a monthly allowance by her friend Peggy Guggenheim. In 1944 an exhibition of her paintings was held at the new gallery Peggy Guggenheim had opened. None of the pictures sold and from then on she did no more painting.

Berenice Abbott's powerful photographs of Barnes and Wood taken in the 1920s show women with very different identities. Barnes appears elegant, sophisticated and confident, the epitome of the New Woman. She was asked to bring two sets of clothes for her sitting and both are equally fashionable. Two portraits were taken. In one she wears a cloche hat, cloak, and dark lipstick and gazes directly, almost defiantly into the camera. In a second portrait, Abbott photographed her in an equally smart set of clothes, but this time in perfect profile. In contrast the portrait of Thelma Wood is almost austere, showing her very simply dressed in a plain blouse and jacket with short-cropped hair. She modestly looks to one side, her head averted. Wood, though far from the conventional and dramatic 'glamour' of Barnes, attracted her own admirers, including Hilaire Hitler, another expatriate American artist who fell in love with her.

8.2 Berenice Abbott (1898–1991) *Djuna Barnes* (c. 1922) (*Berenice Abbott Estate*)

Thelma Wood (1901–1970) was born in St Louis, Missouri, and claimed to have some American Indian blood. A small allowance enabled her to follow her career as an artist, to live reasonably well and to drive a smart red Bugatti. In Paris Wood turned from sculpture, with its difficult demands for studio space, to flat work, choosing the precise art of silverpoint in which a silver-pointed stylus is used to sketch on specially prepared paper. As well as a series of animal drawings

8.3 Berenice Abbott (1898–1991) *Thelma Wood* (c. 1922) (*Berenice Abbott Estate*)

completed during a visit to Africa, which included elephants and giraffes, she did more freely interpreted compositions on the theme of flowers and animals. Like Barnes in *Ladies' Almanac*, she used various flowers to suggest women's genitals, often selecting such plants as orchids and bell-shaped blossoms. Involved and sometimes tortuous, the drawings often make blatant Freudian references with such images as a lady's old-fashioned tall leather shoe or a frog and convey sensuality and eroticism. She presented one of these drawings to Berenice Abbott in 1929 and they remained close friends until Wood's death from cancer in 1970.

Like Wood and Barnes, Berenice Abbott (1898–1991) had wanted to be
a sculptor and a journalist. Like Djuna Barnes, Berenice Abbott had a
traumatic and unhappy childhood. She was born in the Mid-West at
Springfield, Ohio, but her parents divorced very soon after she was born.
She was brought up by her mother and rarely saw her father. In 1917 she
enrolled at Ohio State University, but found the courses dull and
apparently irrelevant to her desire to become a journalist. Invited by a
friend, she moved to New York the following year, settling in Greenwich
Village and becoming friends with amongst others Djuna Barnes.

Her ambition was now to become a sculptor and she set up a studio
near Christopher Street. Marcel Duchamp gave her a commission for a
set of chess pieces and more significantly introduced her to Man Ray.
Encouraged by the eccentric poet and painter Elsa von Freytag-

8.4 Thelma Wood (1901-1970). Silverpoint drawing, given to Berenice Abbott, 1929.

Loringhoven, known as 'The Baroness', she moved to Paris in 1921. A year later Man Ray arrived in the city and set up a studio taking photographic portraits, later giving Abbott the job of photographic assistant. Quickly she learnt the skills of developing and printing and started to take her own portraits. In 1926, over a commission for Peggy Guggenheim, a row ensued and she left to set up her own modest studio.

For the next three years she photographed 'the crowd', chronicling the lesbian and homosexual artistic circles of the city in particular. While admiring Man Ray's work (she described his portraits of men as 'fantastic'), she thought his women were mostly treated as 'pretty objects'. 'I didn't think about the male-female thing at the time, but it turned out the photographs I took were different from his, particularly the women.'[5] So aware was she of how women were usually shown that she was put off working for Paris *Vogue* by the attitudes of staff photographers.

'I strive for psychological value, a simple classicism in portraits',[6] she wrote later, achieving this through lengthy studio sessions in which the sitters were allowed to sit and pose very much as they wished. Her first exhibition in 1926 included photographs of Sylvia Beach, Djuna Barnes, Marie Laurençin and Jean Cocteau. Of the *First Salon of Independent Photographers* 1928 in which she had twelve pictures a reviewer in *Chantecler* said 'her simple portrait of a woman transcends Holbein'.[7]

A return to New York in 1929 did not bring a repeat of her success. She was critical of the 'pictorialists', whom she saw as making pleasant, pretty pictures in the spirit of certain minor painters, she crossed swords with Alfred Stieglitz and later Edward Steichen who was head of the photography department of the Museum of Modern Art.

Eventually she got funding for her *Changing New York* project and in 1935 she started to teach photography at the New School for Social Research but there was little official regard for her work. It was not until 1958 after the launch of Sputnik into space and a renewed interest in science that her imaginative attempts to unite art and science through photography were taken seriously and given the widespread acclaim they deserved.

Berenice Abbott's ideas and work in opposition to the pervailing mood, found little support from official bodies. Though determined to continue, she was for many years unable to persuade them of the seriousness of her work. For artists, particularly women who wanted their work and ideas to be recognised, this was often difficult to achieve, particularly if they were part of a group in which other theories and styles were being developed.

Marie Laurençin (1885-1956), who had been part of the artistic group around Picasso and Apollinaire, was identified with their ideas and styles rather than recognised as an artist in her own right. It was only when

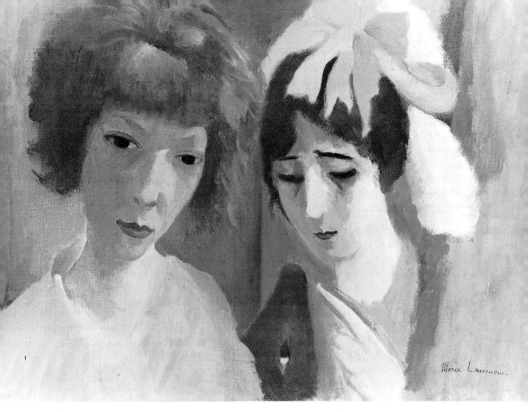

8.5 Marie Laurençin (1885–1956) *Portraits* (1915). Oil on canvas. 33 × 46 cm (13 × 18.12 in) (*Tate Gallery, London*) © ADAGP, Paris, and DACS, London, 1993

she left this circle that she was able to develop her own style, expressive of her own artistic and personal interests. She was born in Paris, an illegitimate only child who lived with her mother and had a close relationship with her until 1913 when she died. She never knew the identity of her father. From early on she had shown talent as an artist and she had been training to become a paintress at the Sèvre porcelain works when she met Georges Braque. Through him she became friendly with Picasso and Apollinaire.

Though usually seen as Apollinaire's mistress, Laurençin did manifest something of her own independent personality and was regarded as 'something of a New Woman' who was 'conscious of her own personality'.[8] Picasso did not warm to her independent ways and Gertrude Stein maintained a formal rather than a close friendship. In 1913 her life changed dramatically when her mother died and her affair with the poet Guillaume Apollinaire ended. Their stormy love affair had lasted for six years during which time she had continued to paint. But most of their friends regarded her much more as the inspiration for the poet, his muse, moving him to write some of his finest work. Their relationship was depicted by Henri Rousseau in *The Poet and his Muse*

(1909) (Museum of Modern Art, Moscow). The full-length double portrait suggests to all intents and purposes a conventional married couple, an impression which was probably far too simplistic a reading of their relationship. A year after her separation from Apollinaire she married a German painter Otto van Waetjen, but at the outbreak of the First World War they had to escape to Spain. The marriage was not a success and by 1920 she was divorced and living again in Paris. Although she had been part of the cubist circle, she did not identify herself with 'scientific cubism'; she was fascinated by the artistic experiments and theories, but felt far removed from the cubists as much 'because they are men' as for the ideas they discussed. 'But if the genius of men intimidates me', she said, 'I feel perfectly at ease with everything that is feminine.'[9] Even Apollinaire, though highly subjective in his criticism of her work, was aware that she was very conscious of 'essential ideal differences'[10] that separate men from women.

8.6 Marie Laurençin (1885–1956) *Group of Artists* (c. 1908–9). Oil on canvas. 64.8 × 81 cm (25.5 × 31.1 in) (*Baltimore Museum of Art. The Cone Collection formed by Dr Claribel Cone and Miss Etta Cone of Baltimore, Maryland BMA 1950.215*) © ADAGP, Paris, and DACS, London, 1993

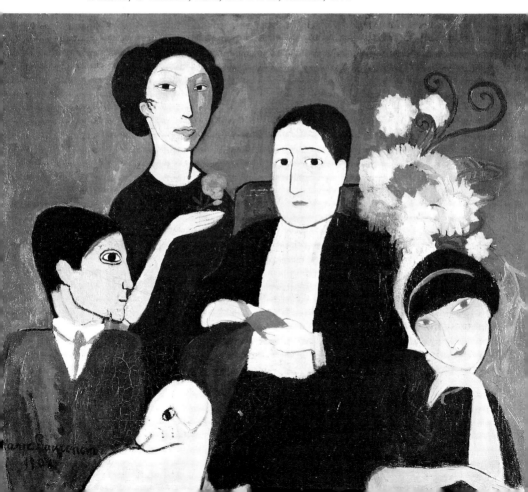

After the war her career as a painter, designer and illustrator was highly successful. Having made a decision to work independently of any particular painting style, she developed her persuasive approach based on a great affection and tenderness towards her favourite subject, women and girls. In her paintings she concentrated on the 'feminine' qualities of women, showing them in close, loving situations.

The post-war paintings have a very different, sensual quality in comparison with her pre-war work. The paintings completed while she was an active member of the cubist circle have more than a hint of the tensions she felt with the group. There is, in fact, little to suggest the calm, docile, wise 'muse' pictured by Rousseau. In one of her early paintings *Group of Artists* 1908 (Baltimore Museum of Art) the pyramid composition places her self-portrait at its peak while below her are Apollinaire, Picasso (with his dog, Frika) and Fernande Oliver, Picasso's lover. Oliver, who disliked Laurençin, is given an empty and vacuous look, while there is a distinct resemblance between Picasso and his sheep-like dog. Apollinaire, the largest figure in the group, though placed centrally, is still below Laurençin.

In her post-war paintings Laurençin employed delicate pastel colours for her portraits, mostly of women, and self-portraits. These sensitive, gentle and affirming images tended to earn her work the description 'distinctly feminine' and are in great contrast, for example, to the work of Picasso. His images of women exude the more obvious qualities of sexual attraction portrayed from an appreciatively heterosexual point of view. Her quiet and peaceful women have a subdued erotic quality with nothing in them to suggest that their affection for each other was based on sacrifice and denial. Instead they subtly achieve an equality, a state in which they have each surrendered their power to the other. *Women with Dove* 1919 (Museum of Modern Art, Paris) beautifully expresses this equality and balance. One woman, dark haired and wearing a shirt and neck-tie, holds a dove. By her side and resting on her shoulder is another woman wearing a feather boa. Soft pinks, greys and greens evoke the intimacy of their relationship.

There is little that is obviously 'feminine' in Gladys Hynes' angry painting *The Fowler* 1920 (Piccadilly Gallery, London) or in the satirical *Private View* 1937 (private collection). In *The Fowler* the sharp, piercing criticism of men and how they behave could hardly be more clear. Born in India but brought up in Cornwall, Hynes worked for some time with Stanhope Forbes at Newlyn in Cornwall and eventually settled in Hampstead, London, where she died. Though she responded to Forbes' enthusiasm for painting in the open air, her figures in *The Fowler* do not entirely subscribe to his view that painting should be about 'ordinary people' in harmony with their surroundings. Already in this painting she had moved from the outdoor realism he taught to a more classical

approach which incorporates elements of early Italian Renaissance art. The painting in its heightened sense of drama, prefigures her later interest in surrealism.

Set on an estuary, the picture shows the grim-faced male bird catcher kneeling on the floor, tightening his net in which three exotic birds are trapped. Looking on are the three graces (one of whom protectively holds a bird) whose quiet strength and harmony contrast with the aggressive determination of the fowler. Around him three other birds, equally exotic, flutter in disturbed excitement. Despite the calmness of the three women looking on at the event which they seem powerless to stop, there is a deeply disturbing quality to *The Fowler* which could be seen to embody some quality of aggressiveness of the male and the thoughtful sensuality of the female. *The Fowler* has trapped the birds and the implication is that he could trap the women.

Private View is a fashionable gathering at Tooth's Gallery, London, and pictures effeminate men and mannish lesbians. Only one visitor seems to be paying any attention to the collection of 'modern' art, the rest are involved posturing or posing. Of independent means, Gladys Hynes concentrated on drawing rather than painting. Her most noted works are illustrations for her friend Ezra Pound's *Cantos* (Yale University Library).

The theme of anger which runs through *The Fowler* is also expressed in the work of the South American-born artist Leonor Fini (born 1908), but she takes this further and shows her women as completely rejecting the power of men, sometimes even destroying them. Where Hynes in *The Fowler* suggests the collective and shared strength of the women through their tall grace and held hands, Fini states this much more directly both in her paintings of lesbians and in her use of androgynous figures. One of Fini's themes, as Estella Lauter has pointed out, is of relationships 'no longer based upon the principle of sacrificial love'.[11] Almost throughout her career and despite the changes in her style. Fini shows women who are protagonists, often involved in some complex drama or sinister ritual in which they are in charge. They champion the idea that woman can be as strong, perhaps stronger than man. In contrast the men are passive and helpless, mere shadows when compared with the vibrant women.

Fini's use of ancient goddesses and references to sorcery state the ways in which women have expressed their power in the past. By using such traditional roles, Fini is able to comment on the 'nature' of women, and to suggest how this could be changed. In her paintings of contemporary life the women are given pale, white faces surrounded by huge heads of hair, suggesting a dream-like, unreal quality. They are not so much about how women can or possibly should behave in male-dominated society, but radically question the way women are traditionally thought to be passive, gentle and giving in their relationships.

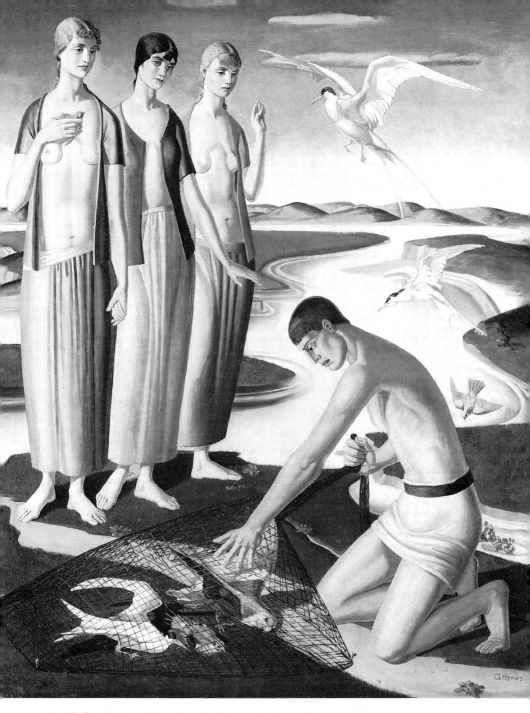

8.7 Gladys Hynes (1888–1958) *The Fowler* (c. 1933). Oil on canvas. 61 × 51 cm (24 × 20 in) (*Piccadilly Gallery, London*)

Much of Fini's work has elements of surrealism, a movement with which she has been identified since she moved to Paris in the mid 1930s, though she found the surrealists' attitude to women oppressive and reactionary. In an interview she said she painted directly from the unconscious without conscious thought of symbols, and in a later interview she explained 'All my painting is an incantatory autobiography of affirmation expressing the throbbing aspect of being.'[12] Nevertheless, in a statement published in 1977 she pointed out that 'the artist unconsciously transposes the complexities of actual life'[13] so no straightforward reading can be made of her work.

Born in Buenos Aires, as a child Fini was taken by her mother to live with her maternal grandparents in Trieste to escape the tyrannical behaviour of her father. She taught herself to draw and paint, finding great interest in the skulls and skeletons discovered on the beach. In Paris in the 1930s, she met Max Ernst and Man Ray amongst other artists, later becoming friendly with Pavel Tchelitchew in New York. She worked in Paris with Jean Genet, and in 1950 he wrote her a letter (published as 'Lettre à Leonor Fini') about her painting. Responding to her violent imagery he identified in her work an element of restrained savagery. Some of her portraits he described as having 'cruel kindness' in that they seek unmercifully to tell the truth. This ambiguity, this unrestrained savagery is implied very directly in the painting of two lesbians in *Le Long du Chemin*. Two women sit opposite each other in a railway carriage, one lies back in ecstasy, her legs around her partner who sits opposite. The partner has a look on her face which would suggest that she is about to make love with great violence or tenderness with the other. It is an erotic encounter which credits female desire as being just as passionate and powerful as that of males.

In paintings produced in the early 1970s, the women not only become more powerful but take on more sinister roles in which they are involved in menacing ritual. The women are never made to disguise or play down their female physical characteristics. They have attractive, firm bodies and long flowing hair which adds to their mysterious activities, making them even more disturbing, for they are not behaving as women are thought to, being neither protective nor kindly. In *The Sending* 1970 (Artist's collection) three naked women tie up a large, black, worm-like object with translucent material. We do not know what the parcel contains but its lumpy shape is vaguely reminiscent of a penis. In another painting of the same period, *The Strangers* 1968, three women peer into a goldfish bowl in which are pickled bits of human body. Though it is not clear if these pieces are of a male or female, there is the implication that it is men whom the women in her paintings are out to destroy. 'The stranger' has ended up in pieces. It may be a coincidence that Fini produced these paintings a year or two after the publication in the United States of Valerie Solnas' *SCUM Manifesto* in 1968.

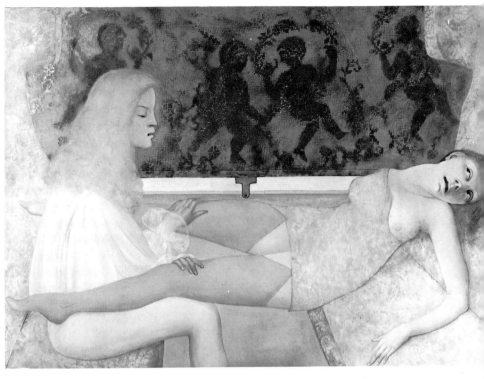

8.8 Leonor Fini (b. 1908) *Le Long du Chemin* (1966). 130 × 89 cm (51 × 35 in)
(*Artist's collection*) © DACS, London, 1993

8.9 Leonor Fini (b. 1908) *Les Etrangères* (1968). 116 × 81 cm (45.6 × 31.9 in)
(*Artist's collection*) © DACS, London, 1993

The changes in the imagery used by Fini in her paintings, including the portrayal of women as becoming more powerful while men moved from idealised masculine types to effeminate, even androgynous, figures, has been clearly analysed by Estella Lauter. Fini's suggestion of female supremacy, of the possibility of a woman's world, certainly does not set out to idealise the female but rather to liberate women from the confines of a crippling stereotype.

The problem of rejecting sexual stereotyping whilst avoiding being dismissed as an eccentric was one which many women who either lived alone or with other women had to deal continually. Leonor Fini accepted and used the traditional beauty of women to add great zest to her pictures, as did the Polish-born artist Tamara de Lempicka (1898–1980). The image she created of herself, cosmopolitan, elegant and haughtily beautiful, epitomised the glamour and hard sophistication of the international scene in the 1920s and 1930s.

A self-portrait in which she shows herself in ski-clothes against the backdrop of the snow-clad slopes of St Moritz was used on the cover of the exclusive women's magazine *The Dame*. An equally dramatic self-portrait of her behind the wheel of an expensive car wearing a tight-fitting hat with a few blonde curls protruding, a pale complexion and crimson lips, appeared on the cover of an issue of *Galerie des Arts* (No 188, 1979) dealing with the 'roaring twenties'. The caption described her as 'the symbol of women's liberation, 1925'.

Her paintings were dramatic and theatrical, her life even more so. She was born in, or near, Warsaw and little is known about her parents (family name Gorska) other than that they had two daughters, Tamara and Adrianne (who became an interior designer) and had connections in St Petersburg. While still in her teens, Tamara married Tedeusz Lempicki and lived with him in St Petersburg until the revolution of 1917 when they moved to the West, settling in Paris.[14]

After the birth of their daughter, Kizette, she studied painting for a time with Maurice Denis who methodically taught her how to paint, and she later studied with André L'hôte, the pioneer of synthetic cubism who was a more important influence on her. Keen to continue her career, she chose to remain in Paris when her husband returned to Poland. In 1934 she married Baron Kuffner, a wealthy aristocratic Hungarian.

She established her reputation in the 1920s and 1930s as a fashionable painter, taking as her subjects the aristocracy and royalty as well as the famous and handsome men and women of the time. Her work had in it elements of cubism, using large areas of colour with accented geometrical forms combined with a feeling for the classical and academic style of mannerism. Pontormo was an important influence. The men she painted were handsome and often feminised, shown as *chic* fashion models wearing well-tailored suits, tuxedos, and even full dress uniform. They

are dressing as much for themselves as for others and suggest the empty vanity of peacocks.

The women, in contrast, appear sensual and voluptuous; almost overloaded with sexual desire they seem to flaunt their pleasure in their own bodies. Some critics, seeing a reference to the work of Ingres, referred to her style as 'Ingresme pervers'.[15] Her paintings exude wealth and power and describe a society unique to the inter-war years. For her female nudes, de Lempicka chose women who possessed physical health and vigour and then posed them in such a way as to suggest that they are willing victims, inviting sexual overtures without any other thought in their heads.

Andromède 1929 (private collection, Paris) kneels seductively on the floor, her wrists in chains, posed against a backdrop of neoclassical architecture, the rounded curves of the body emphasised by the angles of the setting. *Dormeuse* (private collection, Paris) lies back drowsily, a passive but powerful sexual invitation. 'The nudes exude carnality, coming close ... to the bounds of the permissible.'[16] What we do not know and what is not made clear is whether these sexual overtures are being made for men or women. In their explicitly erotic poses they seem like classical or contemporary pin-ups, but an element of satire, a note of excess celebrates and slightly satirises the whole situation. The Spanish dancer, for instance, seems consumed by her physical passion in the dance, as it is expressed through the angular composition.

It is her images of women together that are more suggestive of passionate and sexual relationships. *Printemps* (private collection, Paris) and *Deux Femmes* (Li Sellgren Collection, Paris) show women are more obviously glamorous while *Les Amies* (Galerie du Luxembourg) are more 'modern' in appearance. The two women who embrace have short-cropped hair and dark, plain clothes. They are in a room with the number '47' marked mysteriously twice upon the wall. The images of women as sexually desirous and desiring produced by de Lempicka in the inter-war years and painted with such intense passion and concern contrast with the more pious subjects of nuns and children.

In 1939 at the onset of war, de Lempicka fled with her husband to the United States, eventually settling in Houston, Texas, with a 'rustic' cottage in Beverly Hills. For some years she continued to pursue her career as a painter, having exhibitions of her work in New York, Pittsburgh, Los Angeles and Milwaukee. But with the climate of opinion in favour of abstract art, she ceased to show until the 1970s when the mood changed. In 1972 the Galerie Luxembourg in Paris mounted a major retrospective exhibition of her inter-war paintings, once again to a warm reception; the art world was again responsive to her particular themes.

Artists including Tamara de Lempicka, whose work was about a particular sort of woman, did not feel able to show it in a climate which

was both anti-figurative and would view these women and the lives they lived with prurient interest. Other artists found their work literally banned. In Germany when Hitler came to power in 1933, the cultural and ideological emphasis was on the image of the happy, healthy family. Other sorts of pictures including those by Jeanne Mammen (1910-1976) were banned. In the cosmopolitan atmosphere of Berlin in the 1920s she was able to express many of her own interests in her art, including homosexual relationships between women and her socialist concerns. She lived and studied in Paris where she had a 'carefree childhood and youth'[17] but the family were forced to leave France at the outbreak of war, losing all their possessions. After the war she shared a studio with her sister Adeline and started to obtain work from magazines. Her sharp satirical style soon gained her a high reputation. In her most productive period (1924–33) she not only worked for various fashion and satirical magazines but produced her own watercolours and provided illustrations for lesbian and homosexual magazines and books. As the writer of a catalogue notes: 'The thing which most interests Jeanne Mammen, the thing which fascinates her from the artistic point of view is the woman; the woman the way she presents herself, the way she dresses, the way she behaves – in short the woman as part of society.'[18]

Though Mammen painted and drew other subjects, it was woman with whom she was concerned, and many of the women she painted were from the diverse lesbian subculture of Berlin. Single portraits of women often showed the 'new' look of the time, collar and tie and cropped hair. Other studies, usually carried out in watercolour, depicted women together in a wide range of social situations. Many are engaged in recognisable female activities such as buying a hat, sitting in a cafe, having a manicure or dressing. Some bring together women who are much the same age while others contrast an older with a younger woman. In a watercolour *The New Hat* (early 1920s) an older woman whose clothing and bearing suggest wealth places a hat on the head of a much younger woman whose face is dead and expressionless. Her look conveys resentment rather than pleasure with what is happening.

The New Hat is 'innocent' in that it is apparently about the purchase of a new hat by two women yet it also contains with it a suggestion of a more complex power relationship between the pair. The older woman almost seems to be pressing her seated partner onto her bosom and looks self-satisfied and content while the younger woman seems to be disinterested in the whole proceedings, as if the choice of either hat or partner has little to do with her. Are they 'mistress' and 'servant', mother and daughter, or older and younger lovers?

8.10 Djuna Barnes (1892–1982) Newspaper illustration (c. 1915)

8.11 Jean Mammen (1890–1976) *The New Hat* (c. 1920–25). Watercolour and pencil (*Private collection*) © DACS, London, 1993

For the lesbian clubs, Mammen produced illustrations for various meetings and organised activities. Designs for Curt Morek's *Fuhrer durch das 'lasterhafte' Berlin* (Guide to 'Naughty' Berlin) showed the stilted atmosphere of upper class gatherings as well as the antics of wild parties in the clubs in the poorer parts of the cities. For Magnus Hirschfeld *Sittengeschichte der Nachkriegszeit* (Moral History of the Post-War Period) she did illustrations with such titles as *In the Woman's Club* and

8.12 Jean Mammen (1890–1976) *Two Women in the Club* (c. 1930). Watercolour.
42 × 30.4 cm (16.5 × 12 in) (*Private collection*) © DACS, London, 1993

Masked Ball. Her use of 'femme' and 'butch' women suggests how widespread such roles were.

In 1930 Mammen was commissioned to do ten colour lithographs on Variations of Lesbian Love for the book *Lieder der Bilitis* (The Songs of Bilitis) by Pierre Louys. It was an ambitious project, for the lithographs were not intended as illustrations for the text but as original works on the theme of contemporary love relationships between women. The book

was never published. The Nazis banned the project in 1933 and during the war much of her work including these designs was destroyed. The material that did survive deals explicitly with the erotic intimacy that can exist between women, and how social patterns of wealth and power influence sexuality. In *Jealousy* one woman kneels on the floor behind her lover, her arms wrapped tightly around her hips. The other woman gazes into a mirror with a look of disinterest, even annoyance at the humiliation of her partner's adoration. Other works such as *The Make-up* and *Siesta* deal with similar conflicts of tenderness and denial.

With the rise to power of the National Socialists, not only was the book *Lieder der Bilitis* banned but also all of the magazines for which Mammen worked. As a mark of protest she refused to continue to work realistically since realism was made the officially recognised art style, but instead painted non-figuratively, using a cubist approach. All abstract art was labelled 'degenerate' by the government and was not allowed to be shown. The Second World War brought further difficulties as did the post-war years, but in the 1950s she started working again and continued until her death in 1976.

Against the social and sexual freedom of Paris and Berlin, Britain seemed particularly quiet and domestic. There were advantages to this in that women could hide behind conventional 'women's relationships', but there were no well-established lesbian bars or subculture to offer support. But the group of artists working in Edinburgh before and after the First World War did tolerate unconventional sexual relationships even if they did not approve of them.

In 1902 André Raffalovich had moved to Edinburgh from London, settling with John Gray who had been one of Oscar Wilde's lovers. They attracted around them artists among whom were Eric Robertson (1887–1941), Cecile Walton (1891–1956) and Dorothy Johnston (1892–1980). Robertson, a bisexual who acquired a reputation as a 'dangerous and subversive immoralist',[19] had relationships with the two women, both of whom he declared he loved. They had wild bohemian parties and it was generally accepted that they were free to explore sexually.

Cecile Walton was born in Glasgow. Her father, a landscape and portrait painter, moved to London in the 1890s and lived in Cheyne Walk, Chelsea. Inspired by the work of the pre-Raphaelites, in particular by Burne-Jones, she did not respond to the work of Edinburgh artists when they moved back there some fifteen years later. In 1910 she formed a close friendship with Dorothy Johnston and a year later, together with Robertson, they became an almost inseparable trio. After the war a close relationship was established between Anne Finlay, a student at Edinburgh School of Art, and Dorothy Johnston.

From 1919 the Edinburgh Group started holding exhibitions under that title. Walton, who had married Robertson, was influenced and stimulated

by his work and ideas. A series of twenty watercolour illustrations to *Polish Fairy Tales* 1920 included 'The Truant Wife is Captured'. The couple, both with wings, fly off. Though the 'male' firmly holds the female, his sex is not without ambiguity. Her painting *Romance* 1920 (private collection) is a remarkably forthright self-portrait in which she shows herself lying half naked on the bed shortly after the birth of her second son Edward. Her first son, Gavril, stands at the end of the bed.

Her marriage failed and in 1923 she was separated from Robertson, shattered and disillusioned. In the summer she joined Dorothy Johnston in Vienna but her painting was restricted and she worked in the theatre and in BBC radio.

The concept of the 'New Woman' which had inspired and nurtured radical views and sexual exploration changed radically in the post-war years. Emphasis was once again on family life and attitudes to 'deviant' sexualities were less sympathetic, while women in general were encouraged to take careers as wives and mothers. The absence of any feminist movement with regard to women artists is well demonstrated by the reviews of the work of the Scottish artist Joan Eardley (1921-1963). Many writers concentrated on whether her work was feminine or not (see Ethel Walker's comment, page 108) and most reviewers wanted to define it as an expression of 'feminine sensibility'. One even professed that no matter what, he knew it was by a woman artist.[20] Despite its unconventional subject matter and obvious power to convey the mood and force of the weather, it seemed that to many critics it was essential that Eardley's painting had to be identified as being by a woman.

A special category had to be established. The link between Eardley the person and Eardley the painter is neatly summed up in the catalogue of a London exhibition. Describing her sea paintings and landscapes, the catalogue claims they reflect 'the very depth of her being, they also exactly combine her own qualities of masculine strength with vision and feminine sensibility'. The puzzled writer in *The Scottish Review* (vol. VI, no. 2, pp. 2-6) could only explain the 'strength' of Eardley's painting as 'just one of those curious inversions sometimes found in women artists'. The writer could not resist speculating as to whether the artist was 'a slender and willowy blonde' or a 'straight-browed, strong-jawed brunette with a physique equal to that of men'. To the reviewer it seemed important to know, yet such speculation with regard to men is unheard of.[21]

The question of whether her paintings were 'feminine' dogged her throughout her life. In 1949 a reviewer of a Society of Scottish Artists exhibition compared her paintings with those by her friend Margot Sanderson. 'Miss Sanderson is in many ways a recognisably feminine painter while Miss Eardley displays a virility that few young male painters could match.'[22]

Joan Eardley would have found little help from society's attitudes

towards any unconventional expression of female sexuality in the post-war years and her own traumatic family background did not provide much support. She was born to Scottish parents and lived for a time in Sussex; her father committed suicide when she was seven and the family consisted of her young sister, her mother, an aunt and other female relatives. The family moved to Glasgow at the beginning of the war and Joan Eardley was awarded a place at the Glasgow School of Art. As an art student she soon established her independence. Her long hair was cropped and her kilt abandoned in favour of hard-wearing trousers and jerseys. With Margot Sanderson, a fellow student, she went camping on the quiet roads around Loch Lomond.

After college her training as a teacher was delayed because of the war and she had to find useful work. She became a joiner's labourer and enjoyed the contact with natural materials and the handling of machines and tools. All were to feature one way or another in her paintings. The war over, Eardley settled in the city, making the life of the Glasgow tenements her favourite subject matter. Interiors of homes and particular portraits of children, usually ragged and poor, suggested a strong sense of identification with the poor and deprived of the city. She became particularly friendly with one household and was treated by them as a member of the family. She travelled abroad with women friends, drawing and painting them, and painted portraits of other women. Only rarely did she paint a man. There was one notable occasion when she painted a sleeping male nude, using her friend Angus Neil as a model. When displayed in the Society of Scottish Artists exhibition in 1955 the large painting received the banner headline 'The Sleeping Man Has (Ooooh!) No Clothes'.[23] Given that in the 1980s Scottish art school male models continue to pose in a jock-strap, the nude male was something of a sensation. But for Eardley, whose subject matter was relatively conventional, the male nude had little or no significance as a sexual object for her but was merely a subject she wanted to paint.

Changes in Eardley's life at the beginning of the 1950s resulted in her eventual move from Glasgow to the tiny fishing village of Catterline on the west coast of Scotland. Her father's death continued to trouble her and in 1951 she wrote 'A lonely and dark despondency is with me.'[24] Painting was the major outlet for her feelings, but as her biographer has pointed out, this also increased her loneliness. Her work went largely unreviewed and unrecognised.

In Catterline she became obsessed by the weather, wanting to paint it in all its moods. Like Turner and Homer, she was prepared to suffer any

8.13 Joan Eardley (1921–63) *Street Kids* (c. 1949–51). Oil on canvas. 101.6 × 73.7 cm (40 × 29 in) (*National Galleries of Scotland, Edinburgh*)

discomfort to observe it in full spate, lashing herself and her easel down so she could work in the fiercest storms. The result is a powerful evocation of wind and rain as well as heat and sun. Rarely do people appear in these landscapes.

Ironically her work began to receive serious regard shortly before her death, but with incurable cancer she had no strength to respond. She was unable to attend the Scottish Royal Academy to receive the award of Academician – as one of the few women to be so honoured.

After the Second World War, the concept of 'The New Woman' found little if any sympathy. Women were once again forced back into the role of housewives and mothers; lesbianism ceased to be an issue because to all intents and purposes it went underground, along with any organised or cohesive discussion of feminism. The issues and politics taken up by women in the 1920s and 1930s had to wait until the 1960s and the growth of the Women's Movement before they were again taken seriously.

9 · The Divided Subject

Visiting America in 1929 for the first time, the young society photographer Cecil Beaton met Noel Coward who advised him how to behave and what clothes to wear if 'doors' were not to be closed to him. 'Your sleeves are too tight, your voice is too high and precise,' Coward said, adding that though 'one would like to indulge one's own taste, it is overdoing it to wear tie, socks and handkerchief of the same colour. I take ruthless stock of myself in the mirror before going out. A polo jumper or unfortunate tie exposed one to danger.'[1] The danger implied rather than stated was a tacit acknowledgment between the two fashionable artists that their homosexuality would not hinder them in their desire for social acceptability or success in their careers if they were 'discreet'. While the contemporary popular song declared that *Anything Goes*, it did not apply to public declarations of homosexuality. Recalling the 1920s and 1930s in New York, Charles Henri Ford thought that homosexuality 'was a matter for private conversation—it wasn't talked about'. Protected by wealth and social position, he argued that there was no need to make an issue of his sexuality, or as he put it, he had no 'axes to grind'.[2] This was despite the fact that the novel he wrote with Parker Tyler in 1931, *The Young and the Evil*, about homosexual life in the depression era of New York village, was banned and was not published until the 1960s.

Other artists also remembered the inter-war years as a time when being homosexual was 'not a problem' and among the Bright Young Things even had a modish quality. In England within the fashionable circles around such talented and successful women as Edith Sitwell and Edith Oliver, artists gathered. These included Cecil Beaton, Rex Whistler and Oliver Messel, and the 'foreigners' Pavel Tchelitchew and Gregorio Prieto who enjoyed the privileges and freedoms of a cultivated and

sophisticated society, accepting the limits they themselves seemed prepared to define.

Against a background of appalling war in Europe, a crippling economic collapse and the rising menace of fascism, some artists found the comfort of earlier styles and attitudes better suited to their needs. The ideas of the aesthetes continued to offer an identity to some of the new generation of artists including Glyn Philpot and Vivian Forbes, while the attractions of the eighteenth century Age of Reason with its implication of the natural order of things seemed for Rex Whistler and Martin Battersby preferable to contemporary styles. Other artists including John Banting and Edward Burra could not and would not ignore the terrible forces of war and fascism and the philosophy of the surrealists in their work.

In America a small group of deeply serious, committed artists were resolutely committed to precise figurative compositions placed in contemporary allegorical political and sexual situations. Paul Cadmus, Jared French and the photographer George Platt Lynes refused to follow the mood of abstraction. They wanted to express some homoerotic feelings and developed figurative styles in which this could be done.

In England in the first decades of the twentieth century the latter-day aestheticism of Ricketts and Shannon continued to attract a few followers. They thought when they met Glyn Philpot (1884-1937) around 1911 and later his lover Vivian Forbes (1891-1937) that they had found two enthusiastic supporters. But these proved to be unwilling disciples. Philpot and Forbes met during the First World War and formed a close relationship which lasted for nearly twenty years. When Philpot died suddenly of heart failure, in utter despair Forbes took his own life the day after the funeral. Philpot, the more gifted artist, had already been influenced by Ricketts by the time he was twenty, but also responded to the classical and historical work of Shannon. Later Philpot and Forbes took over their flat in Lansdown House. At this time Philpot was not attracted to the post-Impressionist and modernist styles and for his own painting preferred a more literary approach.

Commercially Philpot's portraits were a great success. Many commissions were received, the most esteemed of which was from the King of Egypt (1923-1924).[3] Overawed perhaps by the subject, Philpot failed to respond with any enthusiasm and the resulting portrait is dull and conventional, though the visit to Egypt was enjoyed. Influenced by Sargent, Philpot's portraits were in every sense skilful but often with little flair. In contrast his portraits of friends and male negroes painted from his own interest had a vigour and sensitivity often lacking in the more formal compositions. He continued to paint and, notably, sculpt negroes throughout his life.

A typical painting of this period, the mythological subject *Melampus*

and the Centaur 1919 (Glasgow City Art Gallery), shows his admiration for Shannon's work. The two well-modelled and muscular men set in a dry, arid landscape also recall the muscular figures of Michelangelo and, though formally composed, have an oddly exposed quality. His large ambitious painting The Coast of Britain c. 1919–20 (private collection), which aimed for a deeper spiritual quality, showed naked men on the seashore. Its mood was sombre with a powerful sense of a menacing stillness. Visits to North Africa introduced him to the exotic life of the middle and near East and inspired paintings set there. An ambiguous study of two men in what could very easily be a sexual relationship occurs in L'après-midi Tunisien c. 1921 (private collection). As Richard Shone comments in The Century of Change, the two Arab men lying facing each other on a bed have a 'wry suggestiveness' which would have been recognised by a small number of those who visited the Royal Academy where it was shown in 1922.

The 1920s were a period of success and consolidation. In 1923 Philpot was made a full member of the Royal Academy and received private and public commissions. These included the design of a decorative frieze for the dining room of Sir Philip Sassoon's new house, Port Lympne, and the ceiling of the Queen's Dolls' House. But despite popular success, by the end of the decade Philpot had a growing dissatisfaction with his painting and his life. The 1926 General Strike, the Great Depression and the growth of fascism in Europe had given rise in him to a new political consciousness. Equally he began to have doubts about the endless stream of portrait commissions and the conservative nature of his painting. His feelings were brought to a head in 1930 when he was invited to sit on the Award Jury of the Carnegie International Exhibition. Henri Matisse was a co-juror and a gold medal was awarded to Picasso. Concerned with the aesthetic problem of loosening up his style and by a new political awareness, Philpot moved his studio to Paris and made visits to Germany. He grappled with the problems of incorporating into painting a horror of fascism and a fascination for Paris nightclubs. There were also difficulties in his relationship with Forbes, who became more dependent on Philpot. Philpot's involvements with other men also caused tensions.

In England his change in style and choice of subject matter seemed to conservative critics sudden, spectacular and unsatisfactory. Even the R.A. Committee asked him to withdraw a picture in 1933 which included a couple about to make love. In an article in the June 1933 issue of Apollo he wrote that 'the change has been towards a simplification of technique, a sacrifice of "expected" qualities of surface in order to obtain more rapidly a flexibility of handling and a greater force of accent'. The sober tones of his article, with its emphasis on stylistic rather than political or subject concerns, belied the deep anxiety of his quest. It also played

down his attempt to unite his work as an artist with his awareness of
current economic and political concerns. The allegorical and religious
themes and the portraits took on a new freedom and strength. Stylistic
influences were taken from contemporary artists including Picasso and
George Grosz but perhaps the greatest change was the expression in his
work of his own psychological involvements and interests. In *Fugue*
1931–2 (private collection) three male figures, one nude, are involved in a
tense and unexplained triangular relationship around a central formal
statue. The fact that one of the figures seen in dramatic profile is of his
current boyfriend suggests that the complex situation describes his own
situation with Forbes. His representations of the bar and club life which
may be homosexual such as *Bistro, Havre* 1937 (Robin Duff of
Meldrum)[4] which depicts the inside view of a crowded sailors' bar,
suggests the delights and pleasures of such places. Paintings of acrobats
such as in *Acrobats Waiting to Rehearse* 1935 (Royal Pavilion Art
Gallery and Museum, Brighton) or ballet dancers are sensitive studies of
solid and real figures and show a concern for muscular and handsome
men.

Some of his cynicism with regard to the desperate political situation in
Germany and the apparent general indifference to it is conveyed in
Weight Lifting, Berlin 1931. Here the heads of the audience are
pictorially equated with empty bubbles which are in turn compared with
the weights in the hands of the brutal looking weight-lifter, empty-
headed onlookers being duped by skilful performers.

Paintings with classical themes suggest some of his own torments.
Oedipus Replying to the Sphinx 1932 (National Gallery of Victoria,
Melbourne) uses the stylistic convention of art deco to show Oedipus in
a G-string with the head in profile and shoulders presented frontally.
Oedipus, about to provide the death-dealing solution to the Sphinx,
carries a forceful contrast between an astute intellect and a cold and
bestial brutality. 'Let us hope', commented F. Gordon Roe in the
Connoisseur (vol. 90, 1932), 'that Mr Philpot can answer the riddle his
own sphinx has set him.' Art critics and reviewers were in general
unsympathetic to Philpot's new work. R. H. Wilenski in *The Studio*
(November 1932) lamented the fact that his paintings could 'no longer
make excellent points of focus in beautifully proportioned and elegantly
furnished rooms'.

During the 1930s Philpot suffered from heart trouble. In November
1937 he underwent a slight dental operation that required anaesthetic and

9.1 Glyn Philpot (1884–1937) *Acrobats Waiting to Rehearse* (1935). Oil on
canvas. 115.5 × 87.6 cm (45.5 × 34.5 in) (*The Royal Pavilion Art Gallery and
Museum, Brighton*)

he died the following day of heart failure. The news of his sudden death was taken to Vivian Forbes in Paris and a few days after the funeral, prostrate with grief, Forbes committed suicide. The depth and extent of Forbes' love for his friend is movingly conveyed in his love poems (private printing), all dedicated to Philpot.

Unlike Philpot, Forbes had had no professional training as an artist but his interest in literary and artistic pursuits were encouraged by Philpot. He was twenty-three when he met Philpot, seven years his senior. Under Philpot's guidance and encouragement, Forbes slowly developed his own style, but often showed influence from Philpot who obtained commissions for him. Like Philpot, he felt a growing dissatisfaction with his work towards the end of the 1930s. His visit to America as a member of the Pittsburg Jury of Award in 1929, brought him in contact with contemporary art and an awareness of his own insularity. With Philpot in France his own work underwent rigorous changes in the search for a style which lay closer to his desire to be more fully expressive of himself. He stayed on in Paris when Philpot returned to London.

Ever aware of the sexual and erotic themes underlying many 'innocent' everyday occupations, Forbes was at his best with quietly suggestive subjects often carried out in watercolours. At a memorial exhibition at the Redfern Gallery, London, in 1938 titles such as *The Athlete*, *The Goal-Keeper*, *Greek Youth* and *St Sebastian* suggest a physical awareness and a sexual ambiguity.

However limited the role-model of the aesthete is, it continued to offer artists a means of recognising and channelling homoerotic feeling into art (and still does). Ralph Chubb (1892–1960), artist and printer, saw his idealised love of youth as something unique to himself and resisted being part of any circle in which he could share his artistic or sexual interests. In his determination to retain his own vision unimpaired, he even went so far as to print his own books and drawings rather than risk them with a commercial printer.

After studying at Selwyn College, Cambridge (1910–13) he served as a soldier in the First World War before being invalided out. A period at the Slade School of Art followed and during the 1920s he exhibited his oils and watercolours at London galleries. *Ganymede* was shown at the Royal Academy in 1925.

The recurring theme in his work was a growing awareness and espousal of his love for boys. This was a fantasised rather than a real love, which incorporated a form of 'spiritual democracy' similar to the ideas expressed by Whitman and Carpenter. His persistent call for a return to 'nature' was based on his belief that there is an intrinsic love between men and that this dynamic, divine spark is within everyone. The realities of the physical love of boys he hoped would be transcended by

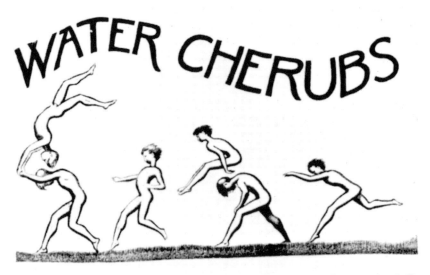

WATER CHERUBS

BY BAPTISMAL STREAMS

which is

The Crystal Age of Innocence

Christ in You & Christ in Me!
Christ in everything we see!

ARGUMENT

The true world of freedom and love is a crystal mirror, wherein Ra-
phnos, Sun of Life, beholds His own image eternally manifested in the
forms of naked boy-angels in perfect scenery. Christ is the "heavenly
Mercury". Our universe is the opaque backing. "Get thee *behind me*, most
useful and necessary Satan!—It is thy true place!" O Men, are you not suf-
fering him, against his will, to cloud the *front* of your mirror? See no
more "as in a glass darkly", I charge you! Learn of my happy boys! All is joy & delight!

9.2 Ralph Chubb (1892–1960) *Water Cherubs*, subtitle page (1936). 38 × 28 cm
(15 × 11 in)

religious and mystical fervour. Aware of his physical as well as his spiritual desires, the experiences of childhood and of youth were to remain as visions which he was continually seeking to recreate pictorially. The sight of a group of naked boys swimming, his passionate desire for an unknown choir boy, his first love affair when he was eighteen with a boy three years younger than himself and the witnessing of the death in battle of a young soldier provided images which he attempted to recreate throughout the rest of his life.[5]

Chubb hated war and saw death in battle of the soldier as evidence of the general indifference to the beauty of English boyhood. In a stirring, thundering message, he identified with working-class youth and sought to act as their redeemer. 'My staunch young brothers', he wrote, 'when you sweat at the mills I am with you.'[6]

Throughout the 1920s, Chubb experimented with various art forms to express his ideas. These included oil and watercolour, pencil sketches, woodcuts, hand and commercial printing as well as poetry and prose. In the catalogue introduction for his exhibition of watercolours at the Goupil Gallery in 1929 he wrote in one version an explicit paragraph extolling the virtues of boy-love. 'I believe absolutely in masculine love — boy-love in particular — of which I claim to be an apostle and a forerunner.' As precedents he listed David and Jonathan, Harmodius and Aristogeiton, Christ and the youthful John, Plato, Socrates, Michelangelo and Shakespeare. Letters of support from other lovers of youth were not acknowledged and he made no attempt to share and nurture his feelings.

From then on he did little painting and no commercial printing, concentrating on reproducing his own work himself so that without hindrance he could create his own fantasies and incorporate mystical messages. In his early work he showed full-length illustrations of slim, dark boys like slim-eyed sylphs. Later these were replaced with blond, curly-haired, tough, overdeveloped adolescents with bulging muscles. In the post second world war years, bitter and disillusioned with his unreceptive audience and with piles of unsold folios, though dimmed with time his vision remained as important as before.

Tucked away from the world, Chubb was determined to keep his vision of perfection even to the extent of refusing to acknowledge that other boy-lovers could experience the same desires. In contrast other artists continually sought the limelight and were drawn to the splendour and conceit of 'high society', even to the point of tailoring their art accordingly. Cecil Beaton (1904–1980) moved from gifted amateur to acclaimed professional, enjoying as much publicity as possible. He began by painting pictures in the style of the English post-Impressionists and by taking photographs in his mother's drawing room. 'Most photographers don't use their imagination. I'm completely disinterested in the technical side of photography. All I want to do is make my sitters look beautiful,'[7]

was his philosophy which he applied to most of his work.

Born into a wealthy English family, Beaton was educated at Harrow School and Cambridge. Experiments with his camera produced some fascinating effects. Using his debutante sisters and their friends as models he posed them in fantastical settings concocted in his mother's London drawing room. Patronised by the Sitwell family, he was encouraged to

9.3 Cecil Beaton (1904–1980) Photographic collage of couples in Edwardian dress with muscle man (Courtesy of Sotheby's, London)

take photographs and by the end of the 1920s he had become recognised as an established society portrait and fashion photographer. A visit to the United States secured his career with a large commission from *Vogue*. His artful use of backgrounds and his careful compositions ensured that his sitters, who were mostly society women, were presented within the mould of pretty if sometimes startling femininity. His clientele of rich and often Royal patrons consolidated his success. Beaton showed women how they wanted to look, after touching up prints to make them more glamorous. Apart from some forays into theatre design (his last and greatest success was for the musical *My Fair Lady* 1958), he continued taking photographs to the end of his life, using variations on the formula of careful composition and the desire for some preconceived notion of theatrically derived beauty. Subtle but persistent homoerotic elements give his portraits of friends such as Rex Whistler and Noel Coward an extra theatrical dramatic quality.

Even the horrors of war were treated as a theatre against which he could produce well-composed and distinctly tasteful images. Along with Coward, he was a convinced patriot and determined to make a contribution to the war effort. His friend Kenneth (later Lord) Clark, then serving in the newly constituted Ministry of Information, suggested that he be employed as an official photographer. Beaton's reputation gained him special status which meant that he was better paid than other photographers, had a wider freedom to interpret his commissions and was allowed to credit his own work. In his photographs of the Home Front, the recurring theme of fervent patriotism recorded the destruction of the Blitz, while on foreign assignments he travelled to the Middle East, India and China and his photographs took on a dramatic quality infused with exoticism.

The debris of war, of wrecked tanks, abandoned equipment and the remains of aircraft carefully silhouetted against bright skies or stretches of desert conjure up the acceptable face of the destruction of war. There is little evidence of injury, of messy wounds or smashed bodies in his photographs and in their unreality they continue his reluctance to 'engage' with the pain and anguish of life. Even in war-torn poverty-stricken China, Beaton could see the aesthetic side, finding to his delight that 'every type of Chinese face seems to have the plastic beauty which is entirely photographic, whether he is an old member of the university, a scholar or professor at the universities, or a poverty-stricken child with a fluttering paper fan'.[8]

Like Beaton, his friend and fellow artist Rex Whistler (1905–1944) found it easier to picture life as a series of light-hearted frolics in which little need be taken seriously. Despite his close friendships with homosexual men and his own 'extravagant' manner, Whistler's own sexuality is as ambiguous and unstated as his art. Born at Eltham, Kent.

Whistler went to Haileybury (1919–1922) where the teachers considered him to be intelligent rather than intellectual. Industriously he pursued his artistic interests, turning out endless drawings, mostly funny or grotesque, rather than working for academic success. At seventeen he enrolled at the Royal Academy Schools in London but the formal academic training did not suit his more flamboyant, carefree approach. After a term he moved to the Slade School of Art, London, studying there from 1922 to 1926. Little concerned with the movements and ideas of contemporary art, Whistler had a deep and tender yearning for a Golden Age, modelled on the eighteenth century ideal of classically inspired motifs and style. The neat, careful order of the temple gardens at Stowe and Wilton appealed to him as did the paintings of such artists as Claude, Poussin, Tiepolo, Watteau and Boucher and the architecture of Vanbrugh. While his fellow students tried to reconcile the various contemporary stylistic movements of European art, Whistler turned his back firmly on the school of Paris, choosing instead the ornate fantasies of Italian and South German baroque and rococo.

All of these influences merged in his first public commission, a mural *The Expedition in Pursuit of Rare Meats* for the restaurant room of the Tate Gallery, painted 1926–27. The pastoral narrative of a hunting party leaving the Ducal Palace to travel the countryside is delightfully told and recalls some of the qualities of Bunyan's *Pilgrim's Progress*. It has an added satirical element which makes it as much an 'entertainment' as a 'serious' commentary. The combination of wit, romanticism and light-hearted fantasy ensured its success and many other commissions followed. Among the best are those for Sir Philip Sassoon at Port Lympne, Kent, 1933, and for Lord Anglesey's dining room at Plas Newydd in which the shape of the room has been completely altered by means of a *trompe-l'oeil* ceiling and false perspectives on the walls.

Versatile as an artist, Whistler accepted commissions for posters, advertisements, magazine covers and book illustrations, but his greatest success came with designs for theatre sets for revues, plays and operas. In all of his work the splendour and order of the eighteenth century is recalled. In a self-portrait painted about 1933 (Tate Gallery) he places himself in front of an eighteenth-century landscape with a grotto in the middle distance. A more serious painting, *In the Wilderness*, is a wistful and as it turned out an accurate prediction of his own death a few years later in the war. St John the Baptist is depicted as a naked youth leaning on a parapet, contemplating and touching a skull. In the background are Roman ruins set against a stormy sunset. The model was Jim, an evacuee from Portsmouth who was billeted at the artist's home in Salisbury in the early years of the war.

With 'an easy effortless charm' Whistler wooed men and women and he wrote shortly before his death 'I am certainly not against marriage

9.4 Rex Whistler (1905–1944) *Self Portrait* (c. 1933). Oil on canvas. 40.6 × 36.8 cm (16 × 14.5 in) (*Tate Gallery, London*)

and might of course marry, but frankly I think now that I shall probably never do it.'[9] A regular guest in country houses, he would cover the visitor's book with 'sheaves of corn, fluted columns, garlands of flowers'.[10] The latter decorated Cynthia Asquith's visitors' book when he stayed during the war with his friend and fellow officer Robert Cleveland Stevens. Though Stevens was younger than Whistler they were, as Cynthia Asquith recalls, full of 'jesting intercourse' and 'strongly bound in fellowship'. Though he was nearly forty, Whistler enlisted at the start of the war and was commissioned in the Welsh Guards in 1940. Tragically he was killed in July 1944 leading tanks into their first action with Germany in Normandy.

Like Whistler, Martin Battersby (1912–1982) too, turned to the splendour of the eighteenth century rather than grapple with

contemporary styles but, unlike Whistler, he accepted his homosexuality as a young man. Tradition and traditional values drew Battersby to a conservative training. From school he was taken on as an assistant in the well-established interior design studio of Gilland Reigate and given what he described as an 'old-fashioned apprenticeship'.[11] The stylistic approach was based on eighteenth-century interior designs with pastel shades and classical architectural embellishment.

As an only child he had been expected to attend university before entering the family solicitors' office, but his enthusiasm to train as an artist overcame objections. His study of architectural draughtsmanship and watercolours provided a sound foundation for his own style of *trompe-l'oeil* painting which he was to develop later. A year at the Royal Academy of Dramatic Art and a period of touring as an actor provided a link with the theatre which remained until the end of his life. His own theatrical illusionistic approach translated well into stage sets and he was invited to produce designs for productions of Shakespeare as well as opera and ballet. *Trompe-l'oeil* interiors were executed in the United States and in Europe. Both in the world of interior design and in the theatre Battersby thought that homosexuality was not necessarily a bar to a successful career or social acceptance provided it 'was not talked about' in society.

9.5 Martin Battersby (1912–1982) *Two Men* (c. 1982). Gouache. 38 × 35.5 cm (15 × 14 in)

His first exhibition of paintings in London in 1948 specialised in *trompe-l'oeil*, mostly collages of various objects drawn from classical and archaic statues or masonry, objects associated with fate or luck such as playing cards, picture frames and the like. It was only in the 1970s that Battersby started to take as his subject matter explicit homoerotic themes, particularly objects and clothes taken from the sado-masochistic subculture. Boots, leather shorts, leather straps, masks and studs and torn blue jeans replaced the archaic motifs of Egyptian statues, Greek urns and a Mycenean gold mask included in *Sphinx and Oedipus* 1972 (Royal Pavilion, Brighton).

It was to the ancient Greeks that the Spanish artist Gregorio Prieto turned as a means of expressing homosexual relationships in their most ideal form. Prieto, the lover of the poet Garcia Lorca who was murdered under mysterious circumstances in 1932, left Spain to travel to Europe and England having studied at the San Fernando School of Fine Arts in Madrid. With the aid of a travelling scholarship he moved around Europe. An exhibition of his work in Paris attracted the attention of Cocteau and Max Jacob.

In England in the late 1930s, Prieto produced a series of crisp line drawings published in book form which evoked some of the ideal beauty of the ancient Greeks. Slim, youthful figures, some male, some without explicit sexuality, hint at the androgynous state of perfection. 'Pure art moves in its own world, independent, without nationality or sex', he wrote, and 'in Greek sculpture the canon of beauty is the abstract union of the two sexes fused in one.'[12] Prieto returned to Spain after the war, where he established a high reputation.

If some artists found the ordered style of neoclassicism or the ideals of ancient Greece more suited to their conservative approach, John Banting and Edward Burra in England and Pavel Tchelichew in Paris did not. All were to some extent influenced by the ideals of surrealism, its involvement with the subconscious mind and its questioning of the notions of 'reality'. Placing himself outside any established art movement, Banting (1902–1972) was something of an anarchist in art and politics, and refused to be categorised. After leaving school he worked as a bank clerk and took evening classes under Bernard Meninsky at Westminster School of Art. A short period was spent in Paris in the early 1920s and later he took a studio in Fitzroy Street, London. The nearby Fitzroy Tavern became the haven of artists, writers and 'intellectuals' of Soho for some thirty years.

In the 1930s in Paris Banting met Duchamp, Breton, the sculptor Giacometti and the writer Rene Crevel. The impact of their ideas was immediately apparent in his work. But Paris and Europe in general meant more to Banting than theories of art or constant wrangling over 'meaning'. (In fact, though deeply influenced by surrealism, he refused to

accept it as a label for his own work.) For him, the delights of Parisian society also included the opportunity for unrestrained sexual freedom. Clive Bell, who had spent several weeks with Banting in France, was firmly convinced that though talented Banting thought about 'nothing but drinking and fucking'.[13]

Passionately committed to the Republican cause in Spain, he travelled with Nancy Cunard in 1937 to join the International Brigade. The failure of the radical cause and the victory of the fascists both upset and depressed him. Throughout the 1930s he continued to paint, illustrate books and design for the stage. As a contributor to the International Surrealist Exhibition in London in 1936, he was hailed as a 'surrealist', a quality he retained but did not acknowledge in his work.

As a committed communist (he saw no difficulty in reconciling the ideals of communism with the style of surrealism) his work consistently attacked the upper classes as well as royalty and religion. The tyrannical values of snobbery and chauvinism were also singled out for comment. An illustrated book, done largely in the 1930s but not published until after the war, *A Blue Book of Conservation* (1946), is a savage and biting satire on the ways, habits, appearances and conversations of the established and powerful middle classes. The surrealist imagery of spindly people with soft, worm-like bodies and huge heads shows them posing and posturing in a range of various social gatherings. 'Let us enjoy the spectacle of the dead burying themselves,' he wrote. He was, as George Melly notes in the catalogue introduction to an exhibition of his work (1972, Gallery Edward Harvane), very much in favour of 'freedom from cant and guiltless sexuality'.

His imagery was often as unconventional as his life and brought unlikely combinations of feathers, odd birds, shells and skulls as well as cabbages and plants. These ranged from the sexually suggestive arum lily to the large-leafed creeper. Some plants sprouted penis flowers. Banting spent the last years of his life living on a boat in Hastings to be near Burra in Rye but doing little serious painting. In post-war England there was little interest in surrealism with much of the political fire having been neutralised by the realities of the horrors of war in which art could not compete. He preferred to explore the backstreets of Hastings and Rye, living with a friend and generally drinking too much alcohol.

Though willing to explore the unconventional in his art, Banting never produced the serious body of work to ensure a lasting and widespread reputation. In contrast, his friend Burra was recognised as a major twentieth-century artist. In his work he had much in common with European artists including George Grosz and Otto Dix in the use of linear composition, the savage caricatures of 'types' and the washes of bright watercolour. A retrospective exhibition at the Tate Gallery, London, in 1973 and the award of the CBE in 1971 were official

recognitions of his art—events he found highly amusing and irrelevant. He refused to attend either event saying he would not take part in 'Fart', his usual way of describing art and the social gatherings around it. 'Art is too serious a matter to be serious about,' he said.[14]

The friendship between Burra and Banting which spread over some fifty years (they met in 1923) encompassed their similarities and differences. Both had been born into well-to-do middle-class homes and both were firmly anti-establishment and iconoclastic. Banting, physically large and strong, was passionately committed to left-wing politics and contrasted with the delicate, fragile and politically more uncertain Burra. Both were attracted by the anarchist ideas of the artists and writers associated with surrealism.

Burra (1905–1976) was born in London, but as a child was taken by his family to Sussex where his father, a solicitor, retired. A particularly bad form of anaemia followed by rheumatic fever brought his school days more or less to an end and left him with fragile health at the age of thirteen. At fourteen he decided to devote all his energy to drawing and painting and two years later enrolled at Chelsea Polytechnic (1921–3) before spending a year at the Royal College of Art in London in 1924. John Rothenstein, who met Burra while he was an RCA student, remembered him as silent and pale, seeming to be continually near the edge of exhaustion.[15] Yet he developed an iron will in his determination to become an artist, continuing to paint even when later in life he was often crippled by arthritis. Physically weak, Burra preferred to use watercolours rather than oils (he could not stand for long periods) though often on a large scale. His friends were continually amazed by the great contrast between his quiet, reserved manner and his exuberant, extrovert paintings. Typical subjects included night-time street encounters in the red-light areas of such continental cities as Marseilles and Paris and the black districts of Harlem and St Louis, and scenes often set in tough water-side cafés and raunchy sailors' bars.

As an admirer of contemporary or near contemporary artists such as Beardsley, de Chirico and George Grosz, and of the writings of J. K. Huysman, he combines religious fervour in his work with the menace of evil intent. Some pictures have exotic and often erotic elements painted in a precise style of crisply drawn forms, often with overlapping layers of watercolour. There is a sense of drama and excitement in his paintings, whether the subjects are landscapes, flower arrangements or allegorical and religious themes. Sometimes it is menacing, sometimes sombre, but the heightened and exaggerated sense of unreality emphasises the nightmarish qualities. He showed work in the 1936 International

9.6 Edward Burra (1905–76) *Silver Dollar Bar* (c. 1948). Watercolour (*York City Art Gallery*)

Surrealist Show in London and continued to exhibit regularly with the surrealists in London and Paris until 1940. The macabre mixtures he put together of the unlikely and unreal have more in common with Dadaism than with surrealism.

With his poor health it would seem likely that the vivid commentaries Burra poured into his paintings were as much a means of living the experiences as creating them in paint. Physical disabilities may have sharpened his ability to feast with his eyes, for no one ever saw him sketch views or scenes, though he stared at them long and hard before re-creating them perfectly weeks or months later in his studio. What was etched on his memory, or what came out in his art, was an uncompromisingly sharp commentary on the behaviour of people in particular situations. With Paul Nash, Burra visited Paris for the first time in 1930 and continued to travel regularly to the Continent. He also visited New York and Mexico in 1933 and after the war. Eventually ill-health restricted travel. Time in Spain (his favourite foreign country) in the 1930s did little to resolve his confusions about his political commitments; he was particularly horrified by the burning down of a church by the Republicans. Some of this ambiguity is evident in his powerful war paintings. In *Death and the Soldier* 1940 and *Soldiers at Rye* 1942, the muscular bodies of the soldiers are defined by tight-fitting clothes and recall in their classic modelling of the body the work of Signorelli. The well-formed bodies contrast with the mask-like quality of the faces, with noses coloured red, yellow and orange. Much the same contrasts are apparent in *Beelzebub* 1938 in which the bright red, menacing figure of the devil gleefully watches violent scenes of murder and destruction.

The ambiguity of the war painting is also a part of the more sexually concerned subjects. *Izzy Orts* 1938 (National Gallery of Modern Art, Edinburgh), set in a sailors' bar, has elements of adoration and desire yet the faces are little more than empty caricatures. Other paintings set in sleezy strip-tease bars have the same ambiguous air of undirected sexuality. The brutal-looking thugs which make up the audience in *Strip-tease* 1934 (Lefevre Gallery, London) could be staring at each other or the nubile female stripper. The general air of sexual expectancy, more homo than hetero, which permeates *Silver Dollar Bar* c. 1948 (York City Art Galleries) both satirises and celebrates the muscular male bodies.

Within the life of the underworld, the outcast, the shady and the unconventional, Burra found a vivid means of expressing both personal and social responses to the violence of war and of sexual activity. Other artists dealt with such themes in different ways. An exhibition at the Galerie Drouet, Paris, in 1926 featured the work of the Russian émigré Pavel Tchelitchew (1898–1957) and earned him the label 'neoromantic'. His insistence on the use of the figure because it could comment more

directly on the human condition as opposed to the impersonal style of cubism found a response among other artists.

Tchelitchew's neoromantic concerns echoed the turbulent events of his life which had until then all the elements of a romantic tragedy. He had been born one of five children in Russia on the wealthy family estate near Moscow. The October Revolution forced the family to leave the estate and flee the country penniless. He eventually arrived in Berlin in 1921 where he designed sets for the Russian Ballet and Theatre. In 1923, with his sister Choura, who was consumptive, and the expatriate American pianist Allan Tanner, he settled in Paris. Gertrude Stein bought his paintings, which replaced some of Picasso's on her walls, and helped him to become established. He called her 'Sitting Bull' and for a short period she adored him. Alice B. Toklas he named 'The Knitting Maniac' and not surprisingly she always distrusted him.[16] By 1926, the year of the Drouet exhibition, Tchelitchew had developed his own style and was friendly with other Americans, among whom was Lincoln Kirstein and the photographer George Platt Lynes. A year later he met and was 'taken up' by Edith Sitwell, thus causing a break with Gertrude Stein. Edith Sitwell diligently promoted his work, particularly in London, where she helped arrange an exhibition for him at the Claridge Gallery in 1928.

Though he did not accept that he was a surreal painter, there were elements of this in much of his work. In *The Annunciation* 1931, for example, the youthful angel appears with one arm resting on a screen beside Mary who sits demurely in an arm chair with a face constituted out of a painter's canvas. Not all of his work was fantastic. *Tattooed Man* 1934 is a straightforward portrait of an exotic subject but the faraway, almost wistful gaze with the face averted to one side suggests internal as well as external markings. More directly homoerotic and more humorous is *Bullfight* c. 1934 which compares the tightly trousered backsides of the matadors with the hindquarters and prominent testicles of the bull.

Throughout the 1930s regular exhibitions of his paintings and commissions for the theatre ensured his popularity and success. In 1933 he started his relationship with the American poet and artist Charles Henri Ford, which was to last until the end of his life. This relationship prompted more visits to America, where his painting was well received. His large retrospective exhibition at the Museum of Modern Art in 1942 included *Hide and Seek*, the second large painting of a trilogy. The first painting was entitled *Phenomena*, the third was never completed. *Phenomena*, which was bequeathed to the National Tretyakov Gallery of Russian Art, Moscow, explored the idea of the figure trapped and held in a complex physical and psychological network. A recurring theme in his work was metamorphic figure compositions in which the liberated body was suspended in space. These have a mystical dimension in which the

events and emotions suggest an extra-sensory awareness rather than any overt religious connotation. Large in scale, both *Hide and Seek* and *Phenomena* describe in a fantastic manner parts of his own life and include portraits of his friends heavily disguised or in symbolic form. With overtones of Dante's *Inferno*, *Phenomena* is peopled by such curious figures as the Half-Man, Half-Woman, the Woman-breasted Boy and the Bearded Lady, Siamese Twins and the Centaur with a gas mask for a head. This intricate personal world filled with misfits and oddities who are physically and sexually ambiguous allows no easy reading nor deals with any obvious themes. It also incorporates his dislike of poverty and hardship, which is contrasted with wasteful overproduction and depleted resources. *Hide and Seek* completed in 1942 is equally full of symbolic forms and double images but is given a more ordered composition. Set inside a huge drop of water, in one sense the narrative tells of the development of a single figure which may be male from foetus through childhood to adolescence. The virtually transparent figure is seemingly suspended in a freezing web of ice and crystal.

Always an outsider, by birth, by sexual inclination and by his choice of stylistic conventions, he did not accept contemporary mores either in the style of painting or in his chosen subjects. With a wide but pointed political consciousness and a view of sexual orientation which distrusted hand-me-down labels, he continued to reject the popular mood and as a result felt unsure and protective of his work. Tchelitchew took American citizenship, though he died on a visit to Italy in 1957.

Other American artists also felt out of step with contemporary trends towards abstraction in the 1930s and 1940s and moved to a form of figurative realism which combined political and sexual concerns with the best of the traditional styles. Paul Cadmus and Jared French were part of this group, which was given various labels which included lyric, magic, social and satirical realisms. Like the neoromantics, their paintings make allegorical references and much emphasis is given to carefully rendered *trompe-l'oeil* effects, given overtones of surrealism by the juxtaposition of the different elements. Their emphasis on academic, precise drawing and modelling of the human figure harks back to Renaissance ideals, as does the preferred medium of egg tempera and silverpoint. The new post-Freudian language of sexual symbolism loads their paintings with explicit or implied meaning. In Cadmus' work this was clearly homoerotic, while in French's work the concerns were more diffuse.

Cadmus, born in 1904, is the eldest and leader of the artistic group. His homosexuality, always an important element in his painting, over the years changed to become in later works the most dominant theme. He believes firmly in artists taking inspiration from contemporary life and using this as a basis for realism in art. His *Credo* in the catalogue of his first solo exhibition (Midtown Galleries, New York, 1937) has remained

9.7 Pavel Tchelichew (1898–1957) *Phenomena* (detail). The man with the third leg and the elephant-skin girl, modelled on Leonor Fini, and the two-headed man.

little changed over the years. At the centre of his work is the study of people, whether 'living or dying, working and playing, exercising all their functions and passions, demonstrating the heights and depths of Man's nature', in preference to inanimate objects.[17]

His humanitarian concerns pervade and influence all his painting and are expressed directly by his avowal for and admiration of E. M. Forster's *Two Cheers for Democracy*. This essay inspired *What I Believe* 1947–8 (private collection) done soon after his initial meeting with Forster. Forster's eloquent insistence on human freedom, dignity, democracy, libertarian values and the primacy of individualism is

expressed by Cadmus in a complex composition of naked figures representing evil and goodness. In the distance a phallic-shaped lighthouse signals both pleasure and enlightenment.

Cadmus took then and has continued to take a 'satirical' viewpoint, seeing little difference between the foibles and follies as well as the ideals and hopes of mankind. In his art Cadmus places himself in the long historical tradition of humanist artists which he sees is based on sound draughtsmanship and classical composition, but with contemporary subject matter. By the use of classical and historical references within the composition, Cadmus' paintings discourse wider political as well as sexual themes.

The training he received was academic and sound; he enrolled at the National Academy of Design in 1919, where the study of lithography and etching consolidated his skills as a draughtsman. From 1928 to 31 he worked for a New York advertising agency, during which period he first experimented with heterosexual love affairs but decided he was homosexual. His close friendship with a fellow student, Jared French (born 1905), at the Art Students' League was consolidated and the two

9.8 Paul Cadmus (b. 1904) *What I Believe* (1947–48). Tempera on panel, 40 × 67 cm (15.75 × 26.5 in) (*Midtown Galleries, New York*)

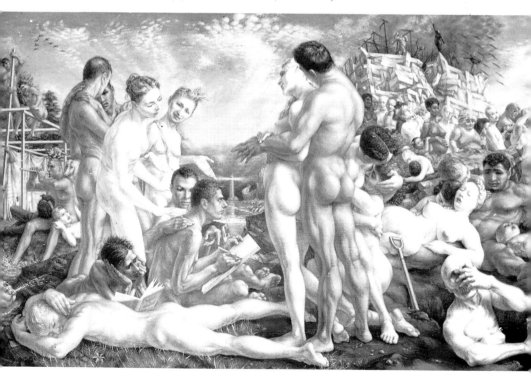

began to plan and save for a visit to Europe. They shared a studio for over thirty years until French moved to Italy.

For two years they toured around France and Spain, Italy and Germany, painting portraits, harbour scenes and landscapes. By 1933 Cadmus' style was well developed. *YMCA Locker Room*, *Shore Leave*, and *Bicyclists* (Regis Collection) all have an homoerotic theme whether expressed more overtly as in *YMCA Locker Room* where the crowded all-male changing room is filled with muscular bodies in stages of undress, or in the more symbolic eroticism of *Bicyclists*. The two riders, French and Cadmus, are shown discussing which direction to take. Strategically positioned handlebars and bicycle saddles take on phallic meaning. Similar but more explicit eroticism is expressed in *Finistere* 1952 (private collection). *Shore Leave* is a satire on randy sailors home on leave surrounded by enthusiastic women. Cadmus implies however that they are rather more attracted to each other than to the females.

A similar theme was pursued in *The Fleet's In* 1934 (Naval Historical Centre, Washington D.C.) and *Sailors and Floosies* 1938 (private collection) in which despite all the sexual cavortings the men either fall down drunk (and are shown in the style of the female nudes of Giorgione or Titian) or are physically and emotionally more interested in each other. Both paintings brought a storm of protest when they were shown and were banned from exhibition.

The satire on sailors and the celebration of their sexual attraction (and of their possible sexual orientation) was often accompanied by more serious commentary. In *Sailors and Floosies*, for example, a crumpled newspaper carries the banner headline '8000 Killed in Air Raid', a grim reminder of the realities of war. The same ability to comment upon social realities and sexual angst is found in such paintings as *Playground* 1948 (Georgia Museum of Art). Set in a New York City working class neighbourhood playground, a group of American youths become an allegory about sexual and financial oppression. Erections are implied by bulging trousers, tops of railings and strategically placed baseball bats. A sign on a wall above a handsome youth says 'No Ped', a possible allusion to pederasty. Discarded newspapers bear headlines about failed peace plans and calls for conscription. In the centre of the painting a half-naked youth stares out bewildered and unhappy.

The post-war fears that Cadmus was expressing so vividly in the euphemistically entitled *Playground* found more hope in later paintings. *The Bath* 1950 (private collection) is an intimate scene of two naked young men in their bathroom. One is kneeling in the bath soaping his backside, the other stands in front of the sink brushing his hair. The mood is post-coital, their sexual contact has been made and within the informality of the bathroom their intimacy is confirmed. Though brought totally up to date, the painting recalls Luca Signorelli's *Two Nude*

Youths c. 1498 (Fitzwilliam Museum, Cambridge) and marks, as Cadmus pointed out, a major change in that from the 1950s he felt able to paint as well as draw the male nude. In recent years Cadmus' watercolour and crayon studies of the male nude are Michelangelesque in their recreation of the beauty of the muscular body. The homoerotic interest is expressed both in the pose and in the treatment.

A photograph taken around 1948 by George Platt Lynes shows Cadmus working on *What I Believe* in his studio. In rooms in the background can be seen Jared French and their student George Tooker, (born 1920) who all shared a similar approach to their art.

French (born 1905) further consolidated his intimate friendship with Cadmus when for a period in the 1930s and 1940s, with French's wife Margaret (Cadmus's sister), they formed the PAJAMA group, a name made up from the first letters of their Christian names, and shared the same studio, had similar humanist beliefs and the same precise approach to their work. However, unlike Cadmus, French's smouldering and provocative sensuality never employed the same homoerotic symbolism. He was inspired first by Rubens and the baroque before making a close study of the techniques of Piero della Francesca and Seurat. In the early 1940s, along with Cadmus, French painted compositions in which strange transmutations of flesh and bone have a quality of science fiction. One painting shows a near clinical study of a cross-section of a foetus in a womb nestling in a pelvic bone. The picture is emblematic of birth except that the foetus has no head.[18]

Studies of naked young men painted in the 1940s and 1950s have a nostalgia for lost youth and virility and predict what was later to be labelled 'the generation gap'. These symbolic confrontations of age and youth, life and art, sexual desire and fulfilment, are expressed in highly idealised and sensualised studies of muscular young men. *The Rope* (Whitney Museum of Art) is a graphic description of bonding and need. The element of sexual longing allied with the ambition and the pride of working-class fathers is conveyed by the gently placed ropes around the waists of their stalwart nude sons. Men and their relationships with each other are recurring themes. In some paintings this is heroic, as in *Crew* in which eight men in a boat all have identical faces or in the more dramatic *Murder* 1942. This shows the murderer standing over his dead victim.

The friend and associate of Cadmus and French, the photographer George Platt Lynes (1907–1955) shared many of their aims and ideals. But in his published photography in the USA he did not deal explicitly with sexuality. He studied with Lincoln Kirstein and in Paris in the mid 1920s he was friendly with the writers Glenway Wescott, Monroe Wheeler, Cocteau and Gertrude Stein. With a camera acquired in 1927, he started to take portraits, his sitters including Cocteau and Stein.

Through the ideas of Man Ray he experimented with the theories of the surrealists, carefully working out compositions which included montage, double exposure and the precise touching up of photographs. *Sleep Walkers* was shown in the surrealist exhibition at the Museum of Modern Art in 1936. Lincoln Kirstein commissioned him to document the work of the American Ballet which he continued to do until his death.[19]

The death of his father forced him to think of more commercial work and in 1933 he opened a studio. He rapidly gained a reputation as a skilful fashion photographer, contributing to *Town and Country*, *Harper's Bazaar* and *Vogue*. At the same time he made detailed studies of the naked male figure, carefully and often dramatically lit to bring out the expressive contours of the body and often conceal the genitals.

9.9 Paul Cadmus (b. 1904) *The Bath* (1951). Egg tempera on pressed wood panel, 40.64 × 40.64 cm (*Private collection*)

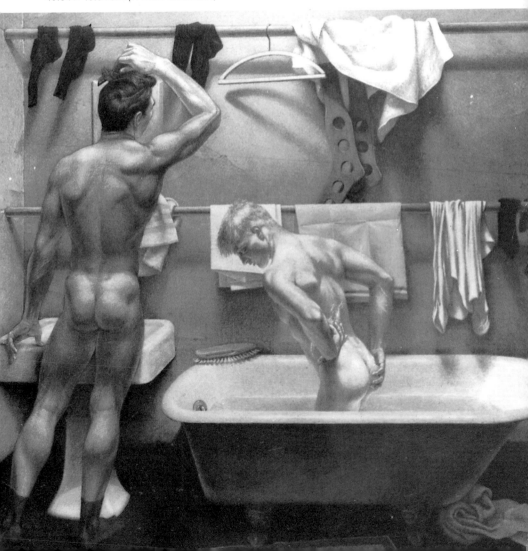

French Sailor c. 1935, of a half-naked tattooed man lying on a dark reflective surface and partly covered with a blanket, has a quiet psychological tension which was to recur in his later work. A photograph of the half-naked Cadmus and French c. 1940 shows them wearing only torn tee-shirts. The suggestion of sado-masochistic rituals was explored more fully in later work. The erotic, very private themes, formally and didactically presented, always with the carefully arranged and theatrical devices of the studio with a minimum of props, present the figure as an object to be admired, even worshipped. The subtle eroticism has little obvious emotional content: the men are objects of contemplation, bodies set in what is virtually empty space, psychologically and physically separate. Studies include simple classical poses of torsos and backs which have the strength and power of ancient sculptures, and carefully constructed, psychologically complex instructive historical narratives such as Dionysius giving birth to Zeus through a womb in his leg.

Disillusioned with the emptiness of commercial work and the death of a close friend, George Tichenov, he closed his studio and moved to Los Angeles in 1942. His documentary photographs of Christopher Isherwood, Igor Stravinsky, Thomas Mann and Aldous Huxley chronicle the society in which he moved. Some, such as his portrait of Christopher Isherwood 1939, were explicitly revealing. Isherwood has a huge naked figure of a youth superimposed by his side.

In 1950 George Platt Lynes met Alfred Kinsey, director of the Institute for Sexual Research. A year later he started contributing nude photographs of men to the Swiss homosexual magazine *Der Kreis* under the pseudonyms Roberto Rolf and Robert Orville. The pleasure and joy he found in these photographs is indicated by the fact that when he knew he had cancer in 1955, he started to destroy the negatives of his fashion plates. He gave many of his photographs to the Kinsey Institute.

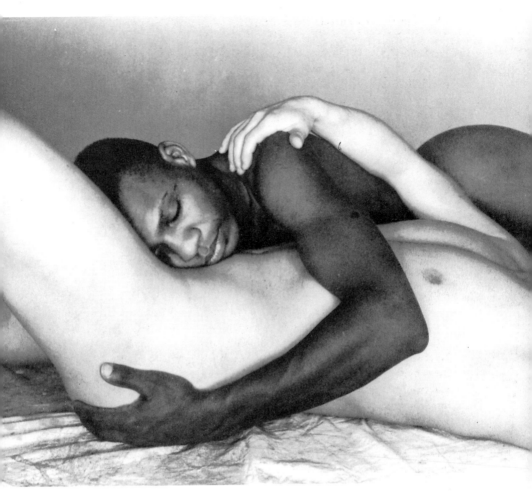

9.10 George Platt Lynes (1907–1955) *Two Men, John Leaphart and Buddy
McCartny* (*Private collection*)

10 · Veiling the Image

The general conservatism and patriotism of the 1940s and 1950s did not encourage artists to make optimistic observations either about themselves or society in general. The appalling economic and social conditions, fascism and the horrors of the Second World War encouraged artists to retreat from explorations of the truth. Either the private self-searching world was veiled behind the public imagery of solitary figures writhing or twisted in agony or in the vigorous swirls and eddies of abstract expressionism apparently uninvolved with the issues of the world or with sexuality. A more explicit art was being produced, however, for private circulation, particularly in the United States. This showed the fantasised erotic world of the homosexual subculture.

Throughout the 1930s any attempt to introduce a wider public discussion of homosexuality was suppressed. In Germany the fascists destroyed many of the case studies and research papers of Magnus Hirschfeld in 1933, while a year later homosexuality was once again made a criminal offence in Soviet Russia. Sexologists were at work, but it was not until 1948 that Alfred Kinsey published his notorious survey of 12,000 adults, *Sexual Behaviour in the Male*. He demonstrated how comparatively widespread homosexual activity was, so the taboo on the subject was breached even if it was some years before open discussion could take place.

In British art the sombre realism of the Euston Road School held sway, though the equally intense neoromantic movement which evoked the tradition of Blake and Palmer offered a more sensitive style within which feeling could be expressed. The hard emotions of the war generated an all-embracing pessimism which continued in the bleak post-war years. The freedoms which had so desperately been fought for were now threatened by zealous bigots at home. Senator McCarthy in the USA

wanted, in his obsessive patriotism, to root out any dissenters who had anti-American sympathies. Within the shadow of McCarthyism artists developed an aesthetic approach based on abstract expressionism which both denied and veiled subject matter. Whatever the emotional content experienced by the artist in the actual putting on of the paint, the viewer was given little if any access to its 'meaning'. The art became at once more personal and opaque.

Ironically the war in Europe resulted in the United States, particularly New York, becoming the art centre of the world, which encouraged the power of dealers and increased the investment value of art. Artists' responses to the prevailing mood of ideological conservatism was to produce art imbued with an aesthetic of indifference. Inner explorations were presented in an almost meaningless form. Recalling his first exhibition in 1943, Theodore Stamos (born 1922) remembered this period as the time when he had entered 'the world of echinoids, sea anemones, fossils and the inside of a stone'.[1] While this was an attempt to 'free the mystery of the stone's inner life', it also served as a metaphor for investigating the difficult darkest chambers of human emotions. The semi-abstract forms of nature seen in microscopic close-up, which he showed in his work, are imbued with mythological and sexual meanings, though the references are half concealed and remote. Sir James George Frazer's *The Golden Bough: Study in Magic and Myth* was widely read in the 1940s and Stamos was one of the artists who found in it an important source for his early paintings.

The detailed study of nature such as fungus or movements on water which, when seen in close-up, take on an abstracted quality was also the concern of the photographer Minor White (1908-1976). Though his photographs are concerned with the outward appearance of objects and landscapes, in their removal into abstracted patterns and forms they become as much about an internal as an external search. After studying botany at the University of Minnesota White travelled around, uncertain what to do. It was not until 1938 that he started taking serious photographs for the Works Progress Administration. His first one-person exhibition in 1942 at the Portland Art Museum included a series of images which he intended to be 'read' for such content that would enrich the experience of looking—a theme he continued in much of his work.

Throughout his creative life White refused to accept that his personal life could be separated from his work and his work from the rest of his existence. This insistence on 'the whole man' extended into a way of life which included a zen-inspired spiritual dimension. 'Things are what they are,' he argued, 'and for what else they are', suggesting perhaps that his photographs can be read as 'depictions of life' but also carry symbolic meanings.[2] Though paradoxically he taught introspection and self-revelation in others, he was constantly struggling with the compulsion to

hide himself to cover his shame, the reason for which was his attitude to his sexuality. His diaries described the pain and misery of being homosexual. One entry records the occasion when 'the flesh had taken the only satisfaction it would recognise in the embrace of strong and subtle arms'.[3] In desperation he sought answers from various religious faiths and philosophies including Catholicism, Zen Buddhism, the teachings of Gurdjieff, the writings of Jung, transcendental meditation, hypnosis and Gestalt psychology. Instead of providing freedom, these beliefs became yet another manacle preventing him exploring and expressing his deepest feelings. Energy was poured into his photography which was 'a sublimation of my inability to have the sex I want'.[4]

Many of White's photographs were of landscapes shown with pristine sharpness and clarity, a view of order and 'naturalness'. For example, handsome old buildings of solid middle America fitted perfectly into the rolling neat landscape. Other images were close-ups of ice and frost formations which in their obvious beauty convey a sense of wonder at the marvels of nature. There is nothing that is controversial in these images, for they are celebrating nature at its most reassuring.

White's studies of the figure take up the celebratory theme. The natural setting continues the idea of 'the wholeness of man', understanding the restrained, sensitive, homoerotic element. Men are shown in images of a sparely expressed love which is unemotional and intellectual rather than one of sexual involvement. Two studies of Bob Bright taken in 1947 show the strong-jawed handsome man a conqueror in an outdoor 'natural' setting. In one he stands by San Pedro Point Marker; in the other, *Man and Moon, Matchstick Cove*, he stands on a hillside under the light of the moon—a light usually reserved for scenes of love.

The homoerotic element is continued in *Sequence 17* (made up from photographs taken over several years) which is given the lines 'Is it you or I who says/out of my love for you/I will give you back to yourself.' Photographs of Bill LaRue are presented side by side with sensual images of drying mud and river bed; they include a male torso and a male nude sitting on the floor with a huge piece of dried driftwood placed between his legs. White's portraits of men have been described as 'seductive idols of masculinity, staring out of the photograph, tempting but untouchable'.[5]

Minor White established a highly respected reputation after the war, teaching at the California School of Fine Art (now San Francisco Art Institute) in 1946 and later joining the staff of Rochester Institute of Technology. In 1953 he helped found and became editor of the influential magazine *Aperture*.

Maintaining his respectable career, whilst acknowledging his own insistence on 'the wholeness of life', was often far more difficult to

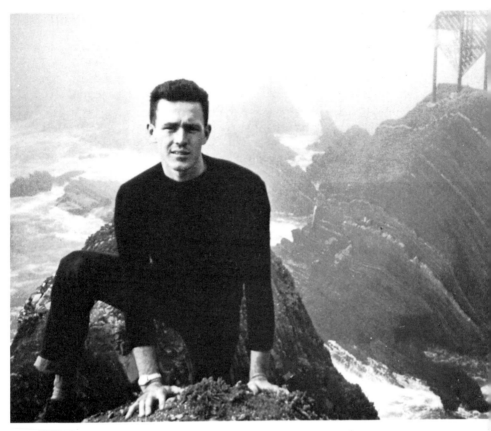

10.1 Minor White (1908–1976) *Bob Bright, San Pedro Point Marker* (1947). From *Song Without Words*. Reproduction courtesy The Minor White Archive, Princeton University. © 1982 The Trustees of Princeton University

achieve. Like many other homosexual men, White feared public exposure and rejection—whether as an artist, friend or lover, and he also found the acceptance of his own homosexuality almost impossible. Try as he might to be open and innocent, 'Being without clothes'[6] as he described it, his constant struggle was to overcome the compulsion to cover and obscure and hide himself away. The struggle took a real form during the war when he came into close physical contact with other soldiers. In correspondence with a woman with whom he was having a love affair he described his love and compassion for his fellow men in terms almost of religious worship. After the war the embittering turmoil of his desire for physical affairs with men and his resistance to the idea led him to give up heterosexual relationships. Yet homosexuality remained 'a wasteland of shame and disgust'.[7]

The struggle that White made with his homosexual desires, with the search for a 'unity' and with the attempt to reject the 'dualism' of western thought, was made very much in isolation: his friendships,

though close and long-lasting, were separated from his sexual contacts. He believed that 'a substantially introverted person' should be 'allowed to remain in his dream world'.[8]

The dream world created so poetically and beautifully by White was echoed in England by the artists of the neoromantic school, even if they were more fascinated by the anguish and the torment rather than the beauty. The political and social upheaval of the 1930s deeply affected artists many of whom associated themselves with socialist ideas. For example, many of them joined the Artists International Association (AIA) set up to oppose fascism. The outbreak of war heralded a period of extreme nationalism and a move toward both romanticism and realism in art. A spirited group of painters formed in and around Fitzrovia (an area of Soho in central London) including the homosexuals Robert Colquhoun and Robert MacBryde (from Scotland), John Minton, John Craxton, Francis Bacon, and later Keith Vaughan.

In the closed atmosphere of a country at war certain national characteristics emerged, many of them celebrating aspects of the British tradition. Given the label 'neoromanticism', the artist's vision was turned away from the idyllic landscapes and peaceful, ivy-clad village cottages of Samuel Palmer towards darkened, tortured landscapes, ruined towns and cities, and twisted, gnarled trees. The appalling tragedies and anxieties of the age were reflected in a dark and sombre art. Unlike Minor White whose still, somnambulent pictures are quiet if not at peace, the neoromantics produced paintings which have a disturbing restlessness.

John Minton's dream was about the perfection and rightness of the English romantic tradition exemplified in the work of Samuel Palmer in which the prevailing trends and movements of abstract and non-figurative art had little place. Minton (1917–1957) was influenced by such contemporary artists as John Piper and Paul Nash who shared his pastoral vision. He was born near Cambridge on Christmas Day 1917, and he had two brothers, the eldest of whom was congenitally handicapped. His younger brother Richard, of whom he was very fond and with whom he had a close relationship, was killed on 'D' Day in the Second World War. He studied in London at the St John's Wood School of Art (1936–38) and quickly made his name as an illustrator. He worked in the English lyrical tradition, catching in his clear linear drawings the peace and quiet of hedges and gardens. The pictures rely for their success on their small scale, careful composition and close observation. He also painted portraits of friends as well as the homely and undulating English countryside.

The outbreak of war, and later the death of his brother, brought the idyll of rural romanticism to an end. In *London Street* 1941 (Fischer Fine Art, London) we are dramatically placed in the dingy war-torn streets of London during the Blitz. Searching among the dark deserted buildings, a

drunken man can be made out lying in the doorway, while a pair of sad, hollow-eyed, forlorn lovers wander the streets. It is a picture which reeks of despair. Minton stated that one of the figures was a self-portrait and added cryptically 'Which is me?' Minton was very fond of alcohol.

In the post-war years his gifts as an illustrator brought him endless commissions. Hardly a week went by without the *Radio Times* carrying his illustrations; Elizabeth David's new books on cooking were enlivened by his skilled and sensitive work and he was commissioned to travel on the continent to record his artistic impressions for other books. But in these years English art, which had become self-contained during the war, was subjected to the threatening blasts of new and challenging ideas, particularly from abstract expressionist art in America. Nevertheless some artists including Minton did not give up their own ideas. 'Painting has one concern—man's reaction to life in terms of paint, colour and drawing,'[9] he wrote, partly as a desperate, defensive response to abstract non-figurative art, and partly as a statement about his commitment to his own work and involvements.

Despite his success he was full of self-doubts. Whilst a tutor at the Royal College of Art, Minton sought desperately to stick to and develop the illustrative, figurative themes in his painting. He developed a style which used his skill as a draughtsman in a modern or contemporary idiom. The result was a series of large pictures which took as their subject matter classical themes such as Greek tragedy, the Bible or history. The graphic quality of the compositions is emphasised by dark lines and formal construction. *The Death of Nelson* (Royal College of Art, London) dates from this period. The pictures were clever and decorative, demonstrating technical skill rather than expressing any involvement with the subject matter.

Minton was much more at home working on a smaller scale or with more intimate subjects. Some of his best paintings are his closely observed portraits, mostly of men. Sexually he was attracted to young, rather ordinary (and often heterosexual) men, usually a formula for disaster and further depression. While it would be crude to read into these works all his frustrated feelings and desires, the portraits have a sensual, almost erotic quality missing in the more formal paintings. Models include soldiers, slim-faced young men and students.

A particularly successful painting is a large, almost life-sized portrait, *Artist and Model*. The sitter is wearing a white tee-shirt, casual trousers and sandals. His fine features and well-built body contrast strongly with the portrait of the artist reflected in a mirror behind the sitter. Minton shows himself as a slim, slight figure with his drawn and refined features and formal clothes suggesting a quite different world. The perspective of the floor boards has been distorted to add a slightly unreal quality to the model, making him a precious and exciting person.

Outwardly Minton was a carefree extrovert who loved telling stories and entertaining friends with accounts in which fact and fiction were hard to distinguish. He was also generous and courageous. Money inherited from his grandmother ensured that, while not rich, he was reasonably well-off and he was a generous host.

Students at the Royal College of Art were bought large meals and taken to smart gatherings. When a biography of Oscar Wilde was published Minton wrote a letter to the *New Statesman* listing all of the great artists of the past who were also homosexual, to the consternation of the art establishment. It was a particularly brave gesture when considered in the context of the general climate of opinion in the 1950s when anti-homosexual feeling ran high in the press.

Yet his feelings led him in 1956 to radically reassess his own life. Unsure about his own work and thinking that he was able to offer little help to students, Minton resigned from the Royal College of Art. For a time he designed sets at the Royal Court Theatre, London (then in one of its most creative periods) but his feelings of satisfaction about his work did not last. In 1956, the year before his own death, he painted *The Death of James Dean* (Tate Gallery, London). This was inspired partly by the death at the age of twenty-four of the handsome film star whose ambiguous sexuality attracted a large following, particularly by homosexual men, and partly by a terrible motorcycle accident he had witnessed in Spain.

A year later he committed suicide, the year in which the Wolfenden Committee in the UK reported its findings on homosexuality, though it may have had little interest for the independent and outspoken John Minton.

Both John Minton and his friend Keith Vaughan were born into respectable middle-class families and had a certain 'class confidence' to help them deal with the world and both were able to cope to some extent with their own sexuality in their work. Artists such as the two Scottish-born painters Robert Colquhoun and Robert MacBryde, with no such privileged background, approached their work more cautiously.

In a society reluctant to recognise the creative side of homosexual relationships it is surprising to find the life-long love affair between Robert Colquhoun (1914-1962) and Robert MacBryde (1913-1966) given the serious recognition and importance in the art world that it so clearly had. This is particularly significant because they both lived before the advent of 'gay liberation' and their relationship was fully accepted both by the bohemian society of Fitzrovia and by the art 'establishment'. Writing about them in *The Times* in 1977, Paul Overy described them as

10.2 John Minton (1917–57) *Artist and Model*. 183 × 198 cm (72 × 78 in) (*Russell-Cotes Art Gallery and Museum, Bournemouth*)

a 'legend' which he said was 'partly because of the alcohol they consumed and partly because . . . they were a homosexual couple who openly lived and worked together'.

The two Roberts as they were usually known, worked mostly in London, part of the group who met socially in Fitzrovia. Colquhoun had the bigger success and was generally considered to be the more able, though the more subtle qualities of MacBryde's work are slowly being recognised and appreciated. Both artists shared very similar backgrounds. They were born twenty miles apart in Ayrshire, Colquhoun at Kilmarnock and MacBryde at Maybole. Both had to leave school and get jobs to support their families and each won scholarships to Glasgow School of Art, where they met in 1932.

Very quickly they became inseparable, working in similar ways. It was, as their friend Anthony Cronin wrote, 'a marriage'.[10] The war ended their stay in Ayrshire and neither spent much time in Scotland again. Colquhoun was called up in 1940 and, despite ill-health, was enlisted in the Royal Army Medical Corps as an ambulance driver, eventually being posted to Leeds. MacBryde, who failed his medical because of weak lungs, was constantly writing to the army canvassing for Colquhoun's release. In 1942 after Colquhoun was discharged (he had collapsed from a heart complaint), they moved to Kensington in London. Befriended by Peter Watson who was then publishing the literary magazine *Horizon*, the two Roberts became friendly with Minton, Craxton, Vaughan, Prunella Clough and Michael Ayrton, as well as writers who included Dylan Thomas. During the day Colquhoun insisted on driving an ambulance for Civil Defence and at night painted in the studio at 77 Bedford Gardens that he and MacBryde shared with John Minton.

Exhibitions at the Lefevre Gallery were well received and their work was hailed as part of the introspection of the English neoromantics with references to the humanist European tradition. Both painted figures often shown in odd or unusual juxtaposition. Black lines inspired by the work of Picasso and by their neighbour and friend, the Polish artist Jankel Adler, were used in their paintings to pick out and define shape giving them a sombre and dark effect.

Neither artist painted explicit homosexual themes and in fact they chided Keith Vaughan for his impropriety in his choice of male nudes as subject matter. This suggests on their part either caution or fear of exposure—or prosecution. In paintings such as Colquhoun's *The Students* 1946 (British Council) and MacBryde's *Two Women Sewing* (Mayor Gallery, London) two closely juxtaposed figures are locked in psychological contact and this intensity has been seen as a representation of the relationship of the two painters.

In Colquhoun's gloomy, brooding paintings of old or elderly women, poor and apparently without purpose, there is a suggestion of a deeply

young Scottish
artist. 1938.

Colquhoun
1938.

drawn with quill and finished with steel.

10.3 Robert Colquhoun (1914–62) *Robert MacBryde* (1938). Drawing (*National Portrait Gallery, London*)

pessimistic view of the world. The figures, with their depressing black outline, look ravaged and harassed. There are also some disturbing elements in his paintings of people and animals, often shown in odd relationships which makes them even more sinister and menacing. On the one hand they seem to be paintings about scenes from everyday life, yet the style has a surreal quality with a sharp, almost bitter edge. John Rothenstein held the view that the paintings and monotypes in which

10.4 Robert MacBryde (1913–1966) *Two Women Sewing*. Oil on canvas. 99.3 × 143.5 cm (39.1 × 56.5 in) (*National Galleries of Scotland, Edinburgh*)

women appear together are in some obscure way personifications of Colquhoun and MacBryde which refer to the situation of their relationship.[11] Certainly the paintings have a complex code of reference. Some of the figures, especially those with animals, have a sensual quality and are often shown physically close, but the view seems bleak and forlorn.

Despite the great similarities of their background and experiences, the two Roberts were different in character and personality. Colquhoun was shy, reserved and introspective, seeming to lack energy, yet he had an ability to concentrate which enabled him to paint in the noisiest and most disturbed of conditions. MacBryde was louder, expressing himself freely and with ease as well as entertaining drinking companions with his rich singing voice. He jealously guarded Colquhoun and made scenes when their relationship seemed threatened by Colquhoun's flirtations with women. He also kept house, washed dishes, cooked and ironed. Unlike Colquhoun, he could only paint in peace and silence and needed time to concentrate. It is he whose work is considered to be 'less

developed', which is not surprising as he continually placed Colquhoun's talents above his own, neglecting his own art. 'The servant of a great master'[12] was how he described himself.

Both artists reached the peak of their success in the late 1940s with acclaimed exhibitions and an extrovert and lively life style. During the 1950s their earlier success evaded them. Changes in the art world tended to favour more abstract work. Equally important, the contemporary air of patriotism praised the family and family life rather than the dour images of weird 'characters'. More practically, Duncan MacDonald who had encouraged them and showed their work at the Lefevre Gallery died and the gallery did not want to continue its support. A disinterested public and a realisation that their paintings were not 'in fashion' had a demoralising effect on their lives as well as causing financial problems.

When they arrived in London neither of them drank excessively; ten years later they were hardly sober. They moved from one friend to another, often causing havoc with their excessive drinking and their boisterous and loud behaviour. For a time they lived at Lewes and later at Dunmow as guests of the poet George Barker. Here drunken scenes resulted in extreme rudeness and sometimes violence. MacBryde's intensely protective attitude towards Colquhoun often resulted in scenes of jealous rage. Their quarrels became longer and louder and more desperate as they found it harder and harder to sell their work. A commission for theatre designs was not a great success.

The offer by Bryan Robertson of a retrospective exhibition to Colquhoun at the Whitechapel Gallery in London in 1958 was a vital spur to new creative efforts. Though the 'late' paintings produced for the Whitechapel show do not have the direct strength of the earlier work, the exhibition received general critical acclaim. Ill-health and alcohol addiction took their toll. In 1962 while working on a drawing of a man in space, Colquhoun died of heart disease in the arms of MacBryde.

Inconsolable for many weeks, MacBryde could not 'draw sober breath'.[13] Francis Bacon gave him money to visit Spain to see Anthony Cronin. On his return he went to Dublin where he made only vague attempts to paint. After a severe attack of hepatitis, MacBryde continued to drink heavily and after a drinking bout he was knocked down by a car and killed. He had survived Colquhoun by four years.

Though much younger than most of the Fitzrovian group of artists, John Craxton (born 1922) became a part of their circle in the war and in 1942-4 shared a studio with Lucien Freud. Like the neoromantics, Craxton rejected the Euston Road Group which he saw as being interested only in 'academic brushwork, the dinginess of the colour, and the dull illusionism of the tonality',[14] in favour of the English pastoral tradition exemplified by Graham Sutherland and derived from Blake and Palmer. The landscapes he drew between 1941 and 1945 were entirely

imaginary and often included the lone figure of a shepherd or a poet—even though he admitted he had never seen a shepherd. 'They were a means of escape and a sort of self-protection,' he said. 'I wanted to safeguard a world of private mystery.'[15]

Immediately the war ended Craxton travelled to the Mediterranean where his romantic idyll found free range in the unspoilt countryside of Greece and Crete. He has lived there ever since. His pastoral vision also found fulfilment in the country when he discovered that 'life is more important than art'.[16] It had a remarkable effect on his work: the imaginary subject matter and the sombre mood were replaced by scenes and people taken directly from the life of the countryside. Sensual renderings of shepherds, lemon harvesters and fishermen have a soft, convincing gentleness in which figure and landscape are intimately united. The hard, surrealistically influenced style of the early 1940s became more responsive and subtle while retaining its angular 'cubist' divisions. All the figures have a tenderness, an element of adoration expressed through their quiet, 'natural' pursuits, their youth and their unity with their setting. Much the same qualities are expressed in portraits of Cretan soldiers such as *Reclining Figure* 1956 (private collection) with the subject matter and the dark, romantic faces adding an homoerotic element. Like his landscapes and figures these are carried out in a style influenced by the angular rhythms of cubism which break up the picture plane. The effect created heightens both the romantic allure of the sailor, including the cap set at a rakish angle, and the physical strength of the soldier's profession.

The freedom that Craxton found in the warmth of the Mediterranean which had such a liberating effect on his painting was similar to that experienced by Robert Medley (born 1905). Based in Cairo during the war, Medley found that in the 'notoriously liberating airs of the Nile valley', 'a capacity for the freer and more sensuous handling of paint' developed in 'the commonplace promiscuity of wartime in a foreign place'.[17] The change in Medley's painting at this time was remarkable for it moved from being stiff and formal to more fluid and sensuous.

Trained at the Slade School of Fine Art, London, in 1924-6 Medley spent much of the 1930s in London involved with his lover, the dancer Rupert Doone whom he had met in 1926, providing designs for the Group Theatre. His paintings, sombre and 'tight', were influenced by the Euston Road School and his choice of subjects, informed by his socialism included East End tenements as well as dancers. After the war his painting techniques changed dramatically. People were painted with greater warmth and shown in more casual and relaxed poses. The hard, formal realism of the 'kitchen sink' approach was replaced by a much freer use of paint which was applied in various thicknesses, dabbed on so that only slowly do various shapes and forms emerge out of the complex

compositions. This subject matter reflected his personal concerns more accurately as well as his socialist views. At Gravesend, by the side of the open-air swimming pool, he observed lean cyclists and bathers in a mood of langorous pleasure, relaxed and enjoying themselves. Paintings of 1933 completed in the old antique room at the Slade School before it was dismantled have ambiguous sexual overtones. *Slave and Wrestlers* 1953 (private collection) shows the classical sculpture of the male wrestlers very much as Francis Bacon was to do at much the same time.

The classical tradition of subject and composition have been a consistent theme in his paintings, whether in hard-edged abstract paintings of the late 1960s and early 1970s (carried out at a time of readjustment after the death of Rupert Doone in 1966) or in later figurative work. Ten years later the move back to figurative work resulted in some of his most personal and strongest painting. *Gilles au Nu* 1908–81 (Collection Norman Rosenthal), based on Watteau's *Gilles*, shows the artist not disguised as a clown or fool; he is naked, vulnerable but proud. The tall, soaring self-portrait literally towers above the figures crouching at his side and conveys a new-found strength and confidence. In *Saul and David* (artist's collection) the biblical couple are shown wearing only jock straps, in close and intimate contact. The homoerotic

10.5 John Craxton (b. 1922) *Reclining Figure* (c. 1956). Oil on board. 45 × 60 cm (17.75 × 24 in) (*Private collection*)

element, though understated and subdued, is a persistent and vital part of the painting.

Though many artists deplored the horrors of war, many found it had a significant effect on their work. For Keith Vaughan (1912–1977) it brought him into close proximity with other soldiers and from his observations and studies of them he began to develop a style based on the theme of the male nude which continued throughout his life. Though he became associated with the artists of the neoromantic group in the years immediately following the war, he resisted the endless drunken revelries and the extrovert pub-crawls in favour of a quieter life. By taking the male nude as his subject matter, he also did not align himself entirely with the dark sombreness of the neoromantics.

In the 1950s Vaughan's view that art has always been about the figure in some way and that when that element is taken away there is a loss,[18] was not in fashion. Part of his own feelings of isolation about his work may have come from the realisation that his figurative style attracted little attention. Vaughan was not interested in straight-forward nude studies; his awareness of contemporary European work by Picasso and Matisse (both were shown in post-war exhibitions in London) and later the abstract work of Nicolas de Stael left him in no doubt about the need to experiment with a freer approach. The process of moving away from a realistic representation of the body towards a more abstracted composition gradually developed through the late 1940s and 1950s and involved not only stylistic changes but the expression of his feelings towards men. 'I paint male nudes because I know what it feels like to be a man,'[19] he said—a view which encompassed his own fears and delights in the beauty and the threat of the male body. Many of these feelings are recorded in Vaughan's diaries, which he kept throughout the war and continued until his death. Extracts from his diaries were published in 1966 and later in the *London Magazine*. Vaughan's writing was an outlet for his feelings, a way of expressing frustration and anger as well as a method of sorting out ideas. When he could not paint they were a great source of consolation.

Vaughan's male figures, though often nude and placed side by side, rarely appear to have any intimate relationship; each one seems complete, and though physically together the figures do not 'need' each other. In *Wrestlers* 1948 (Piccadilly Gallery, London), though the two men are in an activity in which bodily contact is essential, they seem to be pushing against contact. Their movements have the feel of exhaustion, as though the wrestling was taking place in a dream. As in Francis Bacon's treatment of the same subject painted in 1953 (and discussed later in this chapter) it is not clear whether the two men are wrestling sexually or in sport.

10.6 Robert Medley (b. 1905) *Gilles au Nu* (1980–81). Oil on canvas. 101.6 × 88.9 cm (40 × 35 in) (*Collection Norman Rosenthal*)

Vaughan was born in Selsey Hall, Sussex, into a reasonably well-off, respectable middle-class family, but family life was neither calm nor peaceful. His father left home while he was still a boy of ten, making him the 'man of the family' for his mother and his younger brother Dick. The family moved to London where Vaughan lived for the rest of his life. As a boarder at Christ's Hospital near Horsham, he was fortunately taught by the enlightened art master H. A. Rigby, who left him undisturbed to get on with his own paintings. The chapel murals by Frank Brangwyn were an important influence on his early work. Though the spark of an artistic career was lit, on leaving school Vaughan was not put into art school but thrust into the hard commercial world of the advertising studio. This was in 1931, at the height of the Depression, and he spent the next eight years producing successful advertisements. Time was found to pursue his other major interests of drawing, reading, playing the piano and enjoying the beauty of perfectly developed bodies at the ballet.

Visits were made before the war to Highgate Ponds (still famous for nude sunbathing) where he was able to draw and study the men exercising, diving and swimming without causing raised eyebrows. He made friends with two Cockney brothers and they all spent time at Pagham, near Selsey, playing on the beach and swimming naked in the sea. Some of the photographs of men in his published *Journals* (1966) probably relate to this time. Other studies of the male figure were done from magazines, some drawings having an explicit homoerotic content.

With the outbreak of war Vaughan registered as a conscientious objector (he later supported CND) and served most of the time in the Pioneer Corps stationed in Yorkshire. The prolonged contact with and observation of working-class men provided the subject matter he liked without evoking any hostile criticism. Descriptions of his wartime experiences in his diaries vividly evoke the scenes in the gloomy billets and the characters and lives of the other men. At the same time his paintings were shown in London and friends encouraged him to work in oils. Slowly his figurative style began to develop, influenced strongly by the flat plane style of Cezanne and the formal emphasis on the figure learnt from Picasso.

He made constant re-assessments of his work in an attempt to find a style which encompassed his ideas about art and his feelings about the male nude. Over the years this changed and developed; sometimes it was freer and more abstract, at other times he favoured a more realist style. One massive series called *Assemblies* is of men gathered together for some unknown purpose. The figures are made up of roughly rectangular shapes and painted in muted, cool colours and have a monumental though still human quality in which their nakedness expresses a particular intimacy and vulnerability. There is a quality of the heroic in

these figures, though they retain a powerful sexual presence. As is typical in Vaughan's work, they are all separate, apart, and interaction between them is kept to a minimum. The slightly abstracted angular forms comment on the separateness between men and male society, but even so it is not only their individuality that we are aware of but their collective strength.

In a letter to E. M. Forster written in 1962 Keith Vaughan described the problems of painting male nudes: he asks, for instance, whether they should be shown as heroes, or as erotic figures. He concluded that 'come-to-bed' nudes were not what he really wanted to paint and that even though he began a picture by making the figures erotic, this ceased to be important in the painting. This, he said, was not because the genitals were 'decently' covered or castrated—'A man must have his genitals in art as in life'—but because in art they must serve a different purpose. *Nude Study* 1951 (private collection) is an excellent example of a painting of the male nude which is sexually explicit whilst also being a resonant portrait of a youth. In his sketch book Vaughan explored his erotic fantasies showing men sexually involved, sometimes with sado-masochistic overtones.

10.7 Keith Vaughan (1912–77) *Martyrdom of St Sebastian* (1958). Oil on canvas 90 × 122 cm (35.5 × 48 in) (*Bradford Art Galleries and Museum*)

Something of a hypochondriac, Vaughan regularly feared serious illness. Ironically, however, at the age of sixty-four, he got cancer of the bowel and a major operation proved unsuccessful. Heavy radiotherapy left him weak and exhausted—and failed to check the growth. In utter despair, unable to paint or draw and without hope of a cure, Vaughan took his own life. Sitting down to write his diary, he washed down a massive dose of sleeping pills with whisky and continued writing until he collapsed and died.

At his memorial service Robert Gosling described Keith Vaughan as 'a passionate man who held himself private, contained and reasonable. Only occasionally did his vehemence break out in an irritable intolerance or in wild romantic love'.[20] Others described him as 'a stoic Puritan'.[21] His paintings convey something of his own passion and strength and express a Utopian vision of how men can be together.

The deep-felt emotion Vaughan poured into his painting is also evident in the powerful but very different works of Francis Bacon (1909–92), who was born in Dublin. His work first drew great public interest when *Three Studies*, figures for the base of the Crucifixion (Tate Gallery, London), was exhibited in 1944. Almost overnight he became one of the most controversial artists in post-war England. Strongly influenced by Picasso, the organic sub-human form, blind-folded and without arms, writhes and moves as though like some trapped and violent animal reluctantly stretching this way and that fighting off attackers. Presented as a triptych (a favourite Bacon form) *Three Studies* owes little to Christian belief despite the format and subject matter, but was, as Bacon pointed out, merely a device for doing figures. In the violence of their actions these three figures are typical of a recurring theme in his painting.

Most of Bacon's figures are taken from the male nude, a fact which he thinks can be attributed to his homosexuality.[22] In his painting of the male nude he recognises particular influences from Michelangelo who 'made the most voluptuous male nudes in the plastic arts'[23] and from the Victorian photographer Eadweard Muybridge. The series of photographs of the two naked male wrestlers by Muybridge taken in 1887 has a sexual ambiguity which has inspired several paintings by Bacon. The first of these, *Two Figures* 1953 (private collection) is of two men either copulating or struggling on a bed. It was a painting of remarkable candour and completeness and is without the experimental, tentative quality of other paintings of the time, as for example *Study for the Human Body* c. 1953 (National Gallery of Victoria, Melbourne). The subject was particularly remarkable in view of the prevailing mood of the time. The figures' vibratory action recalls Duchamp's *Nude Descending a Staircase* and also makes use of the blurred image, a typical photographic device often used to suggest movement. The 'activity' of the figures also contrasts with Vaughan's more formal *Wrestlers* 1948 and with Medley's

10.8 Keith Vaughan (1912–77) Page from sketch book (c. 1960) (*Private collection*)

painting *Slave and Wrestlers* 1953. The image of two men wrestling successfully evokes a sexuality that can only safely be expressed in physical struggle. During the early 1950s in Britain there was a spate of public prosecutions against homosexuals which reached a peak in 1953 and 1954. In fact Bacon did not return to the theme of wrestling until

1970 in *Triptych—Studies From the Human Body* 1970 (Stedelijk Museum, Amsterdam).

Though often an element in his paintings, homosexuality like any other emotion has never been treated by Bacon literally or as a separate concern. Couples on beds, on carpets or in some form of close embrace have been incorporated into other 'studies' in which the sexual part of the relationship is an act of great violence. Bacon, the observer of men, places them on tables, inside the framework of cages, shaving, and even sitting on the lavatory (*Three Figures in a Room* 1964, Musée National d'Art Moderne, Paris). Enigmatically he refuses to acknowledge any specific aim in his work other than that of the creation of images which, he says, he transfers 'as accurately off my nervous system as I can'.[24]

Ever since his childhood in Ireland, he has been aware of the violence of life. On the Continent before the outbreak of war he saw the violence in Berlin and in Paris. It is not, however, the violence of the streets which he seeks to create but, through paint, it is the violence of the emotions. The distortions of the *Three Studies* that shocked the art

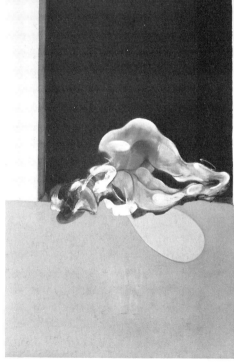

world in 1944 has continued. The violence of the emotions and the violence of our times (the violence of reality) has rarely been expressed so forcibly and so powerfully, as through his distorted forms and swift brush strokes in the series of paintings produced in 1972–3. These searing autobiographical works came after the gruesome death of his close friend George Dyer from a drug overdose in 1971. *Triptych August* 1972 (Tate Gallery, London) is part of this series. The central panel is taken from Muybridge's photograph of male nudes wrestling. The distorted figures can be seen as lovers or mourners. On the left is a portrait of Dyer, his eyes closed and his mouth open, scratched out by a white line. The body is partly destroyed. The figure on the right, which could be a self-portrait, looks away from the central panel. The black background which partly invades the figures adds to the mood of tragedy and despair. The paradox of his intensely private life exposed to public intimacy adds to the emotional content of the painting.

Alone in private personal occupations or in couples, Bacon's subjects recall the horror of a nightmare; their restless turmoil offers no peace.

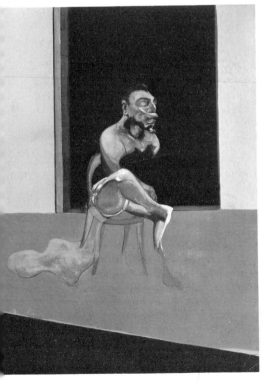

10.9 Francis Bacon (1909–92)
Triptych August 1972. Oil on canvas.
Each 198 × 147.5 cm (78 × 58 in)
(*Tate Gallery, London*)

No figure is still, all are occupied with movements and action. Fresh interpretations and different readings of the old masters enabled new meanings to be made for contemporary situations. Bacon's open admiration for Michelangelo's 'voluptuous males' or his fascination with the scientifically set-up movement studies of Muybridge's wrestlers were taken as legitimate starting points for new explorations—perhaps a necessary context in the light of society's general disapproval of homosexuality.

Though there was a tremendous surge of creative activity in the arts in post-war America, the work had little obvious autobiographical content. Feelings and emotional responses were obliquely expressed. The inventive experimental explorations of Merce Cunningham and John Cage in dance and music which centred on Black Mountain College in the early 1950s broke down many of the barriers between the performing and the visual arts as well as introducing more open attitudes to homosexuality and bisexuality. But by and large the art establishment remained predominantly male and aggressively heterosexual. Official patronage seemed to prefer the work of abstract expressionists and this almost became a national cultural dimension of the cold war against the Soviet Union in which abstract art was posed as the sophisticated capitalist alternative to socialist realism. Such ideological pressure made it difficult for artists to deviate either in their art or their sexuality.

Robert Rauschenberg, (born 1925) who had been at Black Mountain College, maintained a long creative working relationship with Cage and Cunningham; he was one of the first artists in America to produce a minimal painting. In 1954 he met Jasper Johns and for over six years they were to have a powerful creative and liberating effect on each other. Johns, who was born in Augusta, Georgia, in 1930, had had some training as an artist at the University of South Carolina, Columbia, and in a commercial art school in New York before being drafted into the army. Through Rauschenberg he came into contact with the art world.

A year later they were sharing the same building, stimulating new and creative work. Johns, 'soft, beautiful, lean and poetic',[26] approached his work from a serious and intellectual point of view. Flags, targets, alphabets, numerals with oblique references to nationalism and the objects of everyday life, 'things which are seen and not looked at',[27] became his subject matter. *Target with Plaster Casts* 1955 (Castelli Collection, New York) consists of a row of boxes resting on top of an encaustic and collage design. All but two of the boxes contain plaster casts of fragments of a human figure, each cast painted the same colour as its box. A purple foot, white nose and lips, a red hand, pink breast, orange ear, green penis and yellow head. A green object that resembles female genitals is in fact a bone. In all the works there is a sense of cold denial, an impression confirmed by Johns who later said 'I don't want

my work to be an exposure of my feelings.'[28] In paintings made up of cross-hatched patterns or overlayed layers of pigment such as *In Memory of My Feelings—Frank O'Hara* 1961 (private collection) the splashed surface offers little immediate indication of meaning. This has to be looked for elsewhere, in this example in Frank O'Hara's autobiographical poem *In Memory of my feelings*.[29] The poem's central theme of the fragmentation and reintegration of the inner self that threatens to collapse from the assault of outer forces, may also be a theme in Johns' painting. In *Dancers on a plane, Merce Cunningham* 1980 (Tate Gallery, London), a painting which carries a cross-hatched repeating motif, an indication of meaning is carried by knowing the artist's friendship with Cunningham who is a dancer and by the markings on the cast bronze frame. These include a lingam or erect penis, symbols used in tantric art to indicate the god Siva. In one of his manifestations Siva is the Lord of the Dance whose pulsating body contains the entire creation. Yet the titles Johns gives to his work and the references he provides often relate to events in his life beyond the hermetic world of the canvas and its own internal relationships. But to all intents and purposes the autobiography is concealed.[30]

Rauschenberg's 'combines' and 'assemblies' are both more 'open' in that the subject matter is more familiar, and yet equally dense in references. Many of his ideas were used in his illustrations for Dante's *Inferno*, produced in the late 1950s. Using images from current magazines (Dante came from a *Sports Illustrated* advertisement for golf clubs) to avoid 'personal taste', the complex narrative is as impenetrable as any of his work. His assembly *Monogram* 1955-9 of a long-haired angora goat with paint on its face and a rubber tyre round its middle standing on a painting which acts as a base, has been described by Robert Hughes as 'one of the few great icons of homosexual love in modern culture'.[31] As a child Rauschenberg saw his father kill his pet goat, an event which relates to the biblical incident of the ram caught in the thicket and sacrificed by Abraham as a substitute for his son Isaac. The hairy goat, often used as a phallic reference, stranded on the work of the artist, caught up in a rubber band, is an obscure but fascinating assembly.

If fine artists produced images apparently remote from the concerns of everyday life, the explicit homoerotic work of American artists such as George Quaintance and Neel Bates ('Blade') set out to picture the erotic fantasised world of the male homosexual which by the 1940s was well established. The model was the idealised macho stud whose well-filled crotch, large penis, beautiful, developed, muscular body and square-cut features came to define a particular stereotype of powerful, non-sissy manhood which was at the same time homosexual.[32]

In the 1940s Blade produced *The Barn*, a series of highly explicit drawings which were reproduced and circulated underground in the gay

PHISIQUE PICTORIAL

35 cents

10.10 Spartacus *Physique Pictorial* Cover

world. The erotic encounter between a hitchhiker and a driver was too explicit in its sexual detail to avoid problems with the police or to be distributed properly. A police raid in 1948 removed the original drawings, which then appeared in a private underground edition. Photographs of the drawings were taken by the artist's friend George

Platt Lynes and are now available again. At the end of the 1940s respectable physique magazines featuring photographs and drawings of muscular men were produced to cater for the growing homosexual audience. Black and white photographs which centred on an admiration of the male body were discreetly posed and featured cowboys, sailors, bikers, wrestlers or classical settings of ancient Greece or Rome. By artful posing and the use of G-strings full-frontal nudity was avoided, but only just. The magazines claimed to be produced for the benefit of 'artists' and 'physical culture enthusiasts'.

Physique Pictorial, the first magazine to be published, also included 'physique art', drawings by gay artists. These could more freely elaborate

10.11 Quaintance (c. 1915–1957) Drawing (1952)

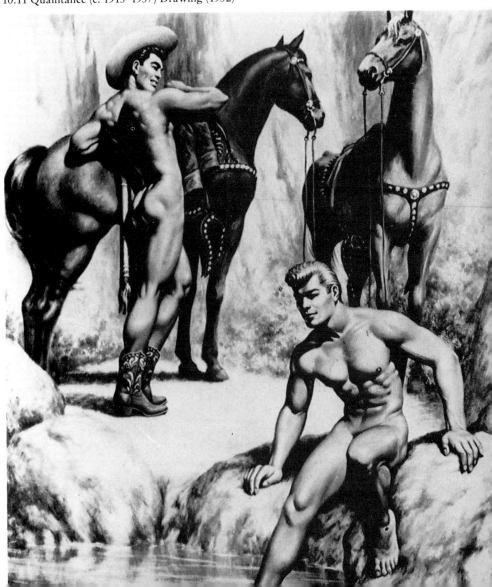

the fantasies in which sexual interest was clearly implied while remaining discreet. George Quaintance (c. 1915–1957) produced finely drawn and painted scenes in which naked muscular cowboys wearing stetsons and boots, or sailors with only a hat on, pose in intimate buddy situations. The highly idealised versions of the American West, Ancient Greece and Rome are powerfully redolent of sexual interest, whilst still remaining sufficiently innocent to avoid prosecution.

Quaintance was born in the Blue Mountain Range, Virginia, and brought up on a farm. An only child, he was more interested in drawing and painting than farming and his parents encouraged his talent. For a time he lived in New York, then moved to Los Angeles where he helped Bob Mizer, the founder and publisher of *Physique Pictorial*, put two early issues together. The magazine was admired by a young Finnish commercial artist who became known as Tom of Finland. Using the models he saw photographed, he started to draw his own fantasies many of which were inspired by erotic memories of farmers and lumberjacks from his rural childhood and by teenage sexual experiences with German soldiers during the war. Tom of Finland's work was first published in the USA in 1957 and, though created by a European artist, has come to exemplify a particular American style. His icons of masculinity include truck drivers, leather-clad motor bike riders, denim-clad cowboys, soldiers and policemen.

Tom of Finland's highly skilled drawings epitomise work that is about gay fantasy for a gay audience. Because the execution is so accomplished they question the difference between the erotic and the pornographic. Their intention is clear and the drawings are technically excellent. They are flawless images of male sex objects who, however unbelievably handsome are still sufficiently human to be acceptable. With this is combined an element of humour and enjoyment even in the most uninhibited situations, a quality photographs can rarely achieve. His series of drawings which feature Kake (Finnish for 'butch') follows the erotic adventures of this apparently insatiable man. The drawings are now regarded as classics of their kind.

During the 1950s, 1960s and 1970s other artists, notably Spartacus, Dom Orejudos and Harry Bush produced drawings exemplifying the gay world. Always highly eroticised and skilled, the muscular handsome studs continue to entertain and excite but only as sexual objects, ready at any time for the ultimate sexual adventure.

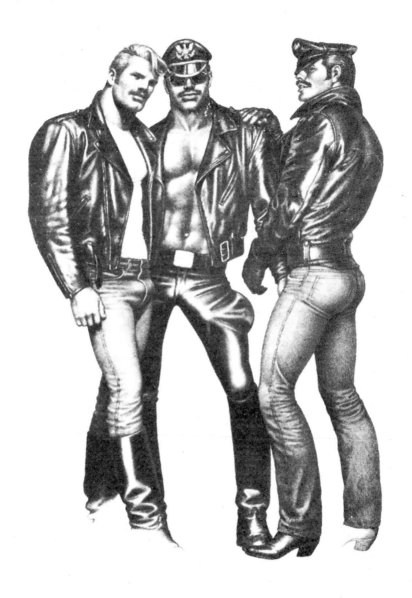

10.12 Tom of Finland (d. 1992) Drawing (c. 1960) (*Tom of Finland Foundation*)

11 · Lesbians Who Make Art

'L esbianism would appear to be so little a threat at the moment that it is hardly ever mentioned,' wrote the sculptor and writer Kate Millet describing the current mood in her pioneering book *Sexual Politics* published in 1969. Though a considerable amount of attention has been given to lesbianism in literature and in film, with regard to the visual arts the silence remains almost as dense as it ever was.

For many artists who are lesbian there seem to be three principal ways of dealing with this. Firstly they can present themselves as artists, ignore their own sexuality and compete in a predominantly male-dominated art world for funding and for exhibition space. Such artists rarely make lesbianism a central part of their subject matter, nor do they come out publicly about their sexuality. A second possibility is to identify as feminists, making their lesbianism a part of the wider struggle of the Women's Movement.[1] Many women who have lesbian relationships do not see themselves as lesbian but as feminists. Important debates about the visual arts and how work by women has been ignored have taken place within the Women's Movement. These have challenged the whole concept of the conventional art aesthetic about what is 'good', arguing that such criteria were formulated by men and largely exclude women. Some also suggest that women artists should not attempt to enter this field but should, for example, set up their own exhibition spaces. Other feminists insist that whatever their declared sexual politics their art should be looked on and assessed along with all other art and not be separated off. Within these useful and constructive debates, the question of lesbianism has not been discussed at any length.

The third possibility is for artists who are lesbian to make this an issue in their work, recognising it as having a major, if not the most important, influence on their practice as artists as well as on their choice

of subject matter. They demand that this be seen as a vital and integral part of their work. It is within these groups of artists that theoretical debate on the work of artists who are lesbian has taken place. Discussion has included the problems of finding exhibition spaces and how to approach the whole question of lesbian representation and presence in art. For instance, there is the question of whether images of naked women together can be done which will not merely be seen by men as soft pornography for their own pleasure. Some artists, determined to confront the issues of their sexuality in their work, to become visible as artists, have directed it specifically at a lesbian or gay audience, while others want it seen in a wider, more general context.

In the United States in the past ten years there has been something of a tradition of showing and thereby encouraging art by lesbians (and gay men). Since 1975 *The Advocate* has regularly included in its 'Portfolio' section work by lesbians and gay men with the emphasis on illustrations accompanied by a brief text. *The Advocate* organised an exhibition of over thirty-five 'Portfolio' artists at the Hibbs Gallery in New York in 1981. David Logan Morrow, the gallery's director, described the show as eclectic, adding that gay art 'is not just representational or figurative, but is art that expresses a gay and lesbian sensibility'. In his view the show affirmed 'the enormous contributions that gay people have made towards our cultural aesthetics'.

In America the Daughters of Bilitis, the first organised and successful lesbian liberation group founded in 1955, published the magazine *The Ladder* from 1956 to 1972. Articles included theoretical and critical appraisals of the visual arts as well as reporting and commenting on events and work. Within the last ten years women have met collectively to discuss lesbian art. The Women's Building in Los Angeles is one venue which has provided a focus for meetings and exhibitions and the Heresies Collective set up a sub-group of eleven lesbians who worked for over a year to produce their important 'Lesbian Art and Artists Issue'. Since then other issues of *Heresies* have carried important articles on visual art by lesbians.

The collective statement of the Lesbian Art and Artists Issue centred on the problem of visibility—the collective saw as vital the need 'to challenge the heritage of secrecy, silence, and isolation which has been a necessity for lesbians who make art'. The issue, which included texts provided by the artists about their lives, their sexuality and their art as well as illustrations of their work, makes clear that they think there is no such thing as 'lesbian art', but that there are some artists who are lesbian.

A year before the publication of the *Heresies* lesbian art issue, the Great American Lesbian Art Show (GALAS) swept across America in a concerted effort to bring the work of lesbian artists to a wider audience.

Various shows were scheduled in many centres and ranged from large 'Invitational Exhibitions' to small, privately held parties. In Boston at the Old Atlantic Gallery, over sixty photographers, painters, craftswomen, sculptresses and performing artists participated in a month-long celebration. A core group of ten lesbian feminist artists shared the common goals of exposure of work and the recognition of 'the richness of lesbian culture'.

Terry Wolverton, a member of the Los Angeles GALAS collective, argued that

> putting together the words 'lesbian' and 'artist' suggests a unique relationship between the two; that there is something about woman-loving that affects our perception of the world and our creativity and that there is something about being a creative artist that empowers our lives as lesbians. . . . We believe that calling ourselves 'lesbian artists' affirms our power of self-definition and self-avowal. It reclaims the long herstory of contributions which lesbians have made to culture.[2]

Also in the United States, a major breakthrough was the exhibition 'Extended Sensibilities—Homosexual Presence in Contemporary Art', held at the New Museum, New York, in 1982. Eight women and twelve men took part in the show which had as its theme the sensibilities of the artists. While little attempt was made to define what these particular sensibilities were, the value and importance of this show lay as much in the fact that it was put on at all, as for any theoretical analysis of the work.

In Britain, apart from modest exhibitions held in association with such events as the annual Gay Pride celebrations, there have been no shows on a similar scale to those held in the USA. One of the first of these 'Art with a Gay Theme' (Night Gallery, London, 1979) included work by three women and fifteen men. The three organisers in their statement about the exhibition said one of the aims was to 'encourage further debate concerning the complex relationship between aesthetics and sexual politics in our society'. Since then, similar shows have included work by women, but to date (1986) there have been no exhibitions of work exclusively by lesbian artists.

The important exhibition 'Women: Images of Men' at the ICA, London, provided no acknowledged work by lesbians and neither was this possibility discussed in the catalogue. Even in 1984 at the Third National Women's Studies Conference, Bradford University, a group of women convened a special Sunday morning session to discuss the lack of lesbian content in the studies.[3] Nevertheless, within the last ten years or so lesbians who make art have produced, exhibited and written about

their work. Magazines such as *Spare Rib* have carried articles on artists, while *Gay News* commissioned illustrations from lesbians including Liz Atkins and Kate Charlesworth[4] and carried regular reports and reviews of the work of lesbian and gay artists.

The need for 'visibility', for the direct expression of lesbians and the lesbian experience whether in drawing, sculpture or photographs, remains a central concern for some artists. Lesbian representation includes scenes of love-making, of lesbian mothers, of women-identified women, of naked females and of portraits of women. Not all such art deals directly with lesbian activities, nor is it obviously by lesbian artists. Sometimes it is the context in which the artist chooses to show the work rather than its subject matter which defines it as being specifically lesbian. Jan U'Ren, a San Francisco artist, for instance, showed her work inside women's clubs and in the form of a women's float for the 1979 Gay Pride March. Her finely detailed pencil drawings are primarily woman-oriented and include nudes, 'feminist still-lifes' such as groups of books on feminism or by feminists, and portaits of well-known women such as Gertrude Stein and Eleanor Roosevelt.

Sandra de Sando also concentrates on drawings which seek to express 'a clear, outspoken record of lesbians and gay men'.[5] Her statement about coming out as a lesbian makes clear the freedom and opportunities this offered: 'Coming out was a joyous time. Suddenly ice blood dissolved, walls became windows and doors.'[6] Part of what she wants to do is to leave records, and this desire to document, to look and record, informs her portraits. Using a technique of projected slide photographs of her sitters, she has developed a photo-realist approach which concentrates on physical appearance. Dense drawing records every detail of skin and hair with every blemish and scar dutifully recorded. But the technique, while apparently concentrating on realism and exactitude, also extends into an emotional involvement through the placing of the sitter and the pencil 'evidence' of the detailed concern.

The freer, more emotional use of paint enabled Scottish-born artist June Redfern to express her identification with various women, combining ancient myths with contemporary imagery. When she left Edinburgh Art School in the early 1970s she had an overwhelming feeling that she would never paint again. Gradually, whilst teaching school children, the urge to paint returned and she took her subjects from the urban working class. At first she painted both women and men. She says it takes confidence to paint only female figures 'because you are painting yourself, your mother, her mother and way back in time—then into the present, the future and then back again'.[7] She also wanted her art to deal with her commitment to socialism and to sexual politics.

Slowly her ideas began to find a figurative form in a freer style of painting. Influenced by the many sorts of images and representations of

women found in magazines and newspapers, and by the 'wild' paintings of artists such as Rainer Fetting, she developed a neo-expressionist style in which rich colour, the thickness of paint and the brush stroke are used to convey emotional and physical involvement. In *Three Figures* 1984 (369 Gallery, Edinburgh) dark, sombre colours are applied in a gestural style to describe the three women who all seem to be part of one body. Their lined faces, their headscarves and their black clothes stare out in a range of expressions. One seems to mock, another to grimace, while the third looks defiant. Their arms move round their heads as if in some sort of mysterious dance. In some sense they are sisters, witches, lovers and the three graces, though they in fact refer to Redfern's friend, mother and herself. The completeness of the figures, their stoicism, their strength comes from their unity and solidarity, referring to the history of women whilst being explicitly contemporary images.

Of this latest work Redfern writes that it 'is nearer to me—I hope the paintings are more intense and sexier and powerful.'[8] Redfern hints at the timeless strength that women have found in the company of others, and a containment that is both admirable and to the outsider almost impenetrable. The 'realism' which Redfern explores in her paintings of women and conveys through an expressionistic style, is to do with respect, even love, and, despite the intense, complex surfaces, has little to do with fantasy. In many ways her concern with the strength of women is the exact opposite of the work of Sheila Sullivan who explores dreams and fantasy in her paintings.

Born in Kentucky, USA, Sheila Sullivan is a member of *Labyris*, a women's coalition of feminists and lesbian feminists. Using a free style of drawing, her paintings are made up of a complex mixture of themes with a dream-like quality. In *The Musician* a black male naked musician stands with one foot on the keyboard of a piano—his instrument. Behind him in the background, two lesbian couples make love. A woman lies on a bed in *Prostitute's Nightmare*. Roots of a plant growing on the bed form themselves into the top of a man. Other men look on while she is caught on the bed, smiling and touching her genitals.

Of her work Sullivan says:

> My entire life has been an extensive tour of people's heads. I have found that the symbols we use in our exterior lives are very watered-down versions of the more universal, abstract and knowledgable ones in our minds. I paint realistic illustrations. I paint in the way that dreams unfold—using unrecognisable images in what most consider illogical sequences, yet all can understand in some part of themselves.[9]

11.1 June Redfern (b. 1951) *Ship of Fools* (1983). Oil on canvas. 182.9 × 152.4 cm
(72 × 60 in) (*Courtesy of 369 Gallery, Edinburgh*)

The experiences Sullivan describes, though they show the figure, describe fears and doubts, desires and pleasures, rather than straightforward representation. This view is one held by other artists who take the argument further. Harmony Hammond, who is very aware of herself as an artist and as a 'class conscious lesbian' says that such artists do not have to make paintings 'with recognisable figurative imagery'.[10] She puts forward the view that aesthetic hierarchies need to be removed and that there should be no ready-made assumptions about what is and is not allowable as art.

Harmony Hammond's sculptural pieces, in shapes which recall organic body forms, evoke the idea of the 'essence' of female qualities. They are the culmination of a thorough search of her own feelings and experiences as a woman and lesbian. Hammond started work as an artist in the mid 1960s and in the 1970s became a feminist before identifying herself as a lesbian. Writing in *Heresies* 'Lesbian Art and Artists Issue', she says, 'I believe that to be a lesbian artist is in itself political' and goes on to argue that full analysis is needed 'of all patriarchal institutions which control our lives'.[11]

In early sculptural pieces she took as her theme the way ritual and myth affect or define women. For some years she and her daughter had collected bits and pieces of Manhattan's endless yardage of discarded clothes. Some of these were treated with a stiffening medium and used in various sculptural pieces. Women's old clothes, painted with acrylic, were assembled as hangings, serving as metaphots for the absent owner or wearer. In *Presence IV* (Collection Best Products Company Inc, Ashland, Virginia) women's dresses, torn and tattered and painted with runny stripes of acrylic, are suspended on a clothes hanger, the bottom edges of the clothes hanging on the floor. Its anti-fashion, anti-glamour message is determinedly aggressive and confrontational, raising the question of whether this is art or political statement.

Female form continued to be a concern throughout the 1970s though in a different way. The clothes pieces were specifically about the way society imposes appearances and conformity on females wearing them out and then discarding them. In later more abstract sculptures her concern moved towards more metaphorical imagery which evokes the intimacy and secrecy of the womb rather than as she describes it, 'the phallic symbolism' of much sculpture. In *Conch* 1977, fabric, wood and acrylic paint are used to make a double form which is made up of two flattened ovals side by side. The fabric, wrapped around a frame of some sort, recalls a bandage or binding, looks soft and inviting, very much like the orifices of the body, though the 'fleshiness' and the full appearance relate to the female rather than to the male. The fact that there are two orifices side by side could be seen to suggest the intimacy of women, and adds to their interest. Equally the title takes on an additional significance

when it is seen in the context in which the conch has often been used to suggest the genitals of the woman.

Sculpture made in the 1980s has continued with the same technique of forming shapes by wrapping and binding fabric. The same theme of intimacy, of the inviting sensuality of the female form has been pursued but with a more active presence. *Grasping Affection* 1981–1982 (Lerner Heller Gallery, New York), formed from cloth, wood, foam rubber, gesso, latex rubber, rhoplex and acrylic, has a more aggressive quality

11.2 Harmony Hammond, *Form of Desire* (1983). Oil on canvas. 180.9 × 119.3 cm (71.25 × 47 in) (*Courtesy Luise Ross Gallery, New York City*)

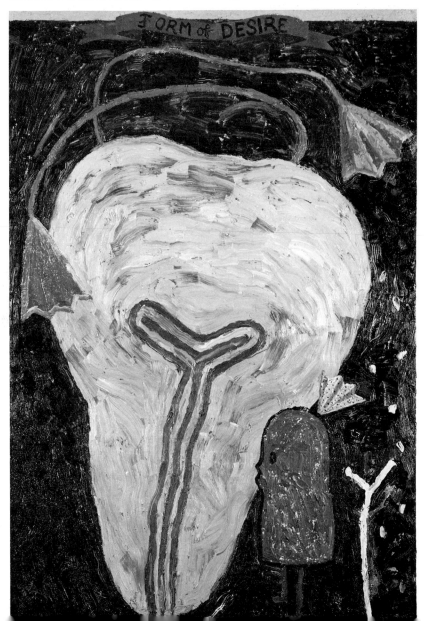

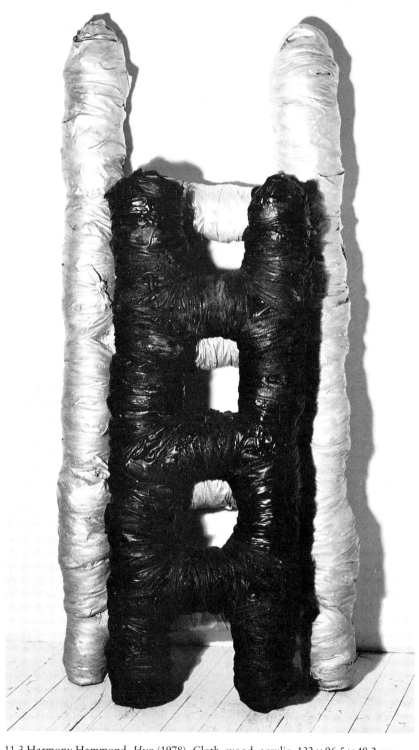

11.3 Harmony Hammond, *Hug* (1978). Cloth, wood, acrylic. 132 × 96.5 × 48.2 cm
(52 × 38 × 19 in) (*Collection Rosemag McNamara*)

which both invites and threatens. Four thick 'fingers' curve round in a U-shape to form an interior and to beckon the onlooker. The technique of using forms which recall organic body parts, created with material which both shapes and defines, gives the sculptures an eerie, almost surreal quality. There are sufficient references to the body to evoke a response, but at the same time it is a creation of fantasy with an element of science fiction.

The idea that some sort of universals exist, but only as mental concepts, informs the sculptural forms of Harmony Hammond, the performances of Betsy Damon, the paintings of Monica Sjoo, the neon sculptures of Lili Lakich (born Washington D.C., 1944), the architectural miniature sculptures of Nancy Fried, the sculptural pieces of Jody Pinto and the ritualistic assemblages of Kate Millet, though all explore this in very different ways.

Like Harmony Hammond, Betsy Damon has sought to epitomise 'female presence' in her work, but she does so on her own terms and based in her own experiences. 'Neither feminism nor lesbianism determine the form and content of my work yet it was only with the security of the former and the coming to terms with the latter (the muse) that my life and art began to be uniquely and overtly me,'[12] she wrote in 1977. In the mid 1970s she was involved with the Women's Building in Los Angeles, meeting artists, activists, and theorists. From this experience she stopped regarding art as a professional activity and started to 'think of time as a division of historical cycles'.[13] Using her own memory and then her thoughts she mentally flowed back in time, employing a knowledge of history and her imagination.

In the *Heresies* 'Lesbian Art and Artists Issue' she describes herself as a performer, sculptor and mother. She moved to New York City in the late 1970s and formed a feminist studio in Ithaca, New York. One project about time involved the transformation of personal activity into ritual by concentrating on movement, behaviour and objects. Through the mid 1970s she used the materials of nature such as feathers and palm bark from which to make head dresses and masks. These were eventually used in performance, organised either for groups or for her alone. 'I began imagining myself covered in small bags filled with flour. For the next two years I constantly saw the image with one change. She became a clown, and I decided to paint my body and face white. Only after completing *Sacred Grove* did I identify her as a 7,000-year-old woman.'[14]

For *Performance Number One* which took place at Cayman Gallery, New York in 1977, Damon covered her body with 420 small bags filled with 60 pounds of differently coloured flour. Walking slowly along a spiral mark drawn by another woman in the centre of the gallery, she cut and punctured the bags with a pair of scissors. 'The ponderous slowness combined with the intrinsic violence of the cutting and the sensuous

beauty of the bag created a constant tension.'[15] When the performance was over, she had, she said, experienced being 'a bird, a clown, a whore, a bagged woman, an ancient fertility goddess, heavy-light, a strip-tease artist, sensuous and beautiful. After the performance I was certain that at some time in history women were so connected to their strength that the ideas of mother, wife, lesbian, witch as we know them did not exist.'[16] Performances were carried out in the gallery and on the street to the assembled crowd. Writing about one performance on a SoHo Street corner in New York she commented: 'Without the bags to protect me, my sense of vulnerability was intolerable and I returned to the centre and squatted to finish the piece.'[17]

In more recent work, Damon has continued to explore the theme of time. Stimulated by her son's growth into adolescence, she has 'expanded her working definition of collective memory to include male consciousness and experience'.[18] Oil, crayon and pastel have been used in drawings which employ pictographic representations of mystical activities. Imagery included rectangles, sticks and torches. *Firegirl* 1982 shows the representation of a figure in the centre surrounded by small dots forming a circle. The ritual described evokes the ancient past as well as more recent experiences. Another series, started out of doors, allowed the forces of nature, rain, wind and sunlight to affect the markings and forces on paper on which small stones had been placed. Time and its effects, though minimal, could be seen to have been at work.

Writing about her own painting, the Swedish-born artist Monica Sjoo (born 1938) who had lived in England for many years, said that the inspiration has been 'my woman experiences ... of natural child birth (I have three children), of bisexuality, of menstrual creative and psychic powers, of visions and dreams of the Goddess and ancient woman, our Herstory, of women of all cultures and races, of journeys to Her sacred sites.'[19] Monica Sjoo has been active within the Women's Liberation Movement since it started in 1969, working around the issues of abortion, contraception, and for some years with the Bristol Gay Women's Group. Her involvement with the Matriarchy Network, Women for Life on Earth and with Radical Pagans led her to co-author with New Mexican poet Barbara Mor *The Ancient Religion of the Great Cosmic Mother of All.*

Sjoo's paintings since 1967 have expressed her ideas and beliefs, and used images of the 'Goddess and of Earth Magic'. But her painting was powerfully inspired when she met lesbians in the Women's Movement, 'feeling the energy being vibrated by them'. A series of paintings completed after a conference where women had danced together in the nude 'released a hidden feeling of joy'.[20] *Lovers* 1975 is a direct representation of two naked women physically and emotionally close, an impression suggested by the interlocking linear outlines of the body. By

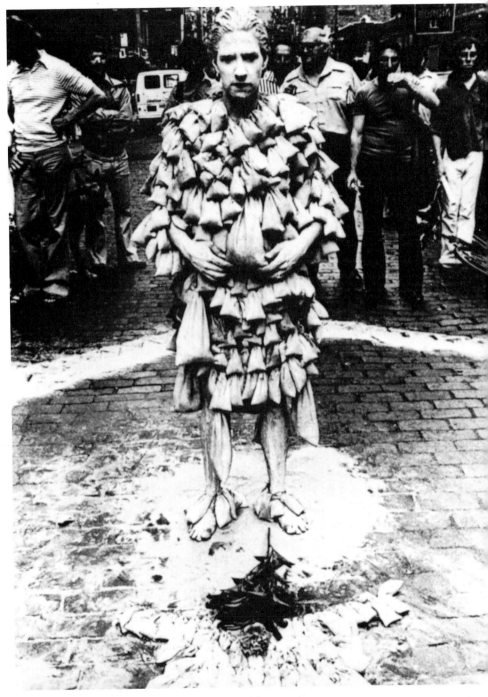

11.4 Betsy Damon, *Performance* 'The 1000 year old woman'.

choosing to work figuratively when the fashion was for more abstract work, Sjoo realised that her paintings would find little popular critical favour.

More controversial is her involvement with the Matriarchy Network. Many feminists do not accept these ideas and some reject them completely, seeing them as a reactionary response to the struggle against oppression. Equally, though for very different reasons, conservative town councils have reacted strongly against paintings which express these ideas. *God Giving Birth* 1968, which Sjoo described as showing her 'religious conception of the cosmic power as the Mother of All', is a representation of the Goddess who is purposefully a woman of indistinct race (but not white) who stands monumentally in space while giving birth. The painting resulted in threats of legal prosecutions for obscenity and blasphemy in St Ives, Cornwall, 1970, in London in 1973 and in Lancaster in 1980. Its powerful message directly told is a hymn of praise for women and their creative strength. The emotional force of Sjoo's ideas finds a direct response in her paintings, which serve almost as religious icons depicting an ideal state in which women rule supreme.

Monica Sjoo's comments on society and the oppression of women are made obliquely. By stating an ideal situation, she describes what she thinks is possible to achieve, but other women look more critically at contemporary society, often using ritual and performance in art as in everyday life to evoke memories and situations and then to challenge assumed meanings. The placing together of apparently unconnected objects assembled to form a complete tableau have the uncanny ability to conjure up human presence even though they are totally deserted. Kate Millet's *Domestic Scene* 1976 is both an intriguing sculptural object and a comment on the apparent ease and conventionality of home life. On a large rounded rug, 4 × 6 foot, stands a foursided square cage, vaguely reminiscent of an old-fashioned fire guard. In the cage, long grass grows. The cosy-looking, reassuring hearth rug is usually associated with security but not imprisonment. Equally, the freely growing grass inside the cage flourishes unhampered by shears or mower. The hearth has become a heath.

Kate Millet, who was born in Minnesota, studied at the State University and at Oxford, England. While teaching at Columbia University, she was dismissed partly due to her controversial public position after the publication of *Sexual Politics*. When she 'admitted' her bisexuality, she suffered very directly for her honesty.

The miniature domestic interiors made up by Nancy Fried (born Philadelphia, 1945) describe a very different and much more personal inside view.[21] The earliest ones were formed from such kitchen materials as bread dough and decorated with water-based paints. They drew on the typical forms of the folk traditions of Mexico, but brought up to

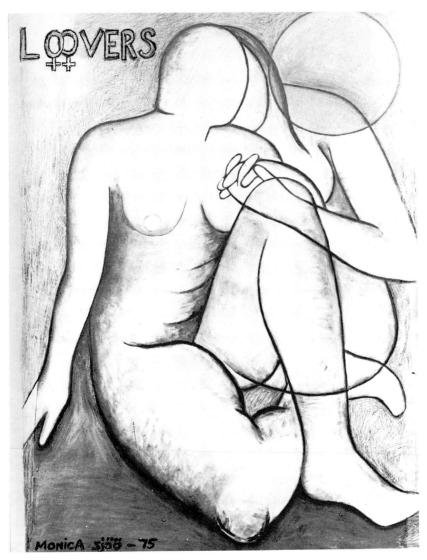

11.5 Monica Sjoo (b. 1938) *Lovers* (1975). Oil. 122 × 182.3 cm (48 × 72 in) (*Artist's collection*)

date to describe such gay experiences as coming-out or the emotional state of love. Within the atmosphere of the Women's Building, Los Angeles, she felt able to deal directly with her feelings, presenting the lesbian content with an intuitive simplicity and directness. Women taking a bath together, lying on a bed or hugging were fashioned from unrisen bread dough into domestic scenes showing everyday events in the life of a lesbian.

Fried's involvement with miniature sculptures has continued. Though

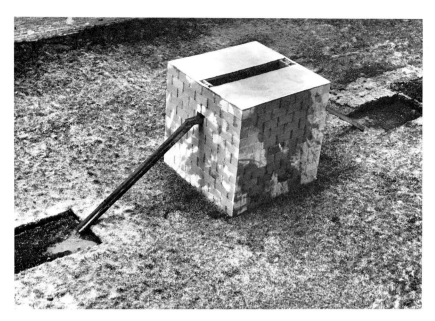

11.6 Jody Pinto (b. 1942) *Heart Chamber for H.C.* (1978). Cement, wood, metal and pigment. Outdoor work at the School of the Art Institute of Chicago. 853 × 243 × 243 cm (28 × 8 × 8 ft) (*Courtesy Hal Bromm Gallery*)

the content has become more complex and emblematic, the naive decoration and straightforward architectural quality remains. In recent work she has used clay decorated with acrylic, employing subject matter which includes myth and other references to suggest the complexity of female relationships. *The Pool* 1981 (Kathryn Markel Gallery, New York) shows a tiny pool surrounded by three walls, one of which has an open arch in it. By the pool, a woman leans on the edge, either praying or resting. The pool, which contains water, also refers to the female and can either cleanse, heal and reassure, or exhaust and threaten.

The female body, its different sections and its functions, usually in representational or in part form, is used by Jody Pinto (born 1942) to suggest the organisation of the universe and its relationship and its intimacy with nature. Her earliest free-standing installation sculpture *Five Black Ovals* and *Bleedpockets* was made up of a series of ten 20-foot long supports holding five personified ovals made up from black resin-coated paper. These, ruined by a storm in Artpark in 1975, were reconstituted to form another work. This involved seven poles which bore pocket shapes made from bleached canvas which were filled with red earth and hay. Whenever it rained, the bags dripped red liquid. Not only were the objects curious to look at but they brought together the cycles of rain and menstruation; they displayed rather than concealed the traditional binding and securing of the female body and made public intimate female body functions.

Much the same theme underlies the large sculptural piece *Heartchamber for H.C.* 1978, built at the School of the Art Institute, Chicago, out of cement, wood, metal and pigment. An 8-foot brick box, built with a slit in the top, has two open drain gullies on opposite sides, running down from small holes in the box, down at an angle of 45° into two black pools filled with water either side. The slit in the top of the box allows rain to enter which becomes stained red before running down the gullies into the pool. The brick chamber, with its intriguing components, also seems to be conducting, moving, straining liquid. It is both heart and womb, apparently only coming to life in response to nature, though the pools either side suggest that the chamber may act as a pump, draining from one and letting out into the other.

More recent graphic work has continued with the theme of body parts. *Henry and the Sea of Red Tongues* 1981 (Hal Bromm Gallery, New

11.7 Jody Pinto (b. 1942) *Henry with Yellow Tongues in a Blue Sea* (1983). Gouache, watercolour, crayon, graphite on paper. 152.4 × 182.9 cm (60 × 72 in) (*Courtesy Hal Bromm Gallery, New York*)

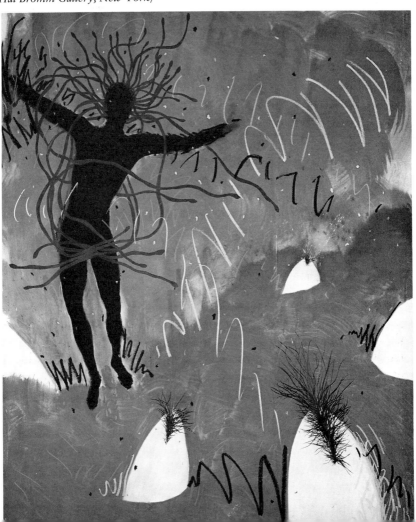

York) shows a pair of women's legs at the top of which is a huge mop of (pubic?) hair floating above an angry 'sea' of red tongues with mouths that resemble the jaws of a shark. Some have hair in their mouths. The tongues, which offer both a threat and a source of pleasure, seem eager to catch, or have released, the floating legs. *Henry with Yellow Tongues in a Blue Sea* takes up similar themes.

The 'language' of form, object, colour and composition created by Jody Pinto allows various 'readings' of the work. The 'language' which is a vital part of Fran Winant's paintings is a secret hieroglyphics of her own devising which only she can 'read'. We can recognise its importance without knowing what it says. Fran Winant (born New York City 1943) brings together in her figurative paintings references to the mythology of ancient Egyptian goddesses and the appearance of cuneiform texts with a startling, almost perverse realism. Winant's involvement in lesbian and gay politics and public activities started when she took part in the first Christopher Street Liberation Day Parade in 1970. Her poetry, published by Violet Press, New York, has the titles *Looking at Women* 1971, *Dyke Sachet* 1976 and *Goddesses of Lesbian Dreams* 1980 and have established her as a writer dealing directly and openly with lesbian themes.

If the language of the poetry is explicit, the dense imagery of her paintings, first shown in 1974, are less clear. Many of her paintings include her dog, Cindy, a blonde and black, part-shepherd, possibly part-greyhound mongrel. The dog either appears alone as in *Cindy* 1976, showing the dog's head, or together with the artist in more symbolic form. In *Dog with Secret Language* (nd) the animal lies prone but alert on a settee and is surrounded with Winant's mysterious language. The letters are a mixture of the Greek and Russian alphabets with a suggestion of Pitman's shorthand. In this way they tie in with secretarial work, a job usually seen as being done by women. In the context of this picture, they add a mystical element which intrigues and adds a religious dimension in the manner of a votive shrine.

This impression is confirmed in a later painting *The Kiss* 1981 in which the animal is transformed into a goddess lying on her back and takes on the appearance of a half-human, half-animal being. The head is that of Cindy, the dog, the arms resemble the legs of a goat, but the whole posture is that of a human. As the artist kneels beside the creature, kissing the animal's extended pink tongue, her lowered face is concealed, shielded from the viewer. It also seems very small in comparison to the head of the goddess. It is the goddess, in the vulnerable position on her back, who is important. The act of physical and spiritual intimacy between human and goddess in animal form takes up the classical theme of Leda and the swan. A poem Winant wrote at the same time as the picture was painted refers to the 'species barrier'

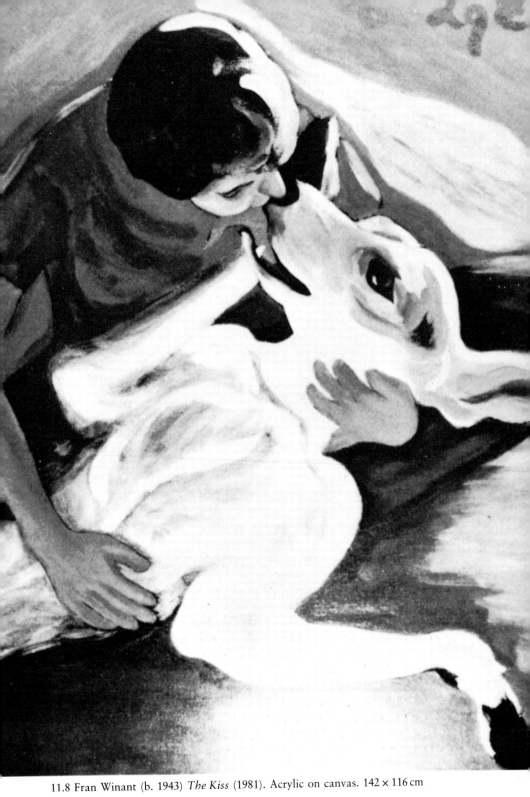

11.8 Fran Winant (b. 1943) *The Kiss* (1981). Acrylic on canvas. 142 × 116 cm
(56 × 46 in)

between humans and animals, but for the writer 'the mouth is a source of purity'.[22]

Significantly, Winant has addressed her paintings directly to a lesbian and gay audience by showing them in such lesbian contexts as the International Woman's Art Festival 1976, New York, A Lesbian Show 1978, New York, and at *Heresies* Benefit Exhibitions 1981 and 1982, New York. At a narrative level, Fran Winant is describing her affections for her dog and the close intimacy that can exist between an owner and a pet. But when this is extended into sexual intimacy, the element of fantasy is increased and there is a rationalised human response of disgust to animal and human sexual contact. It is a response which many lesbians and gay men experience from heterosexuals who find the idea of physical intimacy between members of the same sex 'unnatural' and 'disgusting'. Close emotional relationships are possibly acceptable, sexual ones rarely so.

In this regard, Winant's painting challenges the accepted conventional view of behaviour. While kissing a dog does carry the danger of disease, kissing a goddess does not, albeit one who has some of the appearance of an animal. Winant's subject matter, painted in a free gestural style, is

11.9 Christina Berry (b. 1958) *Cat* (1984). Leather, metal. About 50.8 × 30 × 10 cm (20 × 12 × 4 in) (*Artist's collection*)

controversial and in a sense alarming not only because of the 'health hazard' but because her paintings such as *The Kiss* have an underlying erotic quality: they are in some sense about forbidden love and sex. Spirituality in her painting does not reside only in the aesceticism and in the 'soul' but also in its physical expression.

Indirectly Fran Winant's paintings are also about eroticism and this presents many feminists with problems of visualising their own experiences and desires whilst avoiding the imagery which falls into male sexual fantasy. In Britain, Women Against Violence Against Women (WAVAW) are completely opposed to female erotica: 'We are not against the enlargement of women's culture, but we don't regard the creation of our own erotica as being part of that. . . . The sexual objectification of women is not reclaimable from men, and women cannot neutralise all the social meanings attached to it,'[23] said Jane Egerton of WAVAW. Not all women hold this view and, though they do not discount the problems of producing their own sexual depictions, think it is a struggle that is worth making. 'I am set on the exploration of female erotica, and I feel that women desperately need a creative counterpart to their sexual fantasies', is the view of the photographer Marguerite McLaughlin.[24] Kate Millet, speaking in the film *Not a Love Story*, affirmed this desire, saying 'We got pornography when what we wanted was eroticism.' The photographer Jill Posener has wanted to make photographs of her own sexuality as a lesbian but the difficulties of avoiding censure for producing erotic material has so far proved insurmountable.

Other debates between lesbian feminists centre on the use of sado-masochistic rituals in sexual situations. Such books as *Coming to Power*[25] have argued that between women S & M does not replicate the usual power relationships between men and women, but it enables women to explore, discover and enjoy their sexuality in any way they wish. Other women see S & M as a form of violence associated with men and are appalled at the idea of its practice. But for some lesbians S & M is enjoyable and liberating. Christina Berry (born London 1958) who is a lesbian feminist used her experiences with S & M to inspire her soft leather sculptures and sees no need to explain why she does this. As a Fine Art/Sculpture student at Canterbury School of Art she happened to be among a group of students many of whom were bisexual. The initial question of acceptance of her own lesbianism was therefore helped by the group, and in her final year at art school it started to find expression in her work.

In her series *Cats* 1984 she explores sado-masochistic themes making full use of puns such as 'pussy' and 'cat-o-nine-tails' to evoke both desire, pain, violence and tenderness. The soft black leather is assembled and stitched into cats, sometimes studded, which are strung up, bound and sometimes manacled with metal rings. The series came after the

ending of a relationship with a woman who had two cats. Since then they vary in their intensity and degree of restraint. 'They are always personal and are about my sexuality,'[26] she said. When Berry's sculptures were shown in a gay art exhibition in London the protests came not from other women but from animal rights supporters. So far the only commercial gallery to express interest in her sculptures is one in Amsterdam which specialises in homoerotic art.

In contrast to the way heterosexual male erotic art usually shows women as ideal and unreal victims for male pleasure, female erotica is less likely to objectify and exploit women, who are not shown as helpless and passive victims. Women artists are creating images of women making love or openly showing affection for one another. Erotic images which are primarily intended for female audiences have appeared within the pages of lesbian feminist publications but now extend into painting, sculpture, photography and a variety of graphic forms. Writing in *Gay News*, Sharon Feinstein argued that it is only lesbians who are creating 'explicit images of women making love to each other'. While male and female heterosexual artists do deal with their subject matter, they may do so with a different emphasis.

Two Dutch photographers Diana Blok and Marlo Broekmans explore erotic images of women that include aspects of sexuality, fantasy and dreams. In their photographs they deal with the complexities of their own relationship as well as the relationships between women in general. They first came across each other in 1976 at a summer festival in the south of France where both were trying to sell their photographs. Each observed the similarities in their work and drew back from meeting. Two years later at a party in Amsterdam they met properly, and in the intervening years 'they had been in each other's dreams, shared similar ideas, intentions and even style, and were born only a week apart.' 'It clicked between us. We began modelling for each other and were soon inseparable.'[27]

The relationship involved 'living, loving and working together',[28] connecting totally in the conception and completion of their work as both instigator and portrayer of the images. Each print is signed with each of their signatures and for exhibitions, both photographers often drop their surnames. Bernardien Sternheim, in the introduction to their 1981 show at the Canon Gallery, Amsterdam, said: 'This unusual partnership is not based on a particular conviction, like feminism or socialism, but on knowing each other's dreams and thoughts, illogical and mystical with love as the basic drive.'

Marlo Broekmans was born in 1953 in Hoon in the north of Holland and learnt photography from her father, an avid amateur who recorded her in every stage of childhood. At eighteen she moved to Amsterdam, eventually becoming a professional photographer. Diana Blok was

born in December 1952 in Montevideo, Uruguay, to a Dutch diplomat father and an Argentinian mother. After moving round South America the family eventually settled in Amsterdam. Sociology studies led to Art History and this was followed by some fashion modelling, work as a photographer's assistant, and eventually she became a freelance fashion photographer.

In their photographs the two women explore the personal, sexual self-expressiveness of myths and dreams, relationships and feelings. Their dramatised fantasies display an exhilaration with their own bodies and with each other often posed in the twilight world of fantasy and deep thought. At their most expressive, Marlo and Diana evoke the intense and passionate discovery of love between women. In *The Bite* 1980, for example, one woman lies on her back while the second who is on or beside her is traced as a blur moving from an upright to a position against her partner's body, about to bite her ear. The use of the explicit photographic technique, the generally blurred image, gives dramatic quality to the movement, emphasising the bite. It is a 'natural visual metaphor for what is a psychological and emotional movement as well'.[29] Equally successful is the use of threads or thin white ribbons as a device to suggest both the bonding of relationships and as an indication of internal struggles. The threads may in reality be almost non-existent, but they exert enormous psychological power. *Threading Thought* shows the top third of a woman, her eyes closed and her hands held against the

11.10 Diana Blok and Marlo Broekmans (b. 1952 and 1953) *The Bite* (1980) (*Artist's collection*)

11.11 Diana Blok and Marlo Broekmans (b. 1952 and 1953) *Horses* (1979) (*Artist's collection*)

side of her face. Intense involvement is implied not only in the facial expression but also in the thin thread wrapped round her face and hands.

The device is used in a more heroic vein in *Horses* in which one woman grasps another woman to her of whom we can see only her back and thighs. Both could be thought to be riding on the back of a horse.

Movement is suggested by flying hair and white ribbons streaming back. Equally successful is *Double Portrait* in which the women lie on a bed of crumpled velvet material. They are locked in a fierce, almost tortured embrace; one is asleep. The other, slightly blurred, seems suspended immediately above her. The dream-like quality, the intimacy of the bed, and the horrors of the dream are bound together in taut composition.

Other photographers have set out to record their lives as lesbians, to document the achievements of women outside and beyond the stereotyped image, while others have started to question the whole convention of representational material.

Emily Andersen (born 1956) started using her camera as a sort of diary to capture the important experiences of her life. Born in London, she quickly came to accept her sexuality during her time at a large comprehensive school where there was discussion and openness about homosexuality. Since leaving the Royal College of Art, London, in 1983 she has been commissioned to take fashion photographs for various magazines and newspapers, aiming to make these non-sexist and non-ageist. She describes herself as a lesbian feminist and her own photographs are often of her girl friends. *Lisa in Italy* is a photograph of a girl friend taken while they were on holiday. It is a successful blend of romance, pictorial control and personal memory. Other photographs are more narrative, describing the loss or difficulties of friendships, but in them all she says there is 'a sensitivity towards women that comes through. I don't make loud statements, in being a lesbian there is a strength and if you're supported it can be good.'[30]

In her book of photographs of feminist graffiti *Spray it Loud*[31] Jill Posener (born London 1953) records the result of women who are angry and outraged by large street advertisements which are racist, pro-military

11.12 Emily Andersen (b. 1956) *Lisa in Italy* (1982) (*Artist's collection*)

11.13 Jill Posener (b. 1953) Poster with graffiti (c. 1982). Photograph (*Artist's collection*)

or sexist. The sexist advertisements which portray women merely as heterosexually desirable, dumb sexual objects have resulted in some of the wittiest and sharpest comments. Women spraying captions on large street advertisements or changing existing ones to a completely different meaning have had a remarkable success in highlighting the 'innocence' of much advertising and drawing attention to the way such images oppress women. On an advertisement for beds on which a naked woman lay partly covered by a sheet, the slogan 'We can improve your night-life' had the addition 'Join Lesbian United'.

Other women are more questioning of the 'rules' of representation. In looking at images more critically they seek to subvert them and, by experiment and exploration, to map out new territory and more effective ways of using photographs to express concerns around sexuality. Particularly successful work has been done by Susan Trangmar (born Sussex 1953) and Yve Lomax (born Dorset 1952) who combine photographs and text to produce images which can be 'read' in different ways and are part of a discourse on sexuality. The two artists met as students at St Martins School of Art, London, and were drawn to the more academic department of complementary studies, finding there lecturers who were more inclined to take a critical and questioning approach to representational images and how these work together. The two artists have lived together ever since, sometimes working on joint projects, involving themselves in feminist publishing as well as producing their own work.

In a series entitled *Tattoo* 1982, Susan Trangmar has explored some of the conventions implicit in the notion of the portrait, the mapping and literal marking of the body. Photographs of a woman's face stamped with texts printed with a 'John Bull' printing outfit carry such slogans as 'How much do you want to see' or 'But I'll be brave, I'll flaunt my flaws'. Such statements place as much emphasis on the ability or desire of the viewer to look as on the artist to portray. The portraits are inter- and under-cut by montages to open up and interfere with the apparent integrity of the surface. 'The relentless gaze of the language'[32] combines the printed surface text with the stare of the viewer at the face of the model. It is questioning all that we see, the way the artist works and the constraints of configuration.

The series took Yve Lomax as the model, but it is not 'she' in terms of the individual subject portrayed, but as representative of 'the feminine'.

11.14 Susan Trangmar (b. 1952) Panel extract from *Tattoo* (1983) (*Artist's collection*)

She is a tattoo...she is a variegate...she decorates...she makes bright...she prettifies...she bejewels ...she tattoos...she has a field day...she has great doings...she celebrates...she is a spectacle...she is a tableau...she is a transformation...she is a ceremony...she is a ritual...she brandishes...she blazons...she trumpets...she beats the big drum...she demonstrates...she exhibits...she puts up a show ...she makes a display...she papers over the cracks...she kicks over the traces....................

'In offering up many parts, many lines, the portraits deny the simple and visible truths of a unified identity and essential femininity.'

Yve Lomax is also questioning of the desire we have to construct a unified identity and to make assumptions from the little we see. For one series of works she used fragments of photographs, pieces of off-cut prints and scratched images of women to convey the many sorts of impressions and feelings which are employed to form a 'picture'. One of her pieces *Double Edged Scene* 1982 included the text 'Mirror, mirror, on the wall, who is the most fabulous feminine of all? Mirror, mirror, on the wall, it is but you, the most fabulously framed of all.' The image is of a woman gazing at her own reflection in a mirror. The text serves to remind the viewer of the frame and the almost complete impossibility of moving beyond it, whether the frame is the camera lens, our own preconceptions, the artist's canvas, the frame of the mirror or the frame

11.15 Yve Lomax (b. 1952) *Open Rings and Partial Lines* (1984) (*Artist's collection*)

of our lives. The frame is always there.

For her series *Open Rings and Partial Lines* Yve Lomax questions the way we attempt to strive for unity, of image, politics, and sexuality. The lines on the face of the woman find an echo in the lines behind the figure of the woman: the centre panel or third term 'neither unifies and totalises nor fragments which in turn calls into question the position of the two sides as two *different* sides'.[33] The metaphor used by Lomax allows no simple interpretation. Her work is about the images, about references within them to other things, and about the interaction/relationship between them. There is communication, lines signify this, but the images remain separate and do not form a monolithic whole. As Yve Lomax writes 'There is nothing whole or essential regarding sexuality. Sexuality is a construction which concerns many parts.'

12 · There I Am

In June 1969 the police again raided a popular homosexual haunt, the Stonewall Inn in New York's Christopher Street, but instead of the usual silent hostility they were met by open resistance and a 'riot' ensued. Stonewall, as it became known, marked a turning point in the formation of a positive homosexual identity. The pent-up anger exploded after years of repressive attitudes, resulting in the 'liberation' of the gay presence. Hitherto secretive homosexuals became rebellious and militant almost overnight and were proud to proclaim their sexuality.

The effects were felt in the art world, though the reverberations were less dramatic. While formalists argued that 'art was art' and must be separate from subject matter and the immediate concerns of life, some artists who were gay did deal directly with their feelings, emotions and experiences in their work, though this tended to be out of the floodlights of the commercial art world.

Artists finding a more open acceptance of their homosexuality and wanting to put this in their work could either look creatively at past traditions and archetypes and reform them for themselves, or reject them in favour of relating only to contemporary life and attitudes. Andy Warhol, with a single-minded consistency, was one of the few post-war artists to break almost entirely from past traditions and in the process create new images which for many were to serve as icons for a new age. 'There I am'[1] was how he described his art.

For twenty years artists working in the mainstream of traditional easel painting have incorporated gay subject matter in their work; some such as David Hockney, though influenced by the gay subculture, have directed their work at a wider and possibly non-gay audience. Others such as John Yeadon incorporate their socialist ideas as well as their sexuality in their work. John Perrault's definition of what may constitute

'gay art', that is art dealing with gay subject matter, produced by lesbians and gay men for other gays, cannot by definition be in the mainstream of art but must be located specifically within the gay community.[2] David Hockney thinks there is no such thing as gay art, but it is a convenient shorthand for posing the problems of dealing with sexuality in painting.[3] The erotic drawings of such artists as Tom of Finland and the American Quaintance (see Chapter 10), a very particular form of gay art, had existed for some years. Produced for gay men and dealing with the fantasised sexual imagery of the contemporary gay scene, it is the underground art of the gay sub culture. Such work has been admired by David Hockney, Robert Mapplethorpe, and others for its technical skill and the success of its stated intention.

This chapter is principally concerned with the appearance of male gay subject matter in paintings and photographs in the last twenty years and the changes that have occurred within it. It includes such 'confessional' paintings as those by David Hockney, the autobiographical work of Mario Dubsky, the homoerotic photographs of Robert Mapplethorpe, the broad acceptance of homoerotic themes often based on personal experience which underly the photo-pieces of Gilbert and George, to the questioning rather than the interpretation of images by artists such as Lynn Hewett.

Ironically, while the openly gay communities of such cities as New York and San Francisco provided a model for similar movements and groups in other western countries, its effect on artists was slower to manifest itself. Andy Warhol (1928–87), by the emphatic if enigmatic avoidance of 'content' in his graphic work, confirmed the reluctance of many American artists at the time to use their own lives as subject matter, yet his art films had much the opposite effect, for they introduced and questioned sexual identification and gender roles.

In the early 1960s, after working for five years as an illustrator and commercial artist, he started to make paintings based on comic-strip characters including in 1960 Superman and the ambiguously named 'Puff'. Gradually he rejected expressionist devices involved in the use of hand painting in favour of smooth more impersonal surfaces produced by the mechanical application of paint. Taking everyday images of such things as Campbell soup can labels, he produced multiple screen prints capable of quantity production. At the same time he made multiple-image paintings from pin-up photographs of popular celebrities and film stars reproduced from blown-up photographs. *David Hockney* 1974 (private collection) is the quizzical innocent while *Mick Jagger* 1975 is the sensual pop star. Like the smooth surfaces of the multiple prints which celebrate a mechanical quality, Warhol the artist concealed his feelings.

Deliberately Warhol avoided any mysterious meaning or classical interpretation of his work by using images taken from popular, everyday

life. By reproducing a reproduction he further distanced himself from the traditional unique art work. Even the prints were reproduced in quantity by assistants in his Manhattan 'Factory' so the 'artist' came to mean less. The production of the work of art had been separated from the individual hand of the artist. 'Everyone should be a machine', said Warhol, a machine which has no feelings and no emotions and so prevents the possibility of emotional involvement. 'If you want to know all about Andy Warhol, just look at the surface of my paintings and films and me, and there I am. There's nothing behind it,'[7] he said in 1967. After his near-death in 1968 when he was shot in the chest by Valerie Solanas (the woman who only a few months earlier had founded SCUM, the Society for Cutting Up Men), Warhol was even more reluctant to deal with feelings. He survived, just, and recalled the effects of the incident saying, 'Since I was shot, everything is such a dream to me. I don't know what anything is about. Like I don't know whether I'm alive or whether I died.'[5]

Through his films, which like his screen prints repeated duplicate images of scenes of 'life', stereotypical sex roles were questioned. *Blow-Job* shows in extreme close-up the appropriately changing expressions on the handsome face of a man in the throes of, we are told, being 'blown'. We have only glimpsed the back of a leather-jacketed figure who is performing the act but in fact we do not know if it is actually taking place—whether it is 'acting' or 'real life'. The audience is made a dispassionate voyeur, led to assume all but being given little explicit information. *Flesh* 1968 describes the life of a married male prostitute who earns his living for himself and his family by 'sexual work'.

The true stars of Warhol's films were transvestites such as Holly Woodlawn and Jackie Curtis who refused to accept any defining labels. In an ABC Television chat show in America in 1976, the host in desperation asked Holly Woodlawn 'What are you? Are you a woman trapped in a man's body? Are you a heterosexual? Are you homosexual? A transvestite? A transsexual?'[6] In true Warhol fashion, Holly replied 'But darling, what difference does it make so long as you look fabulous?'

The strategy Warhol devised to distance himself from his art pieces and his films also extended into his life and friendships. By remaining silent and making only brief enigmatic statements, Warhol put the emphasis on observing rather than on participating. Direct communication and the expression of feelings and emotion was avoided. His response to people, of modest self-deprecation, calculated seriousness and an apparent tolerance of all things suggests a complex defence to a hostile universe and reluctance or inability to 'engage'.

Though Warhol aims to be a 'machine', to eliminate human feeling and involvement, to deny the importance of myth and archetype, the images and types he has produced have inspired a wide variety of artists

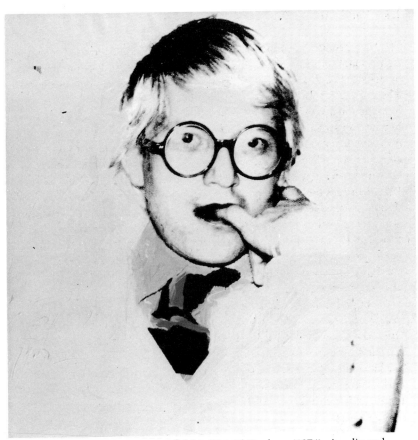

12.1 Andy Warhol (1928–1987) *Portrait of David Hockney* (1974). Acrylic and silkscreen on canvas. 101 × 101 cm (40 × 40 in) (*Private collection*) © 1993 The Andy Warhol Foundation for the Visual Arts, Inc.

and film makers who see in his work a new range of icons. In England, despite the freedom of the 'swinging sixties' when the relatively affluent and expansive economic mood gave rise to experiment and innovation in the arts, all homosexual acts between men were illegal until 1967. The decriminalisation of sexual acts between some men over twenty-one enabled what had been a largely secret and small subculture based in pubs and clubs to become more open. In the early 1960s a homosexual consciousness was developing which prompted David Hockney (born 1937), a young art student at the Royal College of Art, London, to paint a series of 'coming out' pictures. These paintings which he has described as 'propaganda'[7] included a portrait of Walt Whitman as one of his heroes. Poetry by Whitman sparked off *Adhesiveness* 1960 (Cecil Beaton Collection) and *We Two Boys Together Clinging* 1961 (Arts Council of Great Britain).

Within the comparative freedom (and protection) of art school, Hockney made the current pop singer Cliff Richard his pin-up, literally

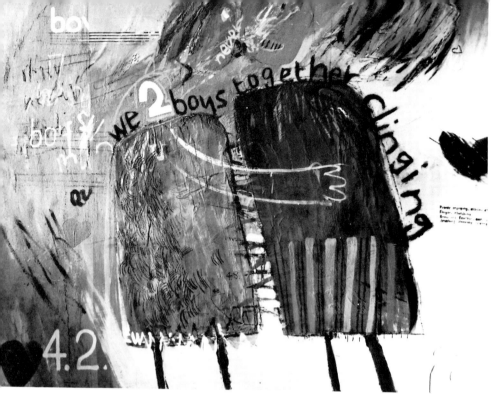

12.2 David Hockney (b. 1937) *We Two Boys Together Clinging* (1961). Oil on board. 121.9 × 152.4 cm (48 × 60 in) (*Collection: Arts Council of Great Britain*)

pinning photographs of the singer on the walls of his studio space. He also illustrated Richard's hit song 'She's a real live walking talking living doll', changing the gender from 'she' to 'he'. Poetry by W. H. Auden inspired *The Fourth Love Painting* 1961 (Collection John Donat), while the writings of the Alexandrian Greek poet Constantine Cavafy, who was homosexual, remained an important influence for many years. In the secure and accepting atmosphere of the RCA, Hockney felt it important to paint out his feelings and emotions; the powerful and complex images that resulted belie the sketchy, *faux-naif* style he was then using and vividly depict his own experiences and desires. Using the coded language of the gay subculture, one figure in *Doll Boy* 1960 (private collection) is labelled 'Queen', an accusatory title which in this painting suggests anguish and unhappiness. It was a mood which did not last for long.

In 1961 Hockney spent the summer in New York and in the well-developed gay subculture of the city his 'coming-out' process was complete: he met and spent the entire three months with a man picked up in a drug store. In New York he was able for the first time to buy magazines specifically about and for homosexuals and together with copies of *Physique Pictorial* (which though not explicitly homosexual were largely produced for gay men), formed a useful reference library of

source material. Paintings such as *Domestic Scene, Los Angeles* 1963 (private collection) of one man taking a shower having his back scrubbed by another man, describe a particular sort of domesticity in which homosexuality can be assumed: it is not a controversial issue. These paintings were also part of the theme of men showering, bathing and swimming to which Hockney continually returns.

In the mid 1960s Hockney returned to Cavafy's writings to produce a series of etchings for his homosexual poems. They include images of naked youths getting into bed or lying down with each other and suggest either pre- or post-coital activity. The spare linear style of the drawing emphasises the ordinariness of the bodies and the situations. They are attractive not because of any stereotypical 'macho' qualities but because they are everyday bodies rather than exotic, fantasised, muscular creations. Though Hockney was to some extent shielded by the literary context of Cavafy's poetry, the emphasis on the tenderness and sensuality rather than skilled sexual performance is too personal and moving to be mere illustration.

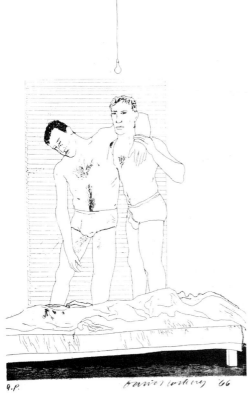

12.3 David Hockney (b. 1937) *One Night.* Etching for *14 Poems* by C.P. Cavafy (1966) (*Private collection*)

12.4 Mario Dubsky (1939–1985) *Agit Prop*. Photo montage mural for the Gay Artists Alliance Building, New York City (1971). 944 × 243 cm (31 × 8 ft) (*Now destroyed*)

The autobiographical theme of Hockney's paintings has continued to inspire some of his finest art. Though never explicitly 'about' sex, there is an underlying theme of homoeroticism which, if often played down, informs the consciousness of much of his work. It is at its most clear in *The Room, Tarzana* 1967 (Collection Rory McEwen) in which a young man lies face down on a bed, his naked, rounded backside offered as a clear invitation either for admiration or for fondling. The man, complete with short white socks and blonded hair, personifies the image of affluent gay youth.

Hockney's success as an artist was assured almost while he was still a student; the fact that he was a homosexual who made no secret of it without 'flaunting it' did little to deter a public eager for cult figures. His working-class, north-of-England upbringing provided a 'real' background for his talent, while his liberal views added to his attraction and demonstrated that success was open to anyone.

Painting as autobiography, which is a persistent theme in his work, extends to include Hockney's friends, lovers, family, travels and his style of life. Smart private swimming pools, elegant hotels, expensive homes and even new luggage convey a cosmopolitan air of wealth and affluence. Some of his finest drawings were of his lover the American artist Peter Schlesinger (born 1948) whom he met in California in 1966 and who almost straightaway became a subject in his paintings. They lived together in California until 1968 when they moved to London and Schlesinger started studying at the Slade School of Art in London. The end of their relationship in 1971 left Hockney unhappy and withdrawn, feelings which are expressed in one of his paintings of Schlesinger *Portrait of an Artist (Pool with two figures)* 1971 (private collection).

Schlesinger, fully dressed, gazes stiffly down into the swimming pool watching a swimmer under the water, prompting the question 'Is he drowning or swimming?' For a period of some years after the breakdown of his relationship Hockney did not paint the figure so often. Though he believes and quotes the line from Auden's long poem *Letter to Lord Byron*—'To me Art's subject is the human clay'—he turned to more impersonal studies of water and to stage designs as an outlet for his creative energies.

The rich, elegant international travels which Hockney pictorialises so well and which have stimulated many other artists to ape are in great contrast to the more sombre, troubled world of his near-contemporary Mario Dubsky (1939–1985). Where Hockney deals in the contemporary world in which he lives and moves, Dubsky explored the world of 'the psyche, the soul, the mind, the inner life of human-kind'.[8] Like Hockney, he was concerned with the 'human image' but his was one which employed myth and legend, the figures angry or rebellious, reflective, powerful or submissive.

Hockney's anxieties about accepting his homosexuality, a process described so vividly in his paintings, were resolved relatively quickly and though he has been a supporter of 'gay rights' he has never identified himself closely with the gay movement. For Mario Dubsky the acceptance of his own homosexuality came more slowly and painfully and he saw the act of stating his homosexuality as political. Acceptance of British culture also came slowly. His parents arrived as refugees in England immediately before the war and recreated their own cultural oasis in London. His foreign name and background made him aware of his 'difference'.

During the late 1950s he studied at the Slade School of Fine Art in London and this was followed by travels around Europe, a journey exploring and finding his 'roots'. It was also a time when he came to accept his homosexuality. A Harkness Fellowship took him for two years to New York where he arrived in 1969. Immediately he was caught up in the atmosphere of post-Stonewall euphoria. The level of personal and political involvement was highly stimulating. Through his friendship with the painter John Button he became involved in the Gay Activists Alliance and he was invited to help make a work for the Firehouse (since burnt down), the G.A.A. building in SoHo. A forty-foot long agit-prop photo-montage was made up of photographs, newspaper cuttings and paint. Naked male and female figures move from darkness to light, suggesting the change from oppression to liberation.

After a period of more abstract work, Dubsky returned to drawing figures during a teaching spell in New York. A few years later, this work was continued in London where he found an excellent male model who could take up and hold complex poses. A series of powerful drawings *Tom Pilgrim's Progress Among the Consequences of Christianity* 1977/8 were inspired directly by the *Gay News* blasphemy trial in London. Appalled at the way Church and State can operate together, Dubsky used the allegory of the pilgrim attempting to find his way to describe the plight of the human condition.

Dubsky has also looked analytically at myths and legends which describe the plight of 'human kind' through such figures as Pan and Oedipus and the Sphinx. Introducing a note of morality, Dubsky suggests that 'human kind' does have some control over the world in which they live and the way people relate to each other. In several images the male is identified with the penis, with both its sexual activity and its representational role as purveyor of power. Men, he implies, need not be helpless victims of the power of the flesh but can transcend and conquer. In one drawing, shaded to take on the tonal quality and strengths of a painting, Dubsky decorates and elaborates the erect penis giving it wings of flight. At its top is the face of a youth whose eyes are sightless. Despite including the subject of space travel in his paintings, Dubsky's vision is directed from the physical concerns of the flesh towards the innermost conflicts and concerns, to internal rather than external space. It is a world of darkness and mystery rather than lightness and pleasure.

Dubsky's response to the Gay Liberation Movement came directly and powerfully. Other artists responded just as strongly, if more slowly. Michael Leonard (born 1933) studied graphic design and illustration at St Martin's School of Art, London, before working as a freelance

12.5 Mario Dubsky (1939–1985) *Pan by Moonlight* (1983). Charcoal on paper. 152.4 × 101 cm (60 × 40 in) (*Artist's collection*)

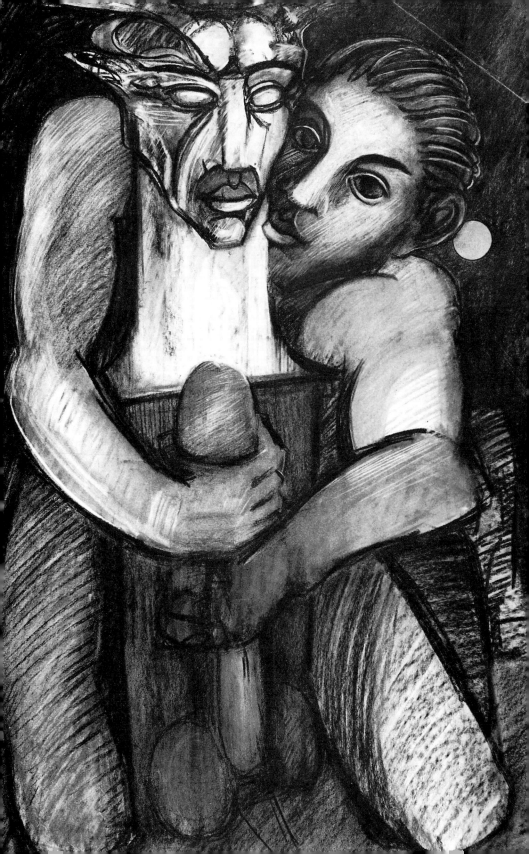

illustrator. During the 1960s he spent more time on his painting, choosing to work realistically and figuratively at a time when this was out of fashion. When he was invited to provide six colour illustrations for the highly successful book *The Joy of Gay Sex* he saw this as an important part of his 'coming out'. His sensitive paintings are as much about tenderness and feelings as sexual performance.

This newly found freedom influenced his painting. Deeply impressed by the skills of Renaissance artists and their long study and detailed knowledge of the naked male form, he used classical compositions as a source of inspiration from which to devise his own complex arrangements of figures set in completely contemporary settings. Rather than taking situations or compositions literally from the great artists of the past, Leonard takes compositional themes, such as the powerful cross structure of Jacque-Louis David's *Oath of the Horatii* 1785 (Louvre, Paris) for a painting of builders working on scaffolding, *Passage of Arms* 1979. He also takes up the theme of heroism but gives it a completely contemporary meaning. Leonard does not see the male body as signifying force, tragedy or weakness but as Edward Lucie-Smith points out, Leonard's drawings are an 'unashamed hymn to male beauty'.[7]

Using a meticulously rendered realistic style both in his pencil drawings and in his painting, Leonard achieves a realism based on a heightened awareness of the moment of transition. Figures are 'real' in that they relate to scenes encountered in everyday life, with men who unselfconsciously develop muscular bodies. For example in compositions of building workers or athletes he shows the pale areas of the body which have been protected by vests or shirts which are not tanned by the sun. We are at once the voyeur, the privileged viewer of those areas of the body usually concealed from public gaze.

Leonard's careful drawings of men to which he gives the general title *Changing* are more explicitly homoerotic. Invariably young, handsome and muscular, the men are shown alone or in groups. Most are in the process of removing or putting on their clothes. They could be in changing rooms—this is not clear—but they all seem in some sense isolated, psychologically and physically, hunky icons in the midst of white space. We the observer are given a keyhole view. The presence of white socks, shorts, vests and so on suggests the fitness and health of ideal specimens enjoying the physical awareness of their own bodies. Sensitively, lovingly observed and meticulously drawn, the men are both objects of desire yet beyond reach, available only to be admired.

The realism and precision of Leonard's drawings can also be seen in the dense photorealism of the work of Roberto Gonzales Fernandez. Born in Spain in 1948 he studied Fine Arts at Escuela Superior de Bellas Artes de San Fernando, Madrid, and eventually settled in Edinburgh in 1977. In the series *Parade*, based on the Gay Parades of San Francisco, he

describes types and situations, but more importantly the relationships between members of the group indicated by looks and gestures. Although at first glance his drawings are about reality, they have a 'twist', a psychological dimension which takes them beyond their literal meaning.

The male nude continues to be the stock-in-trade of the artist who is gay, though some take it into new areas. The American artist Robert Crowl, now over sixty, places his youthful nudes in domestic interiors, the bathroom, lounging on a settee or looking in a mirror. Relaxed, dreaming and in soft focus, his nudes are at ease, painted for pleasure, a 'world of Impressionist odalisques and Fauvist sensualism'.[10] Ian David Baker (born 1945) also draws and paints the youthful male, sometimes naked, sometimes clothed. His sensuous images are soft-focus and gentle, to be admired and savoured; their homoerotic charge is both loving and desiring.

If Crowl's work recalls the traditions of oil painting, David Hutter's male nudes take up the long English tradition of watercolour, but bring

12.6 Michael Leonard (b. 1933) *Passage of Arms* (1979). Acrylic on cotton duck. 80 × 86.4 cm (31.5 × 34 in) (*Private collection*)

12.7 Robert Gonzalez Fernandez (b. 1948) *Machismo* (1981). Pencil and crayon (*Artist's collection*)

it very much into our own time. David Hutter (1935–88) paints very much from a desire to pursue a favourite activity. Though involved and active within the Gay Liberation Front in London from its inception in 1970, this concern was not expressed directly in his painting until ten

12.8 Ian David Baker (b. 1945) *Drawing of a Boy Sitting* (1980) (*Artist's collection*)

years later. Then, working from the naked model, he painted directly on to the paper without first drawing the form, building up the figure from washes and overtones. The result is one of relaxed movement and delicate strength, solidly and convincingly constructed. Yet the tonal

softness of watercolours gives the male forms an added note of vulnerability, with more than a suggestion of softness beneath the firm exterior.

Like Warhol and Leonard, Hutter's figures are psychologically and physically very modern.[11] They are painted in the centre of white space without any particular context. All are posed so as to suggest an involvement with the viewer, whose attention is sought, though none sets out deliberately to solicit sexual interest. With a minimum of props Hutter suggests the idea of a complete context without actually painting it in. The figure is literally isolated. One man leans relaxed against an imaginary wall, another in *Sick Leave* 1982 has his arm in a sling and a bandage around his leg. All are very much at ease. Other figures with titles such as *Watching and Waiting*, *The End of the First Movement*, and *Torse Heroique* are equally descriptive of place and pose. In their quiet and understated way, all are portraits of particular individuals rather than anonymous 'sex objects'. The painting *In Praise of Older Men* 1984 for example is of a model who is far from being a typical homoerotic image.

In contrast to the more gentle and romantic view of Leonard and Hutter, the art of anger, pride and sometimes unashamed propaganda produced in Britain in the 1970s rarely went further than bright colourful banners and ornate clothes—'Life as Art'. More recently artists such as Denis O'Sullivan (1954–92), Colin Hall (born 1952) and Martin Jones (born 1947) have taken the gay experience as their subject matter. Whilst a student at Ravensbourne Art School, as his final project O'Sullivan produced a sculptural installation *Toilet Piece* 1978. The work takes as its theme the way public toilets ('cottages' or 'tea rooms') are used by some gay men for sexual contact. It is made up of a series of panels which realistically recreate a part of the wall complete with 'glory hole' into the adjacent cubicle. Behind each hole is a sequential photograph which depicts the view on the other side. The panels describe the events of the incident. An accompanying text describes the fears, anxieties and desires of the participants involved in the rituals of watching and communicating. By taking this particular sexual activity which for many gay men is an important source of contact, but one often associated with guilt as well as excitement, O'Sullivan's exposure of the 'secret' and 'private' was a direct challenge to the silence and fear of homosexual life.

In some ways O'Sullivan has adopted Genet's philosophy that the most radical act of the homosexual is to positively take pleasure and revel in the 'insults' levelled by heterosexuals; to welcome for example the label 'queen', 'cock-sucker' and 'freak' as a rejection of the stereotypical ideal of what constitutes masculinity. Much the same sort of questioning can be found in O'Sullivan's drawings of himself in female clothes, a personal search for an easy. if unconventional identity. O'Sullivan's work

12.9 David Hutter (1935–1988) *In Praise of Older Men* (1984). Watercolour. 74 × 52.6 cm (29 × 21 in) (*Artist's collection*)

also takes up the late nineteenth-century theme of androgyny, a looking again at the freedoms offered by a 'third sex', operating outside the confines of heterosexual or homosexual stereotyping.

12.10 Denis O'Sullivan (1954–1992) *Toilet Piece*. Single panel, wood, photograph, pencil, paper, pen.

Similar themes have been taken up by Martin Jones whose paintings are filled with characters inspired directly by Andy Warhol. In *Upper Balcony* 1980 (private collection) a man can be seen wearing highly unsuitable and ill-fitting ladies underwear. Behind him can be glimpsed another figure of a sex which cannot be determined. Both seem to know what they are to each other and to themselves and we are dared to question and to make moral judgements.[12] The painting is loosely based on Warhol's film *Lonesome Cowboys*.

In other paintings, many of which have a soft, dream-like quality, Jones deals with male prostitution, with the world of the hustler and punter and again we are invited to observe and accept—we do not need to 'understand'. Neither are we given much opportunity to 'understand' by Colin Hall. His complex and multi-layered collages are made up of the detritus of everyday life, sometimes assembled together with *faux-naif* drawings, to mix 'art' and 'life' in an unseparable combination, and we are left to make of it what we will.

Like O'Sullivan, Hall refuses to accept the conventional constraints of what is 'acceptable' and 'unacceptable'. In public toilets, for example, he

12.11 Denis O'Sullivan (1954–1992) *Transvestite with Torn Stocking* (c. 1982). Charcoal.

traces drawings and graffiti from walls and incorporates them into his work. He also includes messages written on toilet paper which have been passed between himself and the occupant of the adjacent cubicle. The explicit descriptions of sexual desire, the instructions and the sense of urgency, have a rawness and immediacy which carries a powerful erotic charge—though one viewed from a distance. 'We are forced to understand that this is what Colin Hall's sexuality means in everyday terms,' noted Mike Troby in the catalogue of Hall's Acme Gallery exhibition (1981), adding 'We are a long way from the luxury of Hockney's pools.'

Indeed Hockney's gentle images of gay life seem a long way from the sperm and sweat of sexual activity, which is exactly one of the concerns of the oil paintings of Derek Jarman (born 1941). Jarman's wide interests include film-making and designing for the theatre and his paintings have been influenced directly by these interests. Within the gloomy sensualism of the back rooms of gay clubs and in the darkness and impersonality of open-air meeting places, Jarman senses the theatrical, dramatic qualities of the couplings and conjoinings.[13] Using a compositional style of classical relief, his muscular figures are scratched through a dark layer of black, gold and vermilion paint to be almost indistinguishable in the gloom. Added slogans 'Fuck Boys, Fuck Boys' describe and instruct.

The mystery that pervades these sheer sensual activities, enjoyable precisely because they are impersonal and public, is a plea for a recognition that the desires of the senses can be fulfilled without guilt or commitment. In this regard, Jarman reacts to the theme of the American writer John Reichy who argues that impersonal sex outside coupledom or marriage is a deep challenge and a threat to the Judeo-Christian beliefs of western society. Hence such activity makes gay men sexual outlaws, undermining bourgeois attitudes. Such behaviour is exemplary of machismo and is a continuation of the way men have always been able to enjoy sexual freedom without criticism in western society and does little to question the behaviour of men in society.

Men's role, 'masculinity', is rarely examined critically by artists. The growth and extension of machismo, of the strength and glamour of the male body, particularly during the late 1970s when the use of macho clothing (jeans, check shirts, boots, black leather, belts and so on) came to identify a particular sort of homosexual. It is photographers who have mapped out this terrain most precisely. Their point of view has become one of involvement and participation rather than observation.

Photographers have been the pioneers of the new homosexual eroticism. Robert Mapplethorpe (1946–86) has with a beguiling naturalness taken photographs of the world in which he himself is involved; their subject matter is important to him personally and in the world of photography startingly new. His is not the objective view of the camera, but the

active and subjective mood of the participant. Mapplethorpe studied painting and sculpture at the Pratt Institute, Brooklyn, before starting out as an independent photographer in 1972. He moved into the notorious hang-out of artists, the Chelsea Hotel, and during the 1970s became involved in the life around it. Early photo-montage and collage included images from pornographic gay sex magazines and later incorporated his own pictures. These show sado-masochistic scenes of unflinching honesty, as well as portraits of friends and studies of flawless flowers.

Right from the start the photographs were 'honest', seeking to neither glamorise nor play down the physical and sexual extent of the work. Mapplethorpe's work has a 'shocking' quality both for his choice of subject matter and the fact that the photograph is intrinsically more realistic than painting because the images are 'real'. Pornography, always (and often falsely) separated out from 'the erotic', fascinated Mapplethorpe who wanted to remove the boredom of commercial pornography and make pictures which whilst still erotically charged could be artistically beautiful. Where better to take such pictures but in the midst of such activity? With great bravura, Mapplethorpe became the great sexual showman; he photographed himself with a whip butt up his

12.12 Robert Mapplethorpe (1946–1986) *Elliot and Dominick* (1979) (*Robert Mapplethorpe Foundation*)

arse and his friends pressing another into his mouth. With an almost dispassionate sense of observation, he posed his models in carefully arranged compositions. His particular aesthetic involves crystal clarity which has nothing to do with the snap-shot and flash gun technique of commercial pornography. Thus the most extreme S&M scenes involving chains, straps and black leather, men with trussed genitals, bound and gagged, soon take on a 'natural' quality which can be objectively studied even if some people find the subject matter overwhelming. If Mapplethorpe is unflinching in where he points his camera, he never distances himself from the scene depicted. 'I've done everything I show in my photographs,'[14] he said. Each scene has the unhurried quality of the tableau; never do we feel rushed or pushed along.

12.13 Robert Mapplethorpe (1946–1986) *Man in a Polyester Suit* (1981) (*Robert Mapplethorpe Foundation*)

12.14 Arthur Tress (b. 1940) Photograph (*Artist's collection*)

Yet despite the obvious involvement of the participants in such complex situations there is often a note of humour. Mapplethorpe never ridicules the sexual athletes he photographs (indeed, many of his photographs could serve as plates in an instruction manual on S&M) but equally suggests that even in the most serious and involving situation humour is present. This may be the way the participants look directly at the camera or it may be the sheer excess of the situation.

One of his most humorous pictures, *Man in a Polyester Suit* 1981, exploits the sexual stereotype of the well-endowed black male. It shows the man only from chest to thigh, standing three-quarter view to the camera, legs apart, hands held freely by his side, with his large, full,

black penis hanging with casual strength from the open zip of his three-piece suit. It is an image which is both 'shocking' and sensational, a private picture both literally and metaphorically. It is public exposure from which there can be no retreat. Recently Mapplethorpe has taken less explicit, less confrontational images, reflecting the concern for a less sexual lifestyle as the disease AIDS takes its toll.

Another artist who has had a self-identifying link with hard-core homosexuality, though in a more fantasised, dream-like way, is the New York photographer Arthur Tress (born 1940). Since the mid 1970s Tress has explored male sexuality in his pictures, which have been a fusion of personal experience, Shamanism, and Jungian psychology. One of Tress's aims, to give form and body to the male subconscious, has resulted in a series of almost surreal images in which naked men appear in unusual sexual situations.[15] They may be wreathed in flexible tubes straddling up-turned bicycles or bound and gagged in ruined, deserted buildings. One evocative image shows only the crotch of a man with a tattooed hand and penis, with capsules dropping out of the end of his foreskin.

The hardcore imagery of Mapplethorpe and Tress has been taken up by other photographers who include the American artist Robert Giard. His subject is again explicit homoeroticism and includes naked males lying across a motor cycle which suggests a connection between masculinity and a throbbing machine. His allegiance to Tress is clear in his portrait of the photographer; he drapes him in film and presents him as the 'Muse of Photography'.

Such work is in contrast to the equally powerful but less noisy homoerotic sensibility of Duane Michals (born 1930). He is particularly interested in the nude figure which he sees as 'non-specific, universal',[16] expressing both 'vulnerability and sex'. Michals relates his work to the classical Greeks (he prefers the body not to be excessively muscular) and draws inspiration from such figures as Michelangelo, in particular the bound slave, from religious icons such as St Sebastian, and from the ideas of the surrealists.

His series *Man to Man* (1977) explored the relationship between an older dressed man and a younger nude man. Tension and vulnerability are conveyed in the implied erotic relationship, whether between father and son, teacher and student, or related to the concept of lost youth. 'In my work with the nude,' Michals wrote, 'I try to deal with my feelings as openly as I can.'[17] The theme of older and younger men was explored further in the series *Homage to Cavafy* published as a book in 1978. This volume included ten poems by Cavafy and the same number of captioned photographs. In the images Michels investigates desire and love, youth and age, conveyed with a subtle eroticism. Ordinary everyday scenes such as lighting a lover's cigarette or drying after a shower are given an almost ritual significance of great intensity, important because of their ordinariness.

12.15 Arthur Tress (b. 1940) *YMCA* (*Artist's collection*)

12.16 Duane Michals (b. 1930) *The Return of the Prodigal Son*. Photographic sequence (1982) (*Sidney Janis Gallery*)

Ritual, both symbolic and real, is present in *Man with a Knife* 1979 in which a naked man is forced (bound?) against a wall, his hands behind his back (tied?), mesmerised by an outstretched arm which presses a dagger into his nipple. Inspired by paintings of St Sebastian, the danger is both real, in that the skin is being pierced by the point of the knife, and allegorical—the man is being penetrated, the prick may well be the penis. The image, though momentarily threatening, is highly erotic.

Ritual based on agreement rather than force also plays a large part in the photographic imagery of Jean-Marc Prouveur (born 1956) but he adds to his assembly of images a mystical and violent dimension. Some of this is associated with death which gives his work an almost religious intensity. Prouveur studied at the Ecole des Beaux Arts, Cambrai, France, before settling in London in 1976, where he has since had his studio. In

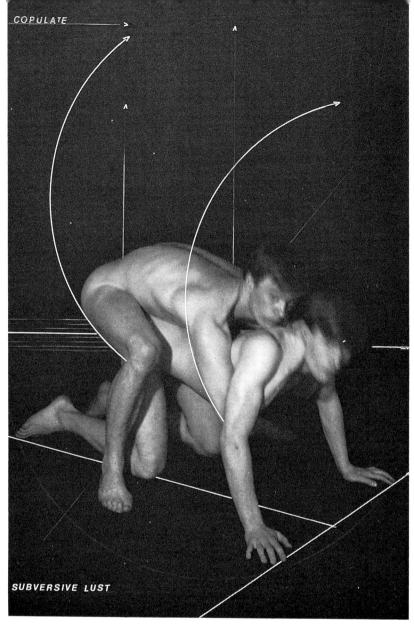

12.17 Jean-Marc Prouveur, *Subversive Lust* (*Artist's collection*)

his early photographs Prouveur used the image as a means of analysis of behaviour and identification. For one series of men photographed in various sexual positions, he drew onto the print neat mathematical circles and lines delineating movement and action. This obvious handworking of careful study of the scene had both the effect of heightening the erotic content and giving the work a scientific, almost

medical purpose. It also serves to distance the highly charged erotic subject with its cool analysis. *Subversive Lust* 1982, of two identical twins apparently performing an act of buggery is circled, lined and labelled 'copulate'.

More recently Prouveur has continued the theme of outlawed sexuality in his series *Altar Pieces* expressed in ritualised evocations presented in the form of triptychs; rather than use the quasi-religious device merely to attract attention, he extended it to link eroticism, religion, beauty and death with a hint of violence, to give a critique of religious art. Prouveur's triptych format, which shows naked or half-naked males flanking the central object of contemplation, has black rather than white imagery. The whole tone of the photograph is dark and mysterious. The handsome bodies of youths make direct references to such men depicted by Caravaggio, but Prouveur gives them the posturing and posing attitudes of London rent boys. Seduction, degradation and possible violence imbue the obvious theatricality and drama of the tableau he sets up, and though the scenes are deliberately artificial it is a tribute to his skill that the pieces retain their power.

Like Prouveur, Lynn Hewett (born 1955) addressed the issue of the construction of masculinity, looking particularly at the significance of the classical concept of male beauty in videos which juxtapose modern

12.18 Lynn Hewett (b. 1955) *Reconstruction* (detail) (1982). Photocopy, video (*Artist's collection*)

....identifiable historical processess

and historical images. Hewett examines the overwhelming importance of the classical ideal of the male body as exemplified in sculpture, of firm smooth, hairless flesh and small genitalia, and the way this suggests both adulthood and sexual innocence. These are compared with mannerist representations of the sixteenth century, in which the male body was as much feminine as masculine, although still idealised and remote. Ambiguous and multi-layered, Hewett's work is both sensitive and complex.

Hewett's concern with the representation of male homosexuality uses slide/tape presentations and photocopies of drawn and photographed images. Writing about his graduation degree show at the Royal College of Art, London, 1982, he described his work as having to do with '... sexuality: a construct. Photographic representations of gay men: a part of the mechanics that construct. Dis-cover and re-build ...' The post-gay-liberation questioning involved in both Prouveur's and Hewett's building of male imagery is a field in which there is still plenty of fascinating analytical work to be done.

The aspect of the world presented by New Orleans artist and photographer George Dureau (born 1930) is both unconventional and at first sight sensational. His work is about male figures, some of which have virile, muscular and well-developed bodies: others are of men disfigured or malformed. But his intimate portraits are not mere curiosities, specimens held up for contemplation or entertainment, but have a noble strength and dignity, a portrayal of the human condition in all its vulnerability. Dureau is honest about his interest in representing 'difficult', lives. It might be, he says, because he feels or has felt, inadequate at different times of his life. 'In painting and in photography, I am using physical inadequacy as a symbol of any sort of inadequacy— including a psychological one.'[18]

The need to make visual representations of gay women and men which seek neither to sensationalise nor glamorise, yet still have sufficient documentary reportage, is central to the work of the photographer Sunil Gupta. Born in India in 1953 but now working in London, Gupta identifies his interests with those of Duane Michals and the documentary portraits of Diane Arbus. In an exhibition in London in 1984 of his portraits of gay and lesbian couples taken in their homes, he quoted Diane Arbus' remark about the camera allowing a 'kind of license' to get past the guard of people without discarding their concern for privacy and respect. His portraits achieve an intimacy, almost a familiarity which is both disarming and yet very informative. His series *Ten Years On* of lesbian and gay couples sets out to be intimate without being

12.19 Sunil Gupta (b. 1953) *Ian and Pavlik, London* (1984). From the series on gay couples entitled 'Ten Years On' (*Artist's collection*)

12.20 Philip Core(1951–1989) *The Chance Meeting on an Operating Table of a Sewing Machine and an Umbrella: Andy Warhol and Marcel Duchamp* (1978). Acrylic on canvas. © Philip Core (*Collection: Arts Council of Great Britain*)

exploitative. The title is both a comment and reflection on the advent of the promiscuity boom of the early 1970s.

The recovery of gay history and imagery and the applying of a late twentieth-century consciousness to the behaviour and characteristics of homosexual figures of the past or the artistic conventions of mainstream art continued to concern artists. As well as performance art, film and video, artists take up established painting styles often combining literary and classical and historical references with an uncompromisingly contemporary feel. None seeks merely to recreate past styles but to extend and add to our awareness of and insight into our own lives.

Philip Core (1951–89), born in Dallas, Texas, moved to Europe in the

early '70s and eventually settled in London. His paintings, uncompromisingly literary, are loaded with classical and artistic references used to 'tell a story'. Classical composition, a pre-Raphaelite concern with narrative but with a highly contemporary graphic style derived from photographic imagery, give his work a deliberately stylish quality which combines pastiche and serious comment. One series of paintings, *Martyrs*, included an explicitly homosexual rendering of St Sebastian. Tied, bound and set on a plinth inscribed 'Nemo Me Impune Lacessit', the naked, muscular body is pierced with arrows. In front of him his punishers in leather boots and straps prepare further tortures.

But as George Melly observed, 'Core's homosexuality is presented without comment, as a fact.'[11] Core is very resistant to any notion of 'gay art' and insists that his homosexuality informs his paintings rather than takes them over. His interest in 'camp'[20] rather than 'gay sensibility' results in a wide range of references – peacocks for jealousy, triangular and unexplained love affairs, and the personalities which personify 'camp' such as Talullah Bankhead, Edith Sitwell and Marilyn Monroe.

The Chance Meeting on an Operating Table of a Sewing Machine and an Umbrella: Andy Warhol and Marcel Duchamp 1978 brings together many of Core's concerns. Warhol, greatly influenced by Duchamp, is shown playing chess with Duchamp in a room filled with both artists' work. Most of this relates directly or indirectly to sexuality. Warhol's *Marilyn*, *Elvis* and *Campbell's Soup Can*, and Duchamp's *Urinal*, *Female Figleaf* (an enigmatic sculpture moulded from a female groin) and so on

12.21 Delmas Howe (b. 1955) *Theseus and Perithous at the Chutes* (1981/82). Acrylic on canvas. 172.75 × 111.75 cm (68 × 44 in) (*Artist's collection*)

litter the room. Warhol, grey-haired and old, sits stiffly in evening dress. Duchamp, in a lounge suit, concentrates on the arrangement of the pieces which he believed represent the male and female principles.

Core's fascination for history and the way it can inform the present is taken one step further in the painting of the American artist Delmas Howe (born 1955). Howe, born in the South West, has since childhood had a great admiration and affection for the cowboys who would hold and play with him. Like the great artist of the South West, Frederic Remmington, who glamorised the cowboy's life, Howe makes them the new ancient but modern gods. He paints them on the ranch, watching or performing at rodeos, on horse back, either naked or wearing the denim and leather of cowboys. Clothed or unclothed, the figures are erotically placed in one painting. It is sexual fantasy given an almost too vivid reality. With titles such as *Atlas, Hermes and Apollo* and *Theseus and Perithous*, Howe places his 'gods', the muscular cowboys of the South West, in typical cowboy situations. In *Zeus (Out of the Chutes)* the 'gods' battle with bulls in the rodeo ring, while in another painting they stand naked with their arms around each other's shoulders. Three 'gods', in denim, shorts and so on, stand in the midst of a ploughed field, as in *The Three Graces*. By clever exaggeration, Howe achieves a powerful depiction of sexual desire, which both satirises and recognises the attraction of the homoerotic.

Mapplethorpe's uncompromising S&M themes introduced 'new' subject matter and to a less extent so has Delmas Howe. Other artists in a similar mood of personal experience have turned their attention to unconventional subjects. The German artists including Rainer Fetting (born 1949) and Salomé (born 1954 Karlsruhe) shared this concern with other artists and together they opened their own artists' co-operative in 1977. They painted in a free, 'wild' figurative style which is a development of German expressionism.

They all took their personal experiences as a means of exposing the 'private' as subject matter for confessional paintings taken much further than, say, Hockney's early pictures. Salomé painted his transvestite sexuality, fetishism and performance. Rainer Fetting painted portraits and scenes of Berlin, the homosexual nightclubs, and in *Large Shower* 1980 (artist's collection) the sensual imagery of the communal shower.

A German Exchange Grant took Fetting to New York 1978-79 where encounters with the gay subculture resulted in the powerful painting *Another Murder at the Anvil* 1979. The Anvil, a raunchy gay bar in New York, has a notorious reputation, and his large painting (270 cm × 380 cm) captures the darkness of the club. Much of the painting is in dark red with the 'murderer' painted green. The figures in the background take up the dancing movements of the wild bacchanalian orgy supposedly taking place there.

12.22 Rainer Fetting (b. 1949) *Another Murder at the Anvil* (1979). Powder paint on cotton, 270 × 380 cm (106.3 × 150 in) (*Anthony d'Offay Gallery, London*) © DACS, London, 1993

Apparently quickly and freely painted with poster or powder paint on duck canvas, Fetting's work has an immediate dramatic, almost theatrical quality which heightens the tableau. He offers the audience in his wild energetic canvases a look at the raw aspect of civilization, a hint of the primitive ritual of abandon. But we view as non-participants, almost like visitors at a zoo.

Fetting has influenced the Welsh-born artist Andrew Williams (born 1954) who after studying at Edinburgh School of Art spent time in New York. His paintings, expressionistic and wild, full of energy and force, are based on his observations of the gay night-club life of the city.

Both Fetting and Williams are two artists who, by painting their own experiences, look critically at the society in which they live. If parts of it seem unattractive, this does not diminish the power of the painting. This is also true of the 'theatrical realist' paintings of John Yeadon (born in Burnley, Lancashire, 1948) who uses both his homosexuality and his socialism as a way in to describing the exploitative and aggressive acts of contemporary western society. For him painting has the power to subvert

and, despite its traditions, can still stir and move. While sexual activity usually has within it an element of humour, it can also be used as a device for making profound comments on abuses of power within society. 'Homosexuality is my access to the imagery,' he wrote in 1984. Graffiti, photographs and historical paintings are used as starting points in his images.[21] In *The Last Chilean Supper*, a satire on the appalling military regime in Chile, a naked man nailed to a wall is sexually abused by army officers while being worshipped by the priest. The painting combines sado-masochistic ritual with Church and State practice. In contrast, his more explicit homoerotic paintings and drawings, such as his series *Happy Families*, relate specifically to his own sexual fantasy. They are drawn practically life-size and have a physicality which cannot be ignored.

The placing together of different photographic imagery and the power artists have to address and comment directly on contemporary rather than historical themes has been the basis of the work of Gilbert and George. Gilbert (born in Austria in 1943) and George (born in England in 1942) have lived and worked together as 'living sculptures' since they met at St Martin's School of Art, London, in 1967. They set up their partnership under the determinedly revolutionary slogan 'Art for All', aiming to reach as wide an audience as possible. They themselves, they said, were works of art. For the last few years they have rejected paint and canvas in order to work exclusively with photographic imagery assembled into photo-sculptures. Taking up many of the concerns of the aesthetic movement of the 1890s, they mix religion, right-wing politics and homoeroticism but they have added the occasional scatalogical scene.

Though the 'Art for All' slogan has been dropped, the artists lead a life which is manifestly dedicated to art. Like Fetting and Williams, Gilbert and George are uncompromising in their look at some of the issues of modern life, and again, if many of the themes are unpalatable, it is not they who created them. Artists, of course, cannot distance themselves from their chosen subject matter. Their deliberate selection of working-class youths, of skinheads and of naked males is adulatory and reverential. One of their most controversial photo-pieces *Patriots* 1980 (Collection Martin Sklar, New York) is of five white youths with an Asian youth in the centre. It can either be seen as a warning, perhaps of an impending racial war in which the victors are clear, or as a cosmopolitan view of 'youth'. We are invited to admire, almost to worship, which is not so unlikely when the huge photopieces, assembled in a black grid format, are coloured with rich primary tones and cover a whole wall. The similarity with ecclesiastical stained glass is overwhelming.

Christian imagery, in particular the cross, 'heroic knights', grimy urban landscapes, close-ups of spiky thorns (more religion?), sexual-

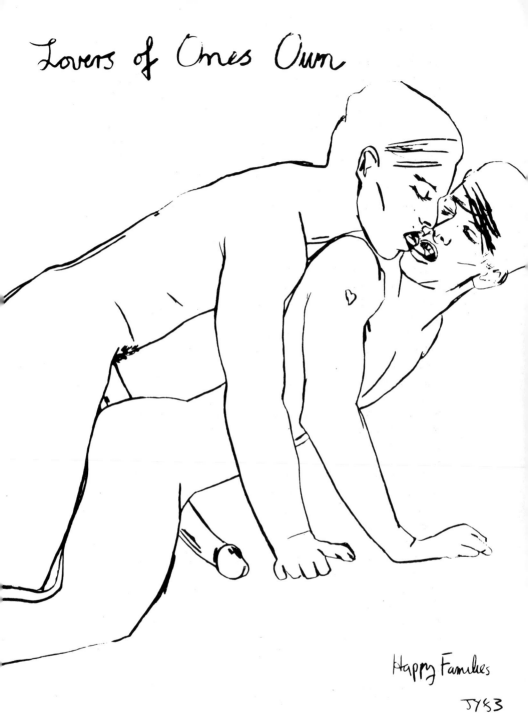

12.23 John Yeadon (b. 1948) *Lovers of One's Own,* Happy Families (1983) (*Artist's collection*)

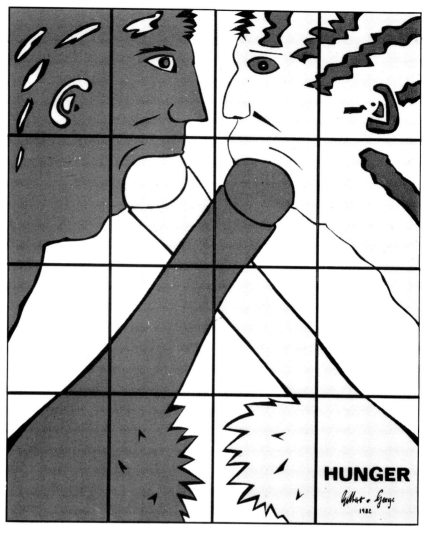

12.24 Gilbert and George (b. 1943 and 1942) *Hunger* (1982). Photo piece (*Anthony d'Offay Gallery, London*)

looking exotic flowers, insects and excrement as well as photographs of the artists themselves feature in their work. It is a powerful mixture achieved by the deliberate use of particular sorts of people, by the exclusion of women, by the careful manipulation of imagery and in the relatively direct treatment of the subject matter, and there are few if any art historical references. The titles which place the images usually have two or more meanings. Homoerotic themes, sometimes explicit as in *Naked Love* 1982 (Anthony d'Offay Gallery, London) and *Naked Beauty* 1982 (private collection) both show naked males. Less obvious is the

ambiguously titled *Street Meet* of a youth seen in the street or *Flower Worship* 1982 of a youth set against a background of huge brightly coloured flowers.

The confessional aspect, the direct use of personal experience, the combination of political comment, characterises the use of homosexual subject matter, making it virtually a 'new art'. While there have been images of homosexuals for hundreds of years, there has never been a systematic examination and portrayal of homosexual life, emotions and sexual experiences such as there is today. Anger, fury, even outrage and shock, contrast with tender emotions and loving feelings.

The overwhelming guilt, the angst of being homosexual, is slowly working its way into and through the art being produced. Art is not diminished by this, but enhanced. Within the foreseeable future there will always be a need for the homosexual presence in art, experienced directly or indirectly, sometimes pensive or celebratory, other times shocking. Art cannot remain fixed, it is changing, and homosexuality has begun to have within it its rightful place.

13 · Shouting and Singing

In the past few years, artists who are gay or lesbian have worked against a background of tremendous political and cultural activity. From London to New York, Paris to Amsterdam, Toronto to Sydney, artists have questioned and celebrated their own identities. Effective activist organisations such as ACT-UP (AIDS Coalition to Unleash Power) and Queer Nation in the USA, and OutRage in the UK, have emerged in response to a common awareness of cumulative anger concerning increasing levels of discrimination, prejudice and physical violence. Anti-gay legislation such as Clause 28 in the UK which prohibits local authorities from funding any activities (exhibitions, workshops, meetings, the production and distribution of leaflets and so on) that could be deemed to 'promote homosexuality' have often been a focus for action. Clause 28 bans the teaching in state-funded schools of the acceptability of lesbian and gay relationships, defining them as 'pretended family relationships'. The clause has resulted in local authorities withdrawing support and in a great deal of self-censorship.

In the USA the Jesse Helms[1] amendment has resulted in an unprecedented defunding programme by the National Endowment for the Arts (NEA) for projects with explicit lesbian or gay homoerotic content. Such legislation is aimed at controlling what is perceived as a threat of homosexuality, while much press publicity around AIDS suggests that gay men are the 'cause' of the disease and that people with the virus should be stigmatised and isolated.

Against such an emotive and turbulent background artists who are gay or lesbian have responded with images which, while affirming and celebrating gay identity, have also investigated and questioned the range of such identities, whether historical, sexual, social or erotic.

The issue of HIV/AIDS has become the focus for many lesbian and gay

artists. In response to the appallingly negative images presented in the media around AIDS, a group of gay and lesbian artists met in London in the late 1980s to discuss ways in which such prejudice could be resisted. Two exhibitions resulted. 'Bodies of Experience: Stories about Living with HIV[2]', through photographs and stories, addressed the impact of the virus on individuals and society. Aimed specifically at a relatively broad audience, it was intended to inform and enlighten largely through documentary images that presented PWAs (People With AIDS) as living with the infection rather than as helpless victims condemned only to pain and suffering. Conventional photo-portraits shown alongside relevant text depicted people with HIV leading ordinary, everyday lives. Both images and text expressed direct personal experiences relating to HIV and AIDS, portraying people in control of their own lives.

In contrast to 'Bodies of Experience', the exhibition 'Ecstatic Antibodies: Resisting the AIDS Mythology'[3] was more ambitious and interrogative.

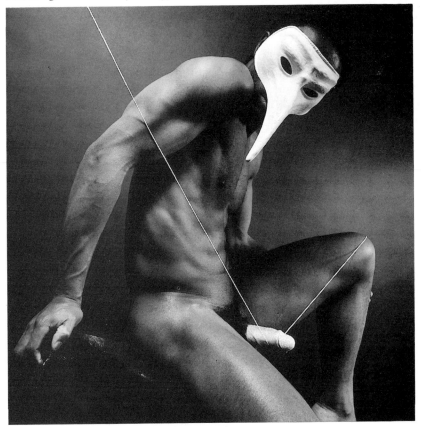

13.1 Rotimi Fani-Kayode (1955–89) and Alex Hirst (1951–93) *The Golden Phallus* (1990). Original in colour (*Artist's collection*)

Intended for a sophisticated gallery audience able to decode more complex and multi-layered commentaries, it included painting, photography, video and installation. Work by Rotimi Fani-Kayode (1955–89) and Alex Hirst (1951–1993), such as *The Golden Phallus* 1990, touched on the impact of HIV within black African culture, on some sense of the 'other', on wider questions of inter-racial relationships, and the conflict between African culture and the impact of the modern world. Other images referred to the importance of the less tangible but equally important emotional aspect which tends to be overlooked—partly because of the problems of representation which must avoid self-conscious parody. 'My reality', wrote Fani-Kayode

> is not the same as that which is often presented to us in Western photographs. As an African working in a Western medium, I try to bring out the spiritual dimension in my pictures so that concepts of reality become ambiguous and are opened to re-interpretation. This requires what Yoruba priests and artists call 'a technique of ecstasy'.[4]

The installation by Nicholas Lowe (born UK 1963) *(Safe) Sex Explained No 3* 1989 looked at the complexities of gay male sexual behaviour and how this has to be re-thought because of AIDS.[5] Text and images were projected on semi-transparent diaphanous sheets, hanging membranes reminiscent of condoms; one image showed a man wearing a black-and-white chequered handkerchief over his face—a signifier of safer sex in Holland but in this image denoting blindness and caution. A video image showed the artist naked, moving in and out of the frame, partly in shadow, evoking the realities of learning to live without abandoning sex or suffering a loss of individual identity. Littering the floor were crumpled and discarded pages from porn magazines, now redundant as models of sexual practice. Eerie and atmospheric, Lowe's installation offered a sensual but directed analysis of changing identity. Despite the well-integrated components of the piece, the crumpled porn sheets were cited by Viewpoint Gallery, Salford, as a reason for cancelling their booking of the show. The excuse—that the show was unsuitable for a 'family gallery' and that they feared prosecution under Clause 28 for 'promoting homosexuality'—indicates the prevalent deep-seated fears around sexual issues.

In the same show Tessa Boffin (UK, 1960–93), in a series of carefully staged photographs *Angelic Rebels: Lesbians and Safer Sex* 1989, raised the question of how lesbians are influenced by AIDS, and how, given the alarmist and sensational reporting in the popular press, they could continue to enjoy sexual activity. In other work Boffin has taken up the issue of lesbian history and stereotyping in the series of portraits *The Knight's Move* 1990, in which posed figures display the names of famous lesbians such as Una Troubridge, Alice Austen, Janet Flanner, Sappho and

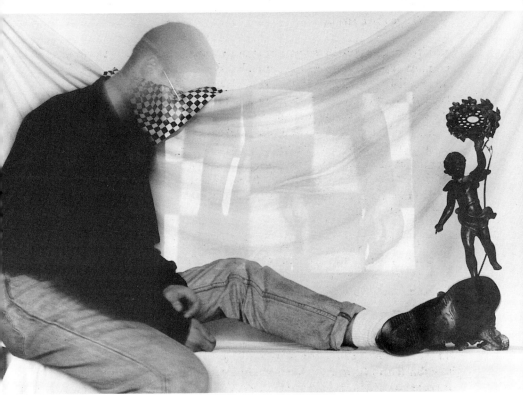

13.2 Nicholas Lowe (b. UK, 1963) (*Safe*) *Sex Explained No 3* (detail) (1989) (*Artist's collection*)

Radclyffe Hall. 'The most important work for saving lives must take place in the minefield of representation', argues Boffin,[6] who while moving away from the tradition of documentary realism, prefers a form of photo-theatre, 'a non-naturalistic form of representation which insists first and foremost that "reality" is mediated, staged and framed.'[7]

Other artists, including Sunil Gupta (see pages 294–6), looked at questions of race, while Lynn Hewett (see also pages 293–4 above) used a series of projected slides for an installation, *Projections* 1989. This considered the way that medicine and medical practice fragments and breaks up the body with little or no regard for the needs or concerns of the individual. The slide sequence, projected one beneath the other, depicted the top, middle and bottom of a naked male figure as three images photographed from different angles as well as archaic-looking medical instruments. The installation made no attempt to represent the body as a whole, but literally broke it up in disturbing ways, implying, along with intimidating medical equipment, the objectification of the individual.

Many of the issues taken up in both these exhibitions were evident in the 1989 show 'AIDS: The Artist's Response' (Ohio State University).

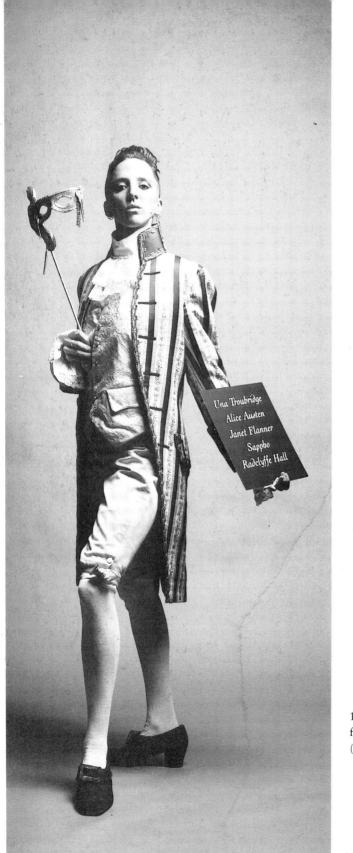

13.3 Tessa Boffin (UK, 1960–93)
from *The Knight's Move* series (19
(*Artist's collection*)

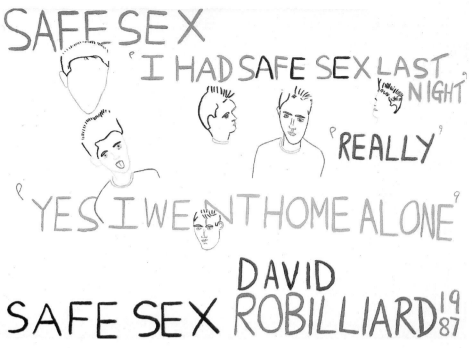

SAFE SEX 'I HAD SAFE SEX LAST NIGHT' 'REALLY' 'YES I WENT HOME ALONE' SAFE SEX DAVID ROBILLIARD 19 87

13.6 David Robilliard (1952–89) *Safe Sex* (1987). Acrylic on canvas. 100 × 150 cm (40 × 60 in) (*Stedelijk Van Abbemuseum*)

idiosyncratic response to safer-sex practices. Produced as postcards and widely distibuted, Robilliard's art, despite its iconoclastic form, is still that of the art gallery where it is exhibited and affirmed.

In a different context—the paintings in the series *Queer* 1991—Derek Jarman (UK, 1941–94) vividly convey his anger and frustration at the way AIDS is reported in the media.[10] Jarman studied fine art and, though now well known as a film-maker, continues to paint. His use of thick impasto pigment, applied over newspaper cuttings from the gutter press bearing homophobic headlines, is a response partly to being diagnosed HIV-positive and partly to the distortions and mis-representations of the tabloid press. Paint smeared and scratched on the canvas suggests a sense of urgency, while such loaded and emotive words as LOVE, DEATH and QUEER, scrawled across a red heart, are powerful and evocative. Jarman's work invites an immediate emotional reaction, and is unequivocal in proclaiming the need for confronting prejudice.

Moving outside the confines of the art gallery has been one of the chief aims of the graphic art produced by AIDS activists. In New York ACT-UP's highly effective graphics emblems have gained world-wide currency. SILENCE = DEATH, printed in white type underneath a pink triangle on a black ground, has come to indicate AIDS activism to entire communities confronting the epidemic. The emblem also calls on the existing history of gay oppression—the pink triangle was used as a mark of homosexuality

13.5 Andy Fabo (b. 1953) *Aphasia* (1990). Installation detail, each panel 24 × 26.7 cm (9.5 × 10.5 in), mixed media (*Artist's collection*)

in Nazi concentration camps. Its appropriation in the late 1980s made reference to the largely suppressed history of gay oppression; by pointing the triangle up instead of down, as in the triangle used in death camps, the emblem implies that silence is no longer acceptable. Visually arresting, making use of powerful evocative words, the Silence = Death emblem works at the level of history and as an agit-prop response to government silence and inactivity.

The gay men who created the emblem extended the idea in a window installation at the New Museum of Contemporary Art, New York, at the invitation of the curator William Olander, himself someone with AIDS and a member of ACT-UP. Entitled *Let the Record Show*, the installation

13.7 Derek Jarman (UK, 1941–94) *Queer* (1991). Oil on canvas. 251.5 × 179 cm (99 × 70.4 in) (*Artist's collection*)

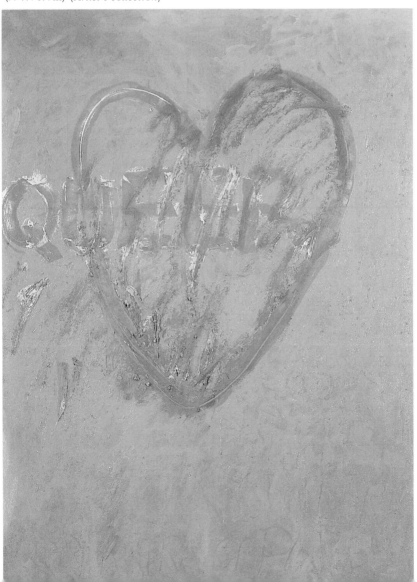

featured prominent homophobes such as President Reagan and Cardinal O'Connor, linking their neglect and indifference with the perpetrators of the Nazi concentration camps.

An ad-hoc collective of some six to ten young artists formed in New York to exploit the power of art took the name Gran Fury, producing highly effective posters, busboards, stickers, postcards and such like with the minimal use of text and image. Adopting the technique of post-modern appropriation, Gran Fury uses available phrases and images to heighten awareness of discrimination and prejudice around AIDS. The emotive message 'The Government Has Blood On Its Hands: One AIDS Death Every Half Hour' is heightened by a blood-red hand print; the slogan on the busboard 'Kissing Doesn't Kill: Greed and Indifference Do' is accompanied by three stylish young couples kissing—two men, two women and a man and woman—in imitation of the style of a 'United Colors of Benetton' advertisement. Other slogans such as 'All People With AIDS Are Innocent' confronts the popular media concept of 'innocent' victims, while 'Boycott Burroughs Wellcome' attacked the drug company for its perceived slowness to respond to the need for new anti-AIDS drugs. Gran Fury's witty blend of minimal illustration and text shows how effective visual art can be in handling and manipulating images while hammering home its message.[11]

The street, as opposed to the rarified mandarin air of the art gallery, has been a feature of much politically directed art in the 1980s, much produced for its temporary visual effect rather than for any possible market value. Outside the confines of galleries, impact had to be direct and relatively quickly read and understood. Without the legitimating context of the art gallery where time is allowed for contemplation, the work must effectively convey a clear and unambiguous message.

The American artist David Wojnarowicz (1954–92) started his artistic career by stencilling designs with spray paint on streets and abandoned warehouses along the Hudson river.[12] His agit-prop approach of using

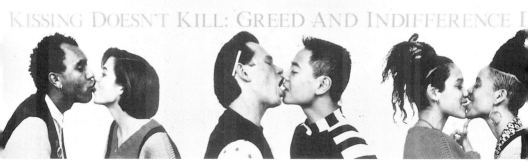

13.8 Gran Fury, *Kissing Doesn't Kill* ... (1989). Printed busboard for American Foundation for AIDS Research. Original in colour.

immediately recognisable motifs and often accompanying them with words and short phrases made them appear like tribal emblems defining territory and raising alarm. His guerrilla acts of anti-establishment terrorism and his unmistakable dismissal of the materialist consumer-led concerns of the art world were part of his avant-garde initiatives against the *status quo* and inertia of the gallery system. As an outsider, Wojnarowicz refused to participate or become involved in the manipulation and mythification within privileged cultural institutions, preferring his art to be an expression of anger and frustration. Confrontational and uncompromising, Wojnarowicz continued to produce a complex blend of sexual imagery, anti-war images and the violence of modern life—even when his work started to be shown in galleries in the early 1980s. Much of Wojnarowicz's work is autobiographical, such as the screenprint *Untitled (One Day This Kid . . .)* 1991, which uses a text around a photograph of himself as a child to confront in a moving personal statement the prejudice and fear around homosexuality.

e day this kid will get larger. One day this kid will me to know something that causes a sensation uivalent to the separation of the earth from axis. One day this kid will reach a point ere he senses a division that isn't thematical. One day this kid will l something stir in his heart and oat and mouth. One day this kid will d something in his mind and body d soul that makes him hungry. One y this kid will do something that uses men who wear the uniforms of ests and rabbis, men who inhabit cer- n stone buildings, to call for his death. e day politicians will enact legislation ainst this kid. One day families will e false information to their chil- n and each child will pass t information down gen- tionally to their families d that information will be signed to make exis- ce intolerable for this . One day this kid will gin to experience all s activity in his envi- ment and that activi-

ty and information will compell him to commit sui- cide or submit to danger in hopes of being murdered or submit to silence and invisibility. Or one day this kid will talk. When he begins to talk, men who develop a fear of this kid will attempt to silence him with strangling, fists, prison, suffocation, rape, intimidation, drugging, ropes, guns, laws, menace, roving gangs, bottles, knives, religion, decapitation, and immolation by fire. Doctors will pro- nounce this kid curable as if his brain were a virus. This kid will lose his consti- tutional rights against the government's in- vasion of his privacy. This kid will be faced with electro-shock, drugs, and con- ditioning therapies in laboratories tended by psychologists and re- search scientists. He will be subject to loss of home, civ- il rights, jobs, and all con- ceivable freedoms. All this will begin to happen in one or two years when he dis- covers he desires to place his naked body on the na- ked body of another boy.

13.9 David Wojnarowicz (1954–92) *Untitled (One Day This Kid . . .)* (1991). Screenprint (*Courtesy PPOW Gallery, New York*)

Diagnosed as HIV-positive, Wojnarowicz completed eight photo-montages of 'found' images in the *Sex Series*. In these, circular insets depict such diverse images as explicit sexual activity, a fetus, a picture of Jesus, money, police in riot gear, and a microscopic image of the virus. Text describes prejudicial treatment of AIDS patients while images of desolate forests, blurred images of buildings, the Hudson river and scenes of war printed as negatives reversed any impression of naturalness. Angry and emotional, Wojnarowicz's work expresses the reality of human life, a bitter but not cynical reflection on modern society, touching on political, psychological and sexual manipulation.

When it was shown in an exhibition partly funded by the NEA, the Revd Donald Wildman, executive director of the American Family Association, denounced the work. He sent a tightly printed, 3-page letter together with photographs of homosexual sex-acts taken out of context and greatly enlarged from Wojnarowicz's art-works to Congressional members, Christian leaders, and to radio and television stars, claiming that the NEA grant violated the so-called 'Helms amendment' banning funding for obscene art. Ironically, the case brought Wojnarowicz's work to the attention of a much wider audience, few of whom saw it as cause for complaint.

Like Wojnarowicz, Keith Haring (1958–90) started his artistic career by painting murals and suchlike on streets and subways of New York.[13] Trained as a graphic artist, Haring developed his own vocabulary of simplified images of the body which described the human condition, whether as child or adult. Taken up by galleries in the early 1980s, his accessible and energetic art broke down the boundaries between fine and graphic art, his inventive and colourful images appearing to reflect the urgency and speed of the decade. When diagnosed as HIV-positive, he turned to producing many images drawing attention to the need for safer sex; for example, *Ignorance = Fear, Silence = Death* 1989 uses the traditional

13.10 Keith Haring (1958–90) *Ignorance = Fear, Silence = Death* (1989) (*Keith Haring Foundation*)

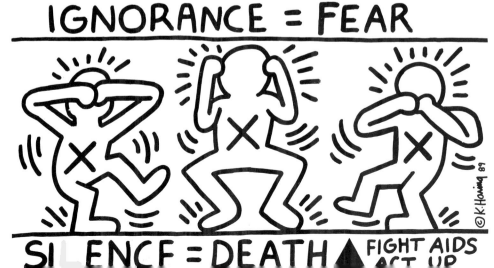

concept of 'see no evil, hear no evil, speak no evil' to express its message with wit and verve. Haring contributed a 'joyously sexual' men's room carnival to the Center Show at New York's Lesbian and Gay Community Center in 1989—only a few months before his death. Some fifty-one artists created site-specific works throughout the building for this show, including Markus Wrong's towering phallus placed in a stairwell.

Of all the manifestations of grief at the tragedy of AIDS, none has been more public than the Names Project, an international AIDS memorial started in the USA in 1985. This takes the form of a huge quilt made up

13.11 Lola Flash (b. 1959) *AIDS Quilt—The First Year* (1991). Original in colour (*Artist's collection*)

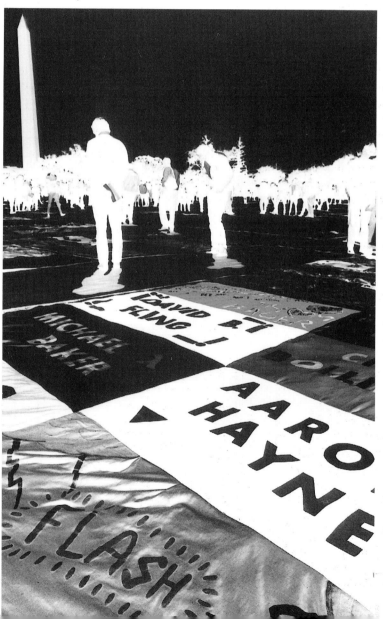

of thousands of individual panels, each of which commemorates the life of someone who has died from AIDS-related illness. The aims of the project—to confront individuals and governments with the urgency and enormity of the AIDS pandemic, to raise funds for PWAs, and to stand as a powerful and positive symbol of hope—have attracted world–wide attention. Most importantly, making the quilt serves as a focus for planning communal action, and a place where people can share expressions of grief.

Some of this emotion is sensitively conveyed in the photographic work by American-born artist Lola Flash (born 1959) such as *AIDS Quilt— The First Year* 1991. In this image the artist implies her own involvement in supporting and presenting the project: she manipulates the photographic images by reversing colours ('red is green, blue is orange') to consider questions of race and 'normality' and to highlight conventional perception of events. This challenges the concept that there is some universal truth, and argues the need to continually reassess our experience.

The practice of sewing quilts calls on home-based traditions that have been a part of American and European cultures for nearly 200 years; the association of making quilts for the marriage bed, perceived as an intimate, warm and close place, is given a new and extended meaning in the AIDS Quilt, but one that, despite its collective strength, emphasises individual loss. The AIDS Quilt commemorates anyone who has died as a result of AIDS and as such addresses a wide audience, acknowledging the fact that the HIV virus is not confined to any particular group.

Despite the importance of looking at and addressing issues around the AIDS epidemic, gay and lesbian artists have also continued to investigate the changing and evolving make-up of identity. Whether from a historical point of view, as an examination of contemporary gay culture, or as part of a concern with the need for visibility, artists have sought to articulate a wide variety of issues. In an examination of the stereotypical representation of lesbians, the Canadian photographer Nina Levitt appropriates front and back covers of popular novels from the 1950s and 1960s for the series *Conspiracy of Silence* and re-presents them in negative form. In *Strange Sisters* 1987 Levitt looks critically at the complex message conveyed by the period representation, where lesbians are fictionally constructed as sex objects intended primarily for the male gaze, while also giving lesbianism some sort of presence in the 'normal' world. 'I choose these bookcovers because of the ways in which the illustrations and texts sexualise and stereotype lesbians for male consumption and fantasy, while simultaneously condemning us as sexual deviants.'[14] By reversing the image from positive to negative, Levitt turns the image back on itself and on us—a negative image in more ways than one.

The crucial question of lesbian visibility and its veiled and coded references in mainstream culture is also the subject of American-born

ONE SISTER WAS NORMAL, THE OTHER WAS NOT—

Strange Sisters

ROBERT TURNER

They were both indescribably lovely—
yet one wanted a man's love...while
the other craved a woman.

THE SAVAGE NOVEL OF A LESBIAN ON THE LOOSE!

B526F 50¢ K

BEACON SIGNAL

13.12 Nina Levitt (b. 1955), from the series *Conspiracy of Silence* (1987). Colour photograph. 76.2 × 101.6 cm (30 × 40 in) (*Artist's collection*)

13.13 Deborah Bright (b. 1950), from the series *Dream Girls* (1990). Photomontage (*Artist's collection*)

artist Deborah Bright in her series *Dream Girls* 1990. Like Levitt, Bright appropriates familiar images, in her case Holywood film-stills, and collages into them specific lesbian scenarios. What at first appears to be a crystallisation of a familiar moment of tension in the plot is subverted and changed by the presence of a new character. This usually involves disrupting male-female interaction, resulting in the male being marginalised or made completely redundant. The woman offering a light for Audrey Hepburn's cigarette makes George Peppard's proffered match—and by implication himself—redundant as the focus switches to the interaction between two women. The up-stagings in what are already carefully set-up scenarios add a witty dimension to the artificiality of life as portrayed by Hollywood. Bright's thoughtful one-liners intruding into mainstream culture are 'politicised appropriations of given signifying systems ... a useful and sophisticated weapon against our invisibility'.[15]

While she subtly affirms lesbian presence, there is no mistaking Deborah Bright's recasting of Hollywood history, implying that the fictions created

in film are both destructive and prejudiced. Much the same criticism can be levied at fine art where representations of lesbians are conventionally intended to whet the appetite of the male gaze. In *Blasphemy Communion* 1990, one of the *Celestial Bodies* series, the UK-born photographer Jean Fraser (born 1955)[16] makes reference to the conventions of painting, using a display of nudity to assert confidence and defiance. Based on the dream-like passivity of Manet's *Déjeuner sur l'Herbe*, in which a naked woman sits out of doors with two fully clothed male companions, Fraser subverts the accepted conventions with gleeful wit. The naked young woman sits beside a picnic-basket of apples—emblem of temptation—her companions two fully clothed nuns, all apparently part of a conspiracy in which the nakedness is for their own rather than the viewer's pleasure. In gazing out of the frame and soliciting our interest, the woman invites our complicity in the tableau. The use of the two nuns touches on religious as well as social taboos to transgress what is thought to be acceptable and safe, while at the same time they are emblematic of closed orders in which men have no part. The photograph asserts the ability of women to carry out independent action, and also indicates that sexual freedom may take many forms.

The need to assert lesbian presence, whether conventionally or in more challenging form, is a continuing concern. Sadie Lee (born UK 1967) makes a strong statement about lesbian relationships in her painting *Erect* 1992. At first glance it depicts two young women who are good friends

13.14 Jean Fraser (b. 1955) *Blasphemy Communion*, from the series *Celestial Bodies* (1990) (*Artist's collection*)

13.15 Sadie Lee (b. 1967) *Erect* (1992). Oil on canvas. 91 × 61 cm (35 × 24 in)
(*Artist's collection*)

confronting the viewer. However, the entwined arms and the contrasting
clothes of the two women, one in a dress, the other in jacket and trousers,
and with each pointing to the other as if to say 'we are one', implies a
more intense relationship. In fact, *Erect* is a portrait of the artist with
her lover—information which comes as no surprise. Lee's clean, graphic
style leaves the painting nicely balanced—a fascinating portrait and an
unequivocal statement about the strength of the partnership.

The artist Rachael Field also paints images that have an important element of autobiography. Her paintings, she says, are about 'my love for women, in particular one woman and our life together'.[17] Her portraits have a monumental quality, describing the private sphere of women's lives within a broad political and public structure. *Illegal, on the Streets*, an image of two women together, was a response to banning of public displays of affection between members of the same sex. *Public Statement* goes beyond this, showing two women on a demonstration, holding

13.16 Rachael Field (b. 1965) *Public Statement* (1991). Oil on canvas. 165 × 125 cm (66 × 50 in) (*Artist's collection*)

13.17 Mandy McCartin (b. 1958) *Force Field* (1989). 167 × 147 cm (66 × 58 in) (*Artist's collection*)

banners and surrounded by a sea of smaller banners. The individual support within collective action is powerfully expressed.

In contrast to the reassuring, almost cosy, images of Rachael Field, those of Mandy McCartin (born UK 1958) address working-class life with vigour and energy. 'I like to paint things I know about in a straightforward fashion. I'm not pretentious and neither are my paintings.'[18] With titles such as *Sappho's Secret Smile, Club Toilets Volumes 1, 2 & 3* and *Force Field* 1989, McCartin's work is concerned with the world she sees and experiences, and not with romanticising or mythologising lesbianism. This

13.18 Rosy Martin (b. UK, 1946) in collaboration with Jo Spence, *Transforming the Suit: What do Lesbians Look Like?* (detail) (1989). Original in colour (*Artist's collection*)

she dismisses as 'a lot of middle-class, earth mother imagery', preferring instead such themes as 'dykes in an urban landscape', which engages with the urgency and speed of city life: 'The issue I'm dealing with more than sex is class. I'm painting as a working-class dyke and the way I see dyke life is urban and sleasy and quite gritty.'[19]

The women McCartin paints are spiky, their cropped hair, leather jackets and aggressive attitudes very much part of urban life. Yet such statements offer only one view of modern lesbian identity. This issue lies at the centre of the series of photographs by Rosy Martin (born UK 1946) *Transforming the Suit: What do Lesbians Look Like?*. She uses Havelock Ellis's definition in *Sexual Inversion* (1897) which suggests that, despite wearing female garments, lesbians usually have 'some trait of masculine simplicity' and that such a person 'ought to have been a man'. In an hilarious series of portraits, Martin explores a diverse range of stereotypes.

> Using the same man's suit in every photograph, with a few additional signifiers, I placed myself within a range of roles and definitions by experts. I re-staged, examined and exploded the mythologies of the lesbian, butch/femme and masculine/feminine, my 'alter ego', and the lesbian still closeted within a heterosexual marriage. My aim was to challenge any reductionist notions of my 'identity-as-a-lesbian', to

13.19 Emily English (b. UK, 1963) *Untitled* (1991). Ink drawing. 42 × 30 cm (16.5 × 12 in) (*Artist's collection*)

break the concept of a fixed immutable sexuality, to destabilise female/male stereotypes, to decode role play, and to foreground role play.[20]

In the argument for lesbian visibility and the desire for a whole series of identities, the need for lesbian erotic material that reflects the diversity of lesbian desire continues to evolve. While radical feminists like Andrea Dworkin argue that any mediation of sexuality is an objectification, and so anti-women, some lesbians see the erotic as a source of political strength, claiming the right to investigate such areas in the visual arts. Audre Lord argues:

> In touch with the erotic, I became less willing to accept powerlessness ... Recognising the power of the erotic within our lives can give us the energy to pursue genuine change. For not only do we touch our most profoundly creative source, but we do that which is female and self-affirming in the face of a racist, patriarcial and anti-erotic society.[21]

The exhibition 'Exposing Ourselves' of some 150 works by fifty-four lesbian artists in London (August 1992) was mounted in a public gallery, principally to confront the question of lesbian visibility rather than to investigate sensitive and problematic issues. Noticeably, it did not include any work that could be construed as specifically erotic, although this theme is touched on in the detailed ink drawing *Untitled* of Emily English (born UK 1963), one of the exhibition organisers.[22] These trance-like sequences may show a naked dreamer surrounded by equally naked women, floating celestially in boats, some shaped like a penis, others in the form of a vagina: 'I've always been concerned with using the unconscious mind, the fantasy world. I've always wondered as a lesbian whether I could conjure up fantasy images that are lesbian based.'[23]

The photographer Della Grace (born USA 1968),[24] also represented in 'Exposing Ourselves', argues that lesbians should feel free to explore erotic fantasy and if this is seen as pornographic, then that is an issue that has to be confronted. Far from attempting to control where the work is shown or the people who see it, she wants it seen by as large an audience as possible. In her carefully staged narratives, she explores themes such as S & M sex through the wearing of leather straps, studded belts and so on, employing naked or semi-naked models to act out fantasy scenes. These images also encroach on what has conventionally been seen as male gay territory, and as such asserts the refusal of lesbians to remain within any prescribed boundaries. Other images, such as *3 Graces* 1992, explore the question of modern lesbian identity and, while acknowledging difference, also express a sense of collective belonging. Far from objectifying and distancing the models, the women take up historical

13.20 Della Grace (b. US, 1968) *3 Graces* (1992) (*Artist's collection*)

references, conveying the intensity of enduring relationships. They may also be seen as representing different aspects of one person. The closeness of the women combined with consensual violence, evoked by the shaved heads and leather clothes, suggests that this is an intrinsic and real part of their shared strength rather than merely a fashionable pose.[25]

Few gay men challenge gay male identity with such vigour, although some touch on the complexities and contradictions of the erotic. The highly sophisticated paintings of Attila Richard Lukacs (born Canada 1962) look at the confusion of sexual attractions in uneasy and ambiguous images of figures emblematic of strength and aggression. Images of the male body, either smartly uniformed in military outfits or as naked skinheads, suggest violence, confrontation and discipline, creating a dark and threatening view of the post-modern psyche.

> This is art that can be fascinating and disturbing because in it Lukacs's obsession with the liturgy of sado-masochism (shaved heads as a reversible sign of defiant challenge and disciplined bodies), uniforms as a sign of 'twentieth century warriors' (The Skinhead series) and now machines (military cadets) spills onto the canvas, as a serial record of what is really at stake in the games of male seduction at the end of the twentieth century.[26]

13.21 Attila Richard Lukacs (b. Canada, 1962) *Love in Union, Daybreak* (1992). Oil, enamel and tar on canvas. 310 × 262 cm (121 × 102 in) (*Courtesy Diana Farris Gallery*)

Despite the seductive masculine look of young skinheads and the virility of soldiers in smart uniform, Lukacs is deeply critical of such images and of the rituals of discipline and bondage. The scenes of male tribal aggression Lukacs's creates, while acknowledging the voyeuristic gaze, are a powerful commentary on the confusions of modern sexual male identity and the dilemma of accepting the contradictions of sexual attraction. In *Love in Union, Daybreak* 1992, Lukacs uses the intensity of Indian miniatures to explore the sexual acts of three young skinheads surrounded by a crowing cock and a wary fox. Despite the erotic charge, this is not an unproblematic celebration of youthful lust.

The sexual adventures that Lukacs describes so well are taken up equally directly in the highly detailed drawn and painted work of the Japanese-born artist Sadao Hasegawa. His highly detailed and fantasised drawings, which call on the work of Tom of Finland, evoke a world of sexual and sensual pleasures in a style that successfully combines the conventions of western and oriental art. In *Gon guedo II* ('Joyfully seeking the impure land II') 1981, Hasegawa depicts his hero in the hands of three devils who serve his physical desires, but at the same time remain aspects of the forbidden. In more recent work Hasegawa has continued to represent the muscular male body, but in less exotic or sensational ways. Frits Staal, arguing that Hasegawa's 'fantastic imagination has lifted his art to a mythical level of homo-eroticism that transcends particular cultures and has become universal',[27] acknowledges the powerful internationalism of erotic desire. Uninhibited and explicit, the scenarios Hasegawa creates with such apparent ease seem far removed from the pressures and limitations of daily life, adding to their attraction.

One of the emerging strengths of art by lesbian and gay men has been a strong autobiographical component, ensuring that individuals are seen to speak for themselves, articulating their own desires, rather than to assume an authoritative and 'objective' voice. Occasionally this gets too narrow, such as when artists make an art installation within their own home, giving them total control but inevitably restricting the audience and limiting the effects of the work. No abstract art has so far successfully addressed the issue of lesbian and gay sensuality without overwhelming ambiguity, although some have used a conceptual approach to be both explicit and broad. The Canadian-born artist Micah Lexier (b. 1960) works at the edge of abstraction and minimalism using brief texts and light to touch on gay history and the richness of gay culture.[28] Concealed fluorescent light is used as a metaphor for understanding, while text may be taken from such well-known gay authors as John Rechy and J. R. Ackerley. In *Quiet Fire: Memoirs of Older Men* 1989, Lexier incorporates a phrase overheard at a gay meeting—'I like sex but I like it with someone who's read a book'—suggesting the desire for sex within the wider context of a relationship. The red glowing light illuminating the piece is also emblematic of warmth and intimacy.

desire. The painter Gavin Maughfling (born UK 1968) also explores desire but using a colourful free-flowing pictorial style. Far from the angst of self-examination, Maughfling suggests the joys of gay relationships and pleasures of physical and emotional engagement. In *Victory Dance* 1990, two matadors, alone in the arena, dressed in the traditional richly embroidered costumes, have their arms around each other, taking part in a celebratory dance; facing each other, they establish their relationship on equal terms. In the distance an industrial landscape asserts the realities of daily life, but we are really only aware of the total involvement of the two men. The ritualised performance is also an indication of the need for care and negotiation in relationships to protect them from disaster.

The influence of the Renaissance and later art which informs Maughfling's paintings also informs the work of Matthew Stradling (born UK 1963). Large in scale, Stradling's paintings are both celebration and an icon of sexuality, their tactile surfaces and naked figures evoking sensual pleasure. In *The Mirror* 1991, the figure is idealised and perfect, appearing to float luxuriantly, free of physical and social constraints, time or motivation. Expensive jewels such as pearls, rubies and diamonds adorn the figures and the surroundings, while an ethereal shade of pale blue defines an untroubled infinity. With a subtle blend of theatricality and camp, Stradling creates an idyllic world, an escape from the mundane stresses and strains of relationships into a carefree existence of pure sensual pleasure.

13.24 Adam Jones (b. UK, 1965) *Toilet* (detail) (1986). Installation mixed media, life-size (*Artist's collection*)

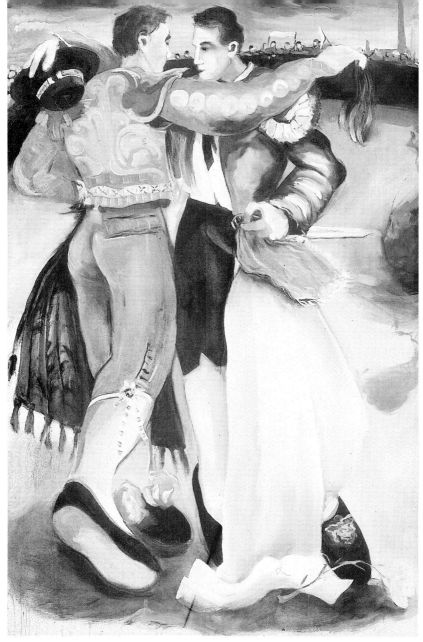

13.25 Gavin Maughfling (b. UK, 1968) *Victory Dance* (1990). Oil on canvas.
183 × 122 cm (71 × 48 in) (*Courtesy Philip Graham Contemporary Art*)

Where Maughfling and Stradling create free-flowing, almost rhythmic
cadences, Alain Rosello (born Spain 1962) is altogether more intense and
introverted, more concerned with the psychological tensions of same-sex
relationships and the pressures they exert. The naked figures who people
his carefully constructed compositions draw on myth and legend to touch

on the mysteries of human need and desire. In *Todos nos reunido, tambien los jovenes que corrompio la muerte, para defender cada momento de la vida* ('We all came together, the young as well, corrupted by death, to defend each moment of life') 1990, Rosello describes some intense moment of ritual in which life and death are juxtaposed with great effect. Nakedness here implies vulnerability and openness rather than sexual desire, of figures caught up in complex and unfathomable actions. Rosello's precise, almost academic, style draws freely on the conventions of seventeenth- and eighteenth-century art, but his subject matter brings them very much into the present.

The cool, almost detached, quality in Rosello's paintings is measured and controlled with the emotional element deliberately low key. These are in great contrast to the turbulent and highly charged paintings of Luis Caballero (born Colombia 1943) whose powerful expressive compositions embody many—and conflicting—aspects of desire.

13.26 Matthew Stradling (b. 1963) *The Mirror* (1991). Oil on canvas. 165 × 210 cm (65 × 83 in) (*Artist's collection*)

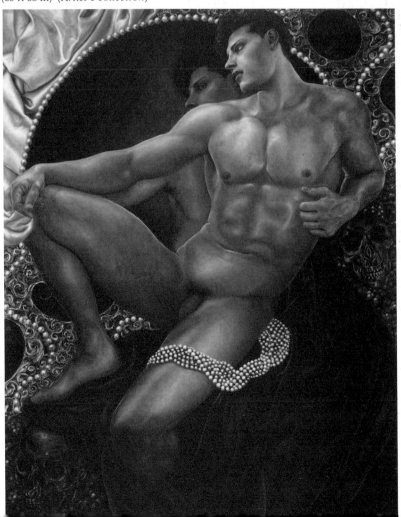

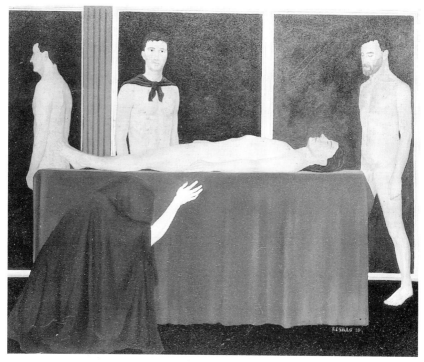

13.27 Alain Rosello (b. 1962) *Todos nos reunido, tambien los jovenes que corrompio la muerte, para defender cada momento de la vida* ('We all came together, the young as well, corrupted by death, to defend each moment of life') (1989). Oil on canvas. 50 × 60 cm (23 × 28 in) (*Courtesy Philip Graham Contemporary Art*)

> The two cornerstones of my work ... pain and pleasure, are anchored in religion. ... Sometimes I would like to indicate death, another time bliss; but it is never clear. If I do not show it in an obvious way, it becomes more ambiguous and multi-layered. In short I would like to unite Eros and Thanatos.[30]

Caballero's *Untitled* 1989 suggests both the strength and vulnerability of the body, with the raw emotions written graphically across its landscape. The arguement that underlies Caballero's pastels and oils brings together private and public despair, linking the binary opposites of agony and ecstacy.

A different sort of complexity is taken up in the photographs of Nicholas Paterson (born UK 1953).[31] Working with the same model over a number of years, Paterson has consistently examined the way the male nude can convey a diverse range of human feelings and emotions, using nakedness less for its erotic qualities than for its suggestion of exposure and honesty. Much of his work takes as its starting-point the sculptures of classical Greece or the carved figures of Michelangelo; some deliberately ape the pose of the Renaissance figures while others seem totally modern. The

13.28 Luis Caballero (b. Colombia, 1943) *Untitled* (1989). Mixed media.
146 × 114 cm (57 × 44 in) (*Courtesy Editions Aubrey Walter*)

sense of reality conveyed by the photographic medium sets up a tension
with the idealisation of the classical or biblical reference. This conflict is
brought out to perfection in *Lucifer* 1991, based on the Old Testament
story of the angel who was banished from heaven because of the sin of
pride. The confrontational stare is a wicked rather than evil look, a sexual
invitation from an earthly rather than a mythical devil.

Deep psychological and physical conflicts are also explored in the
classically referenced paintings of Michael Croft (born UK 1955). His figure
compositions are intensely autobiographical while relating to wider aspects

13.29 Nicholas Paterson (b. UK, 1953) *Lucifer* (1991) (*Artist's collection*)

of same-sex love. *Hercules and Antaeus (after Mantegna)* 1992 is both a literal and an emblematic depiction of the struggle to express the complexities and contradictions of sexuality as the figures grapple sexually and physically. Croft's passionate and energetic compositions look at the darker, more tense aspects of relationships. Painting for him becomes a metaphor for considering the attractions of the body: 'I like the links that can be drawn between the brush and body-hair, and the canvas as human skin. Paint and admixtures have then the effect of bruising and abrasion.'[32]

The 'body as a battlefield', an abiding and rich theme, need not be dark or profoundly serious, as the two French artists Pierre and Gilles[33] make clear in their large-scale, carefully staged painted photographs. Since meeting in 1977 they have worked collaboratively, photographing themselves, professional models, or stars such as Marc Almond and Boy George to represent aspects of contemporary culture. In *Roy* 1992 they call on the convention of the seductive pin-up or stripper, with arch smile, confrontational 'come-hither' look and tinsel sparkle, to gently send up the subject with a light-hearted, naïve image. This is in contrast to the usual presentation of sex as a serious, even dour, business. Using a

13.30 Michael Croft (b. UK, 1955) *Hercules and Antaeus (after Mantegna)* (1992). Oil on canvas. 198.1 × 152.4 cm (78 × 60 in) (*Artist's collection*)

13.31 Pierre and Gilles (b. France) *Roy* (1992). Painted photograph. 106 × 62 cm
(41 × 24 in) (*Courtesy Raab Boukamel Galleries Ltd*)

combination of high camp, kitsch and pastiche in carefully staged settings, Pierre and Gilles comment on aspects of the gay world, using obvious glamour and artifice to create images that both celebrate and examine convention with irony and humour.

The human clay in all its many forms continues to be a constant source of fascination for both lesbians and gay men. The western humanist tradition that places the body at the centre of its concerns is also at the core of much of this art—for it is here that discoveries can be made, complexities of desire explored and truths revealed. Artists, singing with pleasure and shouting with anger, continue to explore the diversity and strength of lesbian and gay identities with vigour and insight.

Notes

INTRODUCTION

1 Particular studies are: Vito Russo, *The Celluloid Closet*, Harper & Row, New York, 1981.
 Stephen Coote (ed.), *The Penguin Book of Homosexual Verse*, Penguin Books, Harmondsworth, 1983.
 Robert K. Martin, *The Homosexual Tradition in American Poetry*, University of Texas Press, Austin and London, 1979.

2 Two exceptions are Cecile Beurdeley, *L'Amour Bleu* (Michael Taylor trans.) Rizzoli, New York, 1978, and Raymond de Becker *The Other Face of Love* (Margaret Crossland and Alan Daventry trans.) Neville Spearman, London, 1976.
 See also Nicolas A. Moufarrege 'Lavender: on Homosexuality and Art', *Arts Magazine*, vol. 57, no. 2, October 1982, pp. 78–81.

3 Many excellent accounts give the history of the homosexual. In particular:
 Jeffrey Weeks, *Coming Out*, Quartet Books, London, Melbourne, New York, 1977.
 John D'Emilio *Sexual Politics*, *Sexual Communities*, University of Chicago Press, Chicago and London 1983.
 Denis Altman, *Oppression and Liberation*, Avon Books, New York, 1971.
 Guy Hocquenghem, *Homosexual Desire* (Daniella Dagoor trans.), Allison & Busby, London 1978.
 Michel Foucault, *The History of Sexuality*, vol. 1 (Robert Hurley trans.), Penguin Books, Harmondsworth, 1978.

4 Carroll Smith-Rosenberg, 'The Female World of Love and Ritual: Relationships Between Women in Nineteenth Century America', *Signs*, vol. 1, no. 1 (Fall 1975), pp. 1–29.

5 Marjorie Housepian Dobkin (ed.), *The Making of a Feminist: Early Journals and Letters of M. Carey Thomas*, Kent State University Press, Kent, Ohio, 1980.

6 Lillian Faderman, *Surpassing the Love of Men*, Junction Books, London, 1981.

7 The debates are well covered in Jonathan Ned Katz, *Gay/Lesbian Almanac*, Harper & Row, New York, 1983, pp. 1–19.

8 One of the early pioneering works is Linda Nochlin and Thomas B. Hess (eds), *Why Have There Been No Great Women Artists: Art and Sexual Politics*, Collier Books, New York, 1971.

9 The notable exceptions are few. *Heresies: A Feminist Publication on Art and Politics* regularly carries articles on lesbian artists (see notes for Chapter 11). Germaine Greer, *The Obstacle Race*, Secker & Warburg, London, 1979, mentions the lesbianism of individual artists, but her rejection of feminism ('Feminism cannot supply the answer for an artist, for her truth cannot be political' p. 325) limits the usefulness of her analysis. See also Elsa Honig Fine, *Women and Art*, Allanheld and Schram/Prior Montclair/London 1978.

10 For illustrations and discussion of this subject see Thomas B. Hess and Linda Nochlin (eds), *Women as Sex Objects*, Newsweek Inc, New York, 1972; Allen Lane, London, 1973.

CHAPTER 1 THE MIRROR OF THE SOUL

1 D. L. Sayers (ed. and trans.), *Dante: The Divine Comedy*, Middlesex, 1949. Dante put the sodomites in the seventh circle of Hell and on the seventh corner of Purgatory.

2 An excellent account of Dürer's work and life can be found in Michael Levey, *Dürer*, Weidenfeld & Nicolson, London, 1964.

3 Giorgio Vasari, *The Lives of the Artists* (George Bull trans.), Penguin, Harmondsworth, Middlesex, 1965.

4 *Ibid.*

5 C. Frey (ed.), *Il Codice Magliabechiano*, Berlin, 1892.

6 Silvio Marone, 'Homosexuality and Art', in *International Journal of Sexology*, vol. VII, no. 4, May 1954.

7 Raymond de Becker, *The Other Face of Love* (Margaret Crosland and Alan Daventry trans.), Neville Spearman, London, 1967, p. 14. Jens Thiis, *Leonardo da Vinci*, Jenkins, London, n.d.

8 Quoted in de Becker *op. cit.*, p. 116. See also Howard Hibbard, *Michelangelo*, Pelican Books, Harmondsworth, Middlesex, 1975.

9 Vasari, *op. cit.*

10 De Becker, *op. cit.*, p. 116.

11 De Becker, *op. cit.*, p. 116.

12 Hibbard, *op. cit.*, p. 232.

13 Rolf Schott, *Michelangelo*, Thames & Hudson, London, 1963, p. 211.

14 Vasari, *op. cit.*

15 Charles Hope, *The Autobiography of Benvenuto Cellini*, Phaidon, Oxford, 1983.

16 F. M. Clapp, *Jacopo Carucci da Pontormo*, Yale University Press, New Haven, 1916.

17 Arthur McComb, *Agnolo Bronzino*, OUP, London, 1928.

18 Michael Levey, *Bronzino*, OUP, London, 1981.
 See also Charles McCorquodale *Bronzino* Jupiter Books, London, 1981.
19 Howard Hibbard, *Caravaggio*, Thames & Hudson, London, 1983.
20 Donald Posner, 'Caravaggio's Homo-erotic Early Work', *Art Quarterly*, vol. 34, no. 3 (1971), pp. 301–24.
21 *The Works of Antonio Canova*, London, 1824, Biographical memoir, p. 35.
22 Letter to Mulready from his wife, dated 1827, Victoria and Albert Museum Library.
23 Phoebe Lloyd, 'Washington Allston: American Martyr?', *Art in America*, March 1984, pp. 145–79.

CHAPTER 2 FREE FROM THE ITCH OF DESIRE

1 Plato's phrase is used by Robert Hughes in *The Art of Australia*, Pelican, Harmondsworth, 1970, in conjunction with the homoerotic art of Donald Friend.
2 Quoted in Thomas S. W. Lewis, 'The Brothers of Ganymede,' *Homosexuality, Sacrilege, Vision, Politics*, Salmagundi, Fall 1983, no. 58–9, New York.
3 *Ibid.*
4 Leonée and Richard Ormond, *Lord Leighton*, Yale University Press, New Haven and London, 1975, p. 48.
5 *Ibid.*, p. 10.
6 Mrs Russel Barrington, *Life, Letters and Work of Frederic Leighton*, George Allen, London, 1906, pp. 262, 268. For the life and work of Laurence Housman see Rodney Engen, *The Artist and the Critic*, Catalpa Press, Stroud, 1983.
7 The homoerotic elements of the drawings are fully discussed in Trevor J. Fairbrother, 'A Private Album: John Singer Sargent's Drawings of Male Nude Models', *Arts Magazine*, December 1981, pp. 70–79.
8 Richard Ormond, *John Singer Sargent*, Phaidon, London, 1970. See also Stanley Olson, *John Singer Sargent: His Portrait*, Macmillan, London, 1986.
9 Lloyd Goodrich, *Thomas Eakins*, Retrospective Exhibition Catalogue, Whitney Museum of American Art, 1970. For a discussion of the homoerotic elements in Eakins' work see Kenneth Hale, 'Thomas Eakins: Artist of Philadelphia', *Gay Community News*, Nov. 13, 1982, pp. 8–9.
10 Goodrich, *op. cit.*, p. 29.
11 Seymour Adelman, *Susan Macdowell Eakins*, Pennsylvania Academy of Arts, Philadelphia, 1973.
12 Paul Fussell in *The Great War and Modern Memory*, OUP, London and New York, 1975, discusses the homoeroticisation of poetry in the 1914–18 war with great conviction. See also Magnus Hirschfeld, *The Sexual History of the World War*, New York, 1934, p. 127.
13 Homer's sensitivity towards women is discussed in Sarah Whitworth's 'Winslow Homer', *Lesbian Essays from the Ladder*, ed. Barbara Grier and Coletta Reid, Diana Press, Baltimore, Maryland, 1976.
14 Quoted in Albert Ten Eyck Gardner, *Winslow Homer, American Art: His World and His Work*, Bramhall House, New York, 1961, p. 212.

15 James Thomas Flexner, *The World of Winslow Homer*, Time Incorporated, New York, 1966.

16 *Ibid.*, p. 70.

17 Gardner, *op. cit.*

18 Maria Tuke Sainsbury, *Henry Scott Tuke, A Memoir*, London, 1933.

19 Caroline Fox, Francis Greenacre, *Artists of the Newlyn School* (1880-1900), Exhibition catalogue, Newlyn Orion Galleries, 1979, p. 132.

20 *The Registers of Henry Scott Tuke* (2nd ed.) and *The Diary of Henry Scott Tuke*, both annotated by B. D. Price, Royal Cornwall Polytechnic Society, Falmouth 1983, give accurate detailed information on Tuke's work.

21 John Shirlow, *Frederick George Reynolds*, Edward A. Vidler, Melbourne, c. 1924.

CHAPTER 3 GENIUS HAS NO SEX

1 Anna Klumpke, *Rosa Bonheur*, Flammarion, Paris, 1908, p. 264.

2 T. Stanton (ed.), *Reminiscences of Rosa Bonheur*, D. Appleton Co, New York, 1910, p. 146.

3 Germaine Greer's *The Obstacle Race*, Secker & Warburg, London, 1979, is one of the few books to discuss the work of lesbian artists.

4 Lillian Faderman in *Surpassing the Love of Men*, Junction Books, London, 1981, concentrates on writers rather than painters but her analysis is helpful in approaching wider questions of lesbian identity.

5 Quoted in Philippe Jullian, *Robert de Montesquiou* (John Haycock and Francis King trans.) Secker & Warburg, London, 1967.

6 Quoted in the extremely useful Jonathan Katz, *Gay/Lesbian Almanac*, Harper & Row, New York, 1983, p. 49.

7 Anthea Callen, *Angel in the Studio*, Astragal Books, London, 1979, p. 177.

8 Stanton, *op. cit.*, p. 269.

9 Stanton, *op. cit.*, p. 114.

10 Stanton, *op. cit.*, pp. 187-8.

11 Stanton, *op. cit.*

12 Discussed in Alison Hennegan's 'Here, Who Are You Calling a Lesbian?' in *Homosexuality: Power and Politics*, ed. Gay Left Collective, Allison & Busby, London, 1980, p. 193.

13 Albert Boime, 'The Case of Rosa Bonheur: Why Should a Woman Want to be More Like a Man?' *Art History*, vol. 4, no. 4, Dec. 1981, Routledge & Kegan Paul, London.

14 Stanton, *op. cit.*

15 Ruskin's comments on her indifference to the human figure are quoted by Boime, *op. cit.*, p. 397.

16 Stanton, *op. cit.*, p. 42.

17 Elsa Honig Fine, *Women and Art*, Allanheld and Schram/Prior Montclair/ London, 1978, p. 118.

18 Karen Petersen and J. J. Wilson, *Women Artists*, The Women's Press, London, 1978, p. 78.

19 Cornelia Otis Skinner, *Madame Sarah Bernhardt*, Michael Joseph, London 1967.

20 A phrase coined by James in 1903 in his essay, 'William Wetmore Story and His Friends': 'that strange sisterhood of American "lady sculptors" who at one time settled upon the Seven Hills in a white marmorean flock'.

21 Eleonor Tufts, *Our Hidden Heritage*, Paddington Press Ltd, London, 1974, p. 161.

22 Quoted in Alicia Faxon, 'Images of Women in the Sculpture of Harriet Hosmer', *Women's Art Journal*, vol. 2, no. 1, Spring/Summer 1981.

23 J. Walter McSpadden, *Famous Sculptors of America*, Dodd, Mead, New York, 1928, p. 336.

24 Leonée and Richard Ormond, *op. cit.*, p. 22.

25 Quoted Petersen and Wilson, *op. cit.*, p. 80.

26 Emma Stebbins, *Charlotte Cushman: Her Letters and Memories of Her Life*, Boston, 1879.

27 Joseph Leach, *Bright Particular Star: The Life and Times of Charlotte Cushman*, Yale University Press, New Haven and London, 1976.

28 Quoted, Tufts, *op. cit.*, p. 162.

29 Quoted Petersen and Wilson, *op. cit.*, p. 82.

30 Leach, *op. cit.*

31 Fine, *op. cit.*

32 Petersen and Wilson, *op. cit.*, p. 83. See also Elizabeth Rogers Payne, 'Anne Whitney Sculptor', *Art Quarterly*, Autumn 1962, pp. 244-51.

CHAPTER 4 SEXUAL AESTHETES

1 The most authoritative account of Simeon Solomon's life is Lionel Lambourne, 'Abraham Solomon, Painter of Fashion and Simeon Solomon, Decadent Artist', *Jewish Historical Society of England Transactions*, 1968, vol. 21, pp. 274-86.

2 Quoted by Lambourne from Walter Pater, *Greek Studies*, Macmillan & Co., London, 1908.

3 Quoted in John Dixon Hunt, *The Pre-Raphaelite Imagination 1848-1900*, Routledge & Kegan Paul, London, 1969, p. 194. See also Ronald Pearsall, *The Worm in the Bud*, Macmillan, London, 1969.

4 Bernard Falk, *Five Years Dead*, Hutchinson, London, 1938, pp. 311-31.

5 Quoted in Philip Henderson, *Swinburne*, Routledge & Kegan Paul, London, 1974, p. 169.

6 Quoted in Percy Fitzgerald, *Edward Burne-Jones*, Michael Joseph, London, 1975, p. 105.

7 Quoted in Henderson, *op. cit.*, pp. 149, 229. See also Pearsall, *op. cit.*, pp. 451-2.

8 William Gaunt, *The Aesthetic Adventure*, Cape, London, 1945, p. 128.

9 Rupert Croft-Cooke gives an interesting account of Solomon's work and life in *Feasting With Panthers*, W. H. Allen, London, 1970.

10 Timothy Hilton, *Pre-Raphaelites*, Thames & Hudson, London, 1970, pp. 9, 202.

11 Philippe Jullian, *Robert de Montesquiou, A Fin-de-Siècle Prince* (John Haylock & Francis King trans.), Secker & Warburg, London, 1967.

12 *Ibid.*

13 Pierre-Louis Mathieu, *Gustave Moreau*, Phaidon, Oxford, 1977.

14 *Ibid.*, p. 159.

15 *Ibid.*, p. 165.

16 Julius Kaplan, *The Art of Gustave Moreau*, UMI Research Press, Ann Arbor, Michigan, 1982, p. 13.

17 Mathieu, *op. cit.*, p. 58.

18 Mathieu, *op. cit.*, p. 185.

19 Philippe Jullian, *Dreamers of Decadence* (Robert Baldwick trans.), Pall Mall, London, 1971.

20 John Rothenstein, *The Artists of the 1890s*, London, 1928.

21 Quoted Frederick L. Gwynn, *Sturge Moore and the Life of Art*, London, 1952.

22 T. Sturge Moore, *Charles Ricketts RA. Self-Portrait taken from the letters and journals of C.R.*, ed. Cecil Lewis, London, 1939.

23 Rothenstein, *op. cit.*

24 Rothenstein, *op. cit.*

25 Quoted in Stephen Calloway, *Charles Ricketts*, Thames & Hudson, London, 1979.

26 Michael Field was the pseudonym of Katherine Bradley (Michael) 1846–1914 and her niece Edith Cooper (Henry) 1862–1913 who lived and wrote together.

27 Orleans House Gallery, Twickenham, *Charles Ricketts and Charles Shannon: An Aesthetic Partnership*, by Stephen Calloway and Paul Delaney, 1979.

28 Malcolm Easton, *Aubrey and the Dying Lady*, Secker & Warburg, London, 1972, p. 43.

29 Charles C. Eldredge, *American Imagination and Symbolist Painting*, Grey Art Gallery and Study Center, New York University, 1979.

30 A full account of Day's life and work can be found in Estelle Jussim, *Slave to Beauty*, Godine, Boston, 1981.

CHAPTER 5 THE SOUL IDENTIFIED WITH THE FLESH

1 Part of a review by Claude Roger-Marx (1910) of Romaine Brooks' painting, quoted in Adelyn D. Breeskin, *Romaine Brooks, Thief of Souls*, Smithsonian Press, Washington DC, 1971. See also Meryle Secrest, *Between Me and Life, a biography of Romaine Brooks*, Doubleday & Co., New York, 1974.

2 Quoted in Oliver Jensen, *The Revolt of American Women*, New York, 1952,

p. 24. Chapter 1 is devoted to Alice Austen's work and illustrates many of her photographs.

3 Quoted Ann Novotny, 'Alice Austen's World', Lesbian Art and Artists Issue, *Heresies: A Feminist Publication on Art and Politics*, vol. 1, Issue 3, New York, 1977.

4 Richard Ormrod's excellent biography *Una Troubridge, the Friend of Radclyffe Hall*, Jonathan Cape, London, 1984, discusses and illustrates her art.

5 Breeskin, *op. cit.*

6 Breeskin, *op. cit.*

7 Breeskin, *op. cit.*

8 Truman Capote, *Other Voices Other Rooms*, Random House, New York, 1968.

9 This incident is referred to in Tony Carroll's Catalogue Introduction, *Gluck 1895-1978*, The Fine Arts Society, London, 1980.

10 Letter to Henry Lamb (4th Feb 1913) quoted M. Holroyd, *Lytton Strachey*, Heinemann, London, 1967.

11 Letter to Vanessa Bell April 11 1932, Virginia Woolf, *Collected Letters*, vol. 5, 1932-1935, ed. Nigel Nicolson and Joanna Trautman, Hogarth Press, London, 1979, p. 45.

12 Wendy Baron, *Miss Ethel Sands and Her Circle*, Peter Owen, London, 1980.

13 Louise Collis, *A Private View of Stanley Spencer*, Heinemann, London, 1972.

14 They showed their work at Dorothy Warren's gallery in 1928 shortly before it was closed down during the exhibition of D. H. Lawrence's paintings.

15 See the catalogue introduction to Dorothy Hepworth's studio sale, Christies, South Kensington, London, 1984.

16 J. Rothenstein, *Stanley Spencer The Man. Correspondence and Reminiscences*, Paul Elek, London, 1979. This account makes an interesting comparison with Louise Collis's book, *op. cit.*

17 Clive Bell, Catalogue, *Recent Paintings 1938*, The Leger Galleries, London.

18 Letter to Alix Strachey, October 1929. David Garnett, *Carrington Letters and Extracts from Her Diaries*, OUP, London, 1970.

19 *Ibid.*

20 *Ibid.*

21 There is a full discussion of Carrington's work and life in G. Elinor, 'Vanessa Bell and Dora Carrington, Bloomsbury Painters', *Women's Art Journal*, vol. 5, no. 1, Spring/Summer 1984.

22 Anne Olivier Bell (ed.), *Diary of Virginia Woolf*, vol. 2, 1920-24, Penguin, Harmondsworth, 1981, p. 524.

23 A fascinating account of Gwen John's life and work can be found in S. Chitty, *Gwen John*, Hodder & Stoughton, London, 1981.

24 Letter from Ethel Walker to Grace English, c. 1930, Tate Gallery Archives.

25 Letter from Ethel Walker to Grace English, April 17, 1939, Tate Gallery Archives.

26 Catalogue. Introduction by Lillian Browse, 'Distinguished British Paintings 1875-1950 An Accent on Ethel Walker', Roland, Browse and Delbanco, May 1974.

27 E. H. McCormick, *A Study of Frances Hodgkins*, University Press, Wellington, New Zealand, 1954.

28 E. H. McCormick, *Portrait of Frances Hodgkins*, Auckland University Press, Oxford University Press, 1981, p. 66.

29 *Frances Hodgkins 1869-1947*, Queen Elizabeth II Arts Council of New Zealand, A Centenary Exhibition Catalogue, 1969.

CHAPTER 6 THE SEXUAL CODE

1 Quoted in Linda Simon, *The Biography of Alice B. Toklas*, Doubleday and Co., New York, 1977, p. 121. For background see J. T. Mellow, *Charmed Circle: Gertrude Stein and Company*, Phaidon, London, 1974.

2 E. Farnham, *Charles Demuth: Behind a Laughing Mask*, University of Oklahoma Press, Norman, 1971, p. 137.

3 William Carlos Williams, *Autobiography*, Random House, New York, 1951.

4 Review of exhibition at Daniel Gallery in *International Studio*, quoted by Farnham, *op. cit.*, p. 116.

5 See Sanford Schwartz, 'Glimpsing the Hidden Demuth', *Art in America*, September/October 1976, pp. 102-3.

6 Quoted in Hearne Pardee, 'A Reading of Marsden Hartley', *Art News*, September 1983.

7 B. Haskell, *Marsden Hartley*, Whitney Museum of American Art, New York University Press, New York and London, 1980, p. 10.

8 *Ibid.*, p. 12.

9 *Ibid.*, p. 18.

10 *Ibid.*, p. 31.

11 *Ibid.*

12 *Ibid.*, p. 32.

13 William Carlos Williams, quoted in Haskell, *op. cit.*, p. 61.

14 Haskell, *op. cit.*, p. 71.

15 Haskell, *op. cit.*

16 Marsden Hartley, *Cleophas and His Own: A North Atlantic Tragedy*, Press Publications, Halifax, Nova Scotia, 1982, p. 14.

17 Haskell, *op. cit.*, p. 124.

18 Quoted in D. Tashjian, *William Carlos Williams and the American Scene 1920-1940*, Whitney Museum of American Art, University of California Press, Los Angeles, London, 1978, p. 53.

19 B. B. Perlman, *The Immortal Eight*, Exposition Press, New York, 1962, p. 169.

20 For a full description of Prendergast and other painters in his circle see M. S. Young *The Eight: The Realist Revolt in American Painting*, Watson-Guptill,

New York, 1973 and *Sketches by Maurice Prendergast 1899*, Museum of Fine Art, Boston, 1960.

21 F. O. Matthiessen, *Russell Cheney: A Record of His Work*, OUP, New York, 1947.

22 Louis Hyde, *Rat and the Devil: Journal, Letters of F. O. Matthiessen and Russell Cheney*, Achon Books, Hamden Coun, 1978, pp. 17–18.

23 *Ibid.*, pp. 17–18.

24 Matthiessen, *op. cit.*

25 Matthiessen, *op. cit.*

26 Matthiessen, *op. cit.*

27 Matthiessen, *op. cit.*

28 M. Schau, *J. C. Leyendecker*, Watson-Guptill Publications, New York, 1974, p. 21.

29 N. Rockwell, *My Life as an Illustrator*, Doubleday, New York, 1960, pp. 188–99.

30 *Ibid.*

CHAPTER 7 BREAKING OUT: PRIVATE FACES IN PUBLIC PLACES

1 Recently republished by Brilliance Books, London, 1983.

2 R. de Becker, *op. cit.*, p. 137.

3 Quoted in Sir Francis Rose, *Saying Life*, Cassell, London, 1961.

4 *Ibid.*

5 Quoted in W. Mason, *Christopher Wood*, Arts Council, London, 1979, p. 28.

6 Quoted in Catalogue Introduction, *Christopher Wood*, Parkin Gallery, London, 1983.

7 M. Holroyd, *Lytton Strachey: A Biography*, Heinemann, London, 1967, p. 292.

8 R. Shone, *Bloomsbury Portraits*, Phaidon, London, 1976, p. 49.

9 *Ibid.*, p. 68.

10 Quoted in Sir John Rothenstein, *Modern English Painters*, vol. II, Eyre & Spottiswoode, London, 1956, p. 57.

11 The complex relationship is fully discussed in Frances Spalding, *Vanessa Bell*, Weidenfeld & Nicolson, London, 1983.

12 Grant's painting in the context of other twentieth century artists is discussed in S. Watney, *English Post-Impressionism*, Studio Vista/Eastview Editions, London, 1980.

13 See Diana Holman-Hunt, *Alvaro Guevara, Latin Among the Lions*, Michael Joseph, London, 1974.

14 Bryan Robertson, Catalogue Introduction, *Edward Wolfe*, Arts Council, London, 1967.

15 Illustrated in Oliver Garnett, 'The Sculpture of Stephen Tomlin', Unpublished thesis, Tate Gallery Archives.

16 Quoted by Garnett, *op. cit.*

17 Richard Morphet, *Cedric Morris*, Tate Gallery, London, 1984, p. 75.
18 *Ibid.*, see footnote 12, p. 93.

CHAPTER 8 THE NEW WOMAN

 1 Quoted in Lillian Faderman, *Surpassing the Love of Men*, Junction Books, London, 1981, p. 371.
 2 Andrew Field, *The Formidable Miss Barnes*, Secker & Warburg, London, 1983, p. 37.
 3 Faderman, *op. cit.*, p. 332.
 4 Field, *op. cit.*, p. 127.
 5 H. O'Neal, *Berenice Abbott: Sixty Years of Photography*, Thames & Hudson, London, 1982, p. 10.
 6 *Ibid.*, p. 10.
 7 *Ibid.*
 8 Renee Sandell, 'Marie Laurencin: Cubist Muse or More?', *Women's Art Journal*, vol. I, no. 1, Spring/Summer 1980.
 9 *Ibid.*
10 *Ibid.*
11 Estella Lauter, 'Leonor Fini: Preparing to Meet the Strangers of the New World', *Women's Art Journal*, vol. 1, no. 1, Spring/Summer 1980
12 *Ibid.*
13 Colin Naylor, Genesis P-Orridge (eds), *Contemporary Artists*, St James Press, London; St Martin's Press, New York, 1977, p. 298.
14 Szymon Bojko, 'Tamara de Lempicka', *Art and Artists*, vol. 15, no. 2, June 1980, Issue 171, pp. 6-9.
15 *Ibid.*
16 Giancarlo Marmori, *Tamara de Lempicka 1925-1935*, Idea Editions, London, 1978, p. 10.
17 Katharina Sykora, Jeanne Mammen and Christian Schad, 'Two Illustrators of Homosexuality in Berlin's Twenties', *Among Men, Among Women*, Conference papers, University of Amsterdam, 1983, pp. 537-47.
18 Catalogue introduction, Jeanne Mammen, Fischer Fine Art, London, 1980.
19 Quoted by John Kemplay, *The Edinburgh Group*, City of Edinburgh Museums and Art Galleries, Edinburgh, 1983, p. 3.
20 Catalogue introduction, *Joan Eardley*, Browse and Darby Gallery, London, 1980.
21 Quoted in J. Hunt, 'Art With a Capital "A", Woman With a Capital "W" ', catalogue *Women's Art Show 1550-1970*, Nottingham Castle Museum, 1982.
22 Quoted in W. Buchanan, *Joan Eardley*, University Press, Edinburgh 1976, p. 23.
23 *Ibid.*, p. 30.
24 *Ibid.*, p. 82.

CHAPTER 9 THE DIVIDED SUBJECT

1 R. Buckle (ed.), *Self-Portrait with Friends: The Selected Diaries of Cecil Beaton*, Penguin Books, Harmondsworth, 1982, p. 12.

2 Interview 'A Traveller Without Touchstone', by James M. Saslow, *The Advocate*, no. 317, May 1983.

3 See Robin Gibson, *Glyn Philpot: Edwardian Aesthete to Thirties Modernist*, National Portrait Gallery, London, 1984.

4 Illustrated and discussed in A. C. Sewter, *Glyn Philpot 1884–1937*, Batsford, London, 1951.

5 A. Reid, *Ralph Chubb*, The Private Library Second Series, vol. 3, no. 3, Autumn 1970.

6 Quoted Timothy d'Arch Smith, *Love in Earnest*, Routledge & Kegan Paul, London, 1970, p. 223.

7 Quoted in D. Patmore, *Private History*, Jonathan Cape, London, 1968, p. 68.

8 Quoted in the exhibition catalogue, *Cecil Beaton War Photographs 1939–45* Imperial War Museum, 1982, p. 4.

9 Quoted in L. Whistler, *Rex Whistler: His Life and His Drawings*, Art and Technics, London, 1948, p. 45. See also L. Whistler *The Laughter and the Urn*: the Life of Rex Whistler, Weidenfeld & Nicolson, London, 1985.

11 C. Asquith, *Happily I May Remember*, James Barrie, London 1950, p. 114. See also pp. 94–113.

11 Interview with the author, 4th Feb 1982, shortly before his death.

12 Quoted in G. Prieto, *Students: Oxford and Cambridge*, The Dolphin Bookshop Editions, London, 1938.

13 Quoted by Richard Shone in catalogue introduction, *John Banting*, Oliver Bradbury and James Birch Fine Art, London, 1983.

14 Quoted in W. Chappell (ed.), *Edward Burra: A Painter Remembered by His Friends*, Andre Deutsch, London, 1945, p. 75 and pp. 117–18. See also *Edward Burra*, Hayward Gallery, London, Arts Council of Great Britain, 1985

15 J. Rothenstein, *Edward Burra*, Penguin Books, Harmondsworth, 1945.

16 Parker Tyler, *The Divine Comedy of Pavel Tchelitchew*, Weidenfeld & Nicolson, London, 1967, p. 308. There is a useful account of the relationship between Tchelitchew and Edith Sitwell in Victoria Glendinning, *Edith Sitwell: A Unicorn Among Lions*, Weidenfeld & Nicolson, London, 1983, pp. 119ff. and in John Pearson, *Facades*, Macmillan, London, 1978, p. 235ff.

17 P. Eliasoph, *Paul Cadmus Yesterday and Today*, Miami University Art Museum, Oxford, Ohio, 1981, p. 31, see also L. Kirstein, *Paul Cadmus*, Imago, New York; GMP, London, 1984.

18 James R. Mellow, 'New York Letter', *Art International* (Lugarno) April 1969.

19 P. Weiermair, *George Platt Lynes*, Allerheiligenpresse, 1982.

CHAPTER 10 VEILING THE IMAGE

1 Quoted in R. Carleston Hobbs and Gail Levin, *Abstract Expressionism*, Cornell University Press, Ithaca, 1978, p. 122.

2 Quoted in James Baker Hall, *Minor White: Rites and Passages*, Aperture, New York, 1978, p. 59.

3 *Ibid.*, p. 49.

4 *Ibid.*, p. 88.

5 Bob Workman, 'Exposures', *Gay News*, 185, February 21–March 5 1980.

6 Hall, *op. cit.*, p. 19.

7 *Ibid.*, p. 58.

8 *Ibid.*, p. 88.

9 Quoted in unpublished thesis, 'John Minton', Hetty Einzig, Courtauld Institute of Art. See also T. H. G. Ward, 'John Minton & Montgomery Cliff. A Parallel', *London Magazine*, April/May, pp. 47–53, and *John Minton 1917–1957*, Morley Gallery, London, February 1979.

10 Anthony Cronin, *Dead as Doornails*, Calder & Boyars, London, 1976, p. 133. Cronin's book contains a personal account of the often stormy relationship between the two Roberts.

11 John Rothenstein, *Modern English Painters*, vol. III, Macdonald & Janes, London, 1976, p. 181.

12 There is an excellent account of the two artists' life and work in Andrew Brown, *Robert Colquhoun*, City of Edinburgh Museum and Art Galleries, Edinburgh, 1981.

13 Quoted by Richard Shone, Exhibition catalogue *Robert Colquhoun and Robert Macbryde*, Mayor Gallery, London, 1977.

14 Quoted in the catalogue, *John Craxton Paintings and Drawings 1941–1966*, Whitechapel Gallery, London, 1976, p. 9.

15 *Ibid.*, p. 6.

16 *Ibid.*, p. 7.

17 Robert Medley, *Drawn From Life: A Memoir*, Faber, London, 1983, p. 183.

18 For Vaughan's views on art see K. Vaughan, *Journal and Drawings 1939–1965*, Alan Ross, London, 1966. Extracts from Vaughan's journals appeared in *London Magazine* March, April, June 1983 and June 1984. See also *Keith Vaughan Images of Man: Figurative Paintings 1946–1960*. Inner London Education Authority, London 1981 (Exhibition catalogue Geffrye Museum, London, 1983).

19 Television interview with Bryan Robertson, 1966.

20 Robert Gosling, Funeral oration.

21 Bryan Robertson, introduction in *Keith Vaughan*, Whitechapel Art Gallery, London, 1962, p. 4.

22 'Bringing Home Bacon', an interview with Francis Bacon by Miriam Goss, *Observer*, London, Nov. 30, 1980.

23 John Russell, *Francis Bacon*, Thames & Hudson, London, 1980, p. 155.

24 David Sylvester, *Interviews with Francis Bacon 1962–1979*, Thames & Hudson, London, 1980.

25 *Ibid.*, p. 81.

26 Quoted by Calvin Tomkins, *Off the Wall: Robert Rauschenberg and the Art World of Our Time*, Time Books, New York, 1980, p. 109. Some idea of the social life of Rauschenberg and Johns is included in John Gruen, *The Party's Over Now*, Viking Press, New York, 1972.

27 *Ibid.*, p. 137.

28 *Ibid.*, p. 197.

29 Frank O'Hara, homosexual, poet and a curator at the Metropolitan Museum of Art, had a significant effect on many artists. See for example Larry Rivers and Carol Brightman's, *Drawings and Digressions*, Clarkson N. Potter, New York, 1980, and Marjorie Perloff, *Frank O'Hara: Poet Among Painters*, George Braziller, New York, 1977.

30 The complex autobiographical imagery of Johns' painting is discussed in Charles Harrison and Fred Orton, 'Jasper Johns: Meaning What You See', *Art History*, vol. 6, no. 1, March 1984.

31 Quoted Michael Newman, 'Rauschenberg Re-evaluated', *Art Monthly*, no. 47, 1981.

32 For a detailed history of gay magazine publication see 'Hard-On Art' by Jerry Mills and Dwight Russ, *In Touch For Men*, no. 31, pp. 60-69.

CHAPTER 11 LESBIANS WHO MAKE ART

1 For a wider discussion of feminism and art see Anna Bonshek, 'Feminist Romantic Painting—A Re-Constellation,' *Artists Newsletter*, May 1985. See also the magazine *FAN*, Feminist Art News (UK).

2 'Lesbian Art and Artists', *Heresies: A Feminist Publication on Art and Politics*, vol. 1, Issue 3, New York, 1977.

3 Susan Sanders, 'Lesbian Invisibility', *Women's Studies International Forum* (Gloria Bowles, ed.), vol. 7, no. 3, Pergamon Press, Oxford 1984, p. iii.

4 See Kate Charlesworth, *Exotic Species. The Field Guide to British Gays*, GMP, London, 1984.

5 James M. Saslow, 'Sandra de Sando', *The Advocate*, Issue 288, March 20 1980.

6 Sandra de Sando, quoted by James M. Saslow, *op. cit.*

7 Statement to the author, December 1984.

8 Statement to the author, December 1984.

9 Sheila Sullivan, *The Advocate*, Issue 289, April 3, 1980.

10 Harmony Hammond, 'Lesbian Art and Artists', *Heresies*, *op. cit.*, p. 36.

11 *Ibid.*, p. 3.

12 *Ibid.*, p. 2.

13 *Ibid.*, p. 11.

14 *Ibid.*, p. 11.

15 *Ibid.*, p. 12.

16 *Ibid.*, p. 11.

17 *Ibid.*, p. 12.

18 Quoted Daniel J. Cameron, *Extended Sensibilities*, The New Museum, New York, 1982, p. 13.

19 Statement by the artist.

20 Quoted in Jules Cassidy and Angela Stewart-Park, *We're Here: Conversations With Lesbian Women*, Quartet Books, London, Melbourne New York, 1977, p. 99.

21 Nancy Fried's sculptures are discussed in *Extended Sensibilities: Homosexual Presence in Contemporary Art*, The New Museum, New York, 1982.

22 Quoted in *Extended Sensibilities*, *op. cit.*

23 Quoted in Sharon Feinstein, 'Our Bodies Ourselves', *Gay News*, no. 245, July 22–August 4 1982. (The second part of this important article appeared in *Gay News*, no. 248, September 2-15 1982.)

24 Quoted by Feinstein, *op. cit.*

25 See Samois (ed.), *Coming to Power*, Alyson Publications, GMP, London, 1983; and *What Colour Is Your Handkerchief: a lesbian s/m sexuality reader*, Samois (ed.), Berkeley, 1979.

26 Interview with the author November 1984.

27 Continental Enquiries, 'The Women Show', *Information Sheet*, October 1981, The Photographic Gallery, Cardiff.

28 *Ibid.*

29 Susan Butler, 'The Women Show', *Open Eye*, 28 December 1981, Open Eye Gallery, Liverpool.

30 Interview with the author, December 1984.

31 Jill Posener, *Spray it Loud*, Routledge & Kegan Paul, London, 1982.

32 Susan Trangmar, statement to the author, December 1984.

33 Yve Lomax, statement to the author, December 1984.

CHAPTER 12 THERE I AM

1 Quoted in Rainer Crone, *Warhol* (John William Gabriel trans.), Thames & Hudson, London, 1970.

2 John Perrault, 'I'm Asking—Does It Exist? What Is It? Whom Is It For?', *Artforum*, November 1980.

3 Interview with the author, *Gay News*, no. 220, July 23–August 5 1982.

4 Crone, *op. cit.*

5 Andy Warhol, *From A to B and Back Again*, Cassell, London, 1975.

6 Vito Russo, *The Celluloid Closet: Homosexuality in the Movies*, Harper & Row, New York, 1981, p. 30.

7 *David Hockney by David Hockney* (ed. Nikos Stangos), Thames & Hudson, London, 1976, p. 68.

8 Mario Dubsky, *Factor X*, Catalogue South London Art Gallery 1984, p. 36. See also 'Mario Dubsky' by Emmanuel Cooper, *Gay News*, No. 169, 1979.

9 See Edward Lucie-Smith, *Changing: 50 Drawings by Michael Leonard*, GMP, London, 1983.

10 Scottie Ferguson, 'Robert Crowl', *The Advocate*, Issue 229, August 21 1980.

11 See Edward Lucie-Smith, *David Hutter: Flowers and Nudes*, GMP, London, 1984.

12 See for example John Russell Taylor's Introduction, 'Martin Jones', Chenil Art Gallery, London, May 1980.

13 Derek Jarman's autobiography, *Dancing Ledge*, Quartet Books, London, 1984, gives fascinating insights into Jarman's own work and the art groups of the 1960s and 1970s in London.

14 Interview with the author, 1983.

15 *The Advocate*, Issue 226, May 3 1979.

16 Quoted Jain Kelly, *Nude Theory*, Lustrum Press, New York, 1979.

17 *Ibid*.

18 Quoted, *The Photographers' Gallery Catalog*, April–May 1983.

19 George Melly, 'A Journey Through Life on Canvas', *The Guardian*, 17 September 1980. See George Melly, *Philip Core: Paintings 1975-1985*, GMP, London, 1985.

20 See Philip Core, *Camp, the Lie That Tells the Truth*, Plexus, London, 1984.

21 See the catalogue John Yeadon, *Dirty Tricks*, Pentonville Gallery, London, 1984.

CHAPTER 13 SINGING AND SHOUTING

1 The Helms amendment to the NEA/NEH appropriation bill reads 'None of the funds authorized for the National Endowment for the Arts or the National Endowment for the Humanities may be used to promote, disseminate, or produce materials which in the judgement of the National Endowment for the Arts or the National Endowment for the Humanities, may be considered obscene, including but not limited to, depictions of sado-masochism, homo-eroticism, the sexual exploitation of children, or individuals engaged in sex acts and which, when taken as a whole, do not have serious literary, artistic, political or scientific value': Congressional Record – 'House' October 2, 1989, p h 640 7. Douglas Crimp's 'The Boys in My Bedroom', *Art in America*, February 1990, pp. 47–8, discusses the wider implications of the Helms amendment following the banning of exhibitions of work by Robert Mapplethorpe and Andres Serrano.

2 Chris Boot and Anna Harding (eds), *Bodies of Experience: Stories about Living with AIDS*, Camerawork, London, 1989.

3 Tessa Boffin and Sunil Gupta (eds), *Ecstatic Antibodies: Resisting the AIDS Mythology*, Rivers Oram Press, London, 1990.

4 Quoted in Rotimi Fani-Kayode, 'Traces of Ecstasy', *Ten 8*, no. 28. See also Alex Hirst (intro.) *Rotimi Fani-Kayode: Black Male/White Male*, GMP, London, 1988.

5 See also Mark Dey (intro.), *Béthune: A Town of Walls, The Work of Nicholas Lowe*, Eurocreation/Pepiniere, London, 1991. See also Nicholas Lowe and Michael McMillan, *Living Proof: Views of a World Living with HIV and AIDS*, Artists' Agency, Sunderland, 1992.

6 Quoted in Jan Zita Grover (ed.), *AIDS: The Artist's Response*, Ohio State University, Columbus, 1989, p. 42. See also Tessa Boffin and Jean Fraser (eds), *Stolen Glances: Lesbians Take Photographs*, Pandora, London, 1991.

7 This sequence is illustrated in Boffin and Gupta, *op. cit.*; Jan Zita Grover, *op. cit.*, p. 34.

8 Douglas Crimp and Adam Rolston, *AIDS Demo Graphics*, Bay Press, Seattle, 1990, p. 34.

9 For a full discussion of Andy Fabo's work see Karen Schoonover (ed.), *Andy Fabo: Diagnosis*, exhibition catalogue, Rosemont Art Gallery, Regina, Saskatchewan, 1990, and Michael Regan (ed.), *Andy Fabo and Michael Lexier*, exhibition catalogue, Canada House Gallery, London, 1992.

10 See Richard Salmon (ed.), *Derek Jarman—Queer Paintings*, exhibition catalogue, Manchester City Art Gallery, Manchester, 1992.

11 This work is fully discussed in Crimp and Rolston, *op. cit.* See also Nicola White (ed.), *Read My Lips: New York AIDS Polemics*, exhibition catalogue, Tramway, Glasgow, 1992.

12 Barry Blinderman (ed.), *David Wojnarowicz: Tongues of Fire*, Illinois State University, Norman, 1990. See also David Wojnarowicz, *Close to Knives*, Vintage Books, New York, and Serpents Tail, London, 1991, and David Wojnarowicz, *Memories that smell like Gasoline*, Artspace Books, San Francisco, and Serpents Tail, London, 1992.

13 Haring's life and work are vividly described in John Gruen, *Keith Haring: The Authorised Biography*, Prentice-Hall, New York, and Thames & Hudson, London, 1991.

14 Artist's statement by Nina Levitt in the 'Stolen Glances' exhibition, Stills Gallery, Edinburgh, May, 1991. The series was originally produced for the landmark multi-media exhibition 'Sight Specific: Lesbians and Representation' (A Space, Toronto, 1987), which was the first of its kind in Canada to address the absence of specific lesbian imagery in the mainstream and alternative communities.

15 Bright, quoted in Boffin and Fraser, *op cit.*, p. 14.

16 Fraser's work is discussed fully in Boffin and Fraser, *op. cit.*

17 Rachael Field's paintings are discussed in Araminta Morris, 'Exploring and Exploding: Rachael Field and Deirdre McConnell (Old Fire Station, Oxford)', *Womens Artists Slide Library Journal*, no. 23. See also *Womens Artists Slide Library Journal*, no. 21, and Wendy Leeks, 'Representing Lesbians', in *Broadening Out* exhibition catalogue, Rochdale Art Gallery, Rochdale, 1991.

18 Mandy McCartin, quoted in *The Face*, August 1989.

19 Mandy McCartin, quoted in Rose Collis, 'Street Life Images', *Gay Times* August 1991, p. 30. See also *Feminist Arts News*, vol. 3 no. 5

20 Rosy Martin, quoted in Boffin and Fraser, *op. cit.*, p. 101.

21 Audre Lord, 'Uses of the Erotic', quoted in Marusia Bociurkiw, 'Territories of the Forbidden', *Fuse*, March/April 1988, p. 28. The erotic as a source of political strength, 'a considered source of power and information in our lives', is an issue that continues to be widely debated within the lesbian and the gay communities.

22 'Exposing Ourselves—The World's Largest Lesbian Art Exhibition', The Worx, London; catalogue published by Lesbian Artists Network, London, 1992.

23 Quoted in David Lister, 'Lesbian Art Comes out of the Closet', *Independent on Sunday*, 16 August 1992, p. 4. Lister reported 'The feeling that lesbian art is not a meaningful genre—any more than one could lump all 20th century art by male homosexuals under one hammer—is brought into question by the exhibition's distinctive style and subject matter. This ranges from "Mona Lisa" in cropped hair, shirt and tie, to less self-mocking images which aim to rebut lesbian stereotypes.'

24 See Sarah Schulman's Introduction in *Love Bites: Photographs by Della Grace*, GMP, London, 1991.

25 For a discussion on lesbian S & M imagery see *On Our Backs: 'Entertainment for the Adventurous Lesbian'*, Bad Attitude for Boston, San Francisco, 1984, and *Quimm magazine*, London, late 1980s on, which also explores lesbian sexual imagery.

26 Arthur Kroker, *Attila Richard Lukacs: Painting the Hysterical Male*, exhibition catalogue, Diane Farris Gallery, Vancouver, Canada, 1990, p. 53. See also Thomas W. Sokolowski (intro.), *Attila Richard Lukacs*, Diane Farris Gallery, Vancouver, Canada, 1990, and Pier Luigi Tazzi, *Attila Richard Lukacs: Gardens*, exhibition catalogue, Diane Farris Gallery, Vancouver, Canada, 1992.

27 Frits Staal, *Sadao Hasegawa: Paintings and Drawings*, Editions Aubrey Walter/GMP, London, 1990, p. 7.

28 See Joan Stebbins (ed.), *Micah Lexier*, Southern Alberta Art Gallery, Lethbridge, Canada, 1991.

29 Adam Jones's work is discussed in Emmanuel Cooper, 'Making a Statement: The Art Works of Adam Jones and Nicholas Lowe', *Square Peg*, no. 17, December 1986, London.

30 Luis Caballero, quoted in Charles Adams, 'Talking to Luis Caballero', *Gay Times*, February 1992, pp. 38–40. See also Edward Lucie-Smith (intro.), *Luis Caballero*, Editions Aubrey Walter/GMP, London, 1992.

31 See Emmanuel Cooper, *Nicholas Paterson: Lazarus*, Slaughterhouse Gallery, London, 1992.

32 Letter to author, May 1992.

33 See 'Pierre and Gilles', *City Limits*, 3–19 September 1992, p. 89; Jane Withers,

'Space Cadets', *Evening Standard Magazine*, August 1992, p. 75; Eleanor
Heartney, 'Pierre et Gilles', *Art News*, March 1991, pp. 141–2; Jane Withers,
'Home des Garçons', *Elle (UK)*, January 1991; Andrew Graham-Dixon,
'Double Talking', *Vogue*, July 1990.

Biographies and General Reference

Caballero Garcia, Manuel (ed.), *Clausura Costus: Exposicion Antologia*, Artes Graficas Luis Perez, Madrid, 1992.

Bolanos Donoso, Piedad (ed.), *Exposition – Homenaje a Gregorio Prieto*, Universidad de Sevilla, Fundacion El Monto, 1993.

Cooper, Emmanuel, *Fully Exposed: The Male Nude in Photography*, Harper Collins (Unwin Hyman), London, 1990.

Cooper, Emmanuel, *Kouros: The Male Photographs of John S. Barrington*, Editions Aubrey Walter, GMP, London, 1993.

Dover, K.J., *Greek Homosexuality*, Duckworth, London, 1979.

Ellenzweig, Allen, *The Homoerotic Photograph*, Columbia University Press, New York, 1992.

Faderman, Lillian, *Odd Girls and Twilight Lovers: A History of Lesbian Life in Twentieth Century America*, Penguin, Harmondsworth, 1992.

Farson, Daniel, *The Gilded Gutter Life of Francis Bacon*, Century, London, 1993.

Gerzina, Gretchen, *Carrington: A Life of Dora Carrington 1893–1932*, John Murray, London, 1989.

Gill, Michael, *Image of the Body: Aspects of the Nude*, Doubleday/The Bodley Head, London 1989.

Goldin, Nan, *Die Andere Seite 1972–1992 (The Other Side)*, Der Alltag/Packett, Scalo Verlag, Zurich, 1992.

Haskell, Barbara, *Charles Demuth*, Whitney Museum of American Art, New York/Harry N. Abrams, New York, 1988.

Hebborn, Eric, *Drawn to Trouble: The Forging of an Artist*, Mainstream Publishing, Edinburgh, 1991.

Katz, Jonathan, 'The Art of Code: Jasper Johns and Robert Rauschenberg', in Whitney Chadwick and Isabelle de Courtivron (eds), *Significant Others: Creativity and Intimate Partnerships*, Thames & Hudson, London, 1993.

Kemplay, John, *The Two Companions: The Story of Two Scottish Artists, Eric Robertson and Cecil Walton*, Ronald Crowhurst, Edinburgh, 1991.

de Lempicka-Foxhall, Baroness Kizette, and Phillips, Charles, *Passion by Design: the Art and Times of Tamara de Lempicka*, Phaidon, Oxford, 1987.

Ludington, Townsend, *Marsden Hartley: The Biography of an American Artist*, Little Brown and Company, Boston, 1992.

MacDowall, Cyndra, 'Sapphic Scenes: Looking through a History', *Fuse*, Spring 1991, pp. 24–39.

Marsault-R, Ralf (intro), *Athletic Model Guild: 160 Young Americans Photographed by Robert Mizer*, Gay Mens Press, London, 1987.

Marsh, Jan, *Jane and May Morris: A Biographical Story 1839–1938*, Pandora, London, 1986.

Nigro, Salvatore S., *Pontormo Drawings*, Harry N. Abrams, New York, 1991.

Oliver, Cordelia, *Joan Eardley RSA*, Mainstream Publishing, Edinburgh, 1988.

Olsen, Stanley, *John Singer Sargent: His Portrait*, MacMillan, London, 1986.

Saslow, James M., *Ganymead in the Renaissance: Homosexuality in Art and Society*, Yale University Press, New Haven and London, 1986.

Showalter, Elaine, *Sexual Anarchy: Gender and Culture at the Fin de Siècle*, Bloomsbury, London, 1991.

Spalding, Frances, *Dance Till the Stars Come Down: A Biography of John Minton*, Hodder & Stoughton, London, 1991.

Souhami, Diana, *Gluck: Her Biography*, Pandora, London, 1988.

Stanley, Nick, *Out in Art*, GMP, London, 1986.

Taylor, John Russell, *Edward Wolfe*, Trefal Books, London, 1986.

Tom of Finland Retrospective, intro. by Denis Forbes, Tom of Finland Foundation, Los Angeles, and GMP, London, 1988.

Tom of Finland Retrospective, II, Tom of Finland Foundation, Los Angeles, and GMP, London, 1988.

Turnbaugh, Douglas Blair, *The Erotic Art of Duncan Grant 1885–1978*, GMP, London, 1991.

Turnbaugh, Douglas Blair, *Paintings by Patrick Angus (1953–1992)*, Editions Aubrey Walter, GMP, London, 1992.

Watney, Simon, *Policing Desire: Pornography AIDS and the Media*, Methuen, London, 1987.

Watney, Simon, *The Art of Duncan Grant*, John Murray, London, 1990.

Webb, Peter, *Portrait of David Hockney*, Chatto & Windus, London, 1988.

Yorke, Malcolm, *Keith Vaughan: His Life and Work*, Constable, London, 1990.

Index